# KOREA LETTERS IN THE WILLIAM ELLIOT GRIFFIS COLLECTION

# KOREA LETTERS IN THE WILLIAM ELLIOT GRIFFIS COLLECTION

*An Annotated Selection*

EDITED BY
YOUNG-MEE YU CHO
AND SUNGMIN PARK

RUTGERS UNIVERSITY PRESS
*New Brunswick, Camden, and Newark, New Jersey*
*London and Oxford*

Rutgers University Press is a department of Rutgers, The State University of New Jersey, one of the leading public research universities in the nation. By publishing worldwide, it furthers the University's mission of dedication to excellence in teaching, scholarship, research, and clinical care.

Names: Griffis, William Elliot, 1843–1928. | Cho, Young-mee Yu, editor. | Park, Sungmin, editor.

Title: Korea letters in the William Elliot Griffis Collection : an annotated selection / Young-mee Yu Cho & Sungmin Park.

Description: New Brunswick : Rutgers University Press, 2024. | Includes bibliographical references and index.

Identifiers: LCCN 2023018629 | ISBN 9781978828797 (cloth) | ISBN 9781978828803 (epub) | ISBN 9781978828810 (pdf)

Subjects: LCSH: Griffis, William Elliot, 1843-1928—Correspondence. | Griffis, William Elliot, 1843-1928—Sources. | Korea—History—1864-1910. | Korea—History—Sources. | Korea—Description and travel. | Korea—Social life and customs—20th century. | Korea—History—Japanese occupation, 1910-1945. | Missions, American—Korea. | Missionaries—Korea—Correspondence. | Diplomats—Japan—Correspondence. | Diplomats—Korea—Correspondence. | William Elliot Griffis Collection (Rugers University. Libraries)

Classification: LCC DS915.15 .G75 2024 | DDC 951.9/02—dc23/eng/20230811

LC record available at https://lccn.loc.gov/2023018629

A British Cataloging-in-Publication record for this book is available from the British Library.

This collection copyright © 2024 by Rutgers, The State University of New Jersey

Introduction and scholarly apparatus copyright © 2024 by Young-mee Yu Cho and Sungmin Park

Individual chapters copyright © 2024 in the names of their authors

All rights reserved

No part of this book may be reproduced or utilized in any form or by any means, electronic or mechanical, or by any information storage and retrieval system, without written permission from the publisher. Please contact Rutgers University Press, 106 Somerset Street, New Brunswick, NJ 08901. The only exception to this prohibition is "fair use" as defined by U.S. copyright law.

References to internet websites (URLs) were accurate at the time of writing. Neither the author nor Rutgers University Press is responsible for URLs that may have expired or changed since the manuscript was prepared.

♾ The paper used in this publication meets the requirements of the American National Standard for Information Sciences—Permanence of Paper for Printed Library Materials, ANSI Z39.48-1992.

rutgersuniversitypress.org

# Contents

Foreword by Fernanda H. Perrone — ix

Fragments of Information across the Borders
by Soo Hur — xiii

An Appreciation: The Korea Letters and Manuscripts in the
William Elliot Griffis Papers and Anglophone Knowledge
Production about Korea, 1888–1927 by Ross King — xv

Introduction — 1

## Part I    Letters from Missionaries

1    Albrecht, George E. (1894) — 19

2    Allen, Horace Newton (1888–1920) — 20

3    Anderson, Naomi A. (1916) — 55

4    Appenzeller, Henry Dodge (1919–1926) — 57

5    Appenzeller, Henry Gerhart (1890–1891) — 71

6    Becker, Louise S. (1919) — 75

7    Bernheisel, Charles F. (1907) — 77

8    Billings, Helen I. (1920) — 79

9    Cable, Elmer M. (1920) — 81

10    Erdman, Julia Winn (1911) — 83

11    Fletcher, Archibald Grey (1927) — 85

12    Frey, Lulu E. (1916) — 89

13    Gale, James Scarth (1895–1921) — 90

14    Gifford, Daniel Lyman (1895) — 105

15    Gillett, Philip Loring (1902–1905) — 108

16    Gilmore, George William (1893–1919) — 111

17    Griffis, William Elliot (1920) — 120

vi   *Contents*

18   Hall, Rosetta Sherwood (1916) — 124

19   Hulbert, Homer B. (1892–1917) — 129

20   Jones, George Heber (1894–1912) — 174

21   Kerr, Grace Kilbourne (1916) — 180

22   Kerr, William Campbell (1921) — 185

23   Loomis, Henry (Date unidentified) — 188

24   Ludlow, Alfred Irving (1926) — 192

25   Macdonald, D. A. (1920) — 194

26   McCallie, Henry Douglas (1910) — 196

27   McCune, George Shannon (1921) — 197

28   McGill, William B. (1895) — 199

29   Moffett, Samuel Austin (1901, 1913) — 201

30   Morris, Charles David (1911–1916) — 214

31   Morris, Clara Louise Ogilvy (1902) — 219

32   Pieters, Albertus (1914) — 224

33   Swearer, Lillian May Shattuck (1911) — 226

34   Underwood, Horace Grant (1900–1909) — 228

35   Vinton, Cadwallader C. (1903) — 237

36   Walter, Jeannette (1919) — 240

## Part II   Letters from Koreans and Japanese

1   Cho, Hi-yŏm (조희염) (1923) — 249

2   Cynn, Hugh Heung-Wo (신흥우) (1922) — 250

3   Harada, Tasuku (原田助) (1915) — 252

4   Itō Hirobumi (伊藤博文) (1908) — 254

5   Jaisohn, Philip (서재필) (1919–1922) — 260

6   Kim, Ch'ang-hŭi (金昌熙) (1927) — 267

7   Kim, Frank Yongju (김용주) (1927) — 269

8   Kim, Henry Cu (김현구) (1914–1920) — 270

9   Komatz, Midori (小松 緑) (1895–1906) — 279

10   Niwa, Seijiro (丹羽 清次郎) (1927) — 282

Contents    vii

11   Paik, Earl Ku (백일규) (1916) — 283

12   Park, Eun Sic (박은식) and Lee, Kwangsoo (이광수) (1920) — 291

13   Rhee, Syngman (이승만) (1919) — 294

14   Saitō, Makoto (斎藤実) (1920) — 300

15   Shibata, Zenzaburo (柴田善三郎) (1921) — 302

16   Sin, Teh Moo (신태무) (1901) — 303

17   Sonoda, Hiroshi (園田寛) (1923) — 304

18   Usami, Katsuo (宇佐美勝夫) (1912) — 305

19   Watanabe, Noboru (渡邊昇) (1910, 1921) — 306

20   Ye, Cha Yun (이채연) (1890–1892) — 310

Acknowledgments — 315
Index — 317

# Foreword

FERNANDA H. PERRONE (RUTGERS
UNIVERSITY LIBRARIES)

"I have never entered 'the Corea,' as it used to be called, in bodily presence, though often there in thought and study," wrote William Elliot Griffis in 1881.[1] In the late nineteenth century, William Elliot Griffis (1843–1928), who worked in Japan from 1871 to 1874, enjoyed modest fame as an "interpreter" of Japan to the West. His books, articles, and lectures introduced this little-known country to a broad Western audience. A Victorian version of a "talking head," he was also considered an authority on U.S.–East Asian relations in general and particularly on Korea, which Griffis initially considered part of greater Japan. As well as a traveler and prolific author, Griffis was a collector of books, documents, photographs, and ephemera about Japan, Korea, China, and many other subjects. In 2022, the William Elliot Griffis Collection, held by his alma mater, Rutgers University, stands as his most important legacy.

William Elliot Griffis, the fourth child of John Limeburger Griffis and Anna Maria Hess Griffis, was born in Philadelphia in 1843.[2] His father was a prosperous coal trader. John Griffis's coal business suffered badly, however, in the financial panic of 1857, forcing his son, after graduating from high school in 1859, to apprentice for a few months to a Philadelphia jewelry firm. This early experience of poverty profoundly influenced Griffis, leading him to constantly seek extra income through tutoring, writing, and lecturing. In June 1863, as the U.S. Civil War raged, he enlisted as a private in the Forty-Forth Pennsylvania Regiment, barely missing the Battle of Gettysburg. After completing his three-month term of military service, Griffis enrolled in Rutgers College in New Brunswick, New Jersey, at that time a small men's institution affiliated with the Dutch Reformed Church.

After graduating from Rutgers in 1869, William Elliot Griffis studied at the neighboring New Brunswick Theological Seminary for a year before he received, through Reformed Church missionary Guido Verbeck, an invitation to teach chemistry and physics in Echizen, today in Fukui Prefecture, in the west of Japan. The offer included a house, a horse, and a handsome salary that was particularly attractive to Griffis because of his family's continuing financial difficulties. After less than a year in Fukui, Griffis moved to Tokyo, where he taught at the *Kaisei Gakko*, a forerunner of Tokyo University. During this period, Griffis first became interested in Korea; apparently while teaching in Tokyo in 1874, he visited the island of Tsuruga, from which he could see the Korean Peninsula.

ix

In 1874, Griffis left Japan after a conflict with the Ministry of Education over his teaching contract. He settled in New York, where he threw himself into writing and lecturing, publishing his first and most famous book, *The Mikado's Empire*, in 1876. After studying at Union Theological Seminary, Griffis served as a pastor of three churches—the First Reformed Church of Schenectady, New York (1877–1886); Shawmut Congregational Church in Boston (1886–1893); and the First Congregational Church in Ithaca, New York (1893–1898). In 1879, Griffis married Katherine Lyra Stanton (1855–1898) of Schenectady and the couple had three children. Throughout this time, he constantly wrote, published, and delivered lectures to augment his clergyman's salary. In 1903, Griffis retired from the ministry to devote himself full-time to his research and writing.

In his lifetime, William Elliot Griffis authored over fifty books and innumerable journal articles and entries in encyclopedias and reference books, including a great many on Japan, East Asia, and the American role in the Pacific, not to mention the Netherlands, American history, and many other subjects. Griffis was an avid reader and collector on all subjects that concerned East Asia, especially Japan, China, and Korea. Although Griffis did not travel to Korea until 1927, he was knowledgeable about the country's culture and politics. An accomplished networker, he maintained an active correspondence with missionaries, educators, and government officials in Korea, who sent him books, photographs, and documents that he used in his research. Griffis's first known publication about Korea was "Corea: The Last of the Hermit Nations," which appeared in the *New York Sunday Magazine* in May 1878. In 1882, he produced his most famous book about Korea, *Corea: The Hermit Nation*, which appeared in nine editions between 1882 and 1909. This work was followed by *Corea, Within and Without* (1885), *A Modern Pioneer in Korea: The Life Story of Henry G. Appenzeller* (1912), *The Unmannerly Tiger and Other Korean Tales* (1911), and *Korean Fairy Tales* (1922), in addition to many newspaper and magazine articles on Korea.

In 1926–1927, William Elliot Griffis at last returned to Japan with his second wife, Sarah Frances King Griffis (1868–1959) of Pulaski, New York. In the course of the 2,000-mile trip, he visited the four main islands of Japan, visited Manchuria, and spent several weeks in Korea, where he visited Seoul and a leper colony, gave lectures, and collected much material. Griffis died suddenly the following year while staying in Winter Park, Florida.

In late 1928, his widow Frances King Griffis donated his extensive collection of books, manuscripts, photographs, documents, and ephemera to Rutgers, where they constitute the William Elliot Griffis Collection at Rutgers University Libraries. Rutgers professor and Griffis scholar Ardath Burks has described Griffis as a "saver of string." Indeed, the Griffis Collection is voluminous, comprising 250 manuscript boxes and thousands of photographs, maps, prints, and rare books. Frances King Griffis had to rent half a boxcar to transport the collection to Rutgers from upstate New York. In the 1960s, the collection was augmented by Griffis's granddaughter Katherine G. M. Johnson and other family members, who donated materials including Griffis's diary of his trip to Korea. Additional books

and manuscripts related to Westerners in Japan and Korea during the late nineteenth and early twentieth centuries have been acquired by purchase.

Among the most important Korean materials in the Griffis Collection are two boxes of letters received by Griffis from missionaries, including Henry G. Appenzeller and Horace G. Underwood; U.S. and Japanese government officials; and prominent Koreans including future president Syngman Rhee, Eun Sic Park, Kwangsoo Lee, and Philip Jaisohn. The letters show Griffis's development from a supporter of Japan's colonial project in Korea to a sympathizer with the Korean independence movement through the influence of exiles whom Griffis met in the United States. Although first described in 1960 by Ardath Burks and original Griffis curator Jerome Cooperman,[3] it was only in the mid-2000s that the true significance of the Korean material was recognized and publicized by Professor Young-mee Yu Cho of Rutgers's Department of Asian Languages and Cultures. In this volume, Professor Cho and Sungmin Park have meticulously transcribed each letter and added much-needed annotations identifying the individuals and events referenced. Over the past twenty years, numerous researchers from Korea, the United States, and elsewhere have come to Rutgers to view the letters or have used the microfilm version. The handwritten letters are difficult to read, however, and lack context. The publication of this volume will greatly enhance the useability of the letters, particularly for students and international scholars. By making the letters accessible and comprehensible to a wide audience, this book makes an important contribution to the understanding of modern Korean history and U.S.-Korean relations.

NOTES

1. Wm. Elliot Griffis, "Corea, the Hermit Nation," *Journal of the American Geographical Society of New York* 13 (1881): 125.

2. Fernanda H. Perrone, "The Griffis Family of Philadelphia," in *Phila-Nipponica: An Historic Guide to Philadelphia and Japan* (Philadelphia: Japan Society of Greater Philadelphia, 2015), 163–168.

3. Ardath W. Burks and Jerome Cooperman, "The William Elliot Griffis Collection," *Journal of Asiatic Studies* 20, no. 1 (July 1960): 61–69.

# Fragments of Information across the Borders

SOO HUR (PROFESSOR OF HISTORY,
SEOUL NATIONAL UNIVERSITY)

The Griffis Korea Letters are being published. William E. Griffis is best known for his role as a writer who informed the Western world of Korea with his publication of *Corea: The Hermit Nation* (1882). As a Korean historian, I am very excited to welcome this invaluable resource into the world. At Professor Young-mee Yu Cho's request, I am adding a few words here.

There are 370 letters in the Korea Letters section of the William E. Griffis Collection, the majority of which were addressed to Griffis directly. The letters dated from the year 1874, right after Griffis left Japan for the United States, until 1927, one year before his death. As letters that are sent to someone presuppose a receiver, the collection of Korea Letters directly and indirectly reveals Griffis's unique interest in Korea. The period covered by the letters is one of the most tumultuous periods of change in modern Korean history. Korea, which had been a member of East Asian Confucian civilization for millennia, suddenly encountered the capitalistic, material civilization of the West. As the clash of Eastern and Western civilizations intensified, the traditional social order premised on ascriptive status began undergoing a reconfiguration. I believe the unique characteristics of modern Korean history can be found in the transformation of the emerging social order in the complex context of the imperial-colonial nexus among the East Asian countries of the late nineteenth century.

The main function of correspondence is connecting people of different localities. Therefore, it is essential to understand the Griffis Korea Letters in terms of space. The Korean geo-space of the time was undergoing an unprecedented transformation. For years, the Korean Peninsula had belonged to the periphery of East Asian civilization, but with the opening of the country Korea suddenly emerged as the borderland where East and West began to clash. Even after colonization by Japan, Korea continued to maintain its border status. The clash of civilizations can be understood as a long-lasting process that indelibly penetrates a society to a microscopic level. Griffis, who was positioned on the outside of the border, diligently collected and systematized extensive information on Korea when he worked in Japan as a modern educator as well as after his return from Japan to the East Coast of the United States. For his writing, he needed firsthand

xiii

information from people working on the ground in Korea. Horace Allen, Henry G. Appenzeller, James S. Gale, Homer B. Hulbert, and Horace G. Underwood, among other Western missionaries, served as valuable informants on the ground. In this respect these letters are analogous to messages sent by carrier pigeons.

The perspective of an outside observer maintained by Griffis leaves behind a blind spot, irrespective of his personal passion, diligence, or intentions. For instance, in his book *Corea: The Hermit Nation* he devoted two pages to the foundation of Tonghak and the 1893 movement to exonerate the name of the Tonghak founder. A new religious movement known as Tonghak (Eastern Learning) was founded by Ch'oe Che-u, who was executed in 1864 by the state, which was threatened by his call for sweeping social reform. Tonghak leaders petitioned for the posthumous exoneration of Ch'oe's honor. Meanwhile the Tonghak Revolution of 1894, a significant historical event that led to the Sino-Japanese War, received only four to five lines in the book. The leader of the Tonghak Revolution, Chŏn Pong-jun, was not even mentioned, in contrast to a rather detailed account of Ch'oe Che-u. Perhaps this has something to do with Griffis's focus on religious issues as a Christian missionary. However, it is also very likely that it could be attributed to a different viewpoint that he adopted in assessing Korean history. For Griffis, the "clashes" in the borderland remained in the background while the task of civilizing a "barbarian" society was foregrounded. The letters will illuminate how to interpret such idiosyncratic discrepancies we find throughout his books.

I expect this book to be of great use for the reasons listed below. First, it will provide a most relevant example in examining the process of knowledge formation in the West and the resulting knowledge structure with regard to Korea. Second, it will stimulate future research that will lead to a much more nuanced view about Korea that Griffis might have held throughout his life. So far, the research on Griffis has been mainly based on his publications. Third, it will provide novel clues that could illuminate many unknown details about the Korean independence movement of the 1920s. Besides, fragments of information contained in the Korea Letters, whether big or small, will work as mirrors that reflect myriad facets of modern Korean society.

In conclusion, I expect the letters to be utilized in the important task of "contextualizing" outside perspectives. Every act of observation carries with it its own unique blind spots. Just as there are blind spots resulting from Griffis's foreign perspective that I mentioned above, the Korean "internal" view of history also cannot avoid carrying blind spots of its own. A concept of history that is absolute and nonchanging does not exist and, therefore, I can say that it is rather fortunate to obtain more mirrors that reflect history. Today we witness ever-increasing global interest in Korean society and culture. No doubt Korean history is inextricably part of world history. The thought-provoking letters from a century ago in the Griffis Collection will allow for new ways of understanding Korea by unsettling any unitary historical framework. I give my sincere compliments to the people at Rutgers involved in this long and tedious project of transcribing handwritten letters to make the content available to the public.

# An Appreciation

THE KOREA LETTERS AND MANUSCRIPTS IN
THE WILLIAM ELLIOT GRIFFIS PAPERS AND
ANGLOPHONE KNOWLEDGE PRODUCTION
ABOUT KOREA, 1888–1927

ROSS KING (UNIVERSITY OF
BRITISH COLUMBIA)

Young-mee Yu Cho and Sungmin Park are to be congratulated for this carefully curated and richly documented collection of fascinating letters from the William Elliot Griffis Collection at Rutgers University. While the Griffis letters are interesting enough in the broader context of the history of American faith-based/missionary engagement with the "Orient" during the heady two decades or so on either side of the beginning of the last century, they are particularly useful to students of the history of Protestant missions in Korea and especially to those of us trying to unravel the missionary contribution to and impact on modern knowledge production about Korea. In this short "appreciation," I therefore highlight what I found to be some of the more interesting and intriguing nuggets buried here and there throughout the letters. For convenience's sake, I divide my appreciation into the following sections:

A Missionary Republic of Letters: Griffis's Epistolary Network
Missionary Praise for Griffis's Publications—Especially the *Hermit Kingdom* Book
Korea Watcher in Absentia: Griffis's Tireless Attempts to Chase Down Data and Sources
Revealing (and at Times Gossipy) Insights into Other Observers of Korea
Life under Japanese Colonialism

## A Missionary Republic of Letters: Griffis's Epistolary Network

The first impression that emerges from a thorough acquaintance with the Griffis letters is the extent of Griffis's personal epistolary network. Though Griffis himself never visited Korea until the very end of his life in 1927, he made up for this lack of direct personal experience in Korea with a thriving correspondence that connected him in one way or another—often quite intimately—with virtually every notable leader and opinion maker in the Korean missionary and diplomatic

community. And although the bulk of the letters are responses to missives from Griffis, the originals of which are no longer available, it is easy enough to discern in these replies to Griffis his main interests and obsessions: Korean history writ large, religion in Korea (but especially the progress of Protestant missions), the place of women in Korea, photographs (this bordered on an obsession, as it is clear he was constantly pestering his correspondents for "pictures" and photographs), and language and writing in Korea—especially the role of the Korean alphabet in modernizing Korea.

Griffis's correspondents included US missionary-turned-diplomat Horace Newton Allen (1858–1932) (to whom Griffis dedicated his *Unmannerly Tiger and Other Korean Tales* of 1911), Korean diplomats posted to the Korean legation in Washington, DC, leaders of the Korean independence movement like Syngman Rhee (1875–1965) and Hugh Cynn (Sin Hǔngu 申興雨, 1883–1959), prominent Japanese and Korean Christians, high-placed officials in the Government-General of Korea (including governors-general themselves), and of course a wide range of Western missionaries based in Korea.

It was these Western missionaries who provided the great bulk of both raw information and interpretation to Griffis for his writing projects, and two names in particular stand out: the Appenzellers and Homer Bezaleel Hulbert (1863–1949). In the case of the Appenzellers, there are letters in the archive from pioneer Methodist missionary Henry Gerhard Appenzeller (1858–1902) himself, but also letters to Griffis from his wife Ella Jane Dodge Appenzeller (1854–1916) and from all of his children: first child Alice Rebecca (1885–1950), Henry Dodge (1889–1953), Ida Hannah Appenzeller Crom (1891–1955), and Mary Ella Appenzeller Lacy (1893–1963). Griffis's intimate connection to the Appenzellers can be seen from his sympathetic and detailed biography of Henry Gerhard Appenzeller, *A Modern Pioneer in Korea* (Griffis 1911).

But Griffis's close ties to this remarkable missionary family (Henry Gerhard founded Paejae Haktang, the school for boys, and his daughter Alice served as president of Ewha Womans University from 1922 to 1939) can also be sensed from the letters themselves. More so than with any other letters in the collection, the tone is intimate, as if writing from one family member to another. For example, on December 4, 1926, Henry Dodge, upon learning that Griffis has arrived in Japan en route to Korea for his first visit ever to the Land of Morning Calm, writes, "Welcome to Japan and to the Land of Morning Splendor! . . . The tribe of Appenzellers extends open arms to you and what little we have is yours so long as you are with us." Henry Dodge's letters also reveal occasional insights into missionary life—both its lighter moments and its denominational squabbles. In a letter dated January 30, 1921, Henry relates to Griffis an anecdote about Western missionaries in Korea who enjoyed delicious Korean persimmons for breakfast, and he spoke fondly of Korea as the "land of the morning *kam*" (*kam* being the Korean word for "persimmon"). In the same letter, Henry (a Methodist, recall) makes a disparaging remark about P'yŏngyang as "the center of Presbyterianism and therefore pre-mil-ism and conservatism."

In many ways the most detailed letters belong to the pen of Homer Hulbert, who was clearly an important source of Korean historical information for Griffis. But Homer's letters are also full of insights into Hulbert's own research and projects. One such project of Hulbert's that has won him an honored place to this day in South Korean history and church circles was his campaign against sinographs ("the Chinese character") and Literary Sinitic (*hanmun*) and in favor of the Korean vernacular script. Thus, as early as May 10, 1892, Hulbert writes to Griffis, "I hope in a day or two to send you a geography of the world in Korean which I published just before leaving Korea. I wrote it in the native character rather than the more scholarly Chinese because I wanted to help along the good work of popularizing the native character and weaning the people from their absurd prejudice in favor of the Chinese. This decision on my part insured the financial failure of the scheme but money has been well lost."

A few months later, on September 26, 1892, Hulbert continues about his campaign on behalf of the vernacular script, and his affirmation of Korea's abiding respect for literary culture accords well with observations made in later years by Canadian missionary James Scarth Gale (1863–1937):

> The work to be done in Korea is first and foremost to set in motion some sort of sentiment which shall point in the direction of popularising the true Korean alphabet as distinguished from the Chinese. That work has already been begun. Before I came away I saw a change begun in this particular. Koreans have told me that within two decades the Chinese character will be discarded in that country. That was a very sanguine estimate and yet I am sure it will come sooner or later. The reason of this is two-fold. In the first place the idea of literary culture can never be eliminated from the Korean mind. Nor would anyone desire to have it so eliminated for it is the one bright spot in the darkness of their lives. The second reason is that the Koreans are coming to see and will come more and more to see that they have not the leisure to prosecute the study of the Chinese character as they have always done.

Other letters from Hulbert give precious insights into his history writing projects—projects that he began substantially earlier than Gale began his. On December 11, 1893, he wrote to Griffis, "Korean History is my special Fad. I am now having the Tong Kuk Tong Gam [*Tongguk T'onggam* 東國通鑑, General Chronicle of Korea] copied. It is a heavy 27 volume work and gives a most thorough and interesting account of Korean history from the earliest times. I have already translated another Korean history of even greater value & these two together with others in my possession will furnish abundant material for a history of Korea." Unfortunately, Hulbert's letter does not offer more details on this "translation" work, but it is safe to assume he was translating not from *hanmun* but from Korean cribs prepared for him by a Korean scholar capable of navigating the *hanmun* sources. Incidentally, this and other letters also reveal that Hulbert had sold various antiquarian books and maps to the British Library, so here too Hulbert was a step or two ahead of J. S. Gale, who later purchased hundreds of antiquarian

books for the Asiatic Society in New York and the Library of Congress (among other collections—see King 2012 and forthcoming for details).

What has never been clear about Hulbert and his work on Korean history is whether he actually learned *hanmun* well enough to use the sources on his own, or whether he relied entirely on Korean scholars to translate them for him. I have yet to encounter any evidence that Hulbert learned *hanmun* to any degree of comfort (unlike Gale, who clearly did, while relying heavily on Korean "pundits" whom he nonetheless named and thanked); given Hulbert's especially vocal and vehement opposition to the use of "the Chinese character" by Koreans and his generally antisinographic sentiment, it would be surprising if he had ever made an investment like this. So it is interesting to find in one of his letters to Griffis dated November 30, 1896, the following: "When I returned to Korea in 1893 I immediately plunged into the interesting field of Korean History. I found a man who for 6 years was a secretary to His Majesty and who had spent fourteen years in working up the history of the present dynasty. I have also had access to some rare manuscripts which help me to carry the ancestry of Kija back some thirteen generations and which give a detailed account of the Kija dynasty. This is a ms that has just come to light in Pyeng Yang among descendants of Kija himself."

The nature of and identity of these "rare manuscripts" will have to remain a mystery. Hulbert does not name the mysterious Korean individual either, but it is almost certainly Yun Ki-jin 尹起晉 (dates unknown), compiler of *Taedong Kinyŏn* 大東紀年 (Chronology of the Great East, the work alluded to in another of Hulbert's letters to Griffis, dated February 18, 1900: "I have had a long hard time getting the history of the present dynasty in Korea printed in Chinese in Shanghai but it is almost done now and will be out this Spring. It is in five volumes and will circulate somehow in Korea and China." According to Yun Kyŏngno's short description of this work in the online *Han'guk minjok munhwa taebaekkwa sajŏn*,[1] Yun worked from 1883 until July 1884 as a low-level official in the T'ongni Amun (Foreign Office). Hulbert confirms final publication of this book in a letter dated December 5, 1903: "I have just published the history of the present Korean dynasty in Chinese 5 vols. 547 pp or rather leaves.[2] It sells here like hot cakes. The first lot of 100 sets from Shanghai went off in 48 hours and dozens of applications are filed waiting a new invoice for which I have cabled to Shanghai. I have heard some extravagant words about it all of which must be heavily discounted. You know the Koreans have absolutely no history of the last 120 years. I bring the history down to 1896." Given the lack of any evidence that Hulbert had the *hanmun* skills to undertake a project like this on his own, it is curious that he makes no mention of Yun Kijin's role and takes credit for the authorship of this book himself.

In another letter on the topic of historical research, Hulbert (June 22, 1901) makes an interesting comparison between historiographical practices in Korea and Japan: "The grand difference between the ancient records of Korea and of Japan is that in the Korean records the supernatural is the exception & not the rule, while in the Japanese records it is only once in a while that you meet anything that could even be guessed to be history."

## Missionary Praise for Griffis's Publications—Especially the *Hermit Kingdom* Book

We have already seen the breadth and depth of Griffis's epistolary network within the missionary community in Korea. First published in 1882, his seminal work (and the book responsible for the enduring but in many ways inaccurate epithet "Hermit Kingdom" for Korea) *Corea: The Hermit Kingdom* was required reading for new arrivals in the Korean missionary field, so in this sense Griffis was already a household name in the missionary community. But what emerges from the letters is a genuine sense of not only gratitude for Griffis's book (and other writings on Korea), but also amazement and wonder at how Griffis could write such works without ever having set foot in Korea. Here are some examples attesting to the appreciation felt for Griffis—typically expressed in letters responding to requests from Griffis for precisely the information that was channeled into his writing and research.

> *Henry Gerhart Appenzeller (March 10, 1890): "I have the pleasure to acknowledge the receipt of "Corea: The Hermit Nation 3d-Ed."[3] and in the name of the mission to sincerely thank you for your magnificent work on Korea. The book will be placed on the shelves of the Library of our school, Pai Chai Hakdang—Hall for rearing useful men, where it will be read not only by us foreigners but by some of our students. I congratulate the reading public in the U.S. that the best work on Korea is by an American."*

> *Daniel L. Gifford[4] (March 13, 1895): "Considering however the size & scope of the work, the few blemishes which I have been able to detect with the aid of the microscope, affect very slightly the solid merit of the book. Indeed we think it remarkable that a person who had never seen the country, should be able to write a book of such permanent value upon Korea. It may be a source of some satisfaction to you to know that the Manual of the Presn Mission (North) requires your new "Corea the Hermit Nation," as being the standard work upon Korea."*

> *Horace Allen (July 24, 1895): "You are still the authority on Korea. By the way, why don't you visit the country for which you have done so much. I will agree to get you an audience and see that the King appreciates you." Then ten years later Allen again writes (May 24, 1905), "You seem able to write of places and people where you have not been and whom you have scarcely seen."*

> *James Scarth Gale (May 7, 1904): "Even though your thoughts and just heart are much in the Far East you cannot know how thoroughly your name has become a household word and familiar to diplomats and to missionaries alike, held in esteem and respected and loved by all."*

> *Homer Miller, writing from Western Theological Seminary in Allegheny, Pennsylvania (January 7, 1907): "I was delighted more than words can express by the receipt of a copy of your scholarly and charming work, "Corea the Hermit Nation." Having read most of the books written on Korea there is no doubt in my mind that your work is the standard history of Korea."[5]*

*Lillian May Swearer, writing from Kongju in Korea (August 10, 1911): "We are glad to hear you are to add a chapter to your book, "Corea: The Hermit Nation" but as to letting it drop out of public view, I hardly think other people will let it. It is read by all the missionaries for it is in the second year's course of study. I have often thought and have heard others express the same, that if is quite remarkable that one who has never been in this land could depict the life and customs so accurately."*

Koreans too were generally quick to note their gratitude to Griffis, but the following letter from two towering intellectuals of the colonial period, historian and independence fighter Park Eun Sic 朴殷植 (1859–1925) and novelist and father of modern Korean literature Lee Kwangsoo 李光洙 (1892–1950), also allows a much more cynical and patronizing reading. The letter is dated June 23, 1920, and was sent from Shanghai—presumably from the Republic of Korea (ROK) government in exile: "It is an undisputed fact that your former work 'Corea, the Hermit Nation'. although seriously mistaken in minor details in certain places, is one of the best, if not the best, records of Korean history existing. We are afraid that we can not be of very much assistance to such a great scholar as you are, but we will do our best to furnish you in so far as possible all the data and facts that you care to incorporate into your new book."

The letters in the Griffis archive also include correspondence with publishers like Fleming Revell, Charles Scribner's Sons, and Harper and Brothers. Prolific and well connected as he was, Griffis clearly had no major problems finding publishers for his works, but we know from the experience of James Scarth Gale during the same period that it was never easy to persuade publishers to take on titles related to Korea—the market and reader interest simply were not as strong as they were for works on Japan or China. There are indications in the Griffis letters that even he was challenged at times to place his books. For example, a letter from Harper and Brothers (August 22, 1919) states, "[W]e wish to thank you for having proposed the matter of a history of Korea to us. . . . Even with the generous suggestion of Dr. Rhee [Syngman] that he would provide for the sale of five hundred copies, we do not believe that there will be enough in the book commercially to make it worthwhile either for you or for us to publish it. . . . We have no doubt at all of the interest of the book, but we do have much doubt as to the interest of the American reading public in Korea."

## Korea Watcher in Absentia: Griffis's Tireless Attempts to Chase Down Data and Sources

It is clear from the majority of the letters to Griffis that they are responses to specific requests (often quite long and detailed lists of questions) for information— for data, observations, photographs and photographers, introductions, and so forth. In short, one of the secrets to Griffis's productivity appears to have been spending inordinate amounts of time writing letters to everybody he could think of and constantly pestering them for raw material for his writing and research. As can be seen from the appreciations of the missionary community above, another

secret to his success was that most of his interlocutors were only too happy to oblige. In the case of missionaries in particular, an added reason for their cooperation was that so many of them felt too overwhelmed by their day-to-day duties in the field to make the time to write anything themselves. Here below are some tidbits gleaned from the letters about Griffis's ongoing quest for source materials.

In King (2019), I noted that Griffis (1911, 187–188) describes two Korean "novels" in his possession. Though he does not name them, they too are among the materials in the Griffis archive at Rutgers University and turn out to be *kyŏngp'an* (Seoul commercial xylographs) editions of *So Taesŏng chŏn* (The Tale of So Taesŏng, in 23 leaves) and *Yang Sanbaek chŏn* (The Tale of Yang Sanbaek, in 24 leaves). In a footnote I wrote, "He must have received them as a gift from Appenzeller or some other westerner in Korea prior to 1912," but the letters now allow confirmation of how and when he acquired them. In a letter dated November 27, 1890, Horace Allen wrote, "[I]n reply I will say that I am sending you a couple of Korean novels such as the common people read. The photographs I will have to give up." And again on December 12, 1890, "By last mail I sent you a letter and a roll of two Korean novels. How are you going to read them?" This makes these two vernacular narratives (*kojŏn sosŏl*) among the earliest to arrive in a Western nation, rivalled only by the collection of sixty or so books (mostly similar vernacular narratives) acquired by German linguist and polyglot Georg von der Gabelentz (1840–1893) and mobilized in his pioneering paper of 1892 on Korean writing and phonetics.[6]

In a letter dated December 18, 1894, George Albrecht supplies information in reply to a query from Griffis about papers and letters by George Clayton Foulk (1856–1893), a U.S. Navy officer who served as U.S. naval attaché to the kingdom of Korea in 1876. At the time, the papers were held by members of the Foulk family, but now they are held by the New York Public Library.[7]

In a letter dated June 18, 1894, George Heber Jones, one of the most scholarly of the missionaries in Korea, writes in response to what must have been detailed questions about historical literature and literature more generally. The theme of difficulty of access to historical sources runs throughout Griffis's correspondence: "In reply to your questions, I would state that 1) The historical literature is quite full & complete but outside certain common and printed works is hard of access. It is preserved in written or mss copies in private libraries. 2) The historical novel exists and is very popular in Korea. In the place of circulating libraries we have reading guilds. 3) The Koreans know little concerning the art of book illustrations. 4) No signs whatever of a literary revival."

James Scarth Gale, another of the more literary and scholarly missionaries, does not figure in the Griffis letters as much as I had hoped, but here he is in a letter from August 23, 1910, reiterating this point by Jones concerning the difficulty of finding written sources in Korea: "Korea is not a bit like Japan, where they have all the pretty things within reach and written out in picture and character, on wood and metal and paper. She has nothing at all that takes the place of these, everything is tumbledown, lost, gone to ruin, missing, spoiled, out of reach of

any satisfactory contact." Gale also turns up much earlier in the Griffis letters, in a letter dated April 12, 1895, responding to a question from Griffis about the status of Buddhism in Korea: "Buddhism has for four centuries now been in disgrace in Korea. The natives treat all priests with lowest forms of speech. Even the abbot of a large monastery is addressed as a coolie. The new regime is attempting reforms in this but I understand that Buddhists are to be admitted to the capital & Buddhism has much power in a secret way in Korea but it is heeded with marked contempt by masses not in any hostile way but simply as a pompous elder would treat a small child—the pompous elder is Confucianism which is the vehicle for the handing down of Korean pride or perhaps I should say, conceit from one generation to another." Needless to say, these remarks by Gale contain sociolinguistic insights as well as a glimpse into how some of the missionaries perceived Confucianism.

A letter from C. D. Morris of the Board of Foreign Missions, dated July 11, 1916, seems to be replying to detailed questions from Griffis about girls and women in Korea—how they are named, how they are educated, whether Japanese Christian women have taken up their cause, and so forth. Another letter, from Gerald Bonwick, chief secretary of the Christian Literature Society, dated June 3, 1921, sheds some light on why copies of *Korea Magazine*—a magazine edited and authored virtually single-handedly by James Scarth Gale from 1917 until 1919— were so difficult to find: "I regret that it is not possible to send you any copies of the "Korea Magazine" from this country. As you are probably aware the magazine was a private venture and the owner, Rev. S. A. Beck, after he went to America had the whole of the stock of all back numbers sent to him there at great expense. Your only hope, therefore, of getting complete volumes, or back numbers is to apply to him."[8]

The Griffis papers also include signs of substantial correspondence with officials at the highest levels in the Government-General of Korea (GGK) about research materials published in Japanese. For example, a letter from Watanabe Noboru (apparently in the GGK), dated April 5, 1921, reveals that an earlier query from Griffis was forwarded to one "Mr. Kanjiro Oda," who in turn passed it on to no less a figure than Yi Nŭng-hwa (李能和, 1869–1943), pioneer scholar of the history of religions in Korea, who "took such pains in writing his answer that it made quite a volume consisting of 550 pages! In this considerable document Mr. Li [Yi] deals principally with Confucianism in Korea." The otherwise unidentified Mr. Oda is Oda Kanjirō 小田幹次郎 (1871–1929), a judge and official in the GGK who wrote a great many scholarly articles about Korea topics, including about Korean movable type and a notorious piece about the production of the 1920 *Chōsengo Jiten* or *Dictionary of the Korean Language* in which he predicts that the Korean language will essentially atrophy and die under Japanese rule (see Oda 1918, 1920, 1931a, b).[9]

Although the letters mostly comprise responses to Griffis's appeals for information and sources, they also reveal his own status as a go-to source for all manner of information on Korea. For example, the letter dated November 21, 1894, from an employee-philatelist of the New York Central and Hudson River Railroad Co.,

makes a number of detailed but well-informed inquiries to Griffis concerning Korean postage stamps and the status of the Korean postal service.

## Revealing (and at Times Gossipy)
## Insights into Other Observers of Korea

As the letters to him reveal, Griffis was the consummate "Korea hand" and Korea observer, albeit a vicarious one, and the Korean missionary scene, at least, appreciated him for it. One interesting theme that emerges from the letters is the low opinion that many of his correspondents had about Korea observers from outside the missionary field, whom they typically deemed unqualified or unfit to pass judgment—and sometimes his correspondents make gossipy or even disparaging remarks about fellow missionaries. For example, Horace Allen was not shy about sharing his low opinion of both Homer Hulbert and "Soh Jay Pill" (Sŏ Chae-p'il 徐載弼, 1864–1951)/Dr. Philip Jaisohn) in a letter dated August 7, 1920: "Last summer Mr. F. A. McKenzie, Ed. London Daily News, wrote me pressing for data to be used in revising his book on Korea. . . . I now have his book which I am mailing to you to look over and return to me. . . . I see he fell under the influence of Soh Jay Pill. Dr. Philip Jaisohn and Homer B. Hulbert—the two most flighty and unreliable, not to say dangerous advocates Korea has ever had. . . . In fact I have never been able to read through, anything of Hulbert's. Dr. Morrison of the London Times Peking said of him once after interviewing him at length, 'He is an inexhaustible source of unreliable information.'"

Horace Allen was also quite critical of George Kennan (1845–1924) for the racist and disparaging picture of Korea that he painted in the American press, especially since Kennan had the ear of President Roosevelt at the time. In a letter dated October 24, 1905, just after the Russo-Japanese War, Allen wrote, "I find it very difficult in view of the one sided and contemptible articles of Geo. Kennan, to write, for I dont want to over praise the Koreans nor do I wish to seem to support Kennan's articles written in the interest of the Japanese and to secure the withdrawal of the foreign legations and to pave the way for the establishment of something stronger than the present Japanese protectorate in Korea. That man's pen seems to be for hire." Allen refers here to articles like Kennan (1905a, b, c) and Kennan's characterizations of Korea as a "degenerate" state and praise for Japan's designs on Korea.

Homer Hulbert dishes up some dirt of his own in a letter dated April 29, 1894, not to Griffis but to George W. Gilmore (1857–?; in Korea with the North Presbyterian mission from 1886–1889), author of *Korea from Its Capital* and *Corea of Today*.[10] His remarks concern Horace Grant Underwood (1859–1916) and James Scarth Gale: "Underwood is the same old fellow. A tremendous worker but jammed into the hole as hard as all the other members of the mission can jam him and they are a big crowd. You did not know Gale did you. Well, he is a smart fellow but he is furiously jealous of U[nderwood] that if U. says white is white he will swear it is black. At the same time I would give more for U. than all the rest of them put together so far as mission work goes." In another letter (this time to Griffis), Hulbert (Jan. 8, 1904) dismisses the new book of British journalist Angus Hamilton

(1874–1913), , *Korea*:[11] "I have word that an Angus Hamilton has published a book on Korea in London. He was here about two weeks!"

If Hulbert was rather spiteful in his remarks about James Scarth Gale, Gale is more measured in his words about Hulbert in a letter to Griffis dated August 23, 1910: "Since Hulbert's going it has been harder than ever. I regret more than I can tell you his campaign against the Japanese here. It has done the Koreans no good and has lost them one of their best and most influential friends, as Hulbert certainly was. We miss him as a friend and an inspiration. His views were not only extreme and in many cases overdrawn, but his giving expression to them gave these childlike people a notion that he would deliver them body and soul from the dominance of the Japanese. I speak specially of Hulbert in answer to your question, as he was our literary man and no one has arisen to take his place." Gale's condescending remarks about the Koreans aside, these are humble words from someone who was already recognized as the "literary man par excellence" of the Korean missionary community by 1910.

Another writer on Korea who attracted the ire of missionaries on the ground and presuming themselves more "in the know" was George Trumbull Ladd (1842–1921). In a letter dated July 14, 1911, Julia Winn Erdman had this to say about Ladd's *In Corea with Marquis Ito*:[12] "[H]ow misleading investigation can be is strikingly illustrated in the case of Dr. Ladd's futile and unreliable portrayal of conditions under the Protectorate." Erdman (1885–1961; served in Korea 1907–1929) was the wife of Walter C. Erdman (1877–1948; in Korea from 1906 to 1931).

### Insights into James Scarth Gale

I have already noted that there are disappointingly few letters from James Scarth Gale in the Griffis archive, but when we recall that the James Scarth Gale papers at the University of Toronto contain precious little in the way of correspondence, every letter one can find by Gale in other repositories is nonetheless potentially valuable. In this respect, there are still some epistles of note here.

First is a personal letter from Gale to Griffis dated August 23, 1910, where he writes:

> It is one of my great advantages now to have Mrs Gale able to speak Japanese. She came out to Japan in 1880 and has lived there nearly all her life. As she was only four when she came to the East she has no recollection of a time when she did not know Japanese. For her to speak it so well brings not only myself into sympathetic relation with the Japanese but is a help to the whole Mission. She has also a sympathetic knowledge of the Japanese, and this serves so good a part just now. Any antagonistic spirit on the part of the foreigner is unconsciously imparted to the Koreans and does very much harm. Only a kindly spirit and wide sympathy extended can help at such a time as this. It is an intensely interesting world and one in which you could be deeply absorbed in if you were here."

Gale married his second wife, Ada Louise Sale, in 1910, and as he notes here, she grew up in a missionary family in Japan. Gale's account here of how beneficial her knowledge of Japanese was, not only to him personally but to the mission as a whole, is fascinating, especially in light of the way Gale—quite unfairly—was branded already during Japanese colonial times as somehow incorrigibly and irredeemably "pro-Japanese." Indeed, this accusation appears in one of the letters from Henry Dodge Appenzeller dated March 18, 1919, where he writes, "But I don't want to get off on a tirade now. Suffice it to say that Dr. J. S. Gale, whom you no doubt know, has been since the annexation in favor of the Japanese, openly so—so much that the Koreans have circulated malicious rumors about him—but now he has gone from admitting that they have made a failure in these ten years of trial, to a more positive position of affirming that he will fight the thing." And indeed, the Gale papers at the University of Toronto show quite clearly that, although Gale initially held high hopes for Japanese rule in Korea, these gradually faded, and they were dashed completely in the wake of Japan's reaction to the March First Movement of 1919.

I have mentioned earlier how Gale—unlike Hulbert—made a serious investment in learning Literary Sinitic and indeed surrounded himself with learned Korean "pundits" (his term) to help him read *hanmun* sources, often co-translating such sources with his Korean collaborators, to whom he almost always gave due credit. But as I noted in King (2012), it has proven excruciatingly difficult to find any information about these half dozen or so pundits or their descendants. In this regard, the letter from Herbert George Welch (1862–1969, bishop of the Methodist Episcopal Church from 1916 to 1928) dated March 23, 1921, sheds some light on one of Gale's pundits: "I found a man named Kim Won Keun who was connected with Dr. Gale. He seemed to have an accumulation of material, which I think is about what you want. The only trouble was that it was in Chinese, and would have to be translated to be available. You were so anxious to get the material that I took the liberty of arranging for its translation, and told the man that you would be responsible for charges up to $50.00. I hope that I have not done wrong in doing this." It is not clear what the materials in question are, but Kim Wŏn-gŭn 金媛根 (1870–1944; styled Chijae 止齋) was indeed one of Gale's pundits. A graduate of Paejae Haktang, Kim taught history and *hanmun* for thirty-five years (1906–1941 at Chŏngsin Girls' School, a school that was dear to Gale's heart, and also engaged in numerous publication and translation projects.[13] Ko Ch'un-sŏp (2013) and Yŏndong Kyohoe (2013) include valuable information and materials about him, but a fuller account is much needed.

Finally, the Griffis letters include correspondence with James Brebner, registrar at the University of Toronto (Gale's alma mater), dated October 28, 1924, concerning Gale. Brebner writes, "[W]hat you have written me of Jim Gale is most gratifying. He was one man in a thousand, full of zeal and earnestness, a man of faith and vision, and his work has been, and is, of the finest."

## Loose Ends and Leads Worth Following Up

I have already noted how tantalizing some of the letters are in terms of mysteries and personalities in need of further clarification. Here are a few more. For example, in a letter dated October 24, 1905, Horace Allen commends Griffis for his article on the "Russian Church" in Korea. The activities of the Russian Orthodox Church in Korea are grossly underrepresented in research about Western missions in Korea, so it would be helpful to identify this lost article. Another article by Griffis not identified in the collection is his article on Korean education for a "Cyclopedia of Education" edited by Paul Monroe, Teachers College, Columbia University. The article in question did indeed appear in the massive five-volume *A Cyclopedia of Education*, edited by Paul Monroe.[14]

Another tantalizing mention in Horace Allen's correspondence comes in his letter dated May 24, 1905, in which he states that "Everett Frazar, long Honorary Korean Consul in N.Y. never came to Korea either. His son who has succeeded his father in a large eastern business is now here and tells me how much his father wished to see Korea but was always prevented." Y. Cho and S. Park note that Everett Frazar (1834–1901) was senior partner of Frazar and Company, which traded in Korea, China, and Japan. I would add that his papers are in the New York Public Library and are listed as containing "materials in English and Korean." And with all the correspondence with various members of the Appenzeller family, it is probably worth noting that Alice R. Appenzeller's letters are kept at the University of Oregon and cover the years 1909–1940.[15]

Finally, it was interesting to learn that Homer Hulbert's brother Archer published a novel about Korea. For example, on August 29, 1902, Hulbert wrote to Griffis, "My brother Archer has published a novel "The Queen of Quelpart"[16] which you may see. He was out here a year." Archer Hulbert's papers, covering the years 1873–1933 (including materials related to his year in Korea), can be found at Colorado College Special Collections.[17]

## Life under Japanese Colonialism

Not surprisingly, much of the correspondence with Griffis also lends insights into what life was like for both Koreans and Western missionaries on the Korean Peninsula under the Japanese Protectorate (1905–1910) and finally as a full-fledged colony. In a letter dated July 3, 1905, Hulbert writes quite devastatingly about the low quality and corruption of Japanese settlers in Korea. The analogy with Texan gunslingers is probably not far off:

> I tell you what is strictly and demonstrably true that the average Japanese who have come to Korea are far below the average Korean in enlightenment. I thoroughly believe that the Japanese officials in Korea, with hardly an exception, are constantly taking large bribes from the most corrupt Koreans to prevent justice taking its proper course. . . . You can form no idea of the state of things here. Imagine ten thousand desperadoes from Texas let loose upon the

streets of New York with us one who dared to tackle them or keep them within bounds and you will have some idea of things here. The missionaries throughout the country are a unit in saying that the common people are treated abominably by them. . . . What an ass Pres. Jordan of Leland Stanford Univ. made of himself when he said there is no such thing as 'graft' in Japan!

In a letter from May 18, 1910, on the eve of annexation, H. D. McCallie wrote this from Mokp'o about Japanese policies: "The Japanese are doing wonders for this land in the way of material improvements but no one is so foolish as to think it is being done for the sake of the Koreans. Their lands and houses are being taken and what is to become of them no one knows. It looks as if they mean to do with them as we did with the Indians. Man's extremity however is God's opportunity hence a great religious work is going on." The analogy drawn with the treatment of Native Americans in the United States is chilling. In a letter written on July 14, 1911, less than a year after annexation, Julia Winn Erdman wrote this about the rapid changes on the peninsula: "But in all respects Korea is becoming rapidly 'Japanised.' The Korea of ten—of five—years ago is gone." Many of the letters speak of the problem of Japanese censorship and of Japanese cruelty to the Koreans more generally. The same letter from Julia Winn Erdman had previously stated, "[Y]our letter implies that you particularly desire information concerning the political conditions in Korea—the Japanese annexation of the kingdom and the resulting conditions. This is the topic upon which missionaries must preserve a strict silence." Eight years later, Henry Dodge Appenzeller, in a letter dated March 18, 1919, writes, "This letter is being taken to the States to be mailed there. It is the only method we have of avoiding the secret censorship that is exercised by the Japanese here. There are things happening in these days that one cannot be silent about."

The corruption of the legal system under the Japanese and the widespread use of torture against Koreans also feature in missionary letters. A letter from Samuel Austin Moffett (1864–1939; in Korea 1890–1936 with the Northern Presbyterian mission), dated January 15, 1913, includes a typed report in answer to the question "Why do you believe the stories of torture in the Korean 'Conspiracy Case?'" prepared by Albertus Pieters (1869–1955) and five other missionaries. And here is Albertus Pieters a year later on January 30, 1914, writing from the relative safety of his mission base in Japan: "May I take this opportunity of offering you authentic information on the subject of Japanese authority and judicial proceedings in Korea? The facts are such that the friends of Japan have been very slow to believe them, but it is becoming impossible any longer to deny or conceal the truth that the administrative measures adopted both in Formosa and in Korea, with much that makes for the material prosperity of the people, contain also a great element of ruthless injustice and almost incredible cruelty."

### Aftermath of the March First Uprising

But missionary reports of the abuses of the Japanese in Korea become more frequent and alarming in the wake of the March First Uprising of 1919 and Japan's

brutal response to it. A letter from Althea Jeannette Walter (1885–1977)[18] dated August 18, 1919, and written "on board the Asia" reads, "The Japanese people are kept ignorant of all the truth about Korea for they can only read what is officially written and most of that is a lie." In a letter dated November 13, 1920, Elmer M. Cable (1874–1949; in Korea 1899–1931) writes on how the uprising has changed Koreans: "I fear Japan will never be able to make atonement for what she has done in Korea and that she has lost all hope of pacifying the Koreans. I never saw such a transformation in a people. The Koreans have changed from creatures of fear to courageous patriots."

In some ways the most harrowing account from this period comes in a letter from Henry Dodge Appenzeller, at this point serving as principal of Paejae Haktang, the boys' school founded by his father. Writing on April 10, 1920, he relates a story about the first anniversary of the March First Movement at the school according to which Japanese police authorities, accompanied by one Okuyama Senzō from the "educational department of the government general," conducted a sort of pogrom at the school in reaction to reports that some of the students had been so bold as to shout out "Mansei" on this anniversary.[19] Some of the boys were basically tortured. Okuyama Senzō 奥山仙三 (dates unknown) was a graduate of the Korean department of Tokyo Gaikokugo Gakko and besides working as an official in the GGK, also taught Korean to Japanese in Korea at various institutions. He was the author later of *Gohō Kaiwa Chōsengo Taisei* 語法會話朝鮮語大成 (Korean language compendium for grammar and conversation), published in 1928 under the auspices of the GGK. It must have been relatively popular, as it came out in another edition in 1930.[20]

Later that same year, in a letter dated June 23, 1921, George Shannon McCune (1872–1941; in Korea 1905–1936)[21] wrote along similar lines: "There is one point that I wish to call your attention to particularly, and that is the so-called reforms introduced into Korea by the Japanese which so many friends of both Korea and Japan in America believe to be true. . . . The only change in Korea after Baron Saito[22] came into authority is that the name military was changed to civil and the uniforms of the gendarmerie changed to those of policemen. It is true that the Japanese school masters no longer wear swords in the school rooms, but they carry on the policy of ruthless 'assimilation' as rigidly as ever."

## Learning the Language

Griffis seems to have had an abiding interest in questions of language and racial origins and identity (see King 2019 for some of his writing on these topics), so it is not surprising to see mentions of the Korean language popping up in some of the letters. Indeed, they show up in some of the earliest letters in the collection. Thus, on November 27, 1890, in response to Griffis's query as to "who among the missionaries were most adept at the language," Horace Allen replied, "Dr. [William Benton] Scranton (1856–1922) is the most prominent student at present. He is rather the authority now on the language." This was certainly true at the time, but James Scarth Gale soon outstripped him and other missionaries and also pro-

duced one of the most successful handbooks of the language (on Korean grammatical forms, in three editions), as well as the mother of all Korean-English dictionaries (likewise in three editions).

I have written elsewhere on how many of the newly arrived missionaries in the field chafed at the language exams one had to pass in order to become a full voting member of the mission (King 2005), and we catch glimpses of this in a letter from Homer Hulbert dated April 29, 1894: "One or two of the new men in our mission kick at having to be examined by [George Heber] Jones on the language every quarter. Well, I sympathize with them some, but if they would show just a little ability to get hold of the language, I should sympathize with them a great deal more." But with the advent of a new century and then Japanese rule, missionaries were faced with the daunting task of learning not just Korean, but also Japanese, if they wanted to be truly effective. Thus, one unidentified author writes on November 24, 1916[23]: "At 1:30 my dignified young teacher, a fine college boy, comes and we tussle with Japanese and Korean. At first it was all Korean, and I made progress, even having high hopes of finishing the three year's course in Feb. my second anniversary. But there was such a splendid opportunity to join a Japanese class with 20 other missionaries, that I felt I must take, and now this study is stealing away my Korean study time; but I must have it, so I try not to worry about it. Mercifully the Japanese is enough like Korean so that we don't see how Japan missionaries ever learn it without learning Korean first! But how would you like to learn two strange languages at once, and try to learn to read these awful Chinese characters besides? It stretches my cranium, I can tell you!"

## Conclusion

As I hope to have indicated in the pages above, the Griffis letters are a treasure trove of valuable firsthand accounts from key movers and shakers in knowledge production about Korea for the approximate period 1890–1927. I have provided an overview of some of the salient themes and personalities based on my own idiosyncratic acquaintance with this period and with some of the key individuals, focusing on Griffis's epistolary network, some of the main themes that animated both him and his correspondents, and some of the insights into both Western missionaries in Korea and the Japan-dominated Korea in which they lived and worked. Other readers and researchers will no doubt find many other choice nuggets and leads that send them off in new directions to explore yet other topics in need of further elaboration. Warm congratulations again to Professors Youngmee Yu Cho and Sungmin Park for assembling and organizing this rich resource, and to all who enjoy rooting around in old letters from and about Korea a century ago: happy hunting.

NOTES

1. See http://encykorea.aks.ac.kr/Contents/Item/E0014231.

2. Homer Hulbert, *Taedong Kinyŏn* 大東紀年 [Chronology of the Great East] (Shanghai: The American Presbyterian Mission Press/Mihwa Sŏgwan, 1903) .

3. William Elliot Griffis, *Corea: The Hermit Nation,* 3rd ed. (New York: Charles Scribner's Sons, 1889).

4. Daniel Lyman Gifford (1861–1900) was a missionary with the Northern Presbyterian mission. He wrote *A Forward Mission Movement in North Korea* (New York: Evangelist Press, 1879) and *Every-day Life in Korea* (Chicago and New York: Fleming H. Revell Company, 1898).

5. Homer Miller's letter is available in Korea Letters digital archive at Rutgers University Libraries.

6. The Gabelentz collection went missing at the end of World War II when Soviet Red Army troops looted the famous Gabelentz family library at Poschwitz and sent all the rare editions back to Moscow, but somehow the Korean books never made it to Russia. But titles can be reconstructed from the descriptions in Courant's *Bibliographie Coréenne.*

7. See https://archives.nypl.org/mss/1052. See Hawley (2008) for a study of George C. Foulk based on these letters.

8. Virtually the only complete sets to be found are Samuel Moffett's copies (now at Princeton) and the set owned by Yonsei University Library. Stephen Ambrose Beck (1866–1927?) was in Korea from 1889 to 1919, but he does not seem to have left behind any papers.

9. The notorious essay is Oda (1931b), where he writes, "Today, with the diffusion of the national language [= *kokugo*/Japanese] in full swing, it has become rare to find anyone in the capitol or the countryside ignorant of or unable to read Japanese. As Korean has become gradually more and more marginalized (*hyup'ye* 休廢), without the compilation of an authoritative Korean dictionary not only has it become extremely difficult to read old documents but *naichijin* [Japanese in Japan] have had difficulties trying to teach Korean." Cited from Hwang (2023, note 36; pp. 576–577). As for the work by Yi Nŭng-hwa alluded to here, it is not entirely clear which work is meant. It is likely the *Chosŏn Yugyo Yŏnwon* [Origins of Chosŏn Confucianism] reprinted in his 1978 *Yi Nŭng-hwa Chŏnjip (Sokchip)* and characterized as "date of publication unknown" by Yi U-jin and Ch'oe Chae-mok (2015, 136). The letter to Griffis in this case could at least help date the piece.

10. George W. Gilmore, *Korea from Its Capital: With a Chapter on Missions* (Philadelphia: Presbyterian Board of Publication and Sabbath-school Work, 1892); and *Corea of Today* (London & New York: T. Nelson and Sons, 1894). The fact that letters like this one—not originally sent to Griffis but shared with him by their original recipients—also appear in the Griffis archive show yet again the absolute centrality of epistolary communication in this missionary "republic of letters."

11. Angus Hamilton, *Korea* (New York: Charles Scribner's Sons, 1904).

12. George Trumbull Ladd, *In Corea with Marquis Ito* (London: Longmans, Green and Co., 1908).

13. Dates from https://www.culppy.org/bbs/board.php?bo_table=23_01&wr_id=307& page=10 and Ko (2013, 22).

14. William Elliot Griffis, "Korea, Education in," in *A Cyclopedia of Education,* ed. Paul Monroe (New York: The Macmillan Co., 1911–1913), 3:526–528.

15. See https://archives.nypl.org/mss/1073; https://scua.uoregon.edu/repositories/2/resources /3440.

16. Archer Butler Hulbert, *The Queen of Quelparte* (Boston: Little, Brown and Company, 1902)

17. Finding aid available here: https://www.coloradocollege.edu/basics/campus/tour /historic/docs/biography%20palerHulbert%20Papers_--%20put%20your%20page%20 title%20here%20--_.htm.

18. See her autobiography, *Aunt Jean,* by Jeannette Walter ( Boulder, CO: Johnson Publishing Company, n.d., but apparently 1969).

19. The Korean word *mansei* literally means "ten thousand years," which in the context of the March 1st Movement denotes "May Korea live for 10,000 years!"

20. Okuyama Senzō, *Gohō kaiwa Chōsengo taisei* 語法會話朝鮮語大成 [Korean language compendium for grammar and conversation] (Keijō: Chōsen Kyōikukai, 1928). See Ueda (2016) for more on Okuyama.

21. His son George McAfee McCune was the "McCune" of the McCune-Reischauer romanization.

22. Saitō Makoto (1858–1936), governor-general of Korea from 1919 to 1927, and again from 1929 to 1931.

23. The editors of this volume have determined that the five unidentified letters (#22–#26), dated between January 31 and November 24, 1916, were sent by Alice Appenzeller, based on the handwriting, the content of the letters, and the dates of Alice's other letters.

## REFERENCES

Courant, Maurice. 1894–1896. *Bibliographie coréenne; tableau littéraire de la Corée, contenant la nomenclature des ouvrages publiés dans ce pays jusqu'en 1890 ainsi que la description et l'analyse détaillées des principaux d'entre ces ouvrages.* Paris: E. Leroux.

Gabelentz, Georg von der. 1892. "Zur Beurteilung des koreanischen Schrift-und Lautwesens" [An assessment of Korean writing and phonetics]. *Sitzungsberichte der Königlich Preussischen Akademie der Wissenschaften zu Berlin* 23 (June–December): 587–600. Berlin: Königlich Preussische Akademie der Wissenschaften zu Berlin.

Griffis, William Elliot. 1911. *A Modern Pioneer in Korea: The Life Story of Henry G. Appenzeller.* New York: Thomas Y. Crowell.

Hawley, Samuel. 2008. *America's Man in Korea: The Private Letters of George C. Foulk, 1884–1887.* Lanham, MD: Lexington Books.

Hwang, Hoduk. 2023. "The Geopolitics of Vernacularity and Sinographs: The Making of Bilingual Dictionaries in Modern Korea and the Shift from Sinographic Cosmopolis to 'Sinographic Mediapolis.'" In *Cosmopolitan and Vernacular in the World of Wen* 文: *Engaging with Sheldon Pollock from the Sinographic Cosmopolis,* edited by Ross King, 534–592. Leiden and Boston: Brill.

Kennan, George. 1905a. "Korea: A Degenerate State." *The Outlook,* October 7, 307–315.

———. 1905b. "The Korean People: The Product of a Decayed Civilization." *The Outlook,* October 21, 409–410.

———. 1905c. "The Japanese in Korea." *The Outlook,* November 11, 609–615.

King, Ross. 2005. "Korean Grammar Education for Anglophone Learners: Missionary Beginnings." In *Han'gugŏ Kyoyungnon* [Korean Language Education], edited by Kukche Han'gugŏ Kyoyuk Hakhoe (IAKLE), vol. 2, 237–274. Seoul: Han'guk munhwasa.

———. 2012. "James Scarth Gale, Korean Literature in *hanmun,* and Korean Books." In *Haeoe Han'gukpon Komunhŏn Charyo ŭi T'amsaek kwa Kŏmt'o* [Uncovering and Examining Overseas Korean Antiquarian Books and Old Document Materials], edited by Sŏul Taehakkyo Kyujanggak Han'gukhak Yŏn'guwŏn, 237–264. Seoul: Samgyŏng munhwasa.

———. 2019. "'Photographs of Mind' and 'Photographs Taken on the Soil': William Elliot Griffis, Korean Language, Writing and Literature, and Koreans in Russia." In *The Photographs of Korea in the William Elliot Griffis Collection,* edited by Yang Sang-hyŏn and Yu Yŏng-mi, 447–466. Seoul: Noonbit Publishing Co., 2019.

———. forthcoming. "I Thank Korea for her Books:" *James Scarth Gale, Korean Literature in hanmun, and Allo-metropolitan Missionary Orientalism.* University of Toronto Press (James Scarth Gale Library of Korean Literature).

Ko, Ch'un-sŏp. 2013. "Keil moksa ka Ko Ch'anik changno ege chugop'ŭn Nobelsang (oe 3 p'yŏn ŭi kŏl)" [The Nobel Prize that Reverend Gale wanted to give to Elder Ko Ch'an-ik (and 3 other essays)]. In *Chosŏn kwa Chosŏnin ŭl kkaeuch'igi wihae hŏnsinhan Keil moksa t'ansaeng 150chunyŏn nonmunjip* [Collection of papers on the occasion of the 150th anniversary of the birth of Reverend Gale who gave so much to enlighten Korea and the Koreans], edited by Taehan Yesugyo Changnohoe Yŏndong Kyohoe, 7–24. Seoul: Taehan Yesugyo Changnohoe Yŏndong Kyohoe.

Oda, Kanjirō 小田幹次郎. 1918. "Chōsen kappan no enkaku" 朝鮮活版の沿革 [History of Korean movable type] (*Chōsen ihō* 朝鮮彙報, January).

———. 1920. "Chōsengo jiten hensan no keika" 朝鮮語辭典編纂の經過 [Progress on compilation of the *Dictionary of the Korean Language*]. (Postface to the GGK's *Chōsengo jiten* of the same year, 1043–1047). Reprinted as Oda (1931). Keijo: Chōsen sōtokufu.

———. 1931. "Chōsengo jiten no hakkan ni tsuite" 朝鮮語辭典の發刊に就て [On the publication of the *Dictionary of the Korean Language*]. In *Oda Kanjirō ikō* 小田幹治郎遺稿 [Posthumous works of Oda Kanjirō], 112–121. Tokyo: Ryūkei shosha.

Ueda, Kōji 植田晃次. 2016. "Okuyama Senzō to Chōsengo: Hensanshita Chōsengogogakushūsho no seikaku ni chakumokushite" 奥山仙三と朝鮮語—編纂した朝鮮語学習書の性格に着目して [Okuyama Senzō and the Korean language: Focusing on the Korean language manuals he compiled]. *Riben yuyan wenhua yanjiu* 日本語言文化研究 (Yanbian daxue chubanshe) 4:101–111.

Yi, Nŭng-hwa. 1978. *Yi Nŭng-hwa Chŏnjip (Sokchip)* [Collected works of Yi Nŭng-hwa (Supplementary volume)]. Seoul: Yŏngsin ak'ademi han'gukhak yŏn'guso.

Yi, U-jin and Ch'oe Chae-mok. 2015. "Yi Nŭng-hwa ŭi Han'guk Yangmyŏnghak yŏn'gu: Chŏng Inbo wa Tak'ahashi Tooru (高橋亨) wa ŭi pigyo rŭl chungsim ŭro" [Yi Nŭng-hwa's research on Korean Yangming studies: With a focus on a comparison with Chŏng In-bo and Takahashi Tōru]. *Yangmyŏnghak* 42: 107–139.

Yŏndong Kyohoe, eds. 2013. *Sŏul YMCA Ch'ŏngnyon Chijae Kim Wŏn'gŭn nonjŏjip 1921–1937 69 p'yŏn* [Collection of writings by Chijae Kim Wŏn-gŭn for *Ch'ŏngnyon* (journal of the Seoul YMCA), 1921–1937 (69 texts)]. Seoul: Yŏndong Kyohoe.

# KOREA LETTERS IN THE WILLIAM ELLIOT GRIFFIS COLLECTION

# Introduction

Korea has functioned as a strategic hub, geopolitically and culturally, throughout its millennia-old history, due to its unique geographic position of being surrounded by Northeast Asia's major powers—China, Russia, and Japan. In addition, the relationship between the United States and Korea has been dynamically complex from the first encounter between the two countries in 1871 (*Shinmi Yangyo*), the Japanese occupation (1910–1945), the division of the Korean Peninsula (1945–), and the Korean War (1950–1953), to the continuing legacy of the Cold War.

Between 1876, when Japan forced the opening of Korea, and 1882, when Korea signed a treaty with the United States, the most important Western publications on Korea were provided by Charles Dallet, John Ross, Earnest Opert, and William Griffis. In particular, Griffis's books on Korea were the most complete in their coverage and had a long-lasting impact. Research on Korea by Westerners often started with an interest in its neighbors, China and Japan, and books about Korea in the late nineteenth and early twentieth centuries exerted great influence in forming contemporary images of Korea. According to Chŏng (2019), the Japanese annexation of Korea in 1910 was a historical event that resulted from complex domestic and international factors, but the images of Korea formed during this time by monographs and newspaper articles guided the destiny and development of the country. These images, due to the cultural background of active "Korea experts," are laden with orientalism and Christian evangelism, treating Korea as barbaric compared to modernized Japan and Western civilizations, as evidenced by often-cited metaphors such as "Korea as a Hermit Nation" and "A Land of Morning Calm." In addition to his best-selling books, Griffis's contributions to encyclopedias (1874–1913) speak volumes about his influence as a producer of knowledge about Korea. For example, Griffis was solely responsible for all entries on Japan and Korea for *The Universal Cyclopedia and Atlas and Annual Cyclopedia* between 1884 and 1902.

To Korean studies scholars, Griffis is best known for his best seller *Corea: The Hermit Nation* (1882), which was reprinted numerous times across nine editions and over thirty years until 1910. This text constituted the single most important entry into Korea for Americans and Europeans as far as the mid-twentieth century and was translated into Korean in the 1970s, thus initiating the current Griffis research in Korea. The Special Collections and University Archives of Rutgers University Libraries holds the William Elliot Griffis Collection, mostly a family gift received after Griffis's death in 1928. The collection consists of Griffis's own work and the materials he collected throughout his lifetime. While three-quarters of its East Asian materials are about Japan, a quarter are about Korea

2    *Introduction*

and China. Portions of the Griffis Collection were published in microfilm as part of *Japan through Western Eyes: Manuscript Records of Traders, Travellers, Missionaries, and Diplomats, 1853–1941.*

Burks and Cooperman (1960a, 1960b) were the first researchers who publicized the existence of the Griffis Collection and expounded its potential significance as a wealth of primary sources in Korean and East Asian studies. However, it took more than four decades for the Griffis Collection to be explored and utilized for in-depth historical research. The Korean materials within the Griffis Collection have never been catalogued in detail, nor has their significance in Korean studies been fully explored until recently (Sim 2008, Cho and Park 2022).

The Griffis Collection is organized in three sections: (1) the manuscript collection, (2) the rare book collection, and (3) the unprocessed non-Asian materials. The manuscript collection is divided into five groups, of which the first group is the William Elliot Griffis Papers. Most of the Korean materials are found in this group while rare books and pamphlets about Korea are included in the rare book collection. Korean photographs are found in Group IV (Papers Collected by Griffis) in the manuscript collection. Serious interest in the Griffis Korean Materials within the Griffis Collection can be traced to the early 2000s when scholars wished to go beyond Griffis's publications for a unique opportunity to explore invaluable materials, hitherto undiscovered. Building on the initial description of the Griffis Collection by Gass and Perrone (2003, rev. 2018), Young-mee Yu Cho organized a workshop in 2008 on the Korean Materials of the Griffis Collection with the help of the Griffis Collection curator, Dr. Fernanda Perrone. This inaugural workshop helped scholars for the first time to uncover the extent of the Griffis Collection in the areas of Korean history, sociology, law, literature, linguistics, and art.

What caught the immediate attention of Korean studies scholars were the Korean photographs in the Griffis Collection. This section consists of four boxes of Korean photographs, totaling 592 photographs; many of these are part of a series published for sale, and the photographers are unidentified. Yang, Park, and Yu (2014) determined that 358 photos were new discoveries that had not been published before. The definitive work on the Griffis Korea photos is a bilingual annotated book, *The Photographs of Korea in the William Elliot Griffis Collection* (2019), by Yang and Yu. The photos are classified into six categories: (1) Royal Family of Chosŏn and the Korean (*Taehan*) Empire, (2) Imperialistic Aggression and Nationalist Movement, (3) The Lives of Chosŏn People, (4) Cities and Architecture, (5) Modern Education and Christianity, and (6) Other.

Through the 2018–2019 project funded by the Overseas Korean Cultural Heritage Foundation (OKCHF) (full title: "Research on the Korean Materials in the William Elliot Griffis Collection at Rutgers University Libraries: Evaluating, Annotating Significant Korean Studies Materials and Hosting an International Workshop"), we were able to produce for the first time a systematic and comprehensive overview of the Korean materials in the collection. Furthermore, we produced the scanned images and metadata of the items in the Korea Letters in its entirety. We also made a draft transcription of the items, most of which were

Introduction     3

handwritten letters. The William Elliot Griffis Papers hold twenty-one series. One of the series, "Correspondence," is composed of the following three subseries: Japan Letters, Korea Letters, and China Letters. Materials in the Korea Letters comprise 420 items (1,087 sheets) in seventy-six archival folders, of which about 375 items are letters across 613 sheets of paper.

The focus of the 2020–2021 project, again funded by the OKCHF (full title: "Research on the Korean Materials in the William Elliot Griffis Collection at Rutgers University Libraries: Transcribing, Annotating Griffis Korea Letters and Unpublished Manuscripts, Building a Supplementary Online Archive, and Publishing a Monograph") was the Korea Letters. We identified each sender, transcribed the material that had not been transcribed (typed and printed), enhanced the draft transcription of handwritten items, and annotated them for this book. Many of the senders are missionaries (total fifty-nine senders) who were mostly stationed in Korea in the late nineteenth and early twentieth century. We also identified twenty-one historically significant Koreans or Japanese people; thirty-five institutions such as publishers, colleges, and museums; and forty-four individuals such as politicians, professors, and lawyers Griffis consulted, although some of them are not fully identified.

As for material types in the Korea Letters, the majority of which are letters, we identified letters, postcards, envelopes, journal article clippings, newspaper clippings, program flyers, admission tickets, bulletins, circulars, manuscripts, publicities, statements, public invitations, speeches, and notes. The Korea Letters subseries only contain those sent to Griffis (some forwarded by the original recipients). The only letter Griffis wrote was addressed to Dr. Scranton in Kobe, Japan, but was returned to Griffis as undeliverable.

The Korea Letters prove to be a valuable historical resource. For instance, when supplemented by his journal entries, these letters were instrumental in clarifying Griffis's views around the time of his visit to Japan and Korea in 1926–1927. Griffis returned to Japan to receive the Order of the Rising Sun and toured the four main islands of Japan, Korea, and Manchuria. His Korean trip (March 22, 1927–April 19, 1927) included major cities such as Seoul, Kaesŏng, P'yŏngyang, Taegu, and Kyŏngju. His journal entries during his visit to Korea and the correspondence surrounding his trip paint a clear picture of his visit from its planning stage to the aftermath. Park and Cho (2019) are able to identify his travel itinerary and produce annotated transcriptions of his journal entries (March 19, 1927–April 20, 1927), aided by the compiled list of the Korea Letters (1926–1927), of which two sample letters from Alice Appenzeller and A. G. Fletcher are of particular interest. Griffis, who had not seen or experienced Korea in person, obsessively collected Korea-related materials for his research and writing to compensate for his lack of firsthand experience. In his journal entry for March 23–25, 1927, Griffis described Seoul as a "City of dreaming from 1871," which was many years before he wrote *Corea: The Hermit Nation* (1882).

Just as the journal entries during Griffis's only trip to Korea in 1927 were essential in identifying Griffis's travel itinerary and understanding the social

4    *Introduction*

atmosphere of the 1920s in colonial Korea, the Korea Letters deserve publication for future intertextual research. Through the Korea Letters, we begin to understand to what extent Griffis relied on correspondence as a way to collect information for his writing. As the Publisher's note of the *JTWE Digital Guide* states, "the correspondence is especially rich and lays bare the entire network of contacts that Griffis built up in Japan, Korea and China and his full range of interests."

Occasionally, Korean visitors to the Griffis Collection have made "discoveries" (e.g., publication of the 1920 letter from Eun Sic Park and Kwangsoo Lee in *Munhak Sasang* (Kim 2008), and Syngman Rhee's letter of August 17, 1919 proposing the purchase of Griffis's forthcoming book on Korean history (Lee 2014). When the transcription of the entire Korea Letters is made public, researchers will be able to explore many first-person accounts of individual senders such as Horace Newton Allen (1858–1932) and Homer B. Hulbert (1863–1949) to better understand the social network among the missionaries in the tumultuous period of modern Korean history (Lee 2021).

The letters from missionaries were written over a long span of time (1877–1927) and a great range of geographical distance (including Molp'o, Taegu, Kongju, Chemulp'o, Seoul, Wŏnsan, Yŏngbyŏn, P'yŏngyang, and Ŭiju, just to name Korean places). Horace Newton Allen liberally shares his experiences in Korean political situations and encounters with King Kojong in his twenty-one letters (1888 to 1920). A letter from Horace G. Underwood sent on July 14, 1900, reports, "Things in Korea are more disturbed than ever . . . politically no one in Korea can be trusted and we cannot tell what will happen." Yet he adds, "in other ways however there has been advances. Railroads are coming in, mainly however for the benefits of foreign investors." On the other hand, Hulbert's twenty-seven letters spanning the years 1892–1917 respond in detail to Griffis's many queries about Korea based on his close encounters with Korean and Japanese people as an educator, missionary, publisher, and political emissary in the decade leading up to the annexation of Korea by Japan. Allen did not hesitate to give a very low opinion of Hulbert and Philip Jaisohn as "the two most flighty and unreliable, not to say dangerous advocates Korea has ever had" (August 7, 1920), responsible for unfairly influencing F. A. McKenzie of the *London Daily News*. We also find a delightful account by Grace Kilbourne Kerr from Sorai Beach; she describes the circumstance of the photo session in Chaeryŏng: "[Y]ou will readily recognize one as that of a woman, washing at a spring, and the other as two ironing women, who came out by request, into the street in front of their house, so that we could get the picture" (June 29, 1916). The latter photo was identified as "Ladies Using Iron Sticks" [#3645, p. 139 in Yang and Yu (2019)], and the mystery of women engaging in flattening freshly washed cloth with sticks, a quintessential indoor activity, in the broad street is now solved.

Letters from Korean and Japanese people are no less interesting. A letter to Griffis from Itō Hirobumi Itō is dated May 6, 1908, shortly before the annexation of Korea by Japan in 1910. It is his response to Griffis's request for photos and pamphlets about Korea. The photos sent by Itō are located in "Korea Photographs" in

the Griffis Collection, and the list of the photos is included in the Korea Letters. Research into the Korea Letters confirmed the source of these photographs labeled "Murakami series," as speculated in Yang, Pak, and Yu (2014).

The letters sent by Korean nationalists after the March First Independence Movement (1919) illustrate attempts to resort to Griffis's influence as an East Asian specialist and media person. Philip Jaison's letter dated July 25, 1921, asked Griffis to write an article on Korea for an upcoming international conference in Washington, DC, about "the Far Eastern questions." According to Yi (2014, 2015), contrary to some speculations, Griffis's view of Korea and Japan did not undergo a fundamental change, even though Griffis criticizes the harsh colonial rule in his many news publications, persuaded by a number of vivid ground reports included in missionaries' letters. In his unpublished manuscript titled "Korea: The Lady of Kingdoms," a seven-page typewritten manuscript written after the March First Independence Movement (probably around 1921), Griffis notes, "Japanese militarism transformed 'a quiet peaceful people into a sullen determined nation united in their hatred of conquest and oppression.'" His view of East Asia was best represented in another of his unpublished manuscripts, "Cupid in Korea," written in 1920. Griffis concludes that the political marriage of the Korean "Prince Heir" and Princess Makoto of Japan has the potential to unite the bride and groom as a symbolic union of Korea and Japan.

The extent to which Griffis tried to obtain information on Korea is best exemplified by two letters (Jan. 13 and 21, 1895) sent by Clayton M. Foulk (1830–1901), father of George Clayton Foulk (1856–1893), one of the first U.S. diplomats in Korea. In response to Griffis's inquiry, the father promised that his dead son's letters concerning Korean affairs and the report of a journey "from the Asiatic Station to the United States through Siberia Europe" would be sent to Griffis. As Samuel Hawley writes in *America's Man in Korea*, "[t]he story of America's initial relations with Korea in the 1880s is . . . the story of George Clayton Foulk", best told in his own private letters to his family. A defining moment of modern Korea can be accessed directly through his letters, "a behind-the-scenes record of a talented and earnest young diplomat struggling to represent America where it really did not want to be" (2008, 22). The Korea Letters show us how wide Griffis's network of correspondents was and how active Griffis was in seeking materials concerning Korea.

## Scope of This Book

Letters related to Korea are mainly found in the Korea Letters, a subseries of the Correspondence series in the Griffis Collection, but the Scrapbook series and the Printed Materials series also include some. We limit the scope of this book to a selection of the letters found in the Korea Letters subseries. In addition to letters themselves, we included most of the material types found in this series except envelopes.

We are not able to include the entirety of the Korea Letters here, due to the enormous size of the subseries (300,000 words). The letters we label as "Others" (those sent by institutions and individuals other than missionaries and Japanese and Korean nationals) are mostly simple business letters dealing with obtaining

6    *Introduction*

information and data or correspondence with publishers and the press, which we deemed less urgent to publish than the firsthand accounts of missionaries, Korean nationalists, and Japanese colonizers on the front line. Even within the missionary letters, we had to move a number of letters to the digital archive. In particular, Alice Rebecca Appenzeller (1885–1950), the daughter of Henry Gerhart Appenzeller (1858–1902), corresponded extensively with Griffis (from 1911 to 1927) before and after she was appointed by the Methodist Church as a missionary teacher at Ewha Haktang where she ultimately served as president. Her vivacious accounts of her life as a teacher are of a personal nature and do not give as much insight into the social and political situation surrounding the March First Independence Movement (1919) as do the detailed reports of her brother, Henry Dodge Appenzeller, about the grim situation at Pai Chai Haktang where he served as the principal for twenty years from 1917. We present letters from Henry Dodge Appenzeller (1919–1926) in the book but not Alice's.

Here we include one letter (April 23, 1920) written by Griffis and sent to an American missionary, William B. Scranton. The letter was returned as undeliverable. This is the only letter written by Griffis in the Korea Letters subseries. This letter illustrates the manner in which Griffis used correspondence to obtain information from missionaries.

In addition to his 1895 letter in the Korea Letters, we also include one letter written by Midori Komatz (小松緑) (May 22, 1906) from the Japan Letters for its relevance to Korean matters.

Table 1 illustrates the entire list of letters; the shaded ones are omitted in this monograph but are available on the digital archive.

## Arrangement of Letters

The Korea Letters subseries in the Griffis Collection is originally arranged first in alphabetical order of the sender's last name (seventy-six folders), then in chronological order (within each folder). There are three types of folders: name folders (filed by senders), alphabet folders (A, B, C . . .), and an unidentified folder.

In this book, after identifying each sender from all three types of folders, we divided the senders into two groups: Missionaries and Koreans/Japanese. In each group, the senders are arranged in alphabetical order of their last name initial. Each sender's letters are then arranged in chronological order. Materials other than those in the letter format (newspaper clippings, journal article clippings, event flyers, etc.) are placed immediately after the letters when we can positively determine that they were originally enclosed in those letters. However, materials we cannot identify with which letters they were enclosed are placed at the end of all the letters of each sender.

## Transcription

Generally, all the punctuation marks and spellings in transcribed text are from the original text. Rarely, punctuation marks such as commas, periods, colons, or semicolons are inserted without any note to clarify the meaning of the original text.

Table 1      Complete List of the Letters in the Korea Letters Subseries in the Griffis Collection

## 1. Letters from Missionaries

1. Albrecht, George E. (1894)
2. Allen, Horace Newton (1888–1920)
3. Anderson, Naomi A. (1916)
4. Appenzeller, Alice Rebecca (1911–1927)
5. Appenzeller, Ella Dodge (1912–1913)
6. Appenzeller, Henry Dodge (1912–1926)[a]
7. Appenzeller, Henry Gerhart (1890–1891)
8. Appenzeller, Ida (1912–1917)
9. Appenzeller, Mary Ella (1912–1920)
10. Appenzeller, Ruth Emily Noble (1926)
11. Beck, Stephen Ambrose (1920)
12. Becker, Louise S. (1919)
13. Bernheisel, Charles F. (1907)
14. Billings, Helen I. (1920)
15. Bonwick, Gerald William (1921–1926)
16. Brown, Arthur Judson (1924)
17. Cable, Elmer M. (1920)
18. Cleary, Patrick H. (1925)
19. Erdman, Julia Winn (1911)
20. Fletcher, Archibald Grey (1927)
21. Frey, Lulu E. (1916)
22. Gale, Ada Louisa (1910)
23. Gale, James Scarth (1895–1921)
24. Gifford, Daniel Lyman (1895)
25. Gillett, Philip Loring (1902–1905)
26. Gilmore, George William (1893–1919)
27. Griffis, William Elliot (1920)
28. Hall, Rosetta Sherwood (1916)
29. Harris, Merriman Colbert (1890, 1913)
30. Hulbert, Homer B. (1892–1917)
31. Jones, George Heber (1894–1912)
32. Kerr, Grace Kilbourne (1916)
33. Kerr, Marcia (1925)
34. Kerr, William Campbell (1921)
35. Loomis, Henry (Date unidentified, 1887)[b]
36. Ludlow, Alfred Irving (1926)
37. Macdonald, D. A. (1920)
38. McAlpine, Robert Eugenius and McAlpine, Anne Ballagh (1927)
39. McCallie, Henry Douglas (1910)
40. McCune, George Shannon (1921)
41. McGill, William B. (1895)
42. Moffett, Samuel Austin (1901, 1913)
43. Moore, John Zachariah II (1927)
44. Morris, Charles David (1911–1916)
45. Morris, Clara Louise Ogilvy (1902)
46. Nollaline, W. T. (1894)
47. Owens, Herbert T. (1927)
48. Pieters, Albertus (1914)
49. Pye, Olive Fawcett (1921)
50. Reiner, Ralph Oliver (1927)
51. Sharrocks, Mary Ames (1921)
52. Swearer, Lillian May Shattuck (1911)
53. Underwood, Horace Grant (1900–1909)
54. Underwood, Hannah Elizabeth Grant (1898)
55. Underwood, Lillias Horton (Date unidentified)
56. Vinton, Cadwallader C. (1903)
57. Walter, Jeannette (1919)
58. Welch, Herbert George (1921)
59. Winn, Florence Bigelow (1921)
60. Wright, Harrison K. (1901)
61. Unidentified (1890)

*(continued)*

Table 1     Complete List of the Letters in the Korea Letters Subseries in the Griffis Collection (*continued*)

**2. Letters from Koreans and Japanese**

1. Cho, Hi-yŏm (조희염) (1923)
2. Cynn, Hugh Heung-Wo (신흥우) (1922)
3. Harada, Tasuku (原田助) (1915)
4. Itō, Hirobumi (伊藤博文) (1908)
5. Jaisohn, Philip (서재필) (1919–1922)
6. Kim, Ch'ang-hŭi (金昌熙) (1927)
7. Kim, Frank Yongju (김용주) (1927)
8. Kim, Henry Cu (김현구) (1914–1920)
9. Komatz, Midori (小松緑) (1895–1906)
10. Niwa, Seijiro (丹羽清次郎) (1927)
11. Paik, Earl Ku (백일규) (1916)
12. Park, Eun Sic (박은식) and Lee, Kwangsoo (이광수) (1920)
13. Rhee, Syngman (이승만) (1919)
14. Saitō, Makoto (斎藤実) (1920)
15. Shibata, Zenzaburō (柴田善三郎) (1921)
16. Sin, Teh Moo (신태무) (1901)
17. Sonoda, Hiroshi (園田寛) (1923)
18. Usami, Katsuo (宇佐美勝夫) (1912)
19. Watanabe, Noboru (渡邊昇) (1910, 1921)
20. Ye, Cha Yun (이채연) (1890–1892)
21. Ye, Koi Sok (이괴석?) (1896)

**3. Others**

**3.1 Institutions**

1. American Geographical Society (1895)
2. American Tract Society (1904)
3. Charles Scribner's Sons (1884–1918)
4. The Chautauquan (1895)
5. The Congregationalist (1929)
6. Cornell University (1905)
7. D. Appleton & Co. (1889)
8. Elmira Star-Gazette (1912?)
9. Fleming H. Revell Company (1912–1919)
10. Funk & Wagnalls (1891)
11. General Electric Company (1894)
12. Hanover College (1890)
13. Harper & Brothers Publishers (1919)
14. Hastings College (1911, 1920)
15. His Imperial Korean Majesty's Consulate General (1898)
16. Korean Relief Society (한인구제회) (1920)
17. Lake Mohonk Mountain House (1912)
18. The Nation (1919)
19. New England Magazine (1902)
20. New York Central & Hudson River Railroad Co. (1894)
21. Preakness Ref. Church Parsonage (1874)
22. Presbyterian Board of Publication and Sabbath-School Work (1890)
23. Presbyterian Church in the U.S. (1911)
24. Princeton University Press (1919)
25. Roanoke College (1894, 1920)
26. The Sunday School Times (1895, 1896)
27. Teachers College, Columbia University (1911, 1912)
28. Thomas Y. Crowell & Co. Publishers (1911, 1921)
29. Twentieth Century Club (1904)
30. United States National Museum (1894, 1899)
31. United States Naval Academy (1911)
32. University of Pennsylvania (1894)
33. University of Toronto (1924)
34. War Department (1904)
35. The Western Theological Seminary (1907)

Table 1    Complete List of the Letters in the Korea Letters Subseries in the
Griffis Collection (*continued*)

| 3.2 Individuals | |
|---|---|
| 1. Adams, Annir R. S. (Date unidentified) | 22. Kohler, Max James (1921) |
| 2. Allen, Richard Hinckley (1895) | 23. Kuhns, Oscar (1912) |
| 3. Baker, Colgate (1874) | 24. Ladd, George Trumbull (1908) |
| 4. Beach, D. N. (1877) | 25. Latimer, R. S. (1877) |
| 5. Beck, T. Rom Eyn (1894) | 26. Leranly, Helen Maxina (1912) |
| 6. Bostwick, H. J. (1912) | 27. MacMaster, Jaime (Date unidentified) |
| 7. Cleveland, K. E. (1874) | 28. McKay, Alexander (1895) |
| 8. Collbran, Henry (1897) | 29. McLane, Louis (1894) |
| 9. Cook, Grace L. (1907) | 30. Miller, Ransford Stevens (1926, 1927) |
| 10. Cowan, Frank (1903) | 31. Montgomery, Douglass William (1921) |
| 11. Daniel, William V. (1895) | 32. Nixon, Myrtle R. (1912) |
| 12. Dinsmore, Hugh Anderson (1888) | 33. Paje, Ganan C. (Date unidentified) |
| 13. Dolph, Fred A. (1920) | 34. Restarick, Henry Bond (1926) |
| 14. Eagleton, Clyde (1921) | 35. Richman, Irving Berdine (1912) |
| 15. Fassett, Jacob Sloat (1900) | 36. Rogers, Edwin E. (1902) |
| 16. Foulk, Clayton M. (1895) | 37. Sargent, George Clark (1921) |
| 17. Harbaugh, Linn (1911) | 38. Thompson, John Bodine (1896) |
| 18. Imlay, J. S. and Wilson, O. H. (1877?) | 39. Townsend, Walter Davis (1895) |
| 19. Jones, Brad (Date unidentified) | 40. Welsh, Helen Dorothy (1921) |
| 20. Jones, Margaret (1912) | 41. Williams, Ellen (Mrs. G. R. Ellen D. B. Williams) (1902) |
| 21. Jorey, Marion S. F. (1894) | 42. Wilson, George Grafton (1921) |
| | 43. Wriston, Henry Merritt (1921) |

[a] Letters from Appenzeller, Henry Dodge from 1912 to 1916 are in the digital archive; the letters from 1919–1926 are included in this monograph.
[b] Henry Loomis's letter (Date unidentified) is included in this monograph while his letter dated February 10, 1887, is in the digital archive.

10    *Introduction*

## Punctuation, Capitalization, Spaces

### PERIODS/COMMAS

When we saw a period or comma, we transcribed it as we saw it. In original texts, periods often resemble commas, and periods or commas are sometimes omitted. In those cases, we used our best judgment to transcribe them. We rarely added a comma or period unless the lack of one was judged to cause serious confusion.

### CAPITALIZATION

We generally transcribed capital letters as we saw them in the original text. When it was not clear or when it was judged that capital letters should be used (e.g., a personal name's initials or the beginning of a sentence), we capitalized them.

### INDENTATIONS

Regular or special indentations (e.g., hanging indentation) in the original text were not transcribed. We used an empty line between paragraphs, while they are usually indented in the original text.

### TEXT ALIGNMENT

Transcribed text is usually left aligned while locations and dates, sign-offs and signatures, are usually right aligned in the original texts. The transcription of the resource types, such as essays and reports, that have a title starts with a center-aligned title.

### SQUARE BRACKETS

Square brackets were used exclusively for editors' comments. If square brackets ([ ]) are used in the original text, we changed them to angle brackets (< >) to differentiate the authors' from the editors' comments.

### HYPHENS

Hyphens that are used in line-break words in the original texts were ignored and not transcribed. Except for those line-breaking hyphens, we transcribed the hyphens as we saw them in the original texts.

### APOSTROPHES

Sometimes the possessive apostrophe is omitted in the original text. We chose not to add it in order to preserve the appearance of the original.

### PROOFREADERS' MARKS

Proofreaders' marks were not transcribed but were applied to transcribe the final version of the text the writer was judged to have intended. For example, when a paragraph mark was inserted, we created a new paragraph. Paragraph marks were mostly used in the original text of the manuscripts in the Manuscripts section.

## SPACES/INITIALS

We generally transcribed spaces as we saw them in the original text, including a space between two initials in a row. We added a period at the end of each initial without a remark only when it was judged likely to confuse the readers not to add it. Sometimes, we added a space if it looks more appropriate. For example, "Wm. Griffs" was transcribed as "Wm. Griffis." We did not mark the editors' omission or insertion of empty spaces.

## UNDERLINING

In the Korea Letters section, we did not transcribe underlining, as oftentimes it is not clear who marked it. In addition, underlining, such as the "m" in "Wm E. Griffis" often has, was not transcribed. Likewise, the underlining (or two dots, as are often found in the original texts of Horace Newton Allen's letters) under the letters in ordinal numbers such as th (in 4$^{th}$), st (in 1$^{st}$), and nd (in 2$^{nd}$) was not transcribed. However, in the Manuscripts section, underlining was transcribed.

## DITTO MARK

Authors sometimes used a ditto mark (") to avoid writing the same word written right above it. We transcribed the repeated words, replacing the ditto marks.

## QUOTATION MARKS

When we encountered a period or comma outside of quotation marks (e.g. " ". or " ",) we did not change it and transcribed it as we saw it.

## Transcription Conventions

### EDITORS' ANNOTATIONS AND IN-TEXT NOTES

All the editors' in-text notes are in square brackets to separate them from the original text. If square brackets are used in the original text, they were replaced with angle brackets to be differentiated from the editors' notes. Transcription comments that are related directly to the text were inserted at the point where the comment is needed, enclosed in square brackets (e.g., [Note in upper left corner of the first page:]). Editors' annotations are given in footnotes.

### CORRECTIONS, INSERTIONS, DELETIONS, ETC., BY THE ORIGINAL AUTHORS

We did not transcribe the original writer's proofreaders' marks but transcribed the final version after they are applied. For example, if an author originally typed out "pies," but then manually inserted an "r" with an insertion mark, we typed out "piers." Likewise, paragraph marks were not transcribed. When a paragraph mark was inserted, we created a new paragraph. Paragraph marks were mostly used in the original text of the manuscripts in the Manuscripts section.

### MISSPELLINGS/ARCHAIC SPELLINGS

We adhered to the style of the original manuscript. Only when a spelling was judged to be confusing to the readers, [*sic* read (suggested spelling)] was added

12 *Introduction*

(e.g., Evinghews [*sic* read Evening News]). If it is a minor misspelling or an archaic form that was judged to be easily guessed by the readers, it was transcribed as it appears without any such comment. Rarely, [*sic*] was inserted when any suggestion was decided to be unnecessary. For example, in "have I have [*sic*]," "[*sic*]" suggests the omission of "have."

### ILLEGIBLE WORDS AND PHRASES

If a word can be guessed from the context and/or from the legible part of a word, it is suggested with a question mark in square brackets (e.g., [piers?], the Sidfather Bureau?)

If the presence of a word is identified, but it cannot be guessed, we inserted [?]. [?] is an equivalent to a word regardless of the number of letters in it.

When an entire paragraph or larger part of a page is not legible, we used [. . . (amount of text) (reason why it was not transcribed)] instead of using many [?]s. The following are examples of these cases: [. . . a page not legible], [. . . page(s) missing], [. . . lines missing].

### OMISSIONS/INSERTIONS FOR CLARIFICATION

Rarely, we added a word enclosed in square brackets when it is judged to be confusing without it. Usually it is the case where the author was judged to have forgotten to add a certain word (e.g., [I] would like to). However, as is written under "punctuation marks," punctuation marks (e.g., periods, commas) were added or omitted without using square brackets only when it was judged to make more sense to the readers to do it.

### NOTES WRITTEN IN MARGINS

What is written at the margin of the letter is inserted where it was judged to be placed without any editors' note when it is clear where it should be placed. However, when it is not very clear where a note was meant to be placed, we added a comment in square brackets: (e.g., [Note at top left corner:])

### GRIFFIS'S NOTES

We did not transcribe Griffis's notes. Griffis's occasional marks such as +, ✓, 大 (probably meaning important), or underlining, rarely with in-text brief notes in the original letters, were not transcribed. His occasional notes, mostly on the back (and occasionally on the front) of a letter, were not transcribed either. In most of these cases, he made a brief note on a sender's name, location, or the theme of a letter (many times "Korea"), and so forth, probably for quick identification or reference.

### KATHERINE G. M. JOHNSON'S ANNOTATIONS

Katherine Johnson, Griffis's granddaughter, who researched many areas of the collection, left marginal notes in the Korea Letters. Her handwritten pencil anno-

*Introduction*   13

tations appear sporadically, mostly with square brackets with her initial "k" at the end ([—]k). We did not include her annotations in the transcription.

PAGE NUMBERS
The page numbers on the original texts were not transcribed.

NUMBERS OTHER THAN PAGE NUMBERS
Occasionally we found letters that have certain numbers (not page numbers of the letter) on top, which probably mean the writer's own numbering of his or her items. We did not transcribe them.

MIMEOGRAPHED OR PHOTOCOPIED LETTERS
A small portion of letters are mimeographed or photocopied. We did not differentiate them from the original ones in our transcription and did not mark them. The originals of photocopied letters are occasionally found in other series in the collection, as Griffis used the backs of the letters to make notes.

SIGNATURE
We transcribed the writer's signature at the end of the letter in bold.

WRITING DIRECTION
Chinese characters written from right to left were transcribed from left to right.

### Transcription Format of Korea Letters

DATE AND LOCATION
Transcription of each letter starts with a place name (transcribed as written, formatted in title case) and a date (formatted as [month (abridged)] [day], [year]). Usually, a date is found at the beginning of a letter right after the location. In our transcription, however, the date was transcribed first and then the location, regardless of the arrangement of the original letter.

If a date and a location are found at a place other than at the beginning of the letter, we recorded them both at the beginning of the letter, with a note where we found them, and also at the place where they were found.

For locations not found at the beginning of the letter, we added the source in square brackets. For dates not found at the beginning of the letter, we added the source as a footnote. When the location or date was not identified, we recorded it as [Location not identified] or [Date not identified]. The following are some examples:

| June 3, 1901 | Sept. 5, 1901[1] | [Location not identified] |
|---|---|---|
| Seoul, Korea | Seoul, Korea [location from letterhead] | [Date not identified] |

[1] Date from the date at the end of the letter

14    *Introduction*

RESOURCE TYPES

Handwritten letters were not marked for their resource type as they are the majority of the documents found. We only marked resource types other than traditional letters at the beginning of a letter (e.g., [Newspaper Clipping], [Postcard]).

Typed letters (compared to handwritten letters) were marked with [Typed Letter] right next to the date. If a letter has both a typed and a handwritten part and the handwritten part is not minimal, we marked [Typed & Handwritten Letter] at the beginning of the letter and marked the beginning of each handwritten or typed section as [Typed] or [Handwritten]. If the handwritten part is only a few words or one or two sentences, we did not mark it.

If any resource type does not start with Typed or Printed, it is handwritten except when it is clearly printed, such as newspaper or journal article clippings. The following are examples: [Printed Circular], [Circular], [Typed Invitation], [Typed Bulletin], [Manuscript].

LETTERHEADS

Information in the letterheads was not transcribed in its entirety. We only transcribed the location information from the letterheads, either at the beginning of a letter (when the writer's location was not found anywhere else in the letter) or as a footnote (when the writer's location was noted somewhere else in the letter). When the location information from letterheads was transcribed, a punctuation mark such as a comma, semicolon, or colon was added to prevent confusion.

BEGINNING OF THE TEXT

After the salutation (or greeting), we started a new line to transcribe what comes next, regardless of the format of the original text.
e.g.:
Dear Mr. Wm. Griffis:—
Thank you for . . .

FORMAT AND ARRANGEMENT OF THE ITEMS OTHER THAN LETTERS

An item that is judged to have been enclosed with a letter was not treated as a separate item but entered under the letter. The transcription of the enclosed item starts with [Type of the item]. When it is not clear with which letter an item was sent, it was entered as a separate entry and placed after all chronologically arranged letters.

JOURNAL/NEWSPAPER CLIPPINGS

Journal or newspaper clippings were not transcribed, but their scanned images replaced the transcription.

POSTCARDS

We followed the same format of transcription of letters (starting with a date and a location). The name of the recipient and his or her address were transcribed at

the end of the letter (after an empty line) regardless of their position in the original postcard. Stamps and postmarks were not transcribed. The printed word "POSTCARD" was not transcribed either. Captions of printed photo(s) were transcribed when they were judged to be meaningful.

INDICATION OF FRONT OR BACK
We marked the front or the back of a document with [front:] or [back:] only when doing it avoids confusion.

REFERENCES

Adam Matthew Publications. 1995. *Japan through Western Eyes: Manuscript Records of Traders, Travellers, Missionaries and Diplomats, 1853–1941*, microfilm. Wiltshire, UK: Adam Matthew Publications.

Adams, Charles Kendall, and Rossiter Johnson. 1902. *Universal Cyclopaedia and Atlas*. New York: D. Appleton and Co.

Burks, Ardath W., and Jerome Cooperman. 1960a. "Dr. William Elliot Griffis (1843–1928) and 'The Hermit Nation.'" *Asea yŏn'gu* 아세아연구 3, no. 1 (June): 169–177.

———. 1960b. "The William Elliot Griffis Collection." *Journal of Asian Studies* 20, no. 1 (July): 61–69.

Cho, Young-mee Yu, and Sungmin Park. 2022. "The Significance of the Korean Materials in the William Elliot Griffis Collection at Rutgers University." In *Beyond the Book: Unique and Rare Primary Sources for East Asian Studies Collected in North America*, edited by J. Yang, 259–300. The Association for Asian Studies, Ann Arbor, MI.

Chŏng, Kŭn-sik 정근식. 2019. "Kŭrip'isŭ ŭi Ŭndun ŭi nara Han'guk ŭi t'eksŭt'ŭ hyŏngsŏng kwajŏng" 그리피스의 '은둔의 나라 한국'의 텍스트 형성과정 [The text formation process of *Corea: The Hermit Nation*]. In Yang, Sang-hyŏn and Yu Yŏng-mi, *The Photographs of Korea in the William Elliot Griffis Collection*, 333–361. Hanbit Publishing. .

Gass, Leah H., and Fernanda Perrone. 2003, rev. 2018. "Korean Materials in the William Elliot Griffis Collection." Special Collections and University Archives, Rutgers University Libraries, New Brunswick, NJ.

Hawley, Samuel. 2008. *America's Man in Korea: The Private Letters of George C. Foulk, 1884–1887*. Lanham, MD: Lexington Books.

Kim, Yun-sik 김윤식. 2008. "Ŭnja ŭi nara Han'guk ŭi chŏja Kŭrip'isŭ ege ponaen Pak Ŭn-sik, Yi Kwang-su yŏnmyŏng ŭi p'yŏnji" <은자의 나라 한국>의 저자 그리피스에게 보낸 박은식·이광수 연명의 편지 [Eun Sic Park and Kwangsoo Lee's letter to Griffis, the author of Corea: The Hermit Nation]. *Munhak Sasang* 문학사상 (November): 21–27.

Lee, Hye Eun 이혜은. 2021. "Kŭrip'isŭ wa Han'guk: p'yŏnji rŭl tonghae pon Williŏm Kŭrip'isŭ ŭi sahoe kwan'gyemang" 그리피스와 한국: 편지를 통해 본 윌리엄 그리피스의 사회관계망 [William Elliot Griffis and Korea: Social network as seen through his letters]. *Han'guk Yŏn'gu* 한국연구 9: 141–172.

Lee, Hyoungbae. 2014. "Lesser-Known but Important: Small Collections on Korea in North America." Presentation at the annual meeting for the Committee on Korean Materials, Council on East Asian Libraries (CEAL), Philadelphia, PA.

Park, Sungmin, and Young-mee Yu Cho. 2019. "William Elliot Griffis and His Visit to Korea in 1927: From his Journals and Korea Letters." In Yang, Sang-hyŏn, and Yu Yŏng-mi, *The Photographs of Korea in the William Elliot Griffis Collection*, 368–393. Hanbit Publishing, Seoul, Korea..

Sim, Huigi. 2008. "Rare Books and Pamphlets in the William Elliot Griffis Collection." [Both Korean and English versions are available upon request at the Special Collections and University Archives at Rutgers University.]

Yang, Sang-hyŏn, Pak So-yŏn, and Yu Yŏng-mi. 2014. "Kŭrip'isŭ k'ŏlleksyŏn e sojangdoeŏ innŭn Han'guk kŭndae sajin charyo ŭi haksulchŏk kach'i e taehan koch'al" 그리피스 컬렉션 에 소장되어 있는 한국 근대 사진자료의 학술적 가치에 대한 고찰[The significance of Korean photographs in the William Elliot Griffis Collection at Rutgers University]. *Han'guk Kŭnhyŏndaesa Yŏn'gu* 한국근현대사연구 71 (December): 7–50.

Yang, Sang-hyŏn, and Yu Yŏng-mi. 2019. *The Photographs of Korea in the William Elliot Griffis Collection*. Noonbit Publishing Co., Seoul, Korea.

Yi, Yŏng-mi 이영미. 2014. "Ilbon ŭi Han'guk chibae e taehan Kŭrip'isŭ ŭi t'aedo" 일본의 한국 지배에 대한 그리피스의 태도[Griffis's attitude towards Japanese occupation of Korea]. *Han'guksa yŏn'gu* 한국사연구 166 (September): 271–297.

———. 이영미. 2015. "Kŭrip'isŭ (1843–1928) ŭi Han'guk insik kwa Tong Asia" 그리피스 (1843– 1928)의 한국 인식과 동아시아 [Griffis's (1843–1928) Perception of Korea and East Asia]. PhD diss., Inha Taehakkyo 인하대학교.

# PART I

# LETTERS FROM MISSIONARIES

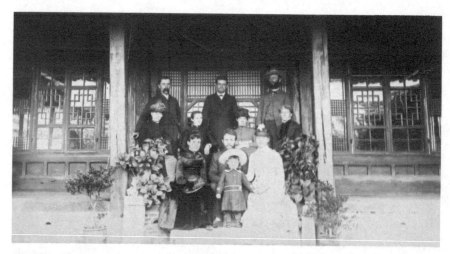

Figure 1 The American missionaries and their families in Seoul in 1887. From left to right, standing: William B. Scranton, Horace Grant Underwood, and Horace Newton Allen. Henry Gerhart Appenzeller is sitting in the middle. (KP 9.1.5, Griffis Collection)

# 1 Albrecht, George E. (1894)

### GEORGE E. ALBRECHT (?–?)

George E. Albrecht was born in Prussia and served as an officer of the Prussian Army. Albrecht enrolled in the Theological Seminary of Oberlin. He went to Niigata, Japan, in 1887 to work at the Maebashi Station for three years. From 1889 until 1904 he worked at the Doshisha Theological Seminary.

1) **Dec. 18, 1894**

**Kyoto**

Dear Sir;

Mr. Foulk has left a large amount of papers, letters etc., all arranged & classified. Among them are copies of his official correspondence while "charge d'affaires" in Corea, geographical notes of his travels in Corea & Liberia, & much miscell. correspondence. Mrs. Foulk, with whom I conferred after the receipt of your favor of the 5th. ult.[1] leaves it to me to select for you what I may deem of service for your purposes. I will therefore go over all his papers & will send you in time such papers as may be of interest to you, both official papers and private notes or letters, such as are not of a confidential nature. From my examination so far I feel convinced that there is much interesting material hidden away in these bundles. His letters to his father on Corea, of which you speak I have not yet discovered. It will take me some time, 3 or 4 weeks, to go through the papers, as I have promised Mrs. Foulk to submit them all to her before sending them. After that, how shall I send them to you? In March or April, some of our missionaries going home could take them along and send them to you by express from their homes. If you wish to have them earlier they could be sent by private parcel-express from Yokohama, but this, I think, is rather expensive. I will await your instructions with regard to this. I think I can also send you a photograph of his grave. Foulk was a noble fellow. His memory is hallowed in the hearts of all who knew him.

With sincere regards,
Yours fraternally,
**Geo. E. Albrecht.**

---

[1] Past month.

# 2     *Allen, Horace Newton (1888–1920)*

## HORACE NEWTON ALLEN (1858–1932)

Horace Newton Allen obtained a bachelor of science degree from Wesleyan University and graduated from Miami Medical School. Afterwards, he travelled to China and Korea to work as a Presbyterian medical missionary. He introduced Western medicine in the region, establishing Chejungwŏn 제중원, the first Western medical institution in Korea. Although he was the first Protestant missionary sent to Korea, he worked as a physician so as to circumvent the government laws prohibiting foreign religions. At the behest of King Kojong 고종, Dr. Allen led a Korean delegation to the United States to help establish the Korean legation in January 1888. After he resigned from his post as the secretary of the Korean legation in 1889, Allen was appointed as a secretary of the U.S. legation in 1890. As a diplomat, Allen helped to secure mines and railroad projects for U.S. contractors. Due to his dissent from the Roosevelt administration's noninterventionist foreign policy toward Korea, Allen was dismissed from his position of minister plenipotentiary to Korea. He permanently left Korea on June 9, 1905, and settled in Ohio, establishing his own private medical practice.

### 1) June 11th, 1888

**1060. N. Halstead Chicago**
Rev Wm [Griffis?]

My dear Sir,

In answer to yours of the 8th, allow me to say that the teaching of Christianity was prohibited when the government school was first started. The skipping of religious passages in the books [however?] only served to increase the desire of the pupils to know more of the subject than they could learn by their private readings, and as this is no objection to private instruction on the subject, the teachers and missionaries were pressed with questions.

You must have in mind the fact that it has only been about a score of years since the usurping acts of the Jesuits brought Christianity into such disfavor that the priests and hundreds of their followers were killed and when Treaties were made religious clauses were carefully excluded when the French came to ratify their treaty in the spring of '86.[1] The ambassador noti-

---

[1] In response to the execution of French missionaries in 1866, France sent seven ships and 600 men and captured a fort on the island of Kanghwa near the mouth of the Han River,

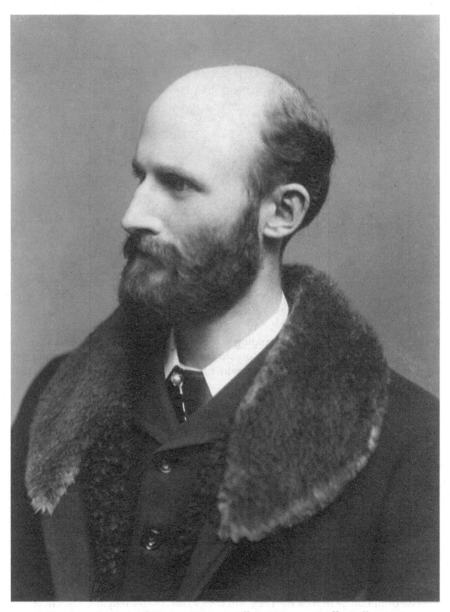

Figure 2  Portrait of Horace Newton Allen (KP 4.3.7, Griffis Collection)

fied the Korean Foreign Office that unless a religious liberty clause would be granted he would not open negotiations. His request was not complied with.

---

demanding a punishment of those responsible for the Catholic persecution. The French were driven back by the Korean troops. It was not until 1886 that the French were allowed access to Korea with the Korea-France Treaty of 1886, preceeded by the Treaty of Kanghwa with Japan (1876) and the Corean-American Treaty of Amity and Commerce (1882).

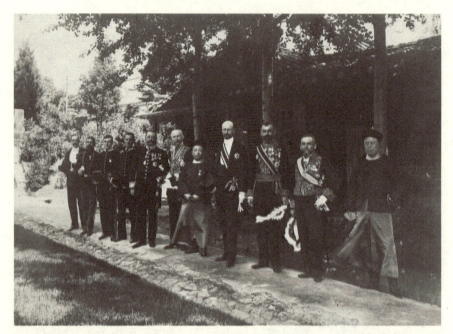

Figure 3 Horace Newton Allen standing in fourth from right. "The diplomatic corps in the Korean capital in 1912 when Korea was annexed to Japan, became part of the Japanese empire and the legations were withdrawn." (from the back of the photo) (KP 15.4.3, Griffis Collection)

He had to swallow his words and make a treaty with no concessions to Christianity.[2]

From this you will see that this is an immense opposition to overcome, and yet when you remember that the Koreans are practically without a religion, that they are decidedly a religious people by nature, that their opposition to Christianity is the result of the usual reaction that sets in in such countries toward sermonizing you will see that once the philanthropic motives of Protestant missionaries is fully understood the opposition will vanish. I have told many Koreans that it [is useless?] for them to object to Christianity, in the face of the fact that they are so in need of a religion and while they are honoring everything else from European nations. They will have to accept this religion. They have invariably seemed to admit it but always say "we are not quite ready yet."

We are fully advised of the present difficulties which are [wholly?] caused by the indiscreet acts of the missionaries in Seoul, and which may lead to serious trouble if they insist on pursuing their rash exercise against the advice of the more sensible ones of their own members and competent outside friends. By virtue of the open manners in which the Protestants have been erecting

---

[2] After Hŭngsŏn Taewŏn'gun (1820–1898), or Taewŏn'gun 대원군, who was a strong isolationist, lost power in 1873, the anti-Christian policy started to weaken rapidly and missionary activities began to increase in Korea.

missionary edifices in the most public places, holding meetings and baptizing converts. The Jesuits have been proposed to come from their obscurity and are building an edifice said to be a cathedral.[3]

It needs no explanation to show you how such sudden aggressiveness will affect the people and tend to ruin all that has been done. Especially is this the case when tis known that the earnest and kindly admonition of the Korean government and advice of foreign representatives is utterly and [?] insolently disregarded.

All this should not change your plans but should induce you in your arrival in Seoul to be more cautious. This is ample opportunity for educational work,[4] which is by far the most profitable of all missionary work, and by the time the way has been properly found in this way the opposition to Christianity may be removed. The Secretary of Legation[5] went home in sick leave, and his going has nothing in the world to do with this or any other question. He will return ere long.

Yours very truly
**H. N. Allen.**

**2) June 18, 1888**

**Washington**
Rev Wm. E. Griffis,
Boston Mass.

My dear sir,

In answer to yours of the 16th allow me to say that I am very glad you are getting out a new edition of your book[6] (I hope it is the large one) and that I am willing and will take great pleasure in sending you every assistance in my power. I am surprised and horrified at the ignorance of our people concerning

---

[3] The construction of Myŏngdong Cathedral began in 1887 amid a land ownership dispute between the Diocese of Chosŏn and the Korean government. Opposing the erection of a cathedral on disputed property, King Kojong issued a blanket ban on Christian missionary activity in April 1888. As a result of this ban, the groundbreaking ceremony for the cathedral was not held until August 5, 1892. The completed building was consecrated on May 29, 1898, under the name Chonghyŏn Cathedral. In 1945, it was renamed Myŏngdong Cathedral.

[4] Chejungwŏn was Korea's first Western hospital. It was founded in 1885 by King Kojong (initially under the name Kwanghyewŏn) upon the proposal of Allen, who served as the hospital's founding director (1885–1887) and also founded Korea's first medical school in 1886. In 1904, Chejungwŏn was restructured and renamed as Severance Hospital by Canadian missionary Oliver R. Avison (1860–1956), with the financial assistance of American philanthropist Louis Henry Severance (1838–1915). (The hospital is now affiliated with Yonsei University.)

[5] Allen was appointed as secretary of the U.S. legation in Seoul in 1890 and promoted to consul general in 1897.

[6] This edition might refer to William Elliot Griffis, *Corea: The Hermit Nation . . . Third Edition, Revised and Enlarged, with Additional Chapter on Corea in 1888* (New York: Charles Scribner's Sons, 1889).

Not confidential

June 11th '88

Rev. Mr. Gardner
1060. N. Halsted Chicago.
My dear sir,

In answer to yours of the 8th allow me to say that the teaching of Christianity was prohibited when the government school was first started. The slipping of religious passages in the books & lessons only served to increase the desire of the pupils to know more of the subject than they could learn by their private readings, and as this was objection to private conversation on the subject, the teachers and missionaries were pressed with questions.

You must bear in mind the fact that it was only now about a series of years since the uamping acts of the Jesuits brought Christianity into such disfavor that the priests and hundreds of their partisans were killed, and when treaties were made religious clauses were carefully excluded. When the Frenchman came to ratify this treaty in the spring of '86. The ambassador notified the Korean Foreign Office that unless a religious liberty clause would be granted he would not open negotiations. His request was not complied with, he used to remove his words and make a treaty min no concessions to Christianity.

From this you will see that there is an immense opposition to converts. And yet when you remember that the Koreans are practically without a religion, that they are decidedly a religious people by nature. that this opposition

Korea, and am continually referring them to your book. The idea that the Koreans are barbarians is somewhat sustained by the absurd collection on the National Museum.[7] Bernadou[8] couldn't have done worse for the Koreans had he tried. We are now making up a careful list of articles at the Legation, which we shall ask the King[9] to send in, as an exhibit, to the Museum. I have made many addresses and have talked till I actually talk of Korea in my sleep. The Century[10] people asked me for an article which I foolishly sent them without revision. They spoke of it as very interesting but returned it. I gave this to a newspaper correspondent to shorten up for a "Sun" article. What I want is to give our people a knowledge of Korea. A Boston man Gen'l. C. B. Dutch, who was highly recommended to me and who has been somewhat interested in Korea, has been urging me to write a book, but as I am no literary man I have steadily declined. He is here now and is [insisting?] that I should furnish the facts and let him write the book. But as I am disappointed in the man I have declined. The object of all this is to say to you that I will be very glad to give you all the information I have or may obtain through the Legation and as your book—though incomplete, is the best we have. I want to see you bring it up to date and make it accurate. Therefore in addition to furnishing new information, [but?] in not present future I will offer to correct some mistakes in your present work.

I have already spoken to the minister about the subject and will see that you get some royal recognition this time. Your other books never reached the King.

You must allow me a little time on your question and please send along any other you may have in the mean time. I already have the Korean data you want but must work them into English. Judge Denny[11] has written a long brief on the Korean political situation which I think I can get for you.

Gen'l Lucius H. Foote[12] is in Baltimore, Capt. Parker[13] in San Francisco. I don't know their addresses. Lieut Foulk[14] and our present excellent minister

---

[7] The United States National Museum (now the Arts and Industries Building at the Smithsonian Institution) held a collection of Korean artifacts assembled in 1886 by John Baptiste Bernadou, a U.S. Navy ensign.

[8] John Baptiste Bernadou (1858–1908) was an officer in the U.S. Navy who served on special duty in Korea with the Smithsonian Institution, between 1883 and 1885. His findings were published in Walter Hough, *The Bernadou, Allen and Jouy Corean Collections in The United States National Museum* (Washington, DC: U.S. Government Printing Office, 1893).

[9] King Kojong.

[10] The *Century Magazine* (1881–1930) was a monthly magazine published in New York, New York.

[11] Owen Nickerson Denny (1831–1900) was an Oregon attorney who served as the advisor to the Korean Ministry of Foreign Affairs.

[12] Lucius Harwood Foote (1826–1913) was the first U.S. minister to Korea, serving from 1883 to 1885. His appointment changed in 1884 from envoy extraordinary and minister plenipotentiary to minister resident and consul general. He and Allen resided in the U.S. legation behind Tŏksugung Palace in Seoul, in a traditional Korean house purchased from the Min family (the family of Empress Myŏngsŏng 명성황후 (1851–1895)). He was replaced by George Clayton Foulk.

[13] William Harwar Parker (1826–1896) was U.S. consul general to Korea from June to September 1886.

[14] George Clayton Foulk.

# 26  LETTERS FROM MISSIONARIES

Hugh A. Dinsmore. I can tell you all about and furnish pictures. No one have gotten out no report of the hospital of late. Thank you for your kind appreciation of my own work. I may say that my future is uncertain. I have been rather more successful than I had dared to hope I should be. And the Koreans seem to appreciate it very highly so that I am spoken of for some very high position. It will perhaps be better for all concerned if I remain in the King's service yet I am undecided.

The refugees are never seen. One very bad man Yuen Chun Sik [?] the Legation kitchen a good deal, and as he is destitute the Korean servants feed him. One man Ye Kay Pill[15] a Christian and student at Lincoln is not of the refugee lot, and he has the entre at the Legation where he is always unclean.

Little Min Chu Ho who sent Prince Min Yong Ihc[16] money foolishly returned to Korea this year and is now in confinement with You Kill Chun[17] (of Boston). These men can never be reconciled to the present govn't, and I must say I have little patience with the injustices of some of our people who seem to think that Korean laws amount to little and should be set aside for their men because they have purposely adopted a religion hostile to the states.

You may get me so worked up over Korea that I will run up and bore you. I warn you in advance that I am an enthusiast and it is dangerous to get me started. Trusting you will allow me to help you all I can. I remain

Yours very truly
**H. N. Allen.**

## 3) June 20, 1888

## Washington[18]

Dear Mr. Griffis,

I must give up trying to figure out these data, and I could not get the desired information from the State Dept. I don't care to [?] the respective Legation here, as we ought to have the foreign text of each of these treaties on file. If you have any trouble in figuring out these dates you might write to each of these Legation men and ask them for the date of the treaties.

---

[15] Yi Kye-p'il 이계필 (?–?) graduated from Lincoln University in Chester County, Pennsylvania, in 1890, becoming one of the first Koreans to graduate from a U.S. college. He had ties with Minister Pak Chŏng-yang, who arranged his study abroad and secured him a job at the U.S. legation.
[16] Min Yŏng-ik 민영익 (1860–1914) was the adoptive nephew of Empress Myŏngsŏng, and he led the first Korean mission to the United States in November 1883. Allen treated him after he was injured during the Kapsin Coup 갑신정변 (Dec. 4–6, 1884), a reformist-led three-day coup d'état demanding domestic reform and independence from Chinese suzerainty.
[17] Yu Kil-chun 유길준 (1856–1914) was attaché to Min Yŏng-ik in Korea's first mission to the United States in 1883. In 1884, he studied at the Governor Dummer Academy in South Byfield, Massachusetts, becoming the first Korean to study in the United States. He was under house arrest from 1885 to 1892 for his ties to the reformists involved in the Kapsin Coup.
[18] In letterhead: Legation of Korea.

Korea has a Commissioner of Trade at Tientsin,[19] a legation at Tokio, established in '87, a legation at Washington (88) and is about to establish a legation to represent the five European countries[20] in treaty relation with Korea.

We have a Consulate General at Hamburg,—Mr. E Meyer[21] of E Meyers & Co Merchants,—and a Consul General to New York in Everett Frazar[22] of Frazer & Co.

There are many flags in use in Korea but the one we have at the legation will be used by ships, the customs, and other foreign departments. (You can find one picture on the cigarette banner issued by Allen & Ginter. It is the national flag.)

Pak Chung Yang,[23] E.E. & M.P. Washington D.C. born, Ye Dynasty[24] 450, 12, 24,[25]—(a noble man of 2nd rank called Champan) Chio Sin He,[26] E.E. & M.P. accredited to England, Germany, France, Russia & Italy, now enroute. Born, Ye Dynasty, 459th year.

Same rank as above, Kim Ka Chin,[27] Charge' d Affairs and interim Talsio.

Tai Wan Kuun,[28] is now living quietly in Seoul. For an account of his recent intrigue with China to defend King; See Dennys paper[29] in political situation in Korea.

---

[19] The Korea-China Treaty of 1882 stipulated that a Korean commissioner of trade be dispatched to Tianjin, China.

[20] England, Germany, France, Russia, Italy.

[21] H. C. Edward Meyer (1841–1926) was appointed honorary consul to Germany in 1887 by King Kojong. Edward Meyer and Company was a merchandising business in East Asia, with a Korean branch office in Chemulp'o 제물포 (now Inch'ŏn) under the name Sech'ang Yanghaeng.

[22] Everett Frazar (1834–1901) was appointed honorary consul to the United States by King Kojong in 1884. He was the senior partner of Frazar and Company, which traded in Korea, China, and Japan.

[23] Pak Chŏng-yang 박정양 (1841–1905) was envoy extraordinary and minister plenipotentiary to the United States from 1887 to 1889, and the first Korean diplomat to the United States. His dispatch to Washington, DC, was delayed because Yuan Shikai (1859–1916), then commissioner of the Qing Dynasty in Seoul, demanded that Korea dismiss its diplomats appointed without prior Qing approval.

[24] Yi (or Chosŏn) is transliterated as Ye.

[25] Pak Chŏng-yang (1841–1905) was born on December 24 in the year 450 of the Chosŏn-Dynasty calendar.

[26] Cho Sin-hŭi 조신희 (1851–?) was appointed envoy extraordinary and minister plenipotentiary to England, Germany, France, Russia, and Germany in July 1887. He never served his term, and he returned to Korea en route to his first diplomatic mission in Europe, when Yuan Shikai demanded the dismissal of Korean diplomats such as Pak Chŏng-yang.

[27] Kim Ka-jin 김가진 (1846–1922) was minister to Japan from 1887 to 1891. He was also a founding member of the Korean Independence Club.

[28] Taewŏn'gun (1820–1898) was the father of King Kojong and the regent of Chosŏn from 1864 to 1873. Born Yi Ha-ŭng, he rose to power when his son became king of Chosŏn in 1864. Assisting King Kojong, who was then a minor, Taewŏn'gun directed various policies that were notably isolationist. He was deposed in 1873 by reformists including King Kojong and his wife, Empress Myŏngsŏng, but he continued to be involved in Korea's internal and foreign affairs until the late 1890s.

[29] Owen Nickerson Denny, *China and Korea* (Shanghai: Kelly and Walsh, Ltd. Printers, 1888).

28    LETTERS FROM MISSIONARIES

Trusting you will ask me any questions. [There are common men, my guest?]. [I remain?]

Yours truly
**H. N. Allen.**

For sketch of present minister [Mr. Cinie?] service chronicle (issued by Genl C. B. Dutch, Boston) for April (I think) I furnished some statistics for that journal which may be of interest to you. I can loan you pictures of the minister, Mr. Dinsmore,[30] Mr. [Frank?], and the King,[31] but you would have to return them.

Korea made treaties with the following European countries.[32]

Great Britain,

Negotiation commenced

Ye Dynasty 492nd year, 10th mon 27th day (1883 Nov. 26th.)

Ratified.

Ye Dynasty 493 year, 4th mon, 4th day (1884——)

Germany

Commenced

Ye Dynasty, 492, 10/27 (1883 Nov. 26th)

Closed

493, 10/1

Russia

Commenced

493, *5, 15 = 1884, June 25th

Closed

494, 9, 7 = 1885, May—

Italy

Commenced

495, *5, 4 = 1884, June 26th

Closed

496, 6, 27 = 1886

France

Commenced

---

[30] Hugh Anderson Dinsmore (1850–1930) was U.S. minister resident and consul general to Korea from 1887 to 1890.

[31] King Kojong (1852–1919) was the twenty-sixth and last king of Chosŏn (r. 1864–1897) and first emperor of the Korean Empire (r. 1897–1907). While he was a minor on the throne, his father, the isolationist Taewŏn'gun, was the de facto regent of Chosŏn. Kojong himself began ruling in 1873, amid political tension between reformists (advocates of trade) and conservatives (isolationists), as well as intense competition among foreign nations (e.g., Japan, the United States, Russia, China) that had begun trading with Korea. His abdication in 1907 was followed by the Japanese annexation of Korea (Aug. 22, 1910).

[32] Korea began trading with foreign nations by signing the Treaty of Kanghwa with Japan (1876), which was followed by treaties with the United States (1882), China (1882), the United Kingdom (1883), Germany (1883), Italy (1884), Russia (1884), and France (1886).

495, 5, 3 = 1886,
Closed
496, *4, 8. 1887, May 30th
Today June 20 in 1888 is Ye Dynasty 497th year, 5th mon, 11th day
An intercalary month runs every five years.
*These months are 2nd months of that number. These years having 13 months out of 12.

## 4) June 25, 1888

### Washington

My dear Dr. Griffis

I am sorry you are so limited in time and space. I write very poorly and would like to see you, but I cannot leave at present, also I would like very much for you to see the article of Judge Dennys to which I opined, but I cannot get it at present. I will [?] send you a little abstract of it that appeared in the San Francisco Examiner. I would like to have you return it to me. I also enclose copy of a letter of advice to a man who is going to Korea you may return this also.

The "Sun" article[33] has not yet appeared but at the risk of being lecturer I will send you the article I wrote, expecting you to return it also. You have doubtless seen Mr. Foulks[34] letter in our "Foreign Relations" p. 85–6 & 7, if not you should see them, and if I can get hold of Dennys paper I will send it you, but John Merrill Young, I think, wants to suppress it.

Yours truly
**H. N. Allen.**

## 5) June 1, 1890

### Chemulpo, Korea

My dear Dr Griffis

I have to thank you very warmly for sending me a pkg of very interesting papers the—deeply interesting from the fact that my own papers are not coming regularly yet.

I have looked several times for your letter sent me to Delaware concerning something you wished me to look up. It is mislaid and I shall have to ask you to write again.

---

[33] The *Sun* (1833–1950) was a daily newspaper published in New York, New York.
[34] George Clayton Foulk (1856–1893) was U.S. naval attaché to Korea from 1885 to 1886, and U.S. chargé d'affaires in Seoul from 1886 to 1887 (following the resignation of Minister Lucius Harwood Foote), and from 1886 to 1887 (following the dismissal of Minister William Harwar Parker).

# 30 LETTERS FROM MISSIONARIES

I did not like the outlook at Fusan and came up here. I had hard work getting off. Saw the King Queen[35] and Queen Dowager.[36] They were very gracious but insisted on my return. They compromised by asking Mr. Dinsmore[37] to telegraph Washington to make me Secty of Legation at Seoul. They have not done so but when the appointment is made I will have to return to go back to W. which will not be pleasant.

This place is growing very fast as is all trade in Korea. This year will continue a ticklish time tho. As the prophetic termination of this dynasty falls in this year. So we have to be very careful.

I shall be very glad to aid you in any way I can over here. With kind regards I am

Yours Truly
**H. N. Allen.**

## 6) Nov. 27, 1890

**U.S. Legation, Seoul, Korea**

My dear Dr. Griffis

Yours of Oct. 19th came by last mail, and in reply I will say that I am sending you a couple of Korean novels such as the common people read.

The photographs I will have to give up. The Jap. artists do not seem to have enlarged their stock any since before I left here. They have the same old ones on hand still [?] but few new ones. Any I might send you now would doubtless duplicate what Dr. Heron[38] sent.

As to his failure to send more as he promised on account for what he had on hand, I would rather not take up the matter. I once sent him several dollars from Washington for the same purpose and on my return he told me he had been unable to get them. Hence had not written. Many amateur pictures are taken and if I can get any of them I will send you copies.

I think Mrs. Heron will remain here. Tho' I believe it is not yet definitely decided.

---

[35] Empress Myŏngsŏng (1851–1895), also known as Queen Min 민비, was the wife of King Kojong. She was a reformist, an advocate of close Korea-Russia relations, and the political rival of her isolationist father-in-law, Taewŏng'un. Members of her family, the Yŏhŭng Min clan, occupied various positions of power during and after her reign. She was assassinated on October 8, 1895.

[36] Queen Dowager Cho 조대비 (1809–1890), or Queen Sinjŏng 신정왕후, was the mother of King Hŏnjong and nominal regent of Chosŏn from 1864 to 1873.

[37] Hugh Anderson Dinsmore (1850–1930).

[38] John William Heron (1856–1890) was a medical missionary to Korea appointed by the Presbyterian Church (U.S.A.) and the second superintendent of Chejungwŏn, following Allen, from 1887 to 1890.

I conveyed your reimbursement to Mrs. Heard[39] who seemed gratified and wanted to be remembered to you in return.

Underwood[40] is away now. He has an infant son and a very sick wife, it is cutting him out of work. Dr. Scranton[41] is the most promising student at present. He is rather the authority now on the language. He goes home in the spring and will be in or near Boston. I think he is a Harvard man, maybe it is Yale.[42]

Yes, I am Sec'y of Legation and am also running my old hospital[43] out of hours till the Board[44] can send a Dr. to take Heron's place. It keeps me very busy and the Board seem to work slowly.

Thank you for remembering me.

Yours sincerely
**H. N. Allen**

## 7) Dec. 12, 1890

**U.S. Legation, Seoul, Korea**
Rev. Dr. Wm. E. Griffis
Boston.

My dear Dr.

By last mail I sent you a letter and a roll of two Korean novels. How are you going to read them?

I find I did not properly read your letter. You did not receive any photographs. Therefore I have sent to Chemulpo[45] (There are none here) for an assortment from which I will select and send you $2.75—$3.00 in a registered letter, so that you will get them by next mail.

I thank you very much for the bundle of paper I received from you by last mail.

---

[39] Jane Leeps Heard (1832–1899) was the wife of Augustine Heard, Jr. (1827–1905), who was U.S. minister resident and consul general to Korea from 1890 to 1894.

[40] Horace Grant Underwood (1859–1916) was a Northern Presbyterian missionary in Korea, an instructor at Chejungwŏn, and the founding president of Chosen Christian College (now Yonsei University). He had a wife, Lillias Stirling Horton Underwood (1851–1921), and a son, Horace Horton Underwood (1890–1951).

[41] William Benton Scranton (1856–1922) was a Methodist missionary in Korea, a doctor at Chejungwŏn, and the founder of Sibyŏngwŏn (now Ewha Womans University Medical Center; est. 1885), a hospital whose name was a gift from King Kojong.

[42] Scranton graduated from Yale University in 1878.

[43] Chejungwŏn

[44] Allen requested the U.S. Board of Foreign Missions to send physicians to Korea. Heron had completed his term (1887–1890) as the second superintendent of Chejungwŏn.

[45] Chemulp'o (now Inch'ŏn) was a port on the coast thirty kilometers directly west of Seoul, and one of the first ports opened to foreign trade. Here, Korea signed several important treaties, including the Treaty of Kanghwa (1876) and the Treaty of Chemulp'o (1882) with Japan, and the Corean-American Treaty of Amity and Commerce (1882).

32    LETTERS FROM MISSIONARIES

I have seen your photograph in the N.Y. Dailys and have read of you in connection with the Minneapolis meeting.[46] You must lead a very busy life.

I am sending some photographs from the Soule Photograph Co. of Boston,[47] and have taken the liberty of giving them an order for $2.60 on you, which I will be greatly obliged if you will honor upon receipt of the photographs I am sending you.

I don't like to trouble you but tho't that by giving them an order you would simply have to pay their messenger on presentation. They will forward the pictures.

With kind regards,

I am

Yours truly,

**H. N. Allen.**

## 8) Jan. 5, 1891

**U.S. Legation, Seoul, Corea**

Dr. Wm. E. Griffis

Boston

My dear Dr.

I wrote you by last mail that I was sending you some photographs. The artist has suddenly left for Japan to develop pictures of the Dowager Funeral[48] and I was unable to do as I intended. He has card size pictures for 10¢ cabinet size for 20¢ but I got 25 mounted cards which I have mailed you under P.O. order.

I gave an order on you in my last, rejecting to send the pictures then, hope it has not inconvenienced you.

Yours in haste

**H. N. Allen.**

## 9) July 24, 1895

**Seoul, Korea**

Dear Dr. Griffis,

I have your note of April 4, and have been delayed in replying. I had some pictures taken in reply to your request, as I have none but, the Japanese artist

---

[46] Possibly the Annual Meeting of the American Board of Commissioners for Foreign Missions, held October 8–11, 1890, in Minneapolis, Minnesota. Griffis and his first wife (Katherine Lyra Stanton Griffis, 1855–1898) were honorary members of the Board.

[47] Soule Photography Company was a photography firm in Boston, Massachusetts, run by John Payson Soule (1828–1904).

[48] Queen Dowager Cho (1809–1890) passed away on June 4, 1890, at Kyŏngbok Palace. Her funeral was held on October 11, 1890.

Allen, Horace Newton (1888–1920)     33

gave me black hair, a death mask and squint eyes so I burned them up and cannot send you one. For which I [?] sorry as I would like to have yours. I sent over to the Seoul Repository[49] to subscribe for your ministering in that way you would get the information you wish, but they told me you were already a subscriber.

I will answer some of the easy questions you ask. We have here about 100 Americans in Korea. Medical science is just now getting quite a boost as the govn't has placed its cholera hospital in the charge of the foreign [Dr's?],[50] who are also keeping in quarantine watching. The Koreans usually prefer their own medical treatment but like foreign surgery best.

The books on Korea you mention, [C?,] Norman Larder & [Canadian?] are very disappointing—mere [rat?], Korean military [?] are conducted on modern principles though archery prevails as a means of [primary?] military examinations. Koreans don't swallow the "Japanese medicine" very freely, and the Japanese have quieted down very markedly since the drench of ice cold Siberian water Russia dropped upon them. So Korea breathes more freely and has more time for the everlasting intrigues that seem to be the chief cap of Korean political life. Corruption is not much lessened, and the Japanese are getting discouraged.

If you see the "Japan mail"[51] you will have read a very good interview[52] with Count Inouye[53] which will show you how effectively his people have cast off "politeness" in dealing with Koreans.

Pak Yong Hyo[54] whom you must have known by reputation at least in Japan. Headed the powerful so-called American Party,[55] but he couldn't let intrigue alone so had to become a refugee again, but American influence is still very strong here.

I am glad to hear you are so comfortably situated and hope you can continue your interesting literary work. You are still the authority on Korea. By

[49] *The Korean Repository* (or *Chosŏn Sosik*; 1892, 1895–1898) was an English-language monthly journal published in Seoul. Its inaugural issue was printed in January 1892.
[50] During the 1895 cholera epidemic in Seoul, a Sanitary Board was organized in conjunction with American and Japanese health professionals. Patients were treated in designated cholera hospitals such as the Frederick Underwood Shelter (est. 1893), a hospital established by physician and missionary Lillias Stirling Horton Underwood (1851–1921).
[51] *The Japan Weekly Mail* (1870–1915) was a newspaper published in Yokohama.
[52] "Count Inouye on Korea," *The Japan Weekly Mail*, June 29, 1895.
[53] Inoue Kaoru (1836–1915) was a member of the Meiji oligarchy and a count in the Japanese House of Peers. He participated in negotiations for the Treaty of Kanghwa (1876) as Japanese vice ambassador extraordinary and plenipotentiary.
[54] Pak Yŏng-hyo 박영효 (1861–1939) was the husband of Princess Yŏnghye (1858–1872) and a reformist politician involved in the Kapsin Coup (Dec. 4–6, 1884) and Kabo Reforms 갑오경장 (1894–1895). In July 1895, he emigrated to Japan after being accused of treason. A pro-Japanese collaborator, he was a colonial officer during the Japanese occupation of Korea and was given the title of marquess by the Japanese House of Peers.
[55] Possibly the Independence Club (Tongnip Hyŏphoe 독립협회), which was a reformist organization established in 1896 by pro-American politicians. Among its core members were colleagues of Pak Yŏng-hyo.

# 34  LETTERS FROM MISSIONARIES

the way, why don't you visit the country for which you have done so much. I will agree to get you an audience and see that the King[56] appreciates you.

Your friend
**H. N. Allen.**

## 10) Apr. 29, 1898 [Typed Letter]

**Seoul, Korea**

Dear Dr. Griffis,-

Many thanks for your kind congratulations of Feb.15'th. last. I hope I may be able to at least not disappoint my good friends.

I am glad to hear you are keeping up your interest in Korea. I shall always be glad to render you any service I may. I have been to the photographers for the pictures as you wish, but they had very few new ones, and it is a very expensive undertaking to have them go out and make photographs. I could find none of the R.R.[57] and wrote to the Company[58] for copies, but was told that they had already sent you a full line, so I presume you had written to some one else as well as to myself. I send you such as I could get that I thought would be of interest to you. The Photographer promised to make a picture of the Independence arch[59] as soon as it is completed, and he said the same of the R.R.

Korea is a land of changes, and during the past few months we have seen a very great change in the withdrawal,[60] for the time of Russian influence, and leaving Korea to her own sweet will. She seems to be abusing the liberty as usual, and the condition of the common people is bad indeed.

Americans have in hand all the great financial undertakings here, and if you get the advance sheets of the Consular reports, you will find some inter-

---

[56] King Kojong.
[57] The Seoul-Chemulp'o Railroad, or Kyŏngin Railroad, was the first railroad to be built in Korea. American entrepreneur James R. Morse (?–?) began its construction on March 22, 1897, but lost the construction rights in 1898 due to insufficient funding. The railroad was completed on July 8, 1900, by the Japanese private enterprise Keijin Railway (Kyŏngin Ch'ŏlto Hapcha Hoesa). It was renamed Kyŏngin Railroad in 1906 after it was seized by the Japanese government.
[58] Perhaps referring to a photography company.
[59] Tongnimmun 독립문 is a triumphal arch in Seoul. Designed by reformist politician Sŏ Chae-p'il 서재필 (Philip Jaisohn; 1864–1951) of the Independence Club, it replaced Yŏngŭnmun, a gate that had been built to greet envoys from China while Korea was its tributary state. Construction began on November 21, 1896, and was completed on November 20, 1897.
[60] On February 20, 1897, King Kojong returned from the Russian legation (where he had been in internal exile after the assassination of Empress Myŏngsŏng) to Kyŏngun'gung Palace (now Dŏksugung Palace), asserting Korea's independence from the influence of Russia and other foreign powers. On October 12, 1897, he declared the Korean Empire (Taehan Cheguk).

esting reading there I think. At least I have written on some interesting subjects.

Sincerely yours,
**H. N. Allen.**

**11) Dec. 1, 1898** [Typed Letter]

**Seoul, Korea**

Dear Dr. Griffis.

In reply to your letter of Oct.22, I send you the best collection of new photographs I can get. Amatuer [sic read Amateur] photographers have many new ones, but I cannot get hold of them. I send one of myself.

The bridge[61] is not built, not even the peirs [sic read piers] are up yet. Mr. Morse[62] was disappointed in his money by the timidity of the American capitalists who had agreed to go in with him, so he had to sell to a Japanese syndicate[63] to the great disappointment of the Koreans and to the detriment of the road, for so many delays have resulted that it will not be completed for more than an other year I fear.

The Queen[64] was never photographed except one by Mrs. Isabella Bird Bishop,[65] and I believe she had an accident to the place.

I have enjoyed your magazine articles very much on our Navy in the East.[66] My boys[67] have read The Pilgrims[68] as a school book. By the way, we go home in the spring to put our two sons in St. Johns school at Manlius,[69] not far from you.

I have been very busy this fall. I send you copy of opinion and judgement in my murder case.

Yours sincerely,
**Horace N Allen**

---

[61] The Hangang Railway Bridge (Hangang Ch'ŏlgyo) runs across the Han River, connecting Yongsan and Noryangjin. Construction began on March 22, 1897, and was completed on July 5, 1900.

[62] James R. Morse.

[63] Keijin Railway.

[64] Empress Myŏngsŏng.

[65] Isabella Lucy Bird (married name Bishop; 1831–1904) was a traveler, writer, and a fellow of the Royal Geographic Societies of the United Kingdom and Scotland. She wrote *Korea and Her Neighbours* (New York, Chicago, Toronto: Fleming H. Revell Company, 1898) based on her travels in Korea.

[66] Not able to identify Griffis's articles on the U.S. Navy.

[67] Allen had two sons, Horace Ethan Allen (1884–1956) and Maurice Everett Allen (1886–1966).

[68] William Elliot Griffis, *The Pilgrims in Their Three Homes: England, Holland, America* (Boston: Houghton, Mifflin and Company, 1898).

[69] The Manlius School (or St. John's School) was established in 1869 in Manlius Village, New York, by the bishop of the Protestant Episcopal Diocese of Central New York.

# 36 LETTERS FROM MISSIONARIES

12) Jan. 8, 1900 [Typed Letter]

**Seoul, Korea**
Dr. Wm. Elliot Griffis,
Ithaca, N.Y. U.S.A.

Dear Dr.Griffis:-

I have your letter of Nov.15, and we were much delighted with your account of your visit to the school at Manlius, and for the first news from an outside source, of our boys. I am glad to hear from you such a good account of the school also.

I thank you for the copy of your new book, "The American in Holland"[70] which I am reading with interest. We enjoyed your "Pilgrim their Three Homes"[71] as well as your "America in the Far East",[72] and lately I have been re-reading Hamils narative [sic read narrative] in your "Korea Without and Within".[73] You manage to do a lot of work.

I at once visited the photographers and have just secured a lot of photographs that I think will interest you. I enclose them herewith. I tried to get all those you mentioned and others of interest along the lines you mention. I hope I have succeeded and will try to get you others from time to time.

We have started a little literary society here for the collection of matters of a philosophical and historical interest bearing on Korea and hope to have the proceedings published later on. If this is done I will be glad to send you copies. We had very interesting papers the other day on The Collosal [sic read Colossal] Buddha of Umjin [sic read Unjin][74] and The Manchu Seige [sic read Siege] of Nam Han.[75]

You won Mrs. Allens[76] heart by your visit to the boys and I trust you will not hesitate to write me for any thing you may wish me to do or get for you. Those are great boys to her and to me, and you gave us just the information we wanted.

With our sincere thanks and kindest regards,

Yours sincerely,
**Horace N Allen**

---

[70] William Elliot Griffis, *The American in Holland: Sentimental Rambles in the Eleven Provinces of the Netherlands* (Boston: Houghton, Mifflin and Company, 1899).

[71] Griffis, *Pilgrims in Their Three Homes.*

[72] William Elliot Griffis, *America in the East: A Glance at Our History, Prospects, Problems, and Duties in the Pacific Ocean* (New York: A. S. Barnes, 1899).

[73] William Elliot Griffis, *Corea, Without and Within: Chapters on Corean History, Manners, and Religion with Hendrick Hamel's Narrative of Captivity and Travels in Corea, Annotated* (Philadelphia: Presbyterian Board of Publication, 1885).

[74] The Maitreya Bodhisattva in Kwanch'oksa Temple, Nonsan, also known as the "Ŭnjinmirŭk" Buddha Statue, was built circa 968 during the Koryŏ Dynasty.

[75] During the Qing (Manchu) invasion of Korea (1636–1637), the Qing army laid siege to the Namhan Mountain Fortress (Namhan Sansŏng).

[76] Frances Ann Messenger Allen (1859–1948) was the wife of Horace N. Allen.

## 13) Jan. 12, 1901 [Typed Letter]

**Seoul Korea**

Dear Dr.Griffis,

I received your letter of Oct.24, some time before the arrival of your new book which you so kindly sent to me, "Verbeck of Japan".[77] I have waited till I could read the book which I have now done, and I think you have raised a very fine monument to the memory of a great and good man. The book is most interesting even to those who had not the honor of knowing the Citizen of No Country.[78] It shows a deal of work also and a most kindly and appreciative spirit. I had just been reading your two books on Korea[79] and Commodre [*sic* read Commodore] Perry's original narative[80] [*sic* read narrative],[81] and I found this to fit in most happily. I am trying to make up a little index of Korea's foreign relations, and I may have it published for private circulation. If I do I will surely send you a copy. I think you make a mistake on page 100 of Verbeck, in reiterating that account of the relations between missionaries and foreigners. Perhaps the foreign element was worse 30 years ago than it has been of late, but my experience has been that the merchant and official classes out here are made up of the same sort of people that city communities are at home. There are good and bad, but there are so many good, that it is a mistake, I think, to put them all in the same class and then hold up the missionary as an example to them. Missionary work has grown to be such an enormous undertaking, that there are all kinds of people among them, and I think the standard has been lowered. At least there are enough foolish or worse ones among them, to give the whole body just cause for criticism, while perhaps the merchant and official class has improved. At any rate, that sort of general condemnation of the one class and entire approval of the other, is neither just nor politic and I dont think you would do it after careful deliberation. I have been of both classes and I have been and am a sort of father confessor for both classes, both as a physician and now as a court of last appeal. I am firmly of the opinion that the lack of sympathy between the two

---

[77] William Elliot Griffis, *Verbeck of Japan: A Citizen of No Country; A Life Story of Foundation Work Inaugurated by Guido Fridolin Verbeck* (New York, Chicago, Toronto: Fleming H. Revell Company, 1900).

[78] Guido Fridolin Verbeck (1830–1898) was a Dutch missionary and educator in Japan, who was also a counselor of the Meiji government. He helped arrange Griffis's teaching appointment at Fukui Domain Academy.

[79] William Elliott Griffis, *Corea: The Hermit Nation* (London: W. H. Allen & Co., 1882); Griffis, *Corea, Without and Within.*

[80] Matthew Calbraith Perry (1794–1858) was a commodore of the U.S. Navy. He commanded ships in the War of 1812 (1812–1815) and the Mexican-American War (1846–1848), as well as the expedition to Japan known as the Perry Expedition (1852–1854), which led to the signing of the Treaty of Kanagawa (1854) and the opening of Japan to the United States.

[81] William Elliot Griffis, *Matthew Calbraith Perry: A Typical American Naval Officer* (Boston: Cupples and Hurd, 1887).

## 38   LETTERS FROM MISSIONARIES

classes, that is seen in other places more than in Seoul, is due quite as much to the boorish and ungentlemanly and unscholarly character of many of the missionaries, as to anything else. The general community is very willing to take up and listen to a real man, such a [*sic* read as] Verbeck must have been. Here in Seoul, a missionary who is a gentleman and a schollar [*sic* read scholar] is as highly respected and as much heeded as any one equal to him, whatever the position. It has been my good fortune to bring about legal marriages between four Americans and the Japanese women they were living with under the loose Japanese arrangement. These men are not all bad, and there is very much to be said in their favor. It is much better to try to help them up than to shove them off as out of the pale. Pardon this long diversion, I know you wish to hear about Korea. What I say to you must of course be kept for yourself, for I am not expected to write about the country. Things here are worse than ever during the 17 years that I have been connected with the place. The rivalry of neighboring states gives Korea a chance to "stew in her own juice" quite unmollested [*sic* read unmolested], and she is doing it to the extreme. Official corruption and oppression of the people was never greater. They all seem inclined to make hay while the sun shines, as though they expected everything to go to pieces soon. Alone it does not seem as though they could accomplish anything for the betterment of their condition, and rival interests prevent their getting the needed help.

The Fusan R.R.[82] you mention, is regarded with much suspicion over here. One man who is very well posted, has called it a gigantic bunco scheme.[83] Nothing has been done toward it yet except to make a sort of running survery [*sic* read survey], and sell some shares.

The Seoul-Chemulpo R.R.[84] is working nicely but is so tied up with red tape that it cant pay.

The French are surveying a R.R. to Songdo, and on to Weiju,[85] but it is another strange thing of which no one seems to know much.

The American Gold Mines[86] are working finely and are a success, a bright glimmer in a very dark field.

---

[82] The Seoul-Pusan Railroad, or Kyŏngbu Railroad, was the second railroad to be built in Korea. Construction began on August 20, 1901 and was completed on December 27, 1904. It was built by the Japanese private enterprise Keibu Railway (Kyŏngbu Ch'ŏlto Chusik Hoesa).
[83] A swindle to persuade a person to buy worthless property.
[84] The Seoul-Chemulp'o Railroad.
[85] The Seoul-Ŭiju Railroad, or Kyŏngŭi Railroad, was the third railroad to be built in Korea. Antoine Grille (1854–1953) of the French private enterprise Fives Lile initially acquired the construction rights to this railroad, but he lost them in 1899 due to insufficient funding. These rights were later taken by the Temporary Military Railway Office of Japan (Rinji Gun'yō Tetsudōkanbu; Imshi Kunyong Ch'ŏltogambu), which illegally commenced construction on February 21, 1904, two weeks into the Russo-Japanese War (1904–1905). Construction was completed on April 28, 1905. ("Songdo" is an archaic name of Kaesŏng, a city in Hwanghae-bukto, central Korea, and "Weiju" is an alternate romanization of Ŭiju, a county in P'yŏngan-bukto, northwestern Korea.)
[86] The American gold mining business in the Unsan District began in 1895, when the royal household of Korea gave the mining rights to James R. Morse through Allen. The Unsan

The Seoul Electric Co.[87] is running its ten miles of street railroad very successfully and the people are beginning to realize that they must be on hand if they wish to catch the car. It is giving them a much better bearing. The 18 mile extension of this road is in progress, and the Co. is putting up an extensive lighting plant for the City of Seoul. The same Co. is now surveying for a water-works plant for Seoul.

I have at last ordered a camera so as to be able to send pictures to my boys. When I get at it I will send you pictures of interest that I may get. It is useless for me to go to the shops here to get you more pictures for I have already gone over their collection for you several times and would only send duplicates if I tried again. These Japanese picture men here, take portraits almost entirely.

Mr. Hulbert[88] is getting out a new magazine,[89] the first number of which will appear this month. I have asked him to send you a copy regularly beginning with the first number. I think you will find much of interest in this.

I am glad you had such a pleasant trip abroad last summer, we are hoping to make a short run to the coast next summer to see our boys. Dont know that I can get leave yet.

I hope that some day the Koreans will appreciate your interest in, and work for them. They are not capable of it yet. The Japanese ought to be able to realize what you have done and are doing for them. Someday they may give you some proper evidence of their esteem. So may Korea if she ever wakes up.

With kind regards, and thanks for your kindness in sending me your new book,

I am,

Yours sincerely,

**Horace N Allen**

P.S

I think you owe it to yourself, Dr. Griffis, to make some mention of the new order of things in your next book touching on missionary subjects.[90] In the

---

mines were first run by the Korean Mining and Development Company, then by the Oriental Consolidated Mining Company.

[87] The Seoul Electric Company (Hansŏng Chŏn'gi Hoesa, now the Korea Electric Power Corporation) was established in January 1898 by King Kojong.

[88] Homer Bezaleel Hulbert (1863–1949) was an American Methodist missionary, journalist, special emissary of King Kojong to the United States, editor of *The Korean Repository*, and founder of the journal the *Korea Review*. He taught at some of Korea's first modernized schools, including Yukyŏng Kongwŏn (est. 1886) and Pai Chai Haktang.

[89] The *Korea Review* (1901–1906) was an English-language monthly journal on Korean culture and affairs, edited by Hulbert and published in Seoul. Its inaugural number was published in January 1901.

[90] Griffis published the following books with a focus on Christian missionaries in Asia: *A Maker of the New Orient, Samuel Robbins Brown: Pioneer Educator in China, America and Japan* (New York, Chicago, Toronto: Fleming H. Revell Company, 1902); *Dux Christus: An Outline Study of Japan* (London: Macmillan and Co., Ltd., 1904); *A Modern Pioneer in Korea: The Life*

40    LETTERS FROM MISSIONARIES

early days of trade with the Orient, it is quite true that the traders were apt to be young, hot blooded, adventurous fellows, assisted by ex-sailormen and such, while the missionary was a most carefully selected man—one among ten thousand. Today, with rapid communication, and all the comforts of life, a better class of merchants come and the official class has grown enormously, while the old timers have settled down and become most respectable men. Family life is now the rule rather than the exception. While the mission work has grown so that men are gathered up here and there with no proper supervision and bundled off to bring the mission work into disgrace. Even here in Korea we had one man who was a drunkard, libertine and gambler, and it took a whole year to get him recalled. Of course that is an gross exception, but it simply illustrates the ease with which any sort of man can get a missionary appointment today. As a rule our missionaries in Korea are a very high class set of people. But we have our awful misfits as well.

### 14) May 24, 1905 [Typed Letter]

**American Legation, Seoul, Korea** [location from letterhead]
Rev. Dr. Wm. Elliott, Griffis,
Ithaca, N.Y. U.S.A.

Dear Dr. Griffis:-

I thank you very much for your kind letter of April 22nd. Such letters make the injustice of the "Rooseveltian rules"[91] more easy to bear. The whole American community here has joined in voluntary telegrams to have me retained, have followed them up by written petitions to be given the President by Senators from all parts of our country. I am credited I see, with instigating this movement, but I had nothing to do with it. The Emperor[92] has telegraphed twice and has received an expression of regret from the President that he could not make a change, and retain me.

My friends, the enemy, seem somewhat at a loss, for I see by the papers they have credited my change to the reported fact that I am violently pro-Russian and anti Japanese. This is a queer statement in view of the fact that the Japanese Govmt instructed his Minister at Washington to express their desire that I be retained, and Mr. Takihira[93] did this several times so that I

---

*Story Of Henry G. Appenzeller* (New York, Chicago, Toronto: Fleming H. Revell Company, 1912).

[91] U.S. president Theodore Roosevelt (1858–1919) played an instrumental role in the signing of the Treaty of Portsmouth (Sept. 5, 1905) between Russia and Japan. The treaty, signed in Portsmouth, New Hampshire, formally ended the Russo-Japanese War (1904–1905) and affirmed the Japanese presence in Korea. Roosevelt had also approved the Taft-Katsura Agreement (1905), a confidential agreement that affirmed the Japanese annexation of Korea, between U.S. secretary of war William Howard Taft (1857–1930) and Japanese prime minister Katsura Tarō (1848–1913).

[92] King Kojong.

[93] Takahira Kogorō (1854–1926) was the Japanese ambassador to the United States from 1900 to 1909.

received a telegram that I was not to be changed. Mr. Rockhill[94] wrote also to D.W. Stevens,[95] here, who has been most anxious to have me retained, on the morning of the appointment of my successor, that it was finished and I would not be changed. I have heard some very strange theories to account for my recall, but am reserving judgement for fuller information.

Yes thank you, I have a lot of material which I expect to work up into some form for publication. I have been offered an engagement to lecture, which seems rather attractive to me if I find I can give satisfaction.

I dont know where I will stop in America for the present but shall hope sometime to meet you in a more satisfactory manner than the short glimpse I had of you at Chicago. You seem able to write of places and people where you have not been and whom you have scarcely seen. Everett Frazar,[96] long Honorary Korean Consul in N.Y. never came to Korea either. His son who has succeeded his father in a large eastern business[97] is now here and tells me how much his father wished to see Korea but was always prevented.

We have celebrated the opening of the Seoul-Fusan Ry.[98] I delivered the English address. The road is a fine piece of work and does credit to the engineering corps.

Thanking you Dr. for writing me on this occasion, and with kindest regards, I am,

Yours sincerely,

**H N Allen**

## 15) Aug. 10, 1905

**Aster House, Mackinac Isld[99]**

Dear Dr Griffis,

We have stopped here for a few weeks of rest for Mrs. Allen[100] with our sons as company.

I must get something to do and I write to ask if you can and will give me the names and address of one or two good lecture bureaus with whom I may

---

[94] William Woodville Rockhill (1854–1914) was the secretary of the U.S. legation in Seoul from 1886 to 1887, and U.S. envoy extraordinary and minister plenipotentiary to China from 1905 to 1909.

[95] Durham White Stevens (1851–1908) was an American adviser at the Korean Foreign Office, appointed in 1904 by the Japanese government through the recommendation of Allen. In 1908, he was assassinated by two Koreans in San Francisco, California.

[96] Everett Frazar (1834–1901) was appointed honorary consul to the United States by King Kojong in 1884. He was the senior partner of Frazar and Company, which traded in Korea, China, and Japan.

[97] Frazar and Company.

[98] The Seoul-Pusan Railroad.

[99] Mackinac Island in Lake Huron in Michigan.

[100] Frances Ann Messenger Allen (1859–1948).

## 42    LETTERS FROM MISSIONARIES

correspond regarding an engagement for the winter. I have a lecture prepared on Korea, which here to whom I have read it seem much pleased with. I also have 250 fine, colored lantern slides of selected Korean views in illustration of the lecture which I think I can make interesting.

My sudden recall was an act of the greatest ingratitude. My successor[101] was under the deepest obligation to me and was my confidante to the fullest extent. His backers were under even deeper obligation. The President[102] was [grossly?] misled and quite unnecessarily too. For if he had called to ask D. W.[103] between the Japanese advisors in Korea and a mutual friend he would have learned better. It was not Mr Hay's[104] intention at all. It seems merit and good science cuts no figure.

Sincerely yours
**H. N. Allen**

### 16) Aug. 24, 1905

**Mackinac Island, Mich.**[105]

My dear Dr. Griffis,

I was quite overcome by your letter of the 17th and now I have your second one of the 22nd. Leaving me under your greater gratitude, your long and painstaking letter of 17th was just what I wanted. I knew really nothing of the subject and that gave me just the information I needed.

I do not intend to make lecturing a profession. Simply wished some remunerative occupation for the winter or until I can get into something suitable. Am new in correspondence regarding a business affinity but have doubts as to my fitness.

After reading your letter I decided to let the bureau go as they seem to want the benefits and leave me the risk and work.

I have an offer from Prst. Patterson[106] of the National Cash Register to [?] the lectures at Dayton for $100 and expenses. In fact when he was in Korea in April last he gave me the idea of doing this and insisted on the security of my having colored lantern slides. After reading your letter I began to have doubts as to my ability but would like to try. Mr. Patterson cannot attend to it until after Sept. 10 for one month so I will probably go to him in October.

---

[101] Edwin Barber Morgan (1865–1934) from June to November 1905, until Japan assumed the direction of Korean foreign relations.

[102] U.S. president Theodore Roosevelt (1858–1919).

[103] Durham White Stevens (1851–1908).

[104] John Milton Hay (1838–1905) was secretary of state from 1898 until his death in office on July 1, 1905. An advocate of the "Open Door" policy to China, he sought to facilitate trade between the United States and China.

[105] In letterhead: The John Jacob Astor House.

[106] John Henry Patterson (1844–1922) was a businessman based in Dayton, Ohio, and the founder of the National Cash Register Company (NCR).

It is my plan to go to Boston the last of Sept.—staying here till about Sept. 10 going to Toledo[107] to attend to some matters for a couple of weeks and then on to B.[108] My tickets read via Mich. Central.[109] I could get my [family?] established and then be at liberty to move about.

Your offer to entertain us and to give me a reception with such distinguished guests is most creative one and is deeply appreciated. I would certainly like to really meet you after all these years of correspondence. Mrs. Allen[110] is something of an invalid at present and will not be able to do any traveling but absolutely necessary.

Before getting your letter I had written off a circular which I sent with my photo to [the Sidfather Bureau?][111] who wished to engage me. I have not heard from them yet. I like your idea better and will probably advertise in the Mens Club Directory[112] after hearing from [Sidfather?].

I shall keep your letter of the 17th as a guide.

Yes, Dr. I have the manuscript for a book, which I hope to revise, amplify and complete this winter and will talk with you about it. I have some interesting matter.

I have never missed an occasion to speak of you as the best and standard work on Korea. I have recorded the mission boards for giving an English book to new missionaries when we have an American work for [superior?].

I got your last edition by mail with some other book enclosed just before I left, but packed it away with my things. You may rest assured that in anything I write or say on the subject I will quote your book as the one to be read. In January I had better try myself before a less critical audience—say at Dayton—before trying such a cultivated one as that which I would have to face at Ithaca. As you say I would like to find myself first.

Your valuable suggests [sic read suggestions] give me pause but I would certainly like to try it. I believe I can succeed, but do not care to make it a business though it may help me to make myself of service in some other public manner.

I feel that I have been [outrageous?] and politically and would like to show that I am not "killed." I will keep you posted as to what I am doing as well as to my whereabouts.

Anticipating great pleasure in meeting you and Mrs. Griffis, and thanking you sincerely for your great and invaluable help.

I am, Sincerely yours

**H. N. Allen.**

I hope to have a type machine soon. I cannot read my own writing.

---

[107] Toledo, Ohio, where Allen later established his private practice.
[108] Boston.
[109] Michigan Central Station in Detroit, Michigan.
[110] Frances Ann Messenger Allen (1859–1948).
[111] Not able to identify the Sidfather Bureau.
[112] Perhaps referring to the Men's Club Directory of the Sidfather Bureau.

# 44 LETTERS FROM MISSIONARIES

**17) Oct. 24, 1905** [Typed Letter]

**The Beaconsfield, Brookline** [location from letterhead]

My dear Dr. Griffis,

We are temporarily located here after much travelling about, and I have been away from here a good deal.

Though my advertisement is in Rev. Rose's publication I dont expect to lecture. There seems not to be much in it and I have more agreeable occupation. Also I dont care to make myself a target for the newspapers. Recently, the "Yellow Journals" of the Hearst class, published a silly charge against me which fortunately the decent papers of the country, so far as I can learn, did not mention. It came from a man named Krumm of Columbus O, whom I had greatly aided in Korea and befriended when he had fallen out with most everyone there.[113] Being of low German origin, but with a partial college course in engineering, he misunderstood my attentions and presumed to propose marriage to my niece. When spurned by her he became violent and acted like an insane man, actually attacked me. He went to Washington when dismissed and made a complaint against me to the effect that I was mixed up with a development company whose interests I had in hand, just as I had his and no more. The charge was sifted and found to be of no foundation but recently he got a hearing in the above named papers and some reporters have been after me for the facts, but from my own inclination and from advice from Washington, I have refused to say anything. I dont care to make myself too public however.

I am at work on a book and will show you the manuscript before I publish it, if I let it go so far. I find it very difficult in view of the one sided and contemptible articles of Geo. Kennan,[114] to write, for I dont want to over praise the Koreans nor do I wish to seem to support Kennan's articles written in the interest of the Japanese and to secure the withdrawal of the foreign legations and to pave the way for the establishment of something stronger than the present Japanese protectorate in Korea. That man's pen seems to be for hire.

I was greatly pleased recently with reading your excellent article on the Russian Church.[115] Our people lose sight of such facts or do not realize them. The Russians certainly stand for the "open Bible" and even give free transpor-

---

[113] Raymond Edward Leo Krumm (1873–1948), a civil engineer from Columbus, Ohio, was hired by the Korean Bureau of Land Survey (Yangji Amun) to direct Korea's first cadastral survey from 1899 to 1902. In 1904, he pressed charges against Allen for malfeasance in office regarding his real estate, stocks, and contracts with the Korean government. In October 1905, Krumm's accusations were published in the "yellow journals," or sensationalist newspapers, run by William Randolph Hearst (1863–1951). Allen denied these charges.

[114] George Kennan (1844–1923) was an American correspondent of the Russo-Japanese War (1904–1905) for *The Outlook* (1893–1928), a weekly magazine published in New York, New York.

[115] Not able to identify Griffis's article on the Russian Church.

tation to our colporteurs over their railways, and free freight for their books, so I was informed by an American agent of the Bible Society.[116]

I have not been well for some time past and am the more content to limit my travelling as much as possible. I may give some talks later on, especially if my book sees the light and succeeds.

With kindest regards,

I am,

Sincerely yours,

**H. N. Allen.**

## 18) Jan. 13, 1911

**Ormond, Florida**

My dear Dr. Griffis,

Your letter of Dec. 29th found me here, and I thank you for your interesting monograph on Mosaics, which fits in nicely with some reading I am enjoying on English Cathedrals.

You are certainly a worker and I am sure your book on The Evaluation of the Korean People[117] will be one which will greatly interest me, whether there are others in sufficient number, to make the publication profitable, I should think might be a question the publisher would consider with some doubt.

They did not care for a book from me unless it should be of a light and anecdotal character,—hence Things Korean, which was even given a title distasteful to me.

I am sorry to say my books are all packed away and I cannot get at them. They will have to remain in storage for some time I fear.

I suggest that you write to Homer B. Hulbert,[118] Springfield Mass. And possibly Mr. F. A. McKenzie editor of London Times[119] Weekly Edition, might be able to help you, as he has written two books on Korea. Also Sec Geo H Jones of the M.E. Foreign Mission Board N.Y.[120] should have an ample set of books at hand as he is lecturing continually.

I did not pursue the lecture program though I have met with much success when I have attempted it and have many requests. I received liberal compen-

---

[116] The American Bible Society (or ABS; est. 1816) is a New York-based organization that promotes, distributes, and translates the Christian Bible.

[117] Not able to identify which book this refers to.

[118] Homer Bezaleel Hulbert (1863–1949).

[119] Frederick Arthur McKenzie (or MacKenzie, 1869–1931) was the editor of *The Times Weekly Edition* published in London. He was also a correspondent on Korea and the author of *Tragedy of Korea* (New York: E. P. Dutton and Co., 1908).

[120] George Heber Jones (1867–1919) was the superintendent of the Methodist Episcopal Mission Board and a Methodist missionary to Korea.

# 46  LETTERS FROM MISSIONARIES

sation for lecturing two days at our Normal War College Newport.[121] Before the Knife & Fork Club Kansas City.[122] At Clark University[123] (not so liberal) and some such places. My health will not permit anything a Chataqua[124] offer that was quite flattering.

Wishing you continued success and regretting that a roving life prevents my complying with your request.

I am

Sincerely Yours
**Horace N Allen**

**19) Mar. 7, 1911**

**Ormond, Florida**

My dear Dr. Griffis,

You certainly do me a great honor in dedicating your forthcoming book of Korean Tales[125] to me, and I appreciate it very highly and thank you.

I return the slip as requested herewith, and will look for the volume. I got out a book of Tales once in which I mentioned you in the preface.

We are still lingering under Southern skies and will continue to do so as long as conditions are satisfactory.

Most sincerely yours
**Horace N Allen**

**20) Sep. 26, 1912**

**2248 Parkwood, Toledo**

Dear Dr. Griffis

I am sorry to say that we have the addresses of very few ex Korean residents now in this country, but I send you a list of such as we have with manner of whether who might be interested in your Appenzeller book.[126]

Yours Sincerely
**H N Allen**

---

[121] The U.S. Naval War College (est. 1884) in Newport, Rhode Island.
[122] The Knife and Fork Club (1898–1934), a gentlemen's club in Kansas City, Missouri
[123] Clark University (est. 1887) in Worcester, Massachusetts.
[124] The Chautauqua Movement promoted adult education, self-improvement, and civic involvement. It grew into a nationwide movement in the mid-1910s, then saw its decline in the 1930s.
[125] William Elliot Griffis, *The Unmannerly Tiger and Other Korean Tales* (New York: Thomas Y. Crowell Company, 1911).
[126] Griffis, *Modern Pioneer in Korea*.

| Rev. Dr. F. Ohlinger[127] | Toledo, O. |
| Gustavus A. Ohlinger | Atty at Law Toledo, O. |
| Rev. Dr. Geo. R. Wallace | 330 Warren Toledo, O. |
| Rev. Dr. Chas Lee | Carbondale, Penn. |
| H. R. Bartineck | 57 Pant. San Francisco |
| H. E. Colleran | Denver, Colorado. |
| B. C. Donham | 52 Broadway N but.Y. |
| Sir Walter Hillier | Kensington Court, London |
| Chas. B. Harris | 350 E. San Fernando St. San Jose, Calif |
| Edward T. Miller | 2321 N. High Columbus O |
| Jas. R. Morse | 25 Broad St. N.Y. |
| F. A. McKenzie | Editor Weekly London Times |
| R. A. McLellan | Ferndale Wasntn |
| Dr. E. E. Rogers | Burling Green, O. |
| S. L. Selden | 66 Wall St. N.Y. |
| Eliza R. Scidmore | 1837 M Washington D.C. |
| Nathan Benetz | Santa Barbara. |

### 21) Aug. 7, 1920

**The Barber Farm, Jericho, Vermont** [location from letterhead]

Dear Dr. Griffis

Last summer Mr. F. A. McKenzie, Ed. London Daily News, wrote me from N.Y. for data to be used in revising his book on Korea. I complied but heard nothing more from him. I now have his book which I am mailing to you to look over and return to me. I had a bookstore send and get it.

I see he fell under the influence of Soh Jay Pill. Dr. Philip Jaisohn[128] and Homer B. Hulbert—the two most flighty and unreliable, not to say dangerous advocates Korea has ever had. You may find something useful in the book.

---

[127] Reverend Franklin Ohlinger (1845–1919) was a Methodist minister and translator of Chinese literature. His son Gustavus Ohlinger (1877–1972) was a lawyer and veteran of the First and Second World Wars. Reverend George R. Wallace (1863–1929) was a Methodist minister. Reverend Charles Lee (?–?) was a graduate of the class of 1882 of Princeton Theological Seminary. Benjamin Curtis Donham (?–?) was a civil engineer who designed the Seoul YMCA building and supervised its construction from 1907 to 1908. Sir Walter Caine Hiller (1849–1927) was British consul to Korea from 1890 to 1896. Charles B. Harris (?–?) was U.S. consul to Japan from 1897 to 1905. James R. Morse (?–?) was an American entrepreneur who initially acquired the construction rights to the Seoul-Chemulp'o Railroad. Frederick Arthur McKenzie (1869–1931) was the editor of *The Times Weekly Edition*. R. A. McLellan (?–?) was Chief Engineer of the Seoul Electric Company. Reverend E. E. Rogers (?–?) was the pastor of a Presbyterian church. Eliza Ruhamah Scidmore (1856–1928) was a geographer, photographer, and correspondent in Japan and Alaska. Nathan Bentz (?–?) was a collector and dealer of Asian art and antiques. Not able to obtain information on H. R. Bartineck, H. E. Colleran, Edward T. Miller, or S. L. Selden.
[128] Philip Jaisohn (Sŏ Chae-p'il; 1864–1951) was a reformist politician who participated in the Kapsin Coup (Dec. 4–6, 1884), sought political asylum in Japan after its failure, and then moved to San Francisco, California, in 1885. He graduated from the Harry Hillman Academy

48    LETTERS FROM MISSIONARIES

In reply to a recent letter from you in which you asked me about Hulbert: I asked you to send me the book in question and I would pass upon it and return it. I have not received it and I am not enough interested in his writings to order a copy. In fact I have never been able to read through, anything of Hulberts. Dr. Morrison of the London Times Peking[129] said of him once after interviewing him at length, "He is an inexhaustible source of unreliable information." But Koreas recent troubles have given him an opportunity to get with the spot light and incidentally to make a living—as is probably true of most of the other agitators. Hulbert took up what I found was impossible and has lived on it ever since.

In 1905 when we had come from Korea and were living out of Boston,[130] The Korean King[131] sent me a long document such as speaks of having been given to him and a credit of $10,000 with which to employ lawyers to work in the Korean interest. I consulted Moorfield Storey,[132] Joseph Choate[133] and Wayne McVey.[134] They were all sympathetic and willing but one condition made by the King was secrecy—that is, the Japanese were under no circumstances to learn that the King had taken this action. As they could not guarantee this, they had to give up the matter. I sent the $10,000 back through the bank that forwarded it to me. Then they got H.[135] to take it up and he has carefully nursed it till now it bears him just the fruit he seems to desire.

Yours Sincerely
**H N Allen**

---

in 1889 and from Columbia Medical College (now the George Washington University School of Medicine) in 1893. After his return to Korea in 1895, he established the Independence Club and *The Independent* (*Tongnip Sinmun* 독립신문; a daily newspaper) in 1896. He was an activist for Korean independence during the Japanese colonial occupation.

[129] George Ernest Morrison (1862–1920) was an Australian journalist and a China correspondent for *The Times* in London. In 1912, he became an adviser to President Yuan Shikai of the Republic of China.

[130] Allen was dismissed from the role of minister plenipotentiary to Korea, and returned to the United States, in June 1905.

[131] King Kojong.

[132] Moorfield Storey (1845–1929) was a lawyer and author based in Boston, Massachusetts.

[133] Joseph Hodges Choate (1832–1917) a lawyer based in Boston, Massachusetts. He was U.S. ambassador to Great Britain from 1899 to 1905, and a proponent of Secretary of State John M. Hay's "Open Door" policy to China.

[134] Isaac Wayne MacVeagh (1833–1917) was U.S. attorney general from March to December 1881 and U.S. ambassador to Italy from 1894 to 1897.

[135] Homer Bezaleel Hulbert (1863–1949).

22) [Magazine Clipping]

# Something About Korea

By HORACE N. ALLEN
U. S. Consul General at Seoul, Korea

*OUR Trade with Korea—Its Gold Mines—Steam and Electric Railways Built by Americans—Electric Light and Water Works—Banking Facilities and Currency—Steamship Companies—Post Office and Telegraphs—Americans in Korea*

ORACE N. ALLEN, United States Consul-General at Seoul, Korea, under date of April 1, 1901, sends a most interesting report as to the industrial progress being made in Korea.

Consul Allen says: No reports of the trade of Korea have been published for the past seven years. I am able now to give some facts relating to imports and exports, with an estimate of the value of American trade, and something of the Social and Industrial progress that is being made in Korea. Foreign goods reach Korea chiefly through Japan and Shanghai, and it is difficult to ascertain just what proportion belongs to each nationality. The chief item of American imports is kerosene, which amounted in 1900 to $896,815. Next comes mining supplies, of which at least $150,000 were imported from the United States last year. American imports into Korea have more than doubled in the past year, and the trade is growing.

### Americans Working Gold Mines Successfully in Korea

Korea seems likely to become an important field for gold mining. Americans are working the mines at Woonsan successfully. They are now running a 40-stamp mill and two mills of 20 stamps each, and other large plants are contemplated. The gold district, which is from 20 to 30 miles in extent, has as yet hardly been prospected. This American mining company now employs about 3,000 natives and 70 foreigners. The development of the English mines at Eunson is just begun, but the prospects of this company are fine. The German mines at Kimsung are also in the period of exploitation. During the year 1900 concessions were granted to Japanese for the Chicsan mines, and to the French for mines to be located.

### Japanese Syndicate Own a Railway Built by Americans

The Seoul-Chemulpo Railroad, built by Americans for an American concessionaire, has been sold to a Japanese syndicate. This road, 26 miles long, connecting Seoul with the port, is now in successful operation. And the railroad projected by the Japanese, the Seoul-Fusan Railway, will soon be completed. The Korean Government has contracted with a French company to build a railroad to connect Seoul with Weiju, the northwest border town—a distance of about 500 miles. The construction of this road will be difficult, as the country is mountainous, and many rivers and wide areas of quicksands must be crossed.

Americans have built and are now successfully operating an electric railway in and about Seoul. The road is now about 10 miles long, but will be extended into the country to the distance of 18 miles. The natives generously patronize the road, like it, and see that it is a necessity. In connection with this electric railway, the same company of Americans is erecting an extensive electric lighting plant for the city of Seoul. It is also under contract to complete a system of water works.

### The Money in Use in Korea—Banking Facilities

The money in use in Korea consists of copper cash and nickel 5-cent pieces. The latter are now being extensively coined by the government to take the place of the bulky copper cash. The government will coin silver pieces before the close of the year 1901. Korea is greatly in need of some standard of money. Japanese currency is largely used. The First Bank of Japan maintains extensive branches at Seoul and Chemulpo, where substantial buildings of brick and stone for the banks have been erected. The Hong Kong & Shanghai Banking Corporation has an agency at Chemulpo, and carries on a big business. The American firm, Collbran & Bostwick, who constructed and now operate the electric railway and electric lighting plants, have a charter for a bank which will soon be opened in a fine brick structure which this firm is now erecting in Seoul.

Korea is very well served in the way of ocean transportation by two lines of Japanese steamers running from Kafu to ports of this country. A Korean steamship company has been in operation for the past year, with two or three steamers, with profitable results. Traffic on the river be-

Figure 5 "Something about Korea" (1), *Social Service* 4, no. 4 (1901) (Box 59, Folder 2, Griffis Collection)

tween Seoul and Chemulpo has greatly increased since the opening of the railroad, though the latter makes discriminating rates in favor of Japanese shippers.

**Post Office and Telegraphs—Americans in Korea**

The Korean foreign post has been in successful operations since January, 1900. The domestic service has been working longer. The Korean telegraph bureau reports a business for 1900 amounting to 72,443.26 yen ($36,222), being an increase of 21,756.37 yen ($10,878), over the preceding year.

Americans are prominent in the trade and development of Korea. There are 296 Americans resident in Korea with their families, as follows: Missionaries, 162; miners, 75; employees of the electric companies, 15; officials of the government of Korea and the United States, 10; merchants, 7.

The capital of the Seoul-Fusan Railway is 25,000,000 yen ($12,450,000). The company has the power to issue debentures to an amount not exceeding 10,000,000 yen ($4,980,000). The government guarantees 6 per cent on the company's paid-up capital, and is also responsible for the payment of debentures.

## France Honors Dr. Tarleton H. Bean

AN HONOR, well earned and deserved, has been bestowed upon Dr. Tarleton H. Bean, who was Director of the Department of Forestry and Fisheries, with the United States Commission at the Paris Exposition of 1900, President Loubet, of the French Republic, has made Dr. Bean, Chevalier of the Legion of Honor of France, and has presented him with the decorations of that notable Order.

This honor is given by the French Government as a token of appreciation of the distinguished services rendered to the Paris Exposition of 1900, while Dr. Bean was performing the duties of Director of Forestry and Fisheries for the United States.

The Danish Fisheries Society for the same reason has elected him an Honorary Foreign Corresponding Member.

The full and complete report of Dr. Bean of the exhibit and work of the Department of Forestry and Fisheries at the Paris Exhibition has great value and shows the most gratifying results for the United States.

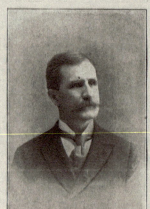

DR. TARLETON H. BEAN.

work of Dr. Bean and his assistants was constant and stupendous. Dr. Bean has the Doctor of Medicine diploma from Columbian University, of Washington, D. C., also "Master of Science," from the Indiana University. He was Acting Professor of Natural Sciences in the State Normal School, of Millersville, Penn., Assistant to the United States Fish Commission and curator of the Department of Fishes, United States National Museum, Washington, D. C. At the World's Columbian Exposition he was the representative of the United States Fish Commission in the Government Board, also a junior in zoology at the World's Columbian Exposition, and representative of the United States Fish Commission at the Atlanta Exposition. He rebuilt the aquarium of New York City, one of the best and finest in the world, and was the Director of that Aquarium. Dr. Bean has participated officially at the Centennial Exposition, Philadelphia, the London Fisheries Exposition, the New Orleans Exposition, the Cincinnati Exposition, the World's Columbian Exposition, the Atlanta Exposition, and the Exposition Universelle, Paris. He is the author of many valuable works on fishes and birds, is an international authority on these subjects, and has world-wide fame.

The magnificent display of the United States of Forestry and Fisheries was collected and installed by Dr. Tarleton H. Bean, Director of Forestry and Fisheries to the United States Commission. It was a labor occupying nearly two years' time, and the

23) [Newspaper Clipping]

7. 1904. 5

# UNITED STATES TRADE WITH EASTERN ASIA.

## ITS PRESENT EXTENT AND FUTURE POSSIBILITIES —RUSSIAN INTERESTS THERE.

The total annual trade of the United States States with all Asia and Oceanica is about $800,000,-000, of which the largest end is imports, say $170,-000,000. The figures for 1903 are not announced yet by the Treasury Department, and the above estimate allows for an increase of $13,000,000 over 1902. Of these vast figures, our trade with Eastern Asia —Manchuria and Siberia—amounts to little as yet, probably not amounting to over $35,000,000 a year, not as much business as we do with England or Germany in a week. It is owing to the smallness of our trade in Eastern Asia, along the Pacific, that both politically and commercially this country is pushing the "open door." It must be admitted that political and commercial interests are apparently opposed to each other. The men controlling the great transcontinental trunk lines apparently are sympathetic with Russia, and ardently desire to see Russia have complete ascendancy in Manchuria. They desire to have the Trans-Siberian Railway (technically the Chinese Eastern) firmly established by Russian strong hands, in order to have a perfect trunk line system around the world, connected by an ocean steamship ferry between American and Asiatic ports. James J. Hill testified in the Northern Securities case that "the whole purpose of the organization of the company was for the protection of a great commerce with the Orient, which the Northern lines had sought to develop in connection with the transportation companies of the world." The Harriman lines are building four mammoth steamships at a cost of upward of $2,000,000 to ply between Portland and Asiatic ports. The Standard Oil Company employs some two hundred vessels of all kinds in its Asiatic trade, the largest of which take oil from New-York by way of the Suez Canal, returning with silks, chemicals, spices, etc., and is continually adding to its great fleet.

Our best market on the Pacific is Vladivostok, just across a narrow strip of Siberia from Manchuria. We supply that cosmopolitan city with one-third of all it eats and wears, to say nothing of nearly all its machinery and utensils. Vladivostok takes from us annually supplies approximately as follows:

| | |
|---|---|
| Flour | $150,000 |
| Cotton flannel | 100,000 |
| Cotton drills, jeans and sheetings | 8,000,000 |
| Cigarettes | 120,000 |
| Other wares | 6,000,000 |
| Refined oil, between 3,000,000 and 4,000,000 gallons. | |

At the new port of Dalny, in Manchuria, flour is about our only export, and because of the competition of the new mills at Harbin we sell there less than $100,000 worth a year. Japan supplies the

March 27, 1898, for twenty-five years, subject to unlimited extensions. The lease covers 800 square miles of territory, in which are Port Arthur and Talien-Wan, for the sole use of Russian and Chinese warships and the Chinese Eastern Railway. Dalny has a population of 41,269, of which 3,113 are Russians, 80 are foreigners, 307 are Japanese and Coreans and 37,760 are Chinese. It is picturesquely situated in an extensive valley, which slopes gently down to the deep and well protected bay of Talien-Wan, and is surrounded on shore by 800-foot hills. It is divided, like Gaul, into three parts, the administrative (Russian) city, the European and commercial city and the Chinese city. It has a water supply and electric lighting. In winter its lowest temperature is 3 degrees Fahrenheit below zero, and its approach by bay is kept open by icebreakers. The earning power of the people of Manchuria is far ahead of most parts of China, and that their capacity to purchase foreign wares is becoming greater is shown, as far as the United States is concerned, by the increase of American goods imported. There are four well established Russian settlements in Manchuria. Port Arthur is the largest and takes the lead in commerce. Dalny, the commercial terminus of the Siberian Railway, is second. It has big piers for vessels drawing thirty feet of water, and possesses the only commercial drydock in Asia north of Japan. The third city of importance is Harbin, with a Russian population of about five thousand people, and it is an important railway junction. Its other settlement of importance to American trade is New-Chwang.

Already the Japanese do a business with Northern China of $15,000,000 annually. With New-Chwang alone its business is nearly $13,000,000, as against $2,946,500 done by Americans. Not much can be said for American shipping in that part of Manchuria. Japanese steamships to the number of 261 landed 202,230 tons at Antung in 1902, as against 192 English steamers landing 196,252 and other countries landing 71,741 tons. While Japan seems ready to surrender Manchuria to Russia for a free hand in Corea, statistics show that the preponderance of her trade is in Manchuria. Japan has large sums invested in the port of Tsin-Van-dao, with the intent to make it the basis of her commerce with northeastern China and Manchuria. If Japan wars with Russia it will find the following condition of affairs: Each of the cities mentioned is a Russian fortress, with a commandant, a military governor, an admiral of the port, a Russian mayor and council, with large expenditures and larger taxation for army, navy, railroad, hydrographic purposes, municipal and sanitary conditions. At Dalny, for instance, the Russian administration section occupies 103 acres

Figure 7 "United States Trade with Eastern Asia" (1) (Box 59, Folder 2, Griffis Collection)

the lumber and timber, Shanghai and other Eastern trade centres the manufactured goods and provisions. Formerly, we supplied the steel rails, which were conveyed on English whalebacks, but railway building is nearly over at present. The American Trading Company is established at Port

Arthur, and just now has a brisk trade in American canned goods for the Asiatic forces. Dalny is on the eastern shore of the Liao-Tung Peninsula, about twenty miles from Port Arthur, and within the territory leased by the Chinese to Russia on

hostility, preceded, indeed, in several instances by

ficials, the governor and officers, for whom there are two hundred buildings. Of these 112 buildings are of brick and stone for residences, administration, seagoing service office, railway office, schools, Greek Church, railway hospital, postoffice, telegraph, telephone, service club, concert hall, yacht club, hotel, Russo-Chinese bank, police, etc., besides electric plant, machine shops, principal stores and shops.

Thus Russia Russianizes the Eastern Asian towns within her sphere of domination. In a sense, the door of Northern China, Manchuria and Siberia is wide open to trade. Russia invites trade there. She has imposed no greater duties on American goods than America has imposed on Russian products, and these duties have only been imposed since a former Secretary of the Treasury barred out Russian sugar. Russia claims to have made every effort to negotiate a commercial treaty with the United States which would admit our products into her empire on an easy basis. She is still ready to sign such a treaty, it is asserted. The sugar incident, however sweet to some interests, resulted in Russia's barring out our trade to the tune of $50,000,000.

The Russian Minister of Agriculture recently established at Habarofsk, Siberia, a government warehouse almost exclusively for American machinery and appliances, under the pre-Amoor management of imperial properties. Information has been quietly secured regarding the names of dealers and manufacturers, prices, steamships calling at Vladivostok, etc. Agents were invited to call there. A great opportunity to do business was thus opened, and has already been productive of splendid results.

The American firm of Clarkson & Co. has been established at Vladivostok six or seven years. It recently got a twenty-four year lease of fifty-four acres of land near the city, and is erecting a flour mill, to be equipped with up-to-date American appliances. The buildings are four and one-half stories, with lodging houses, warehouses and branch railway. The concern has several coal and gold mines, a sawmill, sash, blind and door factory, contract for granite work on a new wharf, and branch offices at Nagasaki, Port Arthur, Tientsin and Harbin.

Enoch Emery, an American, has been for thirty-five years a general merchant, with storehouses at Vladivostok, along the Amoor River, on Lake Baikal, along the Siberian Railway, at Moscow, St. Petersburg and Hamburg. He operated steamers on lakes and rivers. Before the railway was constructed his caravans crossed the mountains and tundras. He dealt in everything, from a shoe to a twin screw steamer, from a cradle to a gravestone —a true Yankee pedler in a foreign land, where he was the richest American. He was born a poor boy in Cape Cod, and ran away a half century ago. He went to Nicolaestk, Siberia, on the mouth of the Amoor River, in answer to an advertisement of a lonely American who wanted a clerk. He was then sixteen years old. He learned the Russian language and mastered the business, which he soon went at on his own hook. He says any upright American can do business anywhere the Russian flag floats, as behind him is the mighty and kindly shadow of Uncle Sam, for whom the Russian has a good will not possible for any other nationality to secure—not even a Frenchman.

Saxony, whose territory was entered on June 15,

Figure 8   "United States Trade with Eastern Asia" (2) (Box 59, Folder 2, Griffis Collection)

24) [Newspaper Clipping]

## TO DEVELOP COREAN GOLD FIELDS.

### Company of Capitalists Formed to Conduct Operations on a Large Scale.

San Francisco, May 6 (Special).—Two days ago Leigh Hunt started for Corea, where he has secured a large concession to develop gold fields of great richness. Hunt lost a fortune at Seattle in railroad speculation, and went to the Orient several years ago. He soon gained the confidence of the King of Corea, and it was then easy to make an exploration for gold. He secured large properties, which he has worked in a crude way, but from which he made a modest fortune.

He came back here to form a big American company, and it is learned that he has formed a syndicate in which are the Rothschilds and Birt & Co., of London; the London Exploration Company, D. O. Mills, Edward Sweet & Co., J. B. Haggin, Hearst & Tate and Smith & Perkins, of New-York. The company is capitalized at $15,000,000, and H. C. Perkins, of New-York, is the President. Mr. Perkins, who is an old California mine manager, has inspected the Corean property and reported favorably on it.

Several California mining men are to have important positions in the management of the enterprise. J. H. Mackenzie, of the Mariposa grant, is to be the manager. Archie Nivers, of the Alaska-Juneau mine, at Juneau, will manage the hydraulic engineering, and Charles Derby, of the Oneida mine, is to be retained. The syndicate will begin operations at once in Corea on a larger scale than has ever before been attempted by any foreign company in the Orient.

### THE PERRY MONUMENT IN JAPAN.

Berkeley, Cal., May 6.—Professor Bankato Bankero, president of the Bei Yu Kyo Kai, the American association of Japan, has asked the assistance of the University of California in arousing public interest in the movement to erect at Kurihama a monument commemorative of the landing of Commodore Perry half a century ago. A considerable fund has already been raised, and it is expected that the monument will be unveiled on the coming anniversary of the landing of the American envoy, which falls on July 14.

Figure 9 "To Develop Corean Gold Fields" (Box 29, Folder 2, Griffis Collection)

## 54 LETTERS FROM MISSIONARIES

### 25) [Newspaper Clipping]

**6**

# OPENING COREAN PORTS TO YANKEE COMMERCE

Many Rebuffs Met by Naval Officers in Trying to Negotiate Treaty with Hermit Kingdom.

### FIRED UPON FRIENDLY FLEET

Memoranda Found Among Papers of Navy Secretary Under President Hayes Gives Interesting Information.

TERRE HAUTE, Ind., Saturday.—Deputy Internal Revenue Collector Harry Thompson has found among the papers of his father, the late Col. R. W. Thompson, who was Secretary of the Navy under President Hayes, some memoranda which tell concisely the inside story of the part the United States played in opening up the Kingdom of Corea. It is as follows:—

In 1886 an American schooner was wrecked in one of the rivers of Corea. The entire crew and passengers were murdered by the natives and the vessel burned. Our government demanded redress from China, but was informed that China was not responsible for the acts of the Coreans, as they were an independent people. Accordingly, in 1867, Commodore Shufeldt, then commanding one of the ships of the Asiatic Squadron, was sent there to investigate, but did not succeed in getting into the country or obtaining any satisfactory information except rumors confirmatory of the previous accounts of the murders.

[...] understood to have been the first foreign vessel that ever anchored in a Corean port.

In 1868 Rear Admiral Febiger, then commanding the Shenandoah, was also sent to Corea to ascertain the truth of the report that some of the men who belonged to the schooner were alive and imprisoned. He made an attempt to survey one of the rivers in order to advance his ship into the interior, but was fired upon by the Coreans. As no harm was done he deemed it expedient not to return the fire and thereby bring on hostilites. He returned to China, satisfied that none of the crew of the schooner was alive.

In 1876 Rear Admiral John Rodgers went to Corea with a fleet of four ships and anchored in a harbor and the King sent Commissioners, who said the schooner's crew had been killed as pirates and the Admiral was informed that Corea wanted no intercourse with the United States. Admiral Rodgers said his mission was peaceful and that he would make surveys to enable him to go further in the river toward the capital, that he might communicate with the King. When two ships advanced up the river they were fired on by a large body of Corean soldiers. The fire was returned and the forts were destroyed. One man was killed on one of the ships.

The fleet returned to China. In 1877 I placed Commodore Shufeldt in command of the Ticonderoga and instructed him to make a voyage around the world to extend American commerce, especially at unfrequented ports of Asia, Africa and the islands of the Indian Ocean. He was especially instructed to revisit Corea and again endeavor to open negotiations. It was believed the Rodgers incident was susceptible of satisfactory explanation and that a conciliatory course might open Corea's ports to commerce.

The reason for this movement was the fact that at the time English, French, German and Russian war ships were in the seas adjacent to Corea and manifestly sent for the same purpose. Commodore Shufeldt failed to open negotiations and did not push the matter to the danger of causing an attack on his ship, because he then would have returned the fire and thus inaugurated a war in which the ships of at least the British and Russian navies would have participated, with the result that the ports would have been opened by force, as were those of China under the fire of British guns in 1841 and 1842.

While Commodore Shufeldt was in China his conduct as a naval officer attracted the attention of the Chinese authorities and they expressed a desire for his services in remodelling their navy. He obtained consent of the Navy Department and went to China. Through this connection he did open negotiations with Corea and eventually negotiated a treaty by which the ports of the Hermit Kingdom were opened to the world.

Figure 10 "Opening Corean Ports to Yankee Commerce" (Box 29, Folder 2, Griffis Collection)

# 3     *Anderson, Naomi A. (1916)*

## NAOMI A. ANDERSON (?–?)

Naomi A. Anderson was the younger sister of Albin Garfield Anderson, a medical missionary in Korea. In 1910, Anderson began to work as a nurse at the East Gate Women's Hospital in Seoul, Korea. With her family members, Anderson founded the first chapter of Swedish missionaries in Korea.

### 1) May 2, 1916

**Seoul, Chosen**
Mr. Wm. Elliot Griffis;-
Ithaca, N.Y.

Dear Sir:-

Your letter of March 2nd received some time ago, and as I have heard a great deal of you through the older missionaries in Korea I was very much pleased to receive your letter.

You ask for photographs and illustrations of our work. Am enclosing two pictures of our nurses, one the class which will graduate May 12th and the second our entire hospital force.

We are no longer in the little old building of Po Ku Nyo Koan,[1] but have a nice large modern building at East Gate. The women of Korea are learning what a hospital is little by little and are not so afraid to come to us. The high class women too come to us because there are no men here, whereas they would not go to a general hospital.

I am getting ready to go home on furlough, and in the meantime have this class to graduate, so my time is more than full, and I must beg you to pardon my briefness.

Thanking you for your interest and prayers for Korea.

Very Sincerely,
**(Miss) Naomi A. Anderson.**

---

[1] Pogunyŏgwan 보구녀관 (1887–1912) was a women's hospital in Seoul.

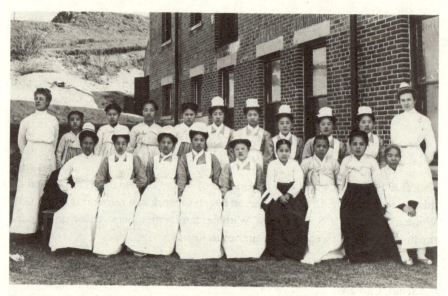

Figure 11  Entire hospital force of Pogunyŏgwan (보구녀관) with Naomi A. Anderson standing at the right end. This is one of the two photos sent by Anderson with the letter dated May 2, 1916. (KP 8.3.3, Griffis collection)

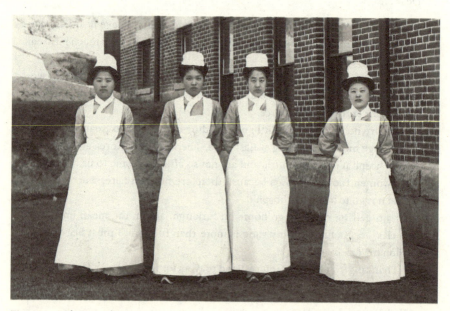

Figure 12  Class graduating from Nurses' Training School of Pogunyŏgwan (보구녀관). This is one of the two photos sent by Anderson with the letter dated May 2, 1916. (KP 8.3.2, Griffis Collection)

# 4     *Appenzeller, Henry Dodge*
## *(1919–1926)*

### HENRY DODGE APPENZELLER
### (1889–1953)

The son of Henry Gerhart Appenzeller and Ella Jane Dodge Appenzeller, Henry Dodge Appenzeller was born in Seoul, Korea.[1] He became proficient in Korean language and literature and went to the United States for his education. Appenzeller was educated at Princeton University, Drew Theological Seminary, and New York University. He earned a doctorate of divinity at the Pacific School of Religion. He returned to Korea in 1917 as a Methodist missionary and served as the principal of the Pai Chai Haktang 배재학당 (est. 1885; now Pai Chai University) for twenty years. Like all missionaries in the last phase of the Japanese colonial rule, he was recalled by the Methodist Church and later settled in California. He was assigned to administer relief activities in Korea in 1950 when the Korean War broke out.

1) **Mar. 18, 1919** [Typed Letter]

**Chemulpo, Korea** [location from letterhead]

Dear Dr. Griffis,

Shamefacedly I face my "Oliver"[2] to talk to you. I wish it might be with you. I say shamefacedly because it has been so long since I have written and I haven't even acknowledged or thanked you for the books you have sent me. I have received the copies of "Salt", "The Monday Club Sermons on the S.S. Lessons," and the Biblical Review.[3] I hope you will accept my belated thanks and in this land where everything is turned up side down think that the ratio of appreciation works inversely from at home—that because I have waited so long I appreciate them the more! The Sunday papers that you send Alice do us lots of good too for she passes them on in exchange for some Advocates[4] I give her. Quite a swap!

---

[1] Letters from Henry Dodge Appenzeller from 1912 to 1916 are in the digital archive.
[2] His typewriter, a product of Oliver Typewriter Company (1895–1928).
[3] *Salt* (a periodical?); *Sermons on the International Sunday-School Lessons* (?–?) was an annual compilation of Sunday school lessons published by the Monday Club in Boston, Massachusetts; The *Biblical Review* (1916?) was a quarterly magazine published by the Bible Teachers Training School in New York, New York.
[4] Possibly *The Korean Christian Advocate* (*Chosŏn Kŭrisŭdoin Hoebo*; 1899–1937), Korea's first Protestant newspaper, established by Henry G. Appenzeller in 1897 and published weekly in

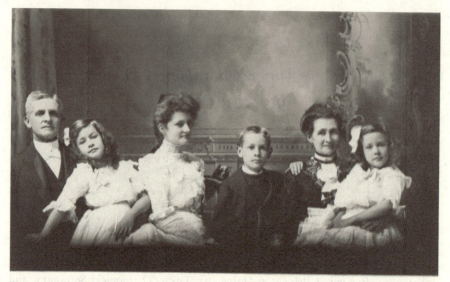

Figure 13 Henry Gerhart Appenzeller and his family in 1900. From left to right: Henry G., Ida, Alice, Henry D., Ella, and Mary (KP 15.4.2, Griffis Collection)

    This letter is being taken to the States to be mailed there. It is the only method we have of avoiding the secret censorship that is exercised by the Japanese here. There are things happening in these days that one cannot be silent about. It is the same battle that we fought out and won in Europe—the same thing cropping out here. May I ask that should you by any chance use any of the things I have said of course my name would not be connected with it, for should any reference to these things come back here it would just mean that my days of usefulness here would probably be at an end. I came out here openminded trying to see the thing fair and square, and I must say that I have grown to hate the administration of affairs as they at present obtain. There are friends of mine among the Japanese whom I like as well as the Koreans, but the government is rotten.

    But I don't want to get off on a tirade now. Suffice it to say that Dr. J. S. Gale,[5] whom you no doubt know, has been since the annexation in favor of the Japanese, openly so—so much that the Koreans have circulated malicious rumors about him—but now he has gone from admitting that they have made a failure in these ten years of trial, to a more positive position of affirming that he will fight the thing.

---

Seoul, or the *Christian Advocate* (1866–1938), a weekly magazine of the Methodist Episcopal Church, published in New York, New York.

[5] James Scarth Gale (1863–1937) was a Bible translator and Presbyterian missionary in Korea between 1888 and 1927. During his stay in Wŏnsan from 1892 to 1897, he cotranslated the Bible into Korean with Henry G. Appenzeller and other members of the Board of Official Translators.

Our personal fortunes are good beyond our dreams. Ruth[6] and I are so happy here in our own home that I sometimes wonder whether it all can last. You know that nice comfortable feeling of possession—of having your own things about you and liking them. Oh it is great. This is the old house that G. H. Jones[7] built when we were kids out here. Our own house is just back and a little higher. Incidentally we have at last managed to spell it. I shall get some postals of the place and send them to you under separate cover. This is a city of about thirty two thousand with several thousand Japanese. The port[8] has had its slump, due to the building of the Fusan railroad,[9] but with the construction of the new harbor[10] here with lock gates business is on the mend and Korean property is going up.

But I started to tell you about our place. We have several acres of compound with nice trees—enough to make me wish that I could turn farmer for a while. The view from here is glorious, we get the sunsets over the water. The islands out at sea are ever changing. Really one hardly needs to go away from here for the summer, except for the lonesomeness of it. I am the only man stationed here. There are three ladies of the W.F.M.S.[11] living here, two of them being appointed here and one living here with the Suwon District[12] as her work.

My work is mostly island work[13]—going about and seeing to the interests of the work. You see my appointment is "Missionary in Charge" whatever that may mean. I have a Korean District Superintendent[14] who has been rather critical of foreigners—rather has the notion that the Koreans can run things now and all that. In fact this District has been so long without resident foreign supervision that things have rather gone to seed and the natives have to learn over again what it means to work together. They are awfully nice to me tho and if I can only manage to come across with some of the funds necessary for carrying on the work they will be behind me to the full.

Sort of on the side I am principal of our primary school here in Chemulpo.[15] I found finances in an awful state and things all running at loose ends. We are still in debt but with its splendid location and history behind it Yung

---

[6] Ruth Noble Appenzeller (1894–1986) was the wife of Henry D. Appenzeller.

[7] George Heber Jones (1867–1919) was the superintendent of the Methodist Episcopal Mission Board and a Methodist missionary to Korea.

[8] Chemulp'o (now Inch'ŏn).

[9] The Seoul-Pusan Railroad, or Kyŏngbu Railroad.

[10] An enclosed dock was built in Chemulp'o between 1911 and 1918, enabling entry for 4,500-ton vessels and raising the dock's unloading capacity to 1.3 million tons per year.

[11] Woman's Foreign Missionary Society.

[12] Suwŏn, a city in Kyŏnggi-do, central Korea.

[13] Henry D. Appenzeller was a Methodist Episcopal missionary and adviser to the Chemulp'o district. The "island" he mentions is Kanghwa Island, adjacent to Chemulp'o.

[14] Working for the Methodist Episcopal Church.

[15] Chemulp'o.

60    LETTERS FROM MISSIONARIES

Wha Hakyo[16] has a bright future before it. I have done some teaching myself and find much pleasure in it. This school was started by Jones and day after tomorrow we are to have our 12th commencement. This is unusual in view of the conditions at present prevailing. As much as possible I am trying to go on the "business as usual" plan, tho there is no telling what will happen the new school year which starts in April. Oh for more scholarships, and help for preachers!

Along this line I might add that we are doing the biggest piece of money raising on the district, for a Higher Common School at Kangwha,[17] that has been done in the history of the Korean church. They are out for fifteen thousand yen! On one little island of two hundred and nice houses they raised the other day two thousand yen for the church and school—the new church that they hope to build. The present one is too small.

Hereafter I am going to try to write oftener and not so long. Again thank you ever and ever so much for the books and papers—they are a constant joy and a different sort of a reminder from the photograph which hangs on my study wall before me as I write. With kindest regards to Mrs. Griffis,

Ever gratefully yours,
**Henry.**

## 2) Apr. 10, 1920 [Typed Letter]

**The Mission of the Methodist Episcopal Church, Chemulpo, Korea**
[location from letterhead]

Dear Dr. Griffis,

The days and weeks have stolen by as a thief in the night and your good letter of yesterday has brought to light the fact that it is many moons since I have written you. But surely you must know long before this that the spasmodic character of a correspondence (in this case mine) is not always indicative of forgetfulness. Your picture is on the wall here in my study above my machine—yes, and often Koreans, no doubt trying to flatter me say, "oh, so that is your father!" But father's picture is on the space above my desk, alone.

First as to what has been happening to us Apps. Alice has had her hands full with the principalship of Ewha but has steered a splendid course thru these days of change. The anniversary of the disturbances found her school

---

[16] Yŏnghwa Haktang (now Younghwa Elementary School; est. 1892) was a school in Chemulp'o founded by Methodist missionary Margaret J. Bengel (?–?), wife of Methodist missionary George Heber Jones (1867–1919).

[17] Methodist Episcopal missionaries built and ran several residential schools on Kanghwa Island, including Kanghwa Habil Hakkyo (now Habil Elementary School; est. 1901) and Hŭngch'on Habil Hakkyo (now Yangdo Elementary School; est. 1908). Higher common schools (kodŭng pot'ong hakkyo) were for students of ages twelve to sixteen under the Japanese colonial education system.

**H. D. APPENZELLER**
**CHEMULPO, KOREA**

March 18, 1919.

Dear Dr. Griffis,

Shamefacedly I face my
"Oliver" to talk to you. I wish it might
be with you. I say shamefacedly because it
has been so long since I have written and
I haven't even acknowledged or thanked you
for the books you have sent me. I have
received the copies of "Salt","The Monday
Club Sermons on the S.S.Lessons," and the
Biblical Review. I hope you will accept
my belated thanks and in this land where
everything is turned up side down think
that the ratio of appreciation works in-
versely from at home--that because I have
waited so long I appreciate them the more!
The Sunday papers that you send Alice do
us lots of good too for she passes them
on in exchange for some Advocates I give
her. Quite a swap!

This letter is being taken to the
States to be mailed there. It is the only
method we have of avoiding the secret cen-
sorship that is exercised by the Japanese
here. There are things happening in these
days that one cannot be silent about. It
is the same battle that we fought out and
won in Europe--the same thing cropping out
here. May I ask that should you by any
chance use any of the things I have said of
course my name would not be connected with
it, for should any reference to these
things come back here it would just mean
that my days of usefulness here would
probably be at an end. I came out here
openminded trying to see the thing fair

Figure 14 Henry Dodge Appenzeller's letter to Griffis, dated March 18, 1919 (first page) (Box 59, Folder 8, Griffis Collection)

62    LETTERS FROM MISSIONARIES

quiet and the new school year has brought more students than can easily be handled. It seems as tho the students in general have at last realized that going out and shouting is nonsense now and that the thing for them to do is to study. Alice leaves in August for her furlo.

Ida has left the wilds of Siberia at last. She was here for a few days last month on her way out and is at this moment on the bounding main, on the transport GREAT NORTHERN with General Graves[18] and other notables. She did a splendid piece of work at Tomsk and Irkutsk in particular, and in general at Harbin[19] and other stops. In fact she has so gotten to love the Russian people that it is her hope at present to join one of the units of the R.C.[20] going to Europe and eventually to work into Russia from that end.

Mary has completed her contract at Ewha but is staying over to go home with Alice. Day before yesterday, her birthday, there was a party given supposedly as a birthday surprise party but really an announcement party. Yes, she is engaged to John Lacy,[21] a new arrival last fall as the secretary of our Board of Sunday Schools[22] here. He is an Ohio Wesleyan, and Union Seminary man,[23] and will we trust make her a good husband. I have never seen Mary so radiantly happy. It is just what she is anyway, a home-maker, and we cannot but feel that it is the best thing for her. Lacy is of the famous missionary family, not one of the sons but one of the cousins—some 25 of them in China I believe. Mary plans to go home and get some clothes, etc. and then come out and be married in December.

Margaret and Ruth are fine as ever. The youngster is teething now and mighty good about it too. I find that it takes me much longer to dress and undress because I simply HAVE to play with the little dear. She isnt walking by herself yet but thinks it is the most fun to hold hands and walk. Ruth is to my mind all that makes up a good wife under these different difficult missionary conditions. You see I simply don't think much of her at all!

---

[18] The SS *Great Northern* was a U.S. passenger ship built in 1914; William Sidney Graves (1865–1940) was a U.S. Army general and commander of the *Great Northern*.

[19] Tomsk, Russia; Irkutsk, Russia; Harbin, China.

[20] Russian Church?.

[21] John Veere Lacy (1896–1965), husband of Mary Ella Appenzeller, was a Methodist missionary, educator, and Sunday school administrator in Korea from 1919 to 1931. He served as the secretary of the Methodist Council of Religious Education in Korea from 1919 to 1923, and married Mary in 1920 during his service. From 1924 to 1925, he was based in Chemulp'o, and from 1926 to 1930, he taught theological pedagogy at Hyŏpsŏng Theological College (est. 1907; now Methodist Theological University) in Seoul.

[22] The Board of Sunday Schools (est. 1908) was an international Methodist Episcopal organization that sought to support theological education and pedagogy.

[23] Lacy was taught at three institutions affiliated with the United Methodist Church: he graduated from Ohio Wesleyan University (est. 1842) in 1915, Boston Theological Seminary (est. 1839; now School of Theology in Boston University) in 1917, and Garrett-Evangelical Theological Seminary (est. 1853) in 1917. He received his MA at Columbia University (est. 1754) in 1919.

My own affairs have been mixed and muddled. I was made a secretary of our Annual Conference[24] and have had to put quite a little time on getting out so simple a thing as the minutes. But getting printing done out here is no small task. Then as secretary of the Finance Committee, pro-tem, it fell to my lot to keep track of our Centenary revision, the detail of two and a quarter million yen. On top of that I was appointed as the principal of Pai Chai,[25] the school which father founded. I didn't want the job because I wanted to do something definite here, but Bishop Welch thot I better take hold there too and so for a time I had that work with the district here as well. But events got me—that is it seems I was a bit too plain spoken or what not. Perhaps I did not give tea to the proper officials, anyway the enclosed statement explains what happened to me. The thing is still unsettled in that it may be that Baron Saito,[26] the Governor General, on his return here may see fit to put me back. They have admitted, even in their own organ, the Seoul Press,[27] that they made a mess of it. But face is a strange thing and in the present instance I am from Missouri! I went to Japan last month to see Bishop Welch and the Baron and so much enjoyed the totally different atmosphere over there. I think it may be taken as axiomatic that correspondence is dealt with as you intimated.

No, I do not know the Taylor, historian, of whom you ask. But the Kang-wha incident[28] I shall try to investigate more thoroughly. One of my preachers told me, as we passed the bend in the river that here was where the American boat had holes bored in her bottom by daring Koreans and that she sank. If that were the case it must have been the rowboat of the landing party and not the steamer itself? But I will write you more at length on this another time—this letter has had to be, perforce, one of the happenings of our family. We enjoy the Sunday papers so much. They give a touch that we could not get otherwise. Here's to a splendid trip to Europe, Europe the scarred and storm tossed. If all that we read is true conditions in the central countries must be unspeakable. Ruth joins me in best wishes to both of you,

Ever sincerely yours,
**Henry.**

---

[24] Possibly the Korea Annual Conference of the Methodist Episcopal Church.

[25] Henry D. Appenzeller was principal of Pai Chai Haktang (est. 1885; now Pai Chai University) from 1920 to 1940.

[26] Saitō Makoto (1858–1936).

[27] *The Seoul Press* (1907–1937) was a Japanese daily newspaper published in Seoul. It was published in English and promoted Japanese imperial rule in Korea.

[28] The Battle of Kanghwa. In August 1866, the armed U.S. vessel SS *General Sherman* illegally invaded P'yŏngyang via the Taedong River and was burned down by its residents. In June 1871, the United States launched an expedition to Kanghwa Island at the mouth of the Han River, destroying and occupying facilities such as Ch'ojijin Fort during a ten-day battle with the Korean Army. The United States demanded that Korea open its borders for trade, but under the isolationist policies of the regent Taewŏn'gun (1820–1898), Korea refused to sign a treaty with the United States until 1882.

64  LETTERS FROM MISSIONARIES

[Typed Statement]

STATEMENT CONCERNING THE AGUELED [sic. ALLEGED] DISTUR-
BANCES IN PAICHAI HAKTANG AND HIGHER COMMON SCHOOL,[29]
MARCH 2, 1920, AND THE INVESTIGATION BY THE POLICE.

H.D. Appenzeller, Principal.

With the approach of the first of March, the first anniversary of the
Independence demonstrations[30] in Korea, the authorities began taking
measures calculated to nip in the bud any celebration of that date by the stu-
dents of the various schools in the peninsula. Along with other schools, Pai
Chai received some half dozen communications from the Provincial Gover-
nor[31] commanding that great care be taken that no disturbances, nor even
failure to attend school, mark the day as anything beyond the ordinary.

I had the government warning against disturbing the peace read to the
students at chapel, and in addition spoke on that and another occasion, advis-
ing the students to apply themselves diligently to their studies, and also twice
cautioned and instructed the teachers.

Monday, the first of March, we had teachers stationed at the gates to see
that none of the students or so-called agitators stood on the outside urging
the boys not to attend. That morning there was an attendance of 138, and the
government representatives from the three branches, namely the provincial
government, and the police and educational departments of the Govern-
ment General[32] were present. Every class room was inspected, and the rolls
taken by the government men. A government representative sat in the office
all morning and until two o'clock in the afternoon. The students seemed res-
tive, but went obediently to their classes. At noon they went out as usual for
lunch, but did not come back that day, and so, to protect the dormitory stu-
dents who alone were present I declared a recess for the afternoon.

Tuesday, the second, at the teachers' prayers before chapel, I deplored the
exodus of the previous afternoon, and announced a meeting to decide upon
the action which should be taken. At chapel I told the students that they had
broken the school rules, and that they would all be punished. There were

---

[29] Pai Chai Higher Common School (est. 1909; now Pai Chai High School) was founded as Pai
Chai Kodŭng Haktang, the high school counterpart of Pai Chai Haktang (est. 1885; now Pai
Chai University). It was restructured in 1916 as a higher common school under the Japanese
colonial education system. Henry D. Appenzeller was its fifth principal, and he was dis-
missed by the Government-General of Korea as a result of his and the school's support of the
March First Independence Movement.

[30] The March First Independence Movement. On March 1, 1919, thirty-three Korean repre-
sentatives delivered the Korean Declaration of Independence, which was accompanied by
student-led protests and nationwide and overseas demonstrations by over two million pro-
testers against the Japanese colonial occupation. March 1 has been observed as a national
holiday in South Korea since 1949.

[31] Possibly Reizō Saitō (1847–?), who was colonial mayor of Kyŏngsŏng-bu (now Seoul) from
1919 to 1921.

[32] The Government-General of Korea was a Japanese colonial government that occupied
Korea from 1910 to 1945.

152 in attendance, and, as the day before, the government inspectors came and took the rolls, and a Mr. Okuyama,[33] from the educational department of the government general remained in the office. This man speaks both English and Korean to some extent, and it was he who was the chief witness for the government of the events of the afternoon.

The boys seemed to be studying as well as ever before, but, as an extra precaution, and to relieve my mind, I went into every class during the last period of the morning, and, saying that I believed in honor rather than force, asked for their word as to whether they were going to attend in the afternoon or not, intending, if there were any dissent to attend to the matter at once. They all, with one accord promised attendance, so I left for lunch, thinking that all would be well.

During the lunch hour I am told that Mr. Okuyama walked around where the boys were playing, an act which was calculated to and did arouse their feelings. Shouting from beyond the city wall to the west found a response in commotion from the boys who were playing around the grounds. From a little distance this sounded like the confused crying of ah!ah!! Hearing this shouting from my house, about two hundred yards away, I rushed out on the porch, but not catching the incriminating word "mansei",[34] went back into the house, for the bell had rung, and the students were marching to their classes.

I started out directly for the school, and was met by one of the teachers who said that I was wanted. At the same time I noticed the janitor running across the field to summon me and I saw that Appenzeller Hall was being surrounded by police. Before I could cross the field the police cordon was complete, and neither exit nor entrance was allowed the boys without police escort. In other words, when I entered the building and asked what was the matter, we were already under police detention. On asking the teachers, I found that the boys had made a noise and were said to have called "mansei". The policeman in charge, Mr. Morigawa, of the West Gate Station, said that he himself was a witness, and that he heard the word shouted from the second story of the school. I ventured to suggest that he might have been mistaken, whereupon the government representative mentioned above said in English, "Oh no, they ALL shouted mansei." This is most significant when we find that the testimony given before the police by all the teachers, including the two Japanese teachers, was that they did not hear "mansei", but simply that there was some commotion outside the building and unusual stamping as the boys went up the stairs.

---

[33] Okuyama Senzō (?–?) was an educator and author of *Ŏpŏp Hoehwa Chosŏnŏ Taesŏng* [Compilation of Grammar and Conversation] (Kyŏngsŏng: Chosŏnŏ Kyoyukhoe , 1928), a Japanese textbook for learners of the Korean language.

[34] *Mansei* in Korean means 10,000 years, or figuratively, eternity. *"Taehan tongnip mansei,"* which means "long live Korean independence," was a slogan for the March First Independence Movement.

66 LETTERS FROM MISSIONARIES

From that time (about 1:30 P.M.) until six-thirty officials, one after another to the number of ten, I think, came and kept trying to induce me to start at once an investigation as to who had shouted "mansei". This demand was based on the instructions sent out by the provincial governor, which said that within three days after any "disturbance", the principal was to investigate, and to expel the leaders. My first reply to this demand was that I would obey the governor's instructions within the three days, but that I could not undertake to investigate immediately because the police had already placed a cordon around the school and the matter had thereby been taken out of my hands, and because if I should begin the search at that time I would inevitably be regarded by my boys as a tool of the police.

The demand for immediate action was persisted in and the discussions continued thru the afternoon hours. My final statement to the officials was that I was ready to deal with any offense against school discipline but that it seemed to me that a political element was involved in this question which transferred the responsibility for the investigation from the principal to the police. Moreover, Americans had been warned from the Consulate General not to interfere in political matters, and having done all in my power to prevent any such occurrence I ought not to be called upon to search out offenders of that sort. When asked as to whether this attitude would not be contrary to the governor's instructions I replied that I did not see it so, but that even if a refusal should not be deemed in harmony with those instructions, still, I did not see how, under the peculiar circumstances, it would be possible for me to comply.

The police then, at about seven in the evening, began their own investigation of the students. They said they would use the school for that purpose and I did not refuse. I was allowed to have the boys fed, and the head of the West Gate police station was polite in his treatment of me and led me to think that the search would be nothing more than a simple questioning of the boys. I was not allowed in the inquiry rooms. The questioning went on till about midnight, when the police departed, taking with them for further examination 14 students and one teacher. By the time they had left, and the boys had gathered their books and other belongings together it was after one o'clock in the morning.

As the out-of-town students would find it difficult or impossible to get home and back in time for classes the next day I declared recess for Wednesday. That afternoon, Mr. Tanaka of the Government General, brought a paper with questions and answers purporting to be a report of the conversation of the afternoon previous, but which so changed my meaning as to make me a flagrant law-breaker because of my Christianity. I refused to sign this document, a Korean translation of a Japanese original, but said that I would have an English statement ready for him at two o'clock on Thursday.

Thursday morning the students turned out in good numbers. As I had heard that the inquiry of Tuesday night had been carried on in a brutal fashion, I commissioned the teachers to gather the facts. I have the detailed state-

*Appenzeller, Henry Dodge (1919–1926)*     67

ments in my possession and they show that a total of 41 were maltreated in one or more of the following ways: slapping, punching, kicking, wrists twisted, an object inserted between the fingers and these pressed until the blood started. One student is said to have had a finger broken, but he was not present on Thursday and his own testimony, therefore, was not received. THIS HAD BEEN DONE IN THE SCHOOL. Finding that the boys were in no condition to study, I declared vacation until Monday, March the eighth.

Thursday afternoon Mr. Tanaka came but being unwilling to accept an English statement, nor to give me time to prepare one in Korean, left to make his report, unsigned by me, to his superiors.

That evening, Thursday, after an account had appeared in big headlines in the Japanese daily, the KEIJO NIPPO,[35] I received notice from the governor of Keiki Province[36] that my permit to act as principal of Pai Chai Haktang and Higher Common School was revoked.

### 3) Jan. 30, 1921 [Typed Letter]

**Chemulpo**[37]

Dear Dr. Griffis,

It has been so long since I have written you that I am almost ashamed to write. As I think of the reasons for this, aside from the constant, and therefore invalid excuse of "the work", I find that I have been thinking of you as wandering around in Europe somewhere, with the Pilgrim Fathers,[38] treading their native heath and mingling with their sons returned after three hundred years to celebrate their great venture into the unknown. I say I have been thinking of you as somehow not readily reachable by post, and this has deterred me from writing.

But just before Christmas came the familiar and faithful friend, "Sermons on the S.S. Lessons"[39] and I rejoiced in its receipt, and the more in that it meant that its sender was safely home again. Thank you so much for it and your many kindnesses to us. The papers began too, a week or so ago and Ruth and I sat down and, with our heads in their pages were lifted out of our surroundings and carried far away from flowing white "tura-maggies",[40] from thatched roofs and filth, to our home land, clean, big, free, wealthy—oh yes,

[35] *Keijo Nippo* (*Kyŏngsŏng Ilbo*; 1906–1945) was a Japanese-language daily newspaper published in Seoul and supported by the Government-General of Korea.

[36] Keiki Province was the Japanese name of Kyŏnggi-do during the Japanese colonial occupation.

[37] In letterhead: Pai Chai Haktang and Pai Chai Higher Common School, Seoul, Korea.

[38] Among the first English settlers of colonial America, especially those in Plymouth, Massachusetts.

[39] *Sermons on the International Sunday-School Lessons* (?–?) was an annual compilation of Sunday school lessons published by the Monday Club in Boston, Massachusetts.

[40] *Turumagi* 두루마기, a traditional Korean overcoat.

68     LETTERS FROM MISSIONARIES

and of course wretched too in spots, but nonetheless OUR land. But this might sound home-sick so I'll turn to other things. I just wanted you to know what continual joy those oft-abused Sunday papers bring to your young missionary friends in, as one remarked as he ate his daily morning persimmon ("kam"), the "land of the morning 'kam'".[41]

Alice will be at her studies in Columbia[42] by the time this reaches you, and you may have already met. She will be telling you all about things out here and it will be interesting to get her letters telling of having seen you, but she has been gone so long already that I will have to be permitted to blow my own horn a bit if I am to tell you what I have been doing, and hope to do.

After a delightful month spent at Sorai[43] we three, Margaret,[44] Ruth and I, returned in the pink of health to our duties here in Chemulpo. The cholera was still on then, the first week of September, and I must have gotten some sort of a bug for I had a severe attack of something which the doctor said must have been a mild form of that thing. It was over, the worst of it, when he got here. But the thing that stood me in best stead was the inoculation taken in July before we went to Sorai. Getting "shot" is a wise precaution out here where there're so many bugs.

Then there was Federal council[45] meeting, Budget estimates to be worked over—we are so shy of men that it means more work for each man—a trip to Pyeng Yang[46] in the north, the center of Presbyterianism and therefore pre-mil-ism[47] and conservatism. But for all this I was greatly pleased to see the way that Mowry,[48] whose name you may recall as having publicity in the press of a couple years ago when we were put in jail etc., the way that he had of handling those college boys. It was an inspiration to me and with a few years of being left alone to work at it at Pai Chai[49] I think I might be able to work myself into the lives of the boys there too. After that came some itinerating and then District and Annual Conferences. They made me secretary of conference again and it sure was easier this year than last. At conference we were appointed back to this district and I was to start in at Pai Chai as soon as the permit to teach was granted. This came in December and I began this

[41] *Kam* 감 means persimmon in Korean.
[42] Alice Appenzeller earned her master's degree from Teachers College, Columbia University, in 1922.
[43] Sorae (now Sorae P'ogu, Inch'ŏn), a port near Chemulp'o.
[44] Margaret Noble Appenzeller (1919–2005).
[45] Possibly the Federal Council of Evangelical Missions in Korea (est. 1911).
[46] P'yŏngyang.
[47] Premillennialism is the Christian eschatological belief that the Second Coming of Jesus Christ will inaugurate a literal thousand-year period of his reign on the physical Earth.
[48] Eli Miller Mowry (1880–1971) was a Northern Presbyterian missionary in P'yŏngyang from 1909 to 1941. He was arrested on April 11, 1919 for assisting student protesters in the March First Independence Movement (1919) against the Japanese colonial occupation. He was also the principal of Soongsil Haktang (est. 1897; now Soongsil University) from 1936 until it was closed by the Government-General of Korea in 1938.
[49] Pai Chai Haktang (est. 1885; now Pai Chai University).

month as a teacher of English. It is rather difficult to move in the dead of winter so the Bishop[50] has let us stay here till spring and I commute three days a week to Seoul. But we expect to move about the middle of March.

Translation work seems to be opening up to me and I am highly glad. They put me on a committee to get out the Epworth League Manual,[51] and recently the Christian Literature Society asked me to head up a committee to get out a new song book, "Songs for the Korean Youth" we will call it. This latter is quite some job and will be lots of fun as well. While these are simply tool books and not the sort of thing that I want to work to ultimately they are a beginning, and it means something to me to be asked to do this sort of thing.

The work at Pai Chai, now that I have tried it three weeks, promises to be very interesting. We have over 400 boys this winter term, a slight falling off from the fall term, but April will find us in our new recitation hall and with over 600 boys. By the way, you would be interested to know that at Conference time there was unveiled, in Appenzeller Hall[52] of Pai Chai School, a medallion of father made by Schuller of Baltimore and brought out by Dr. Goucher.[53] This medallion was paid for by the Koreans and is a very good likeness. The inscription is "A Man of God. An Apostle of Methodism." The ceremony was very interesting. Father founded the school, Alice broke ground for the building which bears his name. The building was named Appenzeller Hall on my birthday[54] last year (1919) and the granddaughter, Margaret Noble Appenzeller unveiled the medallion! Can you beat it! Ruth and I were proud enough to bust, for Margaret was a little dear (pardon a fond parent!). There was a big crowd on the campus in front of the steps of the building and when Bishop Welch lifted Margaret on to the table in front of the crowd they began to clap. Instead of being afraid she clapped her hands too. And then she threw kisses to them, as Ruth had taught her to. She was too cunning for words.

As for Mary's wedding and all that excitement you will no doubt be hearing from her, or Alice, or both. She was beautiful and the ceremony perfect.

---

[50] Herbert George Welch (1862–1969) was a bishop of the Methodist Episcopal Church, Methodist Church, and United Methodist Church. He also served as a bishop of the Seoul episcopal area.

[51] The Epworth League (est. 1889) is a Methodist association for young adults. It has published several manuals outlining its history and activities, including John Bunyan Robinson, *The Epworth League, Its Place in Methodism: A Manual* (Cincinnati: Curts and Jennings, 1890); Byron E. Helman, *How to Make the Wheel Go: Manual of the Epworth League* (New York, Eaton and Mains; Cincinnati, Jennings and Pye, 1900).

[52] The Appenzeller Hall (est. 1916), dedicated to Henry G. Appenzeller, was the East Hall of Pai Chai Haktang (est. 1885; now Pai Chai University) and reopened in 2008 as the Appenzeller Noble Memorial Museum.

[53] Hans K. Schuler (1874–1951) was a sculptor and founder of the Schuler School of Fine Arts (posthumously est. 1959) in Baltimore, Maryland. Reverend John Goucher was a Methodist minister, a financial supporter of the Methodist Episcopal Mission Society's projects in Korea, and the president of Goucher College (est. 1885) in Baltimore from 1890 to 1908.

[54] Henry D. Appenzeller was born on November 6, 1889.

# 70    LETTERS FROM MISSIONARIES

We changed houses and they had their honeymoon here in Chemulpo. They are very happily fixed in a cosy little house on the Theological Seminary[55] compound and it sure does feel good to have someone in the family back here again. We have been alone for months, neither Nobles nor Apps[56] but us. All three of us have been in the best of health all winter and are mighty grateful for it too. There have been quite a number of children die in Seoul this winter, Hugh Cynn[57] lost three in two weeks from a scourge which did and did not resemble scarlet fever.

Ruth joins me in gratitude for your frequent gifts of books and papers and in best wishes to you and Mrs. Griffis,

Very sincerely yours,
**Henry.**

### 4) Dec. 4, 1926

**Pai Chai Higher Common School, Seoul, Korea** [location from letterhead]

Dear Dr. Griffis,

Welcome to Japan and to the Land of Morning Splendor! We have followed with interest the announcements in the papers of your coming and shall bask in the glory of being counted a friend, for from the sound of things you will be having a busy time indeed. The tribe of Appenzellers extends open arms to you and what little we have is yours so long as you are with us. I am just hoping you will be coming over here while school is in session & not during the holidays so that you may be able to see our eight hundred hopefuls. We close the 20th and start up again on the 8th or 10th of January.

Affectionately,
**Henry.**

---

[55] Not clear which seminary this refers to.
[56] Appenzellers.
[57] Hugh Heung-wo Cynn 신흥우 (or Cyn; 1883–1959).

# 5      *Appenzeller, Henry Gerhart (1890–1891)*

### HENRY GERHART APPENZELLER
### (1858–1902)

Henry G. Appenzeller was born to fourth-generation Pennsylvania Dutch parents. While preparing for college, he experienced a spiritual conversion. He attended Franklin and Marshall College to prepare for the German Reformed ministry but later switched to the Methodist Episcopal Church. While attending Drew Theological Seminary in Madison, New Jersey, he submitted a request for a foreign mission in Japan but, with no openings available there, the Board of Foreign Missions sent him to Korea in 1884. He set foot at present-day Inch'ŏn with his wife Ella, on Easter Day, April 5, 1885. He founded the first Korean Methodist church in Seoul and started the first Western educational institution in Korea, Pai Chai Haktang, in 1885. Many leaders, such as Syngman Rhee, graduated from the school. He was traveling to Mokp'o for a Bible translation meeting when his ship collided with another ship. He drowned while helping to save a young girl. A cenotaph was erected on his behalf at the Yanghwajin Foreign Missionary Cemetery, which holds the graves of forty missionaries from the United Methodist Church.

1) **Mar. 10, 1890**

**Seoul**
The Rev. W.E. Griffis, D.D.
Boston, Mass.

Dear Brother:—

I have the pleasure to acknowledge the receipt of "Corea: The Hermit Nation 3d-Ed."[1] and in the name of the mission to sincerely thank you for your magnificent work on Korea. The book will be placed on the shelves of the Library of our school, Pai Chai Hakdang[2]—Hall for rearing useful men, where it will be read not only by us foreigners but by some of our students.

---

[1] William Elliot Griffis, *Corea: The Hermit Nation*, 3rd ed. (New York: Charles Scribner's Sons, 1889).
[2] Pai Chai Haktang (est. 1885; now Pai Chai University).

Figure 15  Portrait of Henry Gerhart Appenzeller (KP 4.3.6, Griffis Collection)

I congratulate the reading public in the U.S. that the best work on Korea is by an American. You still have the right of way and we are not afraid to quote you.

Thanking you again for your "token of sincere regard."
I remain

Sincerely Yours,
**H. G. Appenzeller**

# Appenzeller, Henry Gerhart (1890–1891)

## 2) Oct. 25, 1892

**Phoenix, R.I.**
Rev. W. E. Griffis DD
Boston, Mass.

Dear Brother,—

I visit Boston this week Friday. If I can find out where the author of "Corea: The Hermit Nation" lives and has a few moments to spare I shall give myself the pleasure of "making my bow" to him. A line addressed 72 Mt. Vernon St. c/o[3] Rev. E. S. Hammond[4] will reach me.

With kindest regards, believe me

Sincerely Yours,
**H. G. Appenzeller.**

## 3) June 13, 1891

**Seoul, Korea**
Rev. Wm. E. Griffis D.D.,
Ithaca, N. Y.

Dear Doctor:-

Many thanks for your kindl [*sic* read kind] letter re[5] Korean Repository.[6] Sorry you have had trouble. We have tried and are trying to straighten out this agency for the M.S.[7] I have reason to think Hunt & Eaton[8] will act as agents. I wrote them long ago, they received your subscription, but I am writing by mail and think there will be no more trouble.

We are very happy to find you like the Repository and tho we have not seen your Nation, thank you for noticing our existence. We shall live until the end of this year, sure and if the subscription list warrants, we shall live on.

---

[3] Care of.
[4] Reverend E. S. Hammond (?–?) was a minister at North Stoughton Methodist Church in Stoughton, Massachusetts.
[5] Regarding.
[6] *The Korean Repository* (*Chosŏn Sosik*; 1892, 1895–1898) was an English-language monthly journal published in Seoul. Its inaugural issue was printed in January 1892. "In 1892, he [Hulbert] published a seventeen-page paper titled 'The Korean Alphabet (*Chosŏn Kŭlcha*)' across the January and March issues of *The Korean Repository*. Hulbert completed the paper before he departed for the U.S. in late 1891, and submitted it to Appenzeller, a Methodist missionary and the publisher of *The Korean Repository*. Appenzeller, who recognized the importance of this paper, printed it in the inaugural issue of Korea's first monthly journal, and on its first page." Kim Tong-jin, *Hŏlbŏt'ŭ ŭi Kkum, Chosŏn ŭn P'iŏnari!* [Homer B. Hulbert: Joseon Must Bloom!] (Seoul: Ch'am Choŭn Ch'in'gu, 2019), 78.
[7] Manuscript.
[8] Hunter and Eaton was a publishing house based in New York.

74 LETTERS FROM MISSIONARIES

Mr. Jones[9] and I are editors and Mr. Hulbert[10] publisher and we purpose dividing the gain or sharing the loss. In the East we are receiving substantial encouragement, likewise from England but our own people have not yet impoverished themselves in subscribing to our paper.

While on this subject, will you not send us something for publication, please? As hinted about, we shall not be able to offer substantial remuneration, and therefore have much limitation to make the request, but we should be very pleased to have you contribute to our columns occasionally. Ask some questions, propound some theory on romanization, stir up unpure minds of some of our contributors on a subject you would like to have discussed by sailing into them on us.

The splendid review on "New Korea" published a few months since in the Sunday School Times,[11] revisioning recent publications, I guessed at the time was from your pen. How am I on this "guess"?

Thanking you again for your kind words and framing myself a copy soon of this fourth edition of your Hermit Nation[12] and hoping to hear from you.

I beg to remain

Sincerely Yours,
**H. G. Appenzeller.**

[9] George Heber Jones (1867–1919) wrote "The Japanese Invasion" in the January 1892 inaugural issue of *The Korean Repository* (pp. 10–16). Jones's piece appeared after the first article, "The Korean Alphabet," by Hulbert.

[10] Homer Bezaleel Hulbert (1863–1949).

[11] The *Sunday-School Review* (1859–1966) was a newspaper published by the American Sunday-School Union in Philadelphia, Pennsylvania.

[12] William Elliot Griffis, *Corea: The Hermit Nation*, 4th ed. (New York: Charles Scribner's Sons, 1894).

# 6   *Becker, Louise S. (1919)*

## BECKER, LOUISE S. (CA. 1882—?)

Louise S. Becker served as an educational missionary with her husband, Arthur Lynn Becker (1879–1978), the first scientist and educational missionary to Korea. Arthur Lynn Becker received a PhD in physics from the University of Michigan and went to Korea in 1903. In 1905, together with William Baird, he started Union Christian College (Soongsil) in P'yŏngyang, the first college in Korea. In 1914, Dr. Becker took twenty of his advanced students to Seoul to start Chosen Christian College, today's Yonsei University.

### 1) June 10, 1919

**[Location not identified][1]**

Dear Friend,-

When we left Korea some six wks ago several addressed envelopes were handed to me by friends and I'm glad to write a few words concerning the situation as it was when we left. The folks there cannot write one word, and expect to stay there without being misunderstood they are liable to bring a deal of trouble on themselves—but since we have left the shores of Japan it is quite safe for us to speak—but please do not publish this nor quote me to friends in Korea—I might not be allowed to return to Korea—for they have their spies all over U.S.

This movement[2] affects the whole country. The Koreans are going to carry on I believe until they get a great deal of what they are after. They seem to have this movement splendidly organized. The quiet persistent manner in which they resist is most convincing and upsetting to the government authorities As the Koreans say they are "empty-handed" fighting for right—justice and peace. They have lost the fear of the gun and sword many having already lost their lives and before this this is done many more will lose their lives.

They have a reason for rebelling—that reason is oppression and injustice. Just to state a few facts—no representation in the Government—they have no say whatever in its administration—The Koreans are being crowded out of their country and from their employment—merchants are leaving to make a

---

[1] In letterhead: Pacific Mail S.S. Co., S.S. Equador with a logo.
[2] March First Independence Movement (March 1, 1919).

living in Manchuria and hundreds of the poorer people are being sent up there to live in a country that is not productive—where they cannot raise rice, their staple food. The high cost of living has forced them to move in order to make a living elsewhere. Our hearts ache as we write about the many who are in prison. Many of our brightest and best men and women who have been trained in our schools and who are leaders in our churches are suffering for liberty and an opportunity to grow spiritually physically and mentally.

They realize how much they are missing for themselves as Koreans and what a gasping chance they have under the present administration.

Regarding the safety of missionaries. The American Consul is active and sees to it that no advantage is taken of American citizens as far as their lives are concerned. The Japanese hate us and feel that we are instigators of this trouble but I dont believe they would take our lives. We left everybody calm in mind, perfectly well and safe. They wanted you to know this and I am glad to reassure you in these few lines.

Yours Most Sincerely,
**Louise. S. Becker.**

# 7 Bernheisel, Charles F. (1907)

### CHARLES F. BERNHEISEL (1874–1958)

Charles Francis Bernheisel was a missionary best known for his book *The Apostolic Church as Reproduced in Korea*, detailing the spread of Christianity in Korea. He kept in close contact with Reverend Kil Sŏn-ju, the pastor of the Central Church in P'yŏngyang, Korea, and documented Kil's personal revelations about Christianity.

1) **Mar. 6, 1907** [Typed letter]

**Pyeng Yang, Korea**
Rev. Wm. Elliot Griffis, D. D.
Ithaca New York.

My Dear Dr. Griffis.-

Sometime ago I was honored by the receipt of a very kind letter from you congratulating me on my marriage and expressing your continued interest in Korea. My wife joins me in thanks for your kind wishes. While you are unknown to us personally you have long been known to us by reputation and we have read your books with much interest and profit.

I regret that it is not possible for me at this time to comply with your request for a photograph of the chain of the old General Sherman which is in the East Gate of this city. I have made a number of inquiries but no one seems to have a picture of it. I will, however, bear your request in mind and endeavor to get one for you at a later time and forward to you.

Many changes have been made in Korea since the Japanese occupation of the country. The two greatest material benefits to the country have been the building of railroads, thus putting the two ends of the country into easy and rapid communication with each other, and the establishment of a stable currency. The currency used to be in 'confusion worse confounded' but now it is in a very satisfactory state, and the influence of it is felt from one end of the country to the other.

The country is now in a very quiet condition and the people have settled down to their usual vocations prepared to make the best of the situation in which they find themselves and from which they know it is impossible to extricate themselves. While we believe that the seizure of the country by Japan was and still is for purely selfish motives and the promotion of her own

78    LETTERS FROM MISSIONARIES

welfare we believe that she is coming to believe that her own best interest will be best advanced by a humane and enlightened treatment of the Korean people. A Kongonian treatment of an enlightened people as the Koreans would be an anarchism not to be thought of or tolerated in this day and generation.[1]

Mr. Hulbert did a good work for Korea in the publication of his paper and it is with regret that we hear that he has suspended publication of it.[2] It showed up to the world the condition of things here at that time as did no other publication. Such abuses are much less frequent now than formerly but I am still unable to say that they have altogether ceased.

I send you enclosed herewith a copy of a letter that has recently been issued from here showing something of what the Lord is doing for this people. This same work is spreading all over the country and the church is receiving such a blessing as it has never before received.

Your prayers 'for the coming of the Kingdom of Christ in Korea' have been and are being answered. Keep on praying. We do not know how much of this blessing is due to the faithful prayers of God's people at home.

With sincerest regards I am

Fraternally yours
**Chas. F. Bernheisel**

---

[1] Colonial rule in the Congo that began in the late 19th century continued as The Belgian Congo from 1908 until Independence in 1960.

[2] Homer B. Hulbert (1863–1949) published a monthly, *The Korea Review*, from 1901 to 1906. In 1907 he was sent as part of a secret delegation by King Kojong to the Second International Peace Conference in The Hague. The Korean delegation didn't gain a hearing at the conference, and the Japanese forced the king to abdicate. Hulbert was expelled from on May 8, 1907.

# 8      *Billings, Helen I. (1920)*

### HELEN I. BILLINGS (?—1968)

Helen I. Taylor was the wife of Bliss W. Billings (1881–1969), an educational missionary in Korea. After his retirement in 1951, they moved to Hawaii, where Bliss Billings served as an interim pastor. Their son, Paul Billings, was a missionary in Japan.

1) **Dec. 17, 1920**

**Seoul, Korea**

Dear Mr. and Mrs. Griffis:-

It was so thoughtful of you to send the pictures of the Ewha[1] girls and the Billings[2] family. The girls were delighted and I have not seen any better group of the girls. So many have snapped them but I think you were the only ones who sent them a copy, and it made a great impression. I have misplaced our picture so couldn't find the address and show my appreciation, until I got it from Ewha. I wish you could have gone with me to the church next door where the girls gave their annual Christmas concert. The church was decorated with pine branches festooned around the windows and railing with two large trees in the corners of the church at the right and left of the organ. In the top of our tree was a large white star with an electric globe behind it in the top branches of the other a large white cross illuminated by invisible electric globe. The girls sang beautifully, choruses, quartets, duets, solos and one girl told the story of Van Dyke's "The Sad Shepherd"—at the end they turned out the light and only dimly outlined from the light of the star and cross they sang—"Holy night, silent night" after which the pastor prayed.

I will enclose a picture of the two preaching bands that went out from the Pierson Memorial Bible School[3] to hold evangelistic services in some of our southern work. They had good meetings but we are somewhat saddened at the close because one of the boys was arrested for 28 days. We have not heard the reason but suppose some policeman objected to something which he said. Hope they will let him out after the 28 days examination. There have been a

---

[1] Ewha Haktang (est. 1886; now Ewha Womans University).
[2] Bliss W. Billings (1881–1969) was a Methodist missionary in Korea from 1908 to 1953.
[3] Pierson Memorial Bible School (est. 1912; now Pyeongtaek University)

## LETTERS FROM MISSIONARIES

great many arrests lately—it is most distressing—one of our College boys was taken about two weeks ago. The signers of the Declaration[4] were finally sentenced after being imprisoned for 1 yr 9 mos and 1 year subtracted from the sentence so that our Kim tho' he was sentenced to 2½ years will only be compelled to serve hard labor 1½ yrs. He wrote us such a good letter—no complaint or worry about himself only about his wife and the church and sending 1 Peter 4:1 for our comfort. Mr. Billings and I hope you will have a beautiful Christmas and that the Savior, we love and serve, will shed his glory light about you and make you a blessing.

Sincerely,
**Helen I. Billings**

---

[4] The March First Declaration of Independence (also known as the Korean Declaration of Independence or Kimi Declaration of Independence) was signed by thirty-three representatives of the March First Independence Movement against the Japanese colonial occupation. The declaration was delivered on March 1, 1919, at T'aehwagwan, a restaurant in Insa-dong, Seoul.

# 9  Cable, Elmer M. (1920)

### ELMER M. CABLE (1874–1945)

Elmer M. Cable was a missionary in Korea and the chief editor of *The Korean Christian Advocate*. An advocate for coeducation, he was instrumental in merging the male-only Hyŏpsŏng Seminary and Hyŏpsŏng Women's Seminary in 1925, today known as the Methodist Theological University in Seoul. In the 1930s, he also taught at Yonhui School (now Yonsei University), which he had helped to establish in Sinch'on in 1915. Cable authored "United States-Korean Relations 1866–1871" published in *Transactions of the Korea Branch of the Royal Asiatic Society* (1938).[1] Like all missionaries in the last phase of the Japanese colonial rule, he was recalled to the United States in 1940.

### 1) Nov. 13, 1920

**26 Mt. Avenue, Edgewater, N.J.**
Rev. W. E. Griffis D.D.
New York City

Dear Dr. Griffis:—

I appreciate very much your very kind letter. So glad to know you are still well and able to do active work.

I am in New York City until January, taking special work in Union. I find my time pretty well occupied, and am giving to this work all my time and strength.

I doubt whether I could give you any material on Korea that would be of very much value. However, I hope I may have time to call and see you before I leave the city.

Korea is passing through a terrible time and one can hardly prophesize what the end will be. I fear Japan will never be able to make atonement for what she has done in Korea and that she has lost all hope of pacifying the Koreans. I never saw such a transformation in a people. The Koreans have changed from creatures of fear to courageous patriots. It will mean a relentless struggle and in all probability a struggle to a decision. It will not be a

---

[1] E. M. Cable, "United States-Korean Relations 1866–1871," *Transactions of the Korea Branch of the Royal Asiatic Society* 28 (1938): 1–230.

82 LETTERS FROM MISSIONARIES

conventional struggle of ours but a war of non-resistance; a campaign of strategies.

Thanking you for your kind words of appreciation, and hoping to have the pleasure of meeting you, I am.

Most Cordially
**E. M. Cable**

# 10    *Erdman, Julia Winn (1911)*

JULIA WINN ERDMAN (1885–1961)

Julia Winn Erdman was the daughter of Thomas C. Winn (1851–1948), a Presbyterian missionary in Japan. She served as a missionary in Korea with her husband, Walter C. Erdman (1877–1948), from 1907 to 1929.

1) July 14, 1911

**Camp Diamond, Colebrook, N.H.**

My dear Dr. Griffis:

Your letter found me here, having gone to Korea and then come back in search of me. It was very kind of you to remember my father's daughter and to think of me and mine. We are home on a brief furlough, having been granted a short leave of absence for needed rest and special medical treatment.

In regard to your request for information about Korea, your letter implies that you particularly desire information concerning the political conditions in Korea—the Japanese annexation of the kingdom[1] and the resulting conditions. This is the topic upon which all missionaries must preserve a strict silence. We are all endeavoring to maintain complete neutrality, and any expression of ours liable to get into print must be strictly avoided as it is capable of doing much harm—if pro-Japanese, the Koreans are liable to turn against us; if pro-Korean, the Japanese, who hold us in constant surveillance could make it very hard for us and the work.

I wish I could give you more assistance in your difficult undertaking. Changes are so rapid today in Korea that it would appear to be extremely difficult to attempt any analysis of conditions there except by unbiased personal investigation—and how misleading investigation can be is strikingly illustrated in the case of Dr. Ladd's[2] futile and unreliable portrayal of conditions under the Protectorate.

The people are much absorbed in the material changes going on around, the stores and shops, the implements and articles of foreign manufacture

---

[1] Japan-Korea Annexation Treaty (1910).
[2] George Trumbull Ladd (1842–1921) was an American psychologist, philosopher, lecturer, advisor to Japanese prime minister Itō Hirobumi (1841–1909), and the author of *In Corea with Marquis Ito* (London: Longmans, Green and Co., 1908).

## 84    LETTERS FROM MISSIONARIES

which the Japanese are bringing in and they are apt to spend money foolishly for things which they do not need but which catch their eye in the display windows—for they are children. The five-day market is still kept up in Taiku[3] and the people come in from all the countryside to try and sell. But in all respects Korea is becoming rapidly "Japanised." The Korea of ten—of five—years ago is gone and all is changing too rapidly to allow of description—for todays description would not fit tomorrows picture.

Picture postcards of local scenes can be had in Taiku—Japanese photographers of course producing them. Historic landmarks are rapidly being obliterated, too, once they stand in the way of civic improvements and of course the administration has no interest in preserving Korean landmarks. So that picture postcards preserve the only record now of many an old stone or shrine.

Many Koreans are adopting Western dress—though gradually—shoes first, then hats and then a special-occasion-suit of clothes.

As the title of Dr. Gales book[4] suggests Korea is now in transition and the precise form of the future Korean life as well as moral and economic conditions are hard to predict.

I fear that I have not much to contribute toward your book at this present time and the field of discussion is much limited by political conditions. Trusting however that these few lines may give you some suggestions—

Sincerely yours

**Julia Winn Erdman.**

We return to Korea in October.

---

[3] Taegu, a city near Kyŏngsang-bukto, southeastern Korea.
[4] James Scarth Gale, *Korea in Transition* (New York: Young People's Missionary Movement of the United States and Canada, 1909).

# 11     *Fletcher, Archibald Grey (1927)*

ARCHIBALD GREY FLETCHER

(1882–1970)

Archibald G. Fletcher was a medical missionary for the North Presbyterian Church. Dispatched to Wŏnju in 1909, he began his medical mission at the Andong Missionary School. He moved to Taegu and served until 1942 as the director of the Dongsan Christian Hospital, which ran a center that specialized in treating Hansen's disease. Like many American missionaries, he was expelled from Korea by the Government-General of Korea when the Pacific War started. In 1946 he returned to Korea and served as the director for the Seoul Severance Hospital Restoration Project until his retirement in 1952.

1) Feb. 22, 1927

**Taiku, Chosen, Japan** [location from letterhead]
**Dr. Eliot Griffis**
**Tokyo, Japan.**

My Dear Dr. Griffis:—

Having learned from Mr. Hugh Miller[1] of Seoul that you were expected there about the 20th of March I write to ask if it would be possible for you to stay over at Taiku[2] for a couple of days while on your way to Seoul.   •

There are about 20,000 Japanese and forty or fifty thousand Koreans in addition to twenty five missionaries who would be delighted to see and to hear you speak.

If it is possible for you to pay us this visit please drop a line in advance that we may make the necessary preparations for your coming.

Yours sincerely
**A. G. Fletcher.**

---

[1] Hugh Miller (1872–1957) was a Scotland-born Canadian Presbyterian missionary in Korea from 1899 to 1937. He began his work as a secretary for fellow missionary Horace Grant Underwood (1859–1916) and completed the second Korean translation of the *New Testament* (*Sinyak Chyŏnsyŏ* 신약젼셔) in 1900 with other members of the British and Foreign Bible Society (est. 1804).
[2] Taegu, a city in Kyŏngsang-bukto, southeastern Korea.

86     LETTERS FROM MISSIONARIES

**2) Mar. 30, 1927** [Typed Letter]

**Taiku, Chosen, Japan** [location from letterhead]

Dear Dr. Griffis:—

We were very glad to get your letter from Japan and to know that you would make us a visit on your return trip from the North. We hope you have not forgotten us and that some time in the near future we may have the pleasure of seeing you in Taiku. Whenever it is possible for you to fix your date of visit we will be very glad to know if possible a few days in advance.

Of course, you know all about the wonderfully interesting things to be seen at Kyungju[3] which is only about fifty miles from Taiku and it may be you would like to take a run out there for a day or two.

Hoping to hear from you again and to meet you in Taiku in the near future,

Sincerely yours,
**A. G. Fletcher**

**3) Oct. 10, 1927** [Typed Letter]

**Taiku Leper Hospital, Taiku, Chosen, (Korea) Japan** [location from letterhead]
**Dr. W. E. Griffis,**
**Pulaski, N.Y.**
**U.S.A.**

Dear Dr. Griffis,

We were very glad to receive your recent letter and to know that you have safely arrived at home again. It was a great pleasure to have you and Mrs. Griffis with us in our home even for a short time. We are greatly delighted with the news that you are to give some effort to the great cause of helping the lepers. Whether your help may extend to the lepers in the Philippines or in Korea we will still feel there is a new bond of fellowship as fellow worker for the unfortunate leper. We are enclosing several copies of a leaflet that we prepared after visiting the Government Leper colony[4] off the south western coast of Korea. We hope this information may be of some interest and help to you and we shall be glad to do anything that we can in the way of providing further information.

---

[3] Kyŏngju, a city in Kyŏngsang-bukto, southeastern Korea, was the capital of the Silla Dynasty (57 B.C.E.–935 C.E.).
[4] Sorokto Chahye Ŭiwŏn (now Sorokdo National Hospital; est. 1916) was built by the Japanese colonial government to quarantine and treat people with leprosy. It is located in Sorokto, an island in Chŏlla-namdo, southwestern Korea.

Mrs. Fletcher and the children join in sending their kind regards to you and Mrs. Griffis.

Sincerely yours,
**A. G. Fletcher.**

AGF/CSK

Encl.

**[Printed Leaflet]**

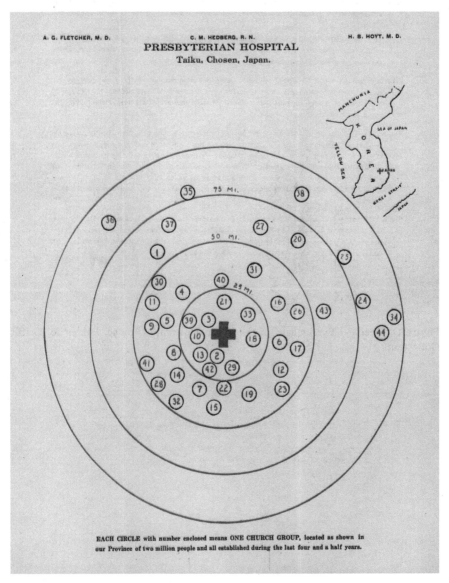

Figure 16 Presbyterian Hospital, Taiku, Chosen, Japan (Box 59, Folder 20, Griffis Collection)

## MEDICAL EVANGELISM in the TAIKU HOSPITAL

**Organization**—Four and one half years ago the Hospital Staff was organized into a Preaching Society which partly supports, by individual contributions, and wholly directs the work of six Evangelists, three men and three women, and one Colporteur.

**Aim**—1. Preach the Gospel to every patient.
   2. Definitely win to Christ as many of the patients as possible.
   3. See that these new converts unite with the Church.

**Method**—Follow up in person new converts in the hospital, when they return to their non-Christian homes in the country, and for one month do intensive preaching to the relatives, friends, and villagers.

The Evangelists work in pairs and alternate in turn so that each pair has one month in the hospital winning converts—next month in the country establishing a new group around a convert—third month visiting and supervising groups recently established.

**Reports**—Once each month the Preaching Society meets to hear an account of the work done by the Evangelists and to plan for the work of the forthcoming month. At these meetings the Evangelists often relate most interesting incidents out of their experience which are very much appreciated by all the members.

**Illustration**—Only sixty miles from Taiku, but isolated by a high mountain pass, ninety houses grouped in small villages are occupied by poor, ignorant people who were never visited by a Missionary. One of their number came to our hospital for treatment—became a Christian and upon his return helped the Evangelist to establish a group of 46 new believers. Four of these new converts had their hair cut for the first time. All of them destroyed every shrine for spirit worship in the home and out of their poverty pledged enough money to buy and put in repair five mud walled rooms for a Church.

**Results**—52 groups established 8 of which disappeared leaving 44 at present. Total membership in these groups is 886, an average of 20. Nearest group is 3 miles from the Hospital and the farthest 100— the average is 39 miles. Of the 44 groups 33 have established leaders. 29 have their own Church buildings, averaging 3 kan each in size (a kan is 8 feet sq.)

Figure 17 "Medical Evangelism in the Taiku Hospital" (Box 59, Folder 20, Griffis Collection)

# 12    *Frey, Lulu E. (1916)*

### LULU E. FREY (1868–1921)

Lulu E. Frey went to Korea as a Methodist missionary in 1893. Even though her advocacy for women's education was met with backlash from Koreans as well as her fellow missionaries, Frey endeavored to make college education accessible for women during her teaching career at Ewha Haktang, where she served as its fourth principal from 1907 to 1921. Frey became an icon in women's liberation through education in Korea. Shortly after her term as principal ended, Frey returned to the United States.

1) **Apr. 14, 1916**

**Seoul, Korea**[1]

Dear Dr. Griffiths [*sic* read Griffis]:

Your letter with word of the lovely gift you are sending us, a library in memory of your sister, reached me today. I read it at the dinner table and I wish you could have heard the cries of delight which came from each of the ladies, and I am sure when the college girls learn of what you have planned for them, they too will be made happy. We shall take care of them as we use them so that for many years to come our Korean girl [*sic* read girls] may have the benefit of them.

Thank you so much for the books, and for the interest you have in our little country and her people. We appreciate your kindness so much, especially at this time when all that is done for Korea means so much.

When the books arrive we will let you know

Sincerely Yours,
**Lulu E. Frey.**

---

[1] In letterhead: Ewha Haktang.

# 13     *Gale, James Scarth (1895–1921)*

## JAMES SCARTH GALE (1863–1937)

James Scarth Gale graduated from the University of Toronto in 1888 and was appointed as a missionary of Toronto University's YMCA to Korea. He arrived in Pusan on December 12, 1888, and travelled from province to province during his first year, after which he returned to Pusan and taught at the Christian School. In February 1891 Gale and Samuel A. Moffett traveled to Manchuria to visit John Ross, who continued translating the Bible into Korean. From 1892 to 1897 he lived in Wŏnsan, serving as a member of the Board of Official Translators of the Korean Bible, wherein he worked with Henry G. Appenzeller, Horace G. Underwood, William B. Scranton, and William D. Reynolds. He returned to North America in 1897 and was ordained as a Presbyterian minister in Indiana. In 1900, Gale became the first minister of Yondong Presbyterian Church in Seoul. Aside from his work translating the Bible, Gale helped found present-day Kongsin Middle and High School as well as Chongsin Girls' School in Seoul. In 1917 he founded the Korean Music Society. He left Korea in 1927 and officially retired in 1928. He published many books on Korean grammar and translated many works of Korean literature into English.

### 1) Apr. 12, 1895

**Gensan, Korea**
Rev. W.E. Griffis D.D.

Dear Dr. Griffis

I must ask you to pardon my seeming neglect in the matter of answering your very kind letter written me now many months ago. I was there as I thought about to take a trip to the Diamond Mountains[1] where I hoped to find something that would help in a measure to answer some of the questions you asked concerning Buddhism. Because of sickness in my family and war disturbances the trip was postponed month after month and I have not yet seen the Diamond Mountains nor obtained the information by which I can hope to answer your letters. Whether I shall find an opportunity to go or not is as yet uncertain. It is a place I desire to see very much not so much because it is the

---

[1] Kŭmgang Mountain, or Kŭmgangsan, in present-day Kangwŏn-do, North Korea. Its name means "diamond mountain."

90

centre of Buddhism as it being a sort of Korean Paradise. They invariably speak of Keumgang San 金剛山[2] as the climax of all mountain scenery where the various propitious atmospheres have met in a state of [interrelation?] that is beyond description. Whenever I go I shall take the liberty of writing you as a proof that that was the stumbling block in the way of acknowledging your kindness in writing me.

I do not live in Seoul as you suppose but [live?] in The East Coast in Wunsan or Gensan (元山)[3] as the Japanese call it. It is the seaport much coveted by Russia and so stands on very uncertain footing in these war times I am afraid that the result of the war may be that Russia will get Gensan and Christian Missions perhaps be turned out.

I lived in Seoul four years and then came here where I have been struggling along in the language with various attempts at translations. A Corean-English Dictionary[4] has occupied my four years here nearly altogether and I plead this as an excuse for a lack of [story?] special subjects that I hope to take up the Dictionary work is general rather than special. The Dictionary has in all some 45000 definitions [making?] the character. It is now in the hand of the various Presbyterian Missions (The Americans and Australians) and they are raising funds for the publication which will likely be next year or that autumn.

We have all profited greatly from your work on Korea. Two years ago Mr. Moffett[5] and I had it put in the course of special story for all new comers as the only work that deals with Korea as it really is. I am very much surprised at your being able to collect accurate information as you do at such a distance as Japan is from here. The Koreans are very inaccurate people in matters of dates and places & and if [will?] to [?] to find anything definite right among them much less could I hope was so at a distance. We all use "The Hermit Nation"[6] Mrs. Bishop has just returned mine which she had the loan of when visiting the Russian border last autumn. I am also studying your work in Japan as a help in the study of Korea.

You ask concerning Buddhism and Confucianism. I hope the Reporting will deal [?] with these subjects. Buddhism has for four centuries now been in disgrace in Korea.[7] The natives treat all priests with lowest forms of speech.

---

[2] Kŭmgangsan (金剛山 in Chinese characters).

[3] Wŏnsan, a port city in present-day Kangwŏn-do, North Korea (pronounced "Gensan" or "Genzan" in Japanese; 元山 in Chinese characters).

[4] James Scarth Gale, A Korean-English Dictionary (Yokohama, Shanghai, Hongkong, Singapore: Kelly and Walsh, Limited, 1897).

[5] Samuel Austin Moffett (1864–1939) was an American Presbyterian missionary to Korea from 1890 to 1936. He was the founder of the Pyongyang Chosun Jesus Presbyterian Seminary (est. 1901; later Pyongyang Theological Seminary), where he taught until 1935, and the president of Soongsil Haktang (est. 1897; now Soongsil University) from 1918 to 1928.

[6] William Elliot Griffis, Corea: The Hermit Nation (London: W. H. Allen and Co., 1882).

[7] After the fall of the Koryŏ Dynasty (918–1392), in which Buddhism was a state religion, the Chosŏn Dynasty (1392–1910) implemented anti-Buddhist, pro-Confucian (sungyu ŏkpul) policies.

## 92 LETTERS FROM MISSIONARIES

Table 2

|  | Seoul | Chemulp'o | Pingyang | Fusan | Gensan |
|---|---|---|---|---|---|
| Roman Catholic | 24 | 4 | 1 | 1 | 2 |
| Church of England | 11 | 3 | | | |
| American E. Methodist | 19 ([?]) | 2 | | | 2 |
| American Presbyterian (North) | 19 | | 1 | 4 | 4 |
| American Presbyterian (South) | 9 | | | | |
| Independent | 3 | | | | 3 |
| Australian Presbyterian | | | | 5 | |

Even the abbot of a large monastery is addressed as a coolie. The new regime is attempting reforms in this but I understand that Buddhists are to be admitted to the capital & Buddhism has much power in a secret way in Korea but it is treated with marked contempt by masses not in any hostile way but simply as a pompous elder would treat a small child—the pompous elder is Confucianism which is the vehicle for the handing down of Korean pride or perhaps I should say, conceit from one generation to another. Confucianism is at the other extreme from Buddhism in the minds of all the natives. The Characteristics of each I hope you may see brought out by the Reporting.

There are stories floating about in which these Hollandies figure who were shipwrecked in the south but all indefinite. I have need to find some definite traces of them but as yet have not succeeded. As for traveling in the south there have been many trips taken to Chulla[8] but not much of interest unearthed as yet. In 1890 I visited the principal place in Kyungsang Prov., the old capital of Silla now called Kyungjou was the most interesting.

I will give you a list of the missionaries in Korea.

The gospel is being heard by many in Korea and while there is not a great harvest there is sufficient to prove that the master is guiding us in His war here. The life one has to lead is very quiet and I suppose some would say monotonous but to us it seems full of interest and the people while defective in many ways are a kind-hearted faithful interesting race given too much to smoke and idleness and the writing of verses but then they have many good points.

You ask about the "press" There are [?] [?] [?] we unfair one which I pray Lord and we [?] the

Methodist Mission[9] both terribly overworked with orders unfulfilled.

Pardon this very hurried letter and accept it as an apology for my delay.

[8] Chŏlla-do is a province in southwestern Korea.
[9] The Methodist Mission for Korea (est. 1885), a missionary organization in Korea for the Methodist Episcopal church.

I shall be very glad to write on any articles to [?] that I may be able to find from you in Korea at any time

Very sincerely yours,
**Jas. S. Gale**

Gensan
P.S. Very many thanks for the interest you took in my "[?] family" JSG

**2) Oct. 27, 1900**

**Seoul, Korea**

My dear Dr. Griffis

The Council of the newly organized Korea Branch of the Royal Asiatic Society[10] at a recent meeting [unanimously?] recorded your name on the list of Honorary Members, two other names being Mori as well, W. G. Aston C.M.G[11] and John Ross, D.D. of Mukden.[12] We are a new society and are just making our beginnings. On Wednesday last we had our first public meeting in which I had the honor of reading a paper on the "Influence of China Upon Korea."[13] It is of course not great a subject to be touched on and treated with any degree of thoroughness in one paper but such as it is I shall send you as soon as it is printed.

The President of our Society is

J. H. Gubbins Esq. C.M.G.

H. B. M. Chargé d'Affaires

Vice President, Rev. G. H. Jones, one of the very best students in the country. I may say the very best

Corresponding Sec., J. S. Gale

Recording Sec., Prof. H. B. Hulbert [?]

Treasurer, Rev. J. S. Badcock, a graduate of Oxford, England

Librarian, A. Kenmure Eng. B & F.

Bible Society [?]

The Members on the Council

---

[10] The Korea Branch of the Royal Asiatic Society (or RASKB; est. 1900), under the Royal Asiatic Society of Great Britain and Ireland (est. 1823), was the world's first organization of Korean studies scholars. It was established in Seoul by a seventeen-member council of Christian missionaries (including Gale, Henry G. Appenzeller, Horace G. Underwood, Homer B. Hulbert, and George Heber Jones) and diplomats (including British chargé d'affaires John Harrington Gubbins). RASKB publishes an annual journal (*Transactions*).

[11] William George Aston (1841–1911) was a British consular officer, Unitarian minister, and scholar of Korea and Japan. In 1884, he became provisional consular general to Korea, as well as the first European diplomat to reside in Korea.

[12] John Ross (1842–1915) was a United Presbyterian missionary from Scotland, and the founder of Dongguan Church (est. 1889) in Shenyang, China (formerly Mukden). He completed the first Korean translation of the Bible in 1887.

[13] James Scarth Gale (1900). "The Influence of China Upon Korea." *Transactions* 1 (1): 1–24.

## 94  LETTERS FROM MISSIONARIES

The Hon. H. N. Allen M.P. U.S. minister

The Hon. S. [Weifoeil?] German Consul

J. McLeary Brown L.L.D. C.M.G. Chief of Customs[14]

[Next?] month we are to have a paper from Mr Jones or Mr Hulbert. I am not yet sure as to who will read it; and at New Years we are to hear a paper on the Island of Kang Wha[15] by Rev. M. N. Trollope[16] which I expect will be very good as Mr Trollope is a very good student of things Korean and has been here for ten years and more.

I take this moment to thank you for a very kind and full review of "Korean English Dictionary"[17] in 1897

With kindest regards and a hearty expression of appreciation of all that you have done for Korea from the Council

Very sincerely yours

**Jas. S. Gale**

Cor. Sec.[18] Korea Branch

R.A.S.[19]

### 3) May 7, 1904

**Seoul, Korea**

My dear Dr. Griffis

How good of you in the midst of your many calls to take time to invite me, and a thousand thanks for your kind and appreciative letter. It is dated Mar 24 and it reached me last night May 6. About two weeks ago I wrote Renee sending

---

[14] John Harrington Gubbins CMG HBM (1852–1929) was an interpreter in the British Japan Consular Service and the British chargé d'affaires in Korea. George Heber Jones (1867–1919) was an American Methodist missionary to Korea, co-editor of *The Korean Repository* (1892, 1895–1898), and the first known Protestant missionary to examine Korean religions from a scholarly perspective. Homer Bezaleel Hulbert (1863–1949) was a Methodist missionary, journalist, and educator, special emissary of King Kojong to the United States, co-editor of *The Korean Repository*, and founder of the journal the *Korea Review* (1901–1906). J. S. Badcock (?–?) was a British Anglican missionary to Korea. Alexander Kenmure (1856–1910), a British Anglican missionary and member of the British and Foreign Bible Society (est. 1804), was among the translators who completed the second Korean translation of the *New Testament* (*Sinyak Chyŏnsyŏ* 신약젼셔) in 1900. Horace Newton Allen (1858–1932) was an American physician, first Protestant missionary in Korea, founder of Chejungwŏn (est. 1885; now Severance Hospital), and U.S. envoy extraordinary and minister plenipotentiary to Korea from 1901 to 1905. John McLeary Brown (1842–1926) was assistant Chinese secretary in the British China Consular Service from 1861 to 1872, and chief commissioner of customs in Korea from 1893 to 1905. No information on the German Consul.

[15] Mark Napier Trollope, "Kang-wha," *Transactions* 2, no. 1 (1902): 1–36.

[16] Mark Napier Trollope (1862–1930) was a British Anglican missionary, chaplain to the Bishop of Korea from 1890 to 1902, vicar general from 1896 to 1902, and bishop from 1911 to 1930.

[17] Gale, *Korean-English Dictionary*.

[18] Corresponding Secretary.

[19] Royal Asiatic Society.

a slip along addressed to you and asking him to kindly enclose in a copy of the Vanguard & send to you.

Even though your thoughts and just heart are much in the Far East you cannot know how thoroughly your name has become a household word and familiar to diplomats and to missionaries alike, held in esteem and respected and loved by all.

Your signature at the [top?] of a page gave me a thrill of joy and [?] and I shall put aside your letter among the few [?] I put away to keep as my bookshelves treasures.

Many thanks for your reading of the story and for the marks of appreciation that are evident.

These are great days in the Far East. The little men whom you have had such an interest in these years are "terrors" in a battle-field.[20]

They combine the reckless disregard of life that we see in the Afghan or Mohammedan with the more cool-headedness of the Anglo Saxon.

This morning brings news of another victory at Pong Whang Sung on the way toward Lao Yang.[21]

I imagine with what interest you will watch the East most days.

My kindest regards and many thanks

Very sincerely Yours,

**Jas. S. Gale**

## 4) June 17, 1905[22]

### [Location not identified]

My Dear Dr. Griffis

Thank you so much for the copy of Sunny Memories[23] which I have read and enjoyed. Especially shall I enjoy it as another link of friendships and regard for me so well [known?] & so highly esteemed in the Far East. You must come to the [Gate?] and know how intimately we are advocates with the Mighty-Empire so [recently?] [?] with the world and also with poor old Korea.

I am sending you a few photos with my best regard. Next year I hope to be in America and [?] to enjoy the privilege of meeting you.

The Rev. T. Harada of Kobe[24] had just been in to call us here. He travelled with you in Holland.

---

[20] The Russo-Japanese War was fought in parts of Korea, Japan, China, and the Yellow Sea, from February 8, 1904, to September 5, 1905.

[21] Fenghuang Fortress, in Liaoyang, China. "Ponghwang" is the Korean pronunciation of Fenghuang, and "sung" in Korean means fortress.

[22] Date from the date at the end of the letter.

[23] Harriet Beecher Stowe, *Sunny Memories of Foreign Lands* (London: Routledge, 1854).

[24] Harada Takusu (1863–1940) was the pastor of Kobe Church (est. 1874) from 1885 to 1888 and from 1890 to 1907. He was the president of Doshisha College (est. 1875) from 1907 to 1919, and

96     LETTERS FROM MISSIONARIES

Your name was a bud of friendship between us at once. I greatly enjoyed meeting him.

In [?], but

Very sincerely Yours,
**Jas. S. Gale**

17th June 1905

## 5) Nov. 18, 1909

**Seoul, Korea**

My dear Dr Griffis

Thank you so much for your kind letter and for your appreciative words regarding "Korea in Transition."[25] I prize them most highly for no one has a more extensive knowledge of the East than yourself, and no one has a deeper Christian sympathy for these Oriental people. Yours are the kind words of a master with School of the O'Neil,[26] and I greatly appreciate them. Just now we Christian Missionaries have before us the task of bringing into nearer relation and sympathy those two peoples—Japanese and Korean. Alas for Korea, she lost her best and kindest friend in the assassination of Prince Itō.[27] His kind of purpose must of necessity put place, more or less, to severe measures and great [exclusion?] on the part of the Government. [Before?] good will between Korean and Japanese [do?] see any hope for the part of Mr. O'Neil.

With kindest regard & very many thanks

Sincerely Yours
**Jas. S. Gale**

## 6) Aug. 23, 1910 [Typed letter]

**Seoul, Korea**

My dear Dr. Griffis:—

A day or two ago I read with very great pleasure an article on Roosevelt in the Japan Mail that I recognized was from your pen. Your unfailing interest in

---

he joined the faculty of the University of Hawai'i in 1921, where he started a Japanese Studies Department in 1922.

[25] James Scarth Gale, *Korea in Transition* (New York: Young People's Missionary Movement of the United States and Canada, 1909).

[26] Hugh O'Neill Jr. Academy (Boys' Academy of Syen Chun (Sinsŏng Hakkyo); est. 1906; now Shinsung High School) in Sŏnch'ŏn.

[27] Prince Itō Hirobumi (1841–1909) was the prime minister of Japan for several terms between 1885 and 1901 and the first governor-general of Korea from 1905 until his assassination in 1909 by Korean independence activist An Chung-gŭn (1879–1910).

the Far East is truly an inspiration to those of us who began our studies of this part of the world later.

Mrs Gale[28] sent a short note of thanks to you for your very kind message of good wishes to us. It is one of my great advantages now to have Mrs Gale able to speak Japanese. She came out to Japan in 1880 and has lived there nearly all her life. As she was only four when she came to the East she has no recollection of a time when she did not know Japanese. For her to speak it so well brings not only myself into sympathetic relation with the Japanese but is a help to the whole Mission. She has also a sympathetic knowledge of the Japanese, and this serves so good a part just now. Any antagonistic spirit on the part of the foreigner is unconsciously imparted to the Koreans and does very much harm. Only a kindly spirit and wide sympathy extended can help at such a time as this. It is an intensely interesting world and one in which you could be deeply absorbed in if you were here.

You asked several questions in your letter which I am so [*sic* sure] cannot be answered satisfactorily.

I_Is the Korean Asiatic Society alive? Any papers been read since the last number was issued some years ago? Who is your literary man now?

The Society has been dead for the last few years. It is impossible to get a sufficient number interested in things Korean to make the Society go. Since Hulbert's going it has been harder than ever. I regret more than I can tell you his campaign against the Japanese here. It has done the Koreans no good and has lost them one of their best and most influential friends, as Hulbert certainly was. We miss him as a friend and an inspiration. His views were not only extreme and in many cases overdrawn, but his giving expression to them gave these childlike people a notion that he would deliver them body and soul from the dominance of the Japanese. I speak specially of Hulbert in answer to your question, as he was our literary man and no one has arisen to take his place.

II_Has any map of Seoul on modern scientific principles been published?

Yes, I shall send you one when I return to the city. (Just now my wife and I and our two step-daughters Annie and Jessie Heron[29] are on Puk-han, the North Fortress,[30] some five miles distant and some two thousand feet above Seoul).

III_Which in your view, is the best map of Korea?

There are several published by the Japanese of course in the Chinese character, that give the most correct outline of the country.

---

[28] Gale married Ada Louise Sale (?–?), his second wife, on April 7, 1910.

[29] Sarah Anne Heron Gale (1886–1975) and Jessie Elizabeth Heron Carroll (1888–1978) were the daughters of Gale's first wife, Harriet Elizabeth Gibson (1860–1908), and her first husband, Northern Presbyterian missionary John W. Heron (1856–1890). Sarah Gale was a missionary in Korea from 1907 to 1910.

[30] Pukhan Sansŏng is a fortress on Pukhan Mountain in Seoul and Kyŏnggi-do.

## 98    LETTERS FROM MISSIONARIES

IV_What local publications in Korean, or European languages in 1908 or 1909? On Korean subjects?

There have been none but The Seoul Press,[31] and this has not taken up any special line of research. Outside of political questions and news of the day, there is almost nothing whatever of special note about Korea.

V_Anything scholarly in The Chinese Recorder[32] or other periodicals published in China concerning Korea during 1908–1910?

Nothing that I have seen.

VI_Anything been done in archaeology on Korean soil in 1908 or 1909?

Nothing in English, quite a good deal I understand in Japanese.

VII_Anything published by the French Catholic fathers or missionaries or travellers, 1908–1910?

"Korea in Transition." A book by an English army officer, Austen, I think is the name. Have just seen the book in a passer's hand but did not get its title.

VIII_Is there any photographer in Seoul, Japanese, native or foreign, who has a list of his photographs?

There are none. There are two photographers Iwata and Murakami[33] but they have no lists.

IX_Could you get me some drawings by Korean artists, of historical, or fairy-world, persons, places, events etc. I do not care for modern or everyday matters in this connection.

It is almost impossible to find anything of any interest in this line. I shall keep my eyes open and make further inquiry.

X_Could you collect and send me the original texts, particularly those illustrated, of Korean fairy tales, or folklore if they exist?

They do not exist. Some years ago I made many efforts to get hold of just such samples but failed altogether. Of Korean native script poems I could get no book but at last I found where wooden plates were stored and at last got an impression so I have a small book of that kind.

You ask also if anyone has collected the nursery tales or baby lullaby songs of Korea?

No one. This again is a very difficult field to find anything satisfactory in. There are some tales and songs floating about, but to find them in print is quite impossible or to get a definite list or copy of them is equally impossible.

The ordinary expressions in Korea are "there are none", "it can't be done", "we haven't any", "it is missing", "there are no more", etc., etc. My letter is very much of the type that corresponds to these unsatisfactory phrases.

---

[31] The Seoul Press (1907–1937) was a Japanese daily newspaper published in Seoul. It was published in English and promoted Japanese imperial rule in Korea.

[32] Chinese Recorder and Missionary Journal (1867–1941) was a monthly journal published in Shanghai. It was published in English by Christian missionaries in China.

[33] Murakami Tensin (1867–?) and Iwata Kanae (1867–?) were Japanese commercial photographers based in Korea.

Korea is not a bit like Japan, where they have all the pretty things within reach and written out in picture and character, on wood and metal and paper. She has nothing at all that takes the place of these, everything is tumbledown, lost, gone to ruin, missing, spoiled, out of reach of any satisfactory contact.

When I get back to the city I shall try to find the maps and the other things that are available and send them to you.

We are into a new regime by the arrival of Viscount Terauchi.[34] He has put out of the field already several newspapers that have long caused trouble, and seems determined to make the people mind what the Government tells them. I have not yet met the new Resident General. He had a Garden Party on the 30th of July to which we were invited but the weather being very hot we did not venture down from our mountain retreat, so we have not seen him yet. For some time past we have been expecting annexation, but no proclamation has as yet been issued. We await the future with some anxiety, trusting that our church people will remain loyal to the government and not in any way give cause for suspicion.

I am quite ashamed to make any reference to the date of your letter, or to the time I been in making this very unsatisfactory answer, but I have been in Japan, in Pyeng-yang,[35] everywhere but home so much of the time it has been so long neglected.

Thank you again for your kind letter to my wife and me. We shall not forget it.

With ever kindest regards,

very sincerely yours,

**Jas. S. Gale**

### 7) **June 13, 1921** [Typed Letter]

**Seoul, Korea**

My dear Dr. Griffis,

Your kind letter of April 18th still remains unanswered. Time goes by on such rapid wing that the working hours of the day are gone before we know it. I would so much like to have you visit Korea and view first hand this old country. Your knowledge of the East, and your experience in comparison and drawing conclusions, would make such a visit of great benefit to us all. I have worked over old musty Korean Literature for many a day and yet find myself but the merest beginner.

---

[34] Terauchi Masatake (1852–1919) was the governor-general (or resident general) of Korea from 1910 to 1916, following the assassination of his predecessor, Itō Hirobumi. He was prime minister of Japan from 1916 to 1918 and held the title of count in the Japanese House of Peers.
[35] P'yŏngyang.

100   LETTERS FROM MISSIONARIES

Your letter asks concerning Ethnology. Korea was originally peopled by the Nine Barbarian Tribes[36] that Confucius refers to. There came in a wave of Chinamen, who left their country to escape the building the Great Wall in 220 B.C. These formed the nucleus of the Kingdom of Silla with capital at Kyung-joo.[37] The two companion kingdoms of Paik-je and Kokuryu were peopled by strangers from the Kingdom of Puyu that occupied territory immediately to the north of the Ever White Mountains.[38] They became the ruling races of these two kingdoms that lasted for over 600 years. No great tidal wave of foreigners have swept over the country since the beginning of the Christian Era.[39] The Kitan Tartars about 1000 A.D. came time and again but they finally found that it was more comfortable for them to stay at home.[40] The Mongols sent armies in from 1200 to 1240; the Japanese came in 1592; the Manchus in 1636 but they all grew weary at last and returned home.[41] The Korean people have been a race quite by themselves. About 1220 A.D. China proposed to make Korea a province and govern it by a Mongol Taotai.[42] This was headed off by a very able petition written by a scholar called Yi Che-hyun[43] and Korea was ever after with the exception of a nominal suzerainty left to her own devices.

Korea's revolutions have been of a limited, but very venomous order. They can be all reduced to the measure of family feuds in which some of the noblest and best of the land have perished. While Buddhism held sway they were comparatively few, but from the 16th Century on they were frequent and terrible. One was 1498, one in 1519, one in 1545, one in 1625, and one in 1721, 1722.[44] Every possible means, foul and fair, were adopted by each party

---

[36] In Book 9 of the *Analects* (*Lun Yu*), Confucius states that he wishes to live among the "Nine Barbarian Tribes" (*jiuyi*), a collective concept referring to ethnic groups east of China.

[37] Silla (57 B.C.E.–935 C.E.) was established by the people of Kojosŏn (2333 B.C.E.–108 B.C.E.) who migrated from the north to the south of the Korean Peninsula. Its capital city was Kyŏngju, now a city in Kyŏngsang-bukto, southeast Korea.

[38] Paekche (18 B.C.E.–660 C.E.); Koguryŏ (37 B.C.E.–668 C.E.); Puyŏ (2nd century BCE-494 C.E.); Paektu Mountain, on the Chinese-North Korean border.

[39] Common Era (1 CE–).

[40] Koryŏ (918–1392) fought wars against Khitan in 993, in 1010, and from 1018 to 1019.

[41] The Mongol Empire invaded Koryŏ in 1231 and 1232, from 1235 to 1239, and in 1251, 1254, 1255, and 1257. The Imjin War, a Japanese invasion of Korea, lasted from 1592 to 1598. The Pyŏngja War, or Qing invasion of Korea, lasted from 1636 to 1637.

[42] The Mongol Empire demanded tribute from Koryŏ after assisting a campaign against the Khitan from 1218 to 1219. A *"taotai"* is the civil and military head of a Chinese territorial unit.

[43] Yi Che-hyŏn (1287–1367) was a Koryŏ politician, scholar, and father-in-law of King Kong-min (1330–1374; r. 1351–1374). In 1323, he wrote a petition against, and prevented, Mongol annexation of Koryŏ.

[44] The literati purges of 1498 (Muo Sahwa), 1519 (Kimyo Sahwa), 1545 (Ŭlsa Sahwa), and 1721–1722 (Sinim Sahwa). Literati purges or *"sahwa"* (scholars' calamities) were persecutions of neo-Confucian Sarim scholars by the Hun'gu faction of the central government (1498, 1519, 1545), or the persecution of one Sarim subfaction by another (Soron against Noron in 1721–1722). The incident of 1625 possibly refers to the aftermath of King Injo's coup (1623) and Yi Kwal's rebellion (1624), rather than a literati purge.

against the other. We see the same trait today. They cannot allow another to think differently and at the same time be friends and have a cup of afternoon tea over it. They must be into each other's wool, so to speak with knife, poison, and dagger.

Dress seems to have held to white against warnings of the Fates, counsels of the Fathers, and Government legislation. White is the colour that pertains to the West. Tibet could dress in white and save the face of Chinese philosophy, but Korea should dress in green. The fairies are the only Koreans that dress thus. They are spoken of constantly as dressed in green.[45]

The characteristics of the different eras are marked religiously somewhat. The 9th and 10th Centuries were strongly Buddhist. Some of the most famous monumental stones scattered over the land belong to these periods. Some of them are made of cement harder than the best Portland.[46] 1200 was also a great Buddhist revival period.[47] When the Crusades were busy, and Francis of Assisi lived and Kublai Khan was master of the East great priests came and went.[48]

The 14th Century is the strongest period of Korean letters. They had cast off the too limited control of the Church (Buddhist) and were free to follow China, Choo, Han and Tang.[49] The most prolific period, however, was that of Shakespeare.[50] It seems as though a spirit of the pen had possessed the earth at that time that touched East as well as West. With the 18th Century came the decline of literature.

Korea's civilization is strongly marked by that of old China. What she has today is still Chinese of the Mings, Songs and Tangs.[51] We are now into the dreary waste of a transition period, colourless and void. Students today have a little smattering of the West and have lost their old mastery of the character. They are neither Occidental nor Oriental. It is a very trying period but out of it will evolve something better I hope.

---

[45] The Five Colors Theory, originating from China and known in Korea as *"obangsaek,"* associates the color white with the west and the color blue (or green) with the east. Gale observes that Tibet is in the west and Korea in the east in relation to China. Meanwhile, white was known as a color commonly worn by Koreans, hence the phrase *"paeg'ŭi minjok"* (people of white clothes).

[46] Portland cement is the most commonly used type of cement, and it is used to make construction materials such as concrete, mortar, and grout.

[47] Buddhism was widely promoted during the Koryŏ period: King Taejo (877–943; r. 918–943) designated Buddhism as the state religion; during the Mongol invasions (1231–1257), Buddhism saw an increase in popularity as a religion of patriotism.

[48] The Crusades (1095–1291), Christian European invasions of the Jerusalem area; Francis of Assisi (c. 1181–1226), Italian Catholic mystic and founder of the Franciscan order; Kublai Khan (1215–1294; r. 1260–1294), emperor of the Mongol Empire and Yuan Dynasty.

[49] Zhou (c. 1046 B.C.E.–256 B.C.E.), Han (202 B.C.E.–220 C.E.), and Tang (618–907 C.E.) dynasties. "Choo" is the Korean pronunciation of "Zhou."

[50] William Shakespeare (1564–1616), English playwright and poet.

[51] Ming (1368–1644 C.E.), Song (960–1279 C.E.), and Tang (618–907 C.E.) dynasties

102 LETTERS FROM MISSIONARIES

I had the great pleasure the other day of visiting an old tomb in north Korea.[52] It has walls decorated in colour that have stood the damp and mould of 1500 years and still hold good. They are wonderfully executed symbolic characters of Chinese philosophy: the Green Dragon on the east wall, the White Tiger on the west, the Black Snake and Tortoise to the north, and the Vermilion Bird to the south.[53] It is a wonderful proof of the high skill of the artists in those ancient days.

Pardon this very imperfect letter,

with kindest regards,

very sincerely yours
**James S. Gale**

**8) [Journal Article Clipping]**

---

[52] Possibly the complex of Koguryŏ tombs in P'yŏngan-namdo, which were constructed in the third or fourth centuries CE.

[53] Four guardian deities (*sasin*) associated with four of the color-cardinal direction combinations in the Five Colors Theory: the green dragon (*ch'ŏngnyong*) of the east, white tiger (*paekho*) of the west, black snake and tortoise (*hyŏnmu*) of the north, and vermillion bird (*chujak*) of the south.

## A New Korean Bible.

1925. All Korean work, three Koreans having borne the burden of it: Yi Wun-mo, the author of the composition, style, etc., from Genesis to Revelation; Yoon Chiho, who stood back of the funds necessary, twenty thousand Yen and more, for machines, labor, paper, binding, etc.; and Chung Kyung-tuk, an expert printer who had supervision of that part of the work.

"The actual printing took less than a year. Genesis was done April 28, and the whole December 17, 1925."

Since Dr. Gale was requested to prepare the memorandum, one naturally can gain no idea of the tremendous amount of labor of mind, heart and body he personally gave to this work. Dr. Gale's ability as a Bible translator is well established, having had thirty-three years experience at this work, and God led him in this present task, giving him definite answers, day after day, in the special hour of prayer.

All the work from Genesis to Revelation, with the Chinese characters introduced, was done by Dr. Gale and Yi Wun-mo. Dr. Gale speaks beautifully of his friend and helper, Yi Wun-mo. "I have had many men in my day, but never one his equal. A silent man, whose mind is just as keenly ordered as his deft fingers." As a Korean friend says, "God raised Yi Wun-mo up especially for translating work." His belief in Christ, too, sanctified by the loss of his only son, is just as sweet and clear-cut as the labor of his hands.

Dr. Gale read and O. K.'d all the pages. One million, three hundred thousand syllables there were to be examined, each and every one. Four times in proof reading they have been gone over, making five million focussings of the eye, all done heartily by the Korean helper, and with good spirit. Difficulties there were without number, but some turned into opportunities. For instance, some one got into the printer's office and designedly changed the type of the O. K.'d pages of Genesis till it read nonsense. God, however, overruled this and by a mere chance had it discovered and corrected and made a help to the better ordering of all the rest of the work.

After the translation had been finished and the work copied off, Dr. Gale had to follow the revised version of the English three separate times all the way from Genesis to Revelation to see that there were no slips and nothing missing. Yet in spite of it all, as in all translation and revision work, Dr. Gale has since found some errors.

The extraordinary and delightful side of

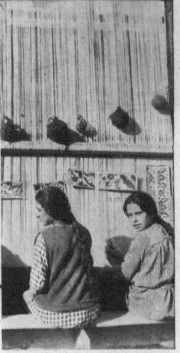

Oriental women have long been noted for their skill in the art of rug-making. By means of such handiwork they not only provided beautiful coverings for their floors and couches, but earned their "extra" money as do women of American rural communities from the sale of butter and eggs. The war and the consequent deportation of Eastern Christians from their ancestral homes largely destroyed this industry. It is now being revived in the Near East Relief orphanages, where during the past year the girl-students turned out 600 Oriental rugs, involving the tying of 300,000,-000 knots.

Figure 18 "A New Korean Bible," *Record of Christian Work*; volume number not identified; probably published in 1926. *Sinyŏk Singuyak Chŏnsŏ* (Seoul: Chosŏn Kidokkyo Ch'angmunsa, 1925), a Korean translation of the Christian Bible, began as a project under the British and Foreign Bible Society, of which Gale was president from 1917 to 1923. Gale resigned and started his own project due to disagreements over translation methods: he prioritized the readability of the translated Korean text, while other members of the society argued for a more literal translation. In 1924, Gale and a team of Korean translators (including Yi Wŏn-mo, Yi Kyo-sŭng, and Yi Ch'ang-jik) finished translating the Old Testament; in 1925, they finished the New Testament. The completed *Sinyŏk Singuyak Chŏnsŏ* was published on December 31, 1925. (Box 59, Folder 23, Griffis Collection)

# 448 Record of Christian Work.

this work has been the financing and printing of it by the Koreans, who have put into it many thousands of Yen without any hope or expectation of getting back their original money. We think that in no other mission field has so marked a contribution been made for the advancement of the knowledge of God's Word. Let us rejoice in every effort to get God's Word to his hungry children!

"For this cause also thank we God without ceasing, because when ye received the word of God which ye heard of us, ye received it not as the word of men, but as it is in truth, the word of God."—"Korea Mission Field."

---

## LIFE STORY OF A HOPI INDIAN.

### Miss Clara J. Flint.

Some twenty-eight or thirty years ago a baby boy was born into a Hopi home in the old village of Walpi, the most historic and ancient of all the Hopi Indian villages. Most Hopi babies are attractive, and this bright-eyed little fellow was without doubt no exception. All went well until a few months later, when the mother died, leaving the father helpless with a three-year old child and this tiny baby. Relatives readily took the older child, but what could be done with an infant, as no one had either a milk cow or a goat in those days?

At last, after going from house to house begging women to nurse his hungry babe, he found a woman who had lost a child, and she gladly took this little one to her heart and home, bringing him up as her own.

Robert was sent away to school at the age of nine or ten, and when a few years later the Indian school at Grand Junction, Colorado, was closed, he was not forced to take further education in some other school. Instead, he chose to remain on the Reservation, not realizing then the white man's methods of learning were best. He took a youth's pleasure in the many ceremonies of his people, and in the rabbit-hunts, races, etc., which made him strong of body and fleet of limb. Thus he grew to manhood, with a man's love of fun, but with no spiritual guide, and no food for the hunger of his soul.

At an early age he found the girl of his choice, and married beautiful Lucile, one of the prettiest young women in either Walpi or the neighboring villages. A Hopi child's uncle has more influence over him than either father or mother, and often in the old days some old uncle was to blame if certain young people made little progress, or if they turned out either good or bad. Robert was blessed with a good uncle, and although he did not encourage him to get an education as did his older brother, yet when he died he made a lasting impression by urging him to be a good man. Whether his uncle said anything about Jesus or the Christian teaching making him good, Robert does not seem to know, but from that time on he wanted to be a Christian. He often listened to the gospel message in testimony and song at the street meetings held in front of their house when in that village. He also learned to sing the Christian songs, and often heard the Bible read or quoted in the homes of two of the Christians who lived near the place where he planted his corn.

Once every year a chachina visits the Hopi villages, who is known as "Mousoua," or the red-headed man. He represents the devil to these people. He is called the red-headed man because he appears wearing a white mask streaked or dipped in blood. This year he was said to look so frightful that even the men were afraid of him, yet the people call him "Our Father," and prayer is actually made in the kievas (underground places of worship) to the devil. In 1924, when a ceremony was in progress in one of the kievas, Robert was asked by the other men to pray to the devil. He felt that it was not right, so instead he prayed to God and asked that he might be shown the right way.

How wonderfully God answers prayer! This summer, when the Indian Bible Conference was in session at Flagstaff, Robert was invited by his brother to accompany him to the conference. Here he was led to accept Jesus Christ, and came home to acknowledge himself a Christian before his opposing relatives and friends. His old foster mother, who had been so kind to him when a child, turned against him, and Lucile his wife at first was against him and treated him badly. However, he was baptized and continued faithful, and two

Figure 19 "A New Korean Bible" (continued) (Box 59, Folder 23, Griffis Collection)

# 14     *Gifford, Daniel Lyman (1895)*

DANIEL LYMAN GIFFORD (1861–1900)

Daniel Lyman Gifford went to Korea as a Presbyterian missionary in 1888 and served as a pastor at Saemoonan Church in Seoul, established by Horace G. Underwood. In 1890, he married Mary E. Hayden, an American Presbyterian missionary who served as the headmistress of the Jŏngdong Girls' School (today's Chungshin Girls' High School). While traveling in the southern part of Korea, he contracted dysentery and died on April 10, 1900.

**1) Mar. 13, 1895**

**Seoul, Korea**
Rev. Wm Elliot Griffis D.D.,
Ithaca N. Y.,

Dear Dr. Griffis,—

Your very kind letter was received a long time since, & be assured that it was not from any lack of appreciation that it was not answered long ere this; but because I desired to read carefully again a large part of your "Corea the Hermit Nation,"[1] before venturing, as you suggested, to render anything like a criticism upon a work, which up [to] the present time has held its own as the standard authority upon Korea. I have only a few things to suggest.

(1.) You write of a few things in a way which you would hardly have done, had you visited the country. For instance, you speak repeatedly of the Han River,[2] near which the city of Seoul is located, as if it were a Mississippi[3] in size & velocity, when in truth it is more like the Mohawk River, say at Utica, N.Y.[4] On P. 220, you mention a moat, 50 feet in width, as encircling the enclosure of the Royal Palace of His Majesty, in Seoul. Such a moat had no present existence. The Curfew Bell you mention (P. 221) is hung, not "in the Castle," but in the center of the business part of the city, perhaps half a mile

---

[1] William Elliot Griffis, *Corea: The Hermit Nation* (London: W. H. Allen and Co., 1882).
[2] The Han River (or Han-kang) is the major river of Seoul and the fourth longest river on the Korean Peninsula. It flows from east to west, from the Taebaek Mountains across Kangwŏn-do, Ch'ungch'ŏng-bukto, Kyŏnggi-do, Seoul, and into the Yellow Sea.
[3] The Mississippi River, which runs from Minnesota to Louisiana.
[4] The Mohawk River, a tributary river of the Hudson River in New York.

106    LETTERS FROM MISSIONARIES

from the Palace Enclosure.[5] "Chemulpo" not "In chiun"[6] is the seaport of
Seoul (P. 191). On P. 183 Ping-an[7] is credited with 293,400 houses, while on
P. 189, Seoul, the Capital, has only 30,723 houses assigned to it. As a matter of
fact Seoul is two or three times larger than Ping-an.

(2.) The illustrations do not adequately depict Korean life, at least as we
on the field know it. See Pages 161, 196, 264, 275, & 355. Also we find it hard to
locate the "City of Seoul," as represented in the Frontispiece.

(3.) It would have been better if in the spelling of the names of certain
persons & places, you could have used the transliteration of the Korean
instead of the Japanese spelling. For example of Japanese spelling, Kin Rin-
shio[8] (P. 213) & Bin Kenko,[9] etc. (P. 429) & the City of Sunto[10] (P. 191). Con-
sidering however the size & scope of the work, the few blemishes which I
have been able to detect with the aid of the microscope, affect very slightly
the solid merit of the book. Indeed we think it remarkable that a person who
had never seen the country, should be able to write a book of such permanent
value upon Korea. It may be a source of some satisfaction to you to know that
the Manual of the Presn Mission (North) requires our new missionaries to
read during their first year upon the field, "Corea the Hermit Nation," as
being the standard work upon Korea. I think, personally, too, that in the
future your book is going to prove of greatest permanent value in the manner
it has put upon record the life & customs of picturesque "old Korea," a coun-
try which in the last twelve mo. has been rapidly passing away—more is the
pity, in some ways! Thank you very much for the Kind way in which you
spoke of my articles in the first volume of the "Korean Repository."[11] I men-
tioned what you wrote of the desirability of resuscitating the defunct "Korean
Repository" to Mr. Appenzeller of the M.E. Mission,[12] & I have no doubt that
it influenced him in starting the Magazine in Col-laboration with Messrs

[5] Posin'gak, a bell pavilion built in 1396, is located in Chongno, Seoul, 1.2 kilometers outside
Kyŏngbokkung Palace. It holds a large metal bell that was struck twice a day (approximately
at 4:00 A.M. and 7:00 P.M.) during the early Chosŏn Dynasty.
[6] Chemulp'o (now Inch'ŏn) was a port on the coast thirty kilometers directly west of Seoul.
[7] P'yŏngyang in northwestern Korea.
[8] Kin Rinshio 김인승 金麟昇, who helped the Japanese during negotiations for the Treaty of
Kanghwa between Korea and Japan: "Through the Russian possessions, the Corean liberal,
Kin Rinshio, made his escape. From this man the Japanese officials learned so much of the
present state of the peninsula, and by his aid those in the War Department at Tokio were
enabled to construct and publish so valuable a map of Corea" (from *Corea: The Hermit Nation*).
[9] Min Kyŏm-ho (1838–1882), a member of the Yŏhŭng Min clan, was an uncle of King Kojong
(1852–1919; r. 1864–1907) and a brother-in-law of Taewŏn'gun (1820–1898). He held various
government positions including minister of penal affairs, minister of rites, minister of civil
services, and director of the Foreign Office. In 1881, he and Japanese military officers founded
the Pyŏlgigun, Korea's first modernized military unit. He was killed during the Imo Sol-
diers' Riot (1882) in protest of the mistreatment of the existing traditional military units.
[10] Songdo (now Kaesŏng), a city in Hwanghae-bukto, central Korea.
[11] *The Korean Repository* (or *Chosŏn Sosik*; 1892, 1895–1898) was an English-language monthly
journal published in Seoul.
[12] Henry Gerhart Appenzeller (1858–1902) of the Methodist Episcopal Mission.

Hullbert & Jones[13] of the same Mission. Mrs. Bird-Bishop[14] has come & gone. We valued her even more for her Earnest Christian character than we did for her fine literary gifts. I have jotted down on a separate sheet of paper a few notes on Medicine as practiced among the nations of Korea, which I believe was one of the points upon which you desired information.

Korea is changing rapidly, radically wonderfully; &, if I mistake not, the Gospel is going to get such a hearing from the people here, as we little dreamed of one year ago. I should be greatly pleased to hear from you again.

Yours Respectfully,
**D. L. Gifford.**

[Notes]

A few notes on Medicine as practised by the nations in Korea.

The Koreans have apothecary shops, doctors, & mid-wives. The nation doctors either prescribe medicine to be bought from the apothecary shops, or furnish the medicines themselves. They know nothing of surgery, except what is worse than nothing, the use of large needles ("chims")[15] to be thrust into the flesh. Their knowledge of medicine is gotten largely from books prepared in China.

In cases of child-birth, no instruments whatever are used. If a doctor is summonsed, he simply prescribes medicine. An elderly woman is called in who acts as a mid-wife, assisting nature by manipulating the patient, sometimes using pressure with the knee. The patient is placed in either a kneeling or sitting posture. Koreans are a kindly people: rather helpful to one another. Sometimes however a poor man living in a room in another man's house, contracts a contagious disease, like the dreaded "impiung"[16] fever. He is then forced out of the house & somewhere along the City wall, or outside the City,[17] a tent of thatch is made for him by his miserable family, & there he lies for better or for worse. We have now a "Shelter"[18] where such unfortunates can be cared for temporarily, medically superintended by Dr. Avison of our Pres'n Mission (North).[19]

**D. L. Gifford**

---

[13] Homer Bezaleel Hulbert (1863–1949); George Heber Jones (1867–1919).

[14] Isabella Lucy Bird (married name Bishop; 1831–1904).

[15] *Ch'im* 침 means needle.

[16] *Imbyŏng* 임병 refers to *Yŏmbyŏng* 염병, typhoid fever.

[17] "City" refers to the area of Seoul enclosed by the city wall and its four gates: Hŭnginjimun (east gate), Tonŭimun (west gate), Sungnyemun (south gate), and Sukchŏngmun (north gate).

[18] This letter was likely written during the 1895 cholera epidemic in Seoul. The Frederick Underwood Shelter (est. 1893), established by physician and missionary Lillias Stirling Horton Underwood (1851–1921), was designated as a cholera hospital during this epidemic.

[19] Oliver R. Avison (1860–1956) of the Northern Presbyterian Mission.

# 15     *Gillett, Philip Loring (1902–1905)*

### PHILIP LORING GILLETT (1874–1938)

Philip Gillett studied theology at Colorado and Yale University and was appointed as the first secretary of the Seoul Association, launching the YMCA (Young Men's Christian Association) in Korea. He established the foundation for the Christian Youth Association and introduced baseball and basketball to Korea. Gillett also tried to inform the world of Japan's "105-Man Incident" and was forcibly expelled by Japanese authorities in June 1913. Until his death, he stayed in Shanghai, China, supporting the Korean Provisional Government's independence movement.

1) **Oct. 23, 1902** [Typed Letter]

**Station Hotel**[1]
Dr. Wm. Elliot Griffis,
Ithaca, N.Y.

My dear Sir:-

I have read your book "Korea the Hermit Nation" and know of your interest in a scientific way in all that concerns Korea its people and customs. I have been in this country just about a year and am attempting to study the Korean language and the character and life of the people. It seems to me that it would be of great advantage to me if I could make my study systematic and to some extent thorough. If I should choose a definite line of study and focus my energies upon that it would be better than a scattering study of many phases.

I wish very much to get an M.A. degree and should hope to make my study serviceable to this end. I have an A.B. degree from Colorado College and have taken a year and a half of post graduate work in Yale, also the course at the Young Men's Christian Ass'n. I desire especially to deal with some phase of life connected with the young men of this nation. Possibly you have some ideas in mind of just such a course as I am meditating. If so and it is not asking too much I should be glad to hear from you on the subject. I shall be glad to

---

[1] In letterhead: The International Committee of Young Men's Christian Associations, 3 West Twenty-ninth Street, New York.

serve you in any way possible in your efforts to advance the interests of Korea by the dissemination of knowledge regarding it.

Sincerely yours,
**Philip L. Gillett**

**2) Feb. 29, 1904** [Typed Letter]

**Seoul, Korea**[2]
Rev. W E GRIFFIS
ITHACA, NY.

My dear Sir:-

Thank you for your letter of Dec. 8th 1903. I am a long time in answering it, yet I thank you heartily for your thought and the time given to answer my questions.

The subject you suggested, "The origin and history of the feudal system in Korea," would hardly do as it is a question if there ever was a feudal system in Korea. The past of Korea is very unlike the past of Japan. You may think otherwise.

I am working on a subject which affords me considerable data and is going right to the heart of Korean social life—Guilds. As you know the country is full of them and they have worked out a system of self government and written constitutions which are exceedingly interesting to study in comparison with the developments of our Western organizations. I should be glad to learn of any books in English which it might be well to study in connection with this subject.

Enrolled please find a view of modern Chemulpo. You will note that these four pictures fit together and make a continuous view. A photographer can so mount them.

We are in the midst of some excitement here but hopeful that the outcome will mean good things to Korea. It is most remarkable what a thorough lesson the Japanese learned during their former experience in Korea. This time they seem to handling the Koreans in such a wise way that they are gaining the good will of the people and at the same time carrying all their points. There seems to be good statesmanship evident in their methods, judging from what we see at close quarters.

Thanking you for past favors,

Very Sincerely,
**Philip L. Gillett**

---

[2] In letterhead: The International Committee of Young Men's Christian Associations, 3 West Twenty-ninth Street, New York.

110    LETTERS FROM MISSIONARIES

**3) June 15, 1905** [Typed Letter]

**Seoul, Korea**[3]
Rev. Wm Elliot Griffis, D.D., L.H.D.
Ithaca, New York.

My dear Mr. Griffis:—

The other morning, when I felt a bit "off color," I took one of the books you sent me so kindly—John Chambers[4] and climbed to the summit of one of the mountains overlooking Seoul and spent a delightful morning in that splendid air on the mountaintop reading the life of this strong man. I wish to thank you most kindly for remembering me in this way. You also sent me SUNNY MEMORIES OF THREE PASTORATES[5] and the addresses in this book have been suggestive to me in a number of instances where I was looking for ideas.

Herewith a few pictures illustrating some recent doings in this part of the world.

Our Y.M.C.A. in Seoul now has over 600 members drawn from the highest and most influential classes and we are hoping to have a fine new building as soon as it can be erected.

Sincerely and Heartily,
**Philip L. Gillett**

---

[3] In letterhead: The International Committee of Young Men's Christian Associations, 3 West Twenty-ninth Street, New York.
[4] William Elliot Griffis, *John Chambers: Servant of Christ and Master of Hearts, and His Ministry in Philadelphia* (Andrus & Church, 1903).
[5] William Elliot Griffis, *Sunny Memories of Three Pastorates, with a Selection of Sermons and Essays* (Andrus & Church, 1903).

# 16     *Gilmore, George William (1893–1919)*

GEORGE WILLIAM GILMORE (1858–1933)

At the behest of King Kojong of Korea, George Gilmore was appointed in 1886 by the United States commissioner of education to teach in the Royal English School (Yukyŏng Kongwŏn 육영공원), with Homer Hulbert and Dalziel Bunker. Gilmore returned to America in 1889 to teach at Bangor Theological Seminary.

1) **Nov. 1, 1893**

**Theological Seminary, Bangor, Me.** [location from letterhead]
The Rev. Wm. E. Griffis, D.D.
Ithaca, N.Y.

My dear Dr. Griffis,

I have been endeavoring for some time to get your address that my thanks might be expressed for your (I fear) too appreciative review of my little book. Allow me now to thank you for the very kind notice which you gave me in the October "Thinker."[1] I can say very little as to sales—In July they had sold nearly half the edition. I should judge that was doing fairly well. No very severe criticisms have been heard—the "National Baptist"[2] raked me a little on style.

It was a great pleasure to learn that you are to lecture here, and on a topic so attractive to others and in which you are so at home. You will have in me— not a critic—but a most interested listener.

Among the many good things I have missed must be reckoned the World's Fair, and with it the Korean Exhibit.[3] A crush of work kept me at home—in fact I have been preparing a little book on the Japanese problem, which I have just completed and sent off for examination. The call to Bangor[4] came so

[1] *The Thinker: A Review of World-wide Christian Thought* (1892–1895?) was a biannual magazine published in London.
[2] *National Baptist Magazine* (1894–1901) was a quarterly magazine published in Washington, DC, by the National Baptist Convention.
[3] The World's Columbian Exposition (May 1–Oct. 30, 1893) was held in Chicago, Illinois, to celebrate the 400-year anniversary of Christopher Columbus's arrival in America. The Korean delegation was organized by Horace Newton Allen (1858–1932), who was then secretary of the U.S. legation in Seoul.
[4] Bangor Theological Seminary (est. 1814).

112    LETTERS FROM MISSIONARIES

suddenly that it left me no time for anything but the hardest kind of work—
This year I'm on the gallop.

Of course you know that Hulbert[5] has returned to Korea under the aus-
pices of the Methodist Mission. I thought he was to publish a book on Folk-
Lore of Korea.[6] Have you heard of it?

Allow me to congratulate you on your present congenial surroundings. I
can appreciate your satisfaction.

In concluding may I beg the pleasure of being remembered to
Mrs. Griffis,[7] whom I think, I had once the honor of meeting. With anticipa-
tion of pleasure in meeting you next Spring, I am

Yours most sincerely,
**Geo. W. Gilmore.**

**2) July 11, 1894**

**700 Park Ave. N.Y.**

My dear Dr. Griffis

Thank you very much for your letter of the 3rd which has just got to hand,
and also for the clipping, which came to hand some days ago. Of course all
discussions on Biblical problems are of interest, especially now that I have to
deal with the criticism of the Bible in the class-room.

It is very gratifying to hear of the success of the English Department in
Bangor, and pleasant to receive your congratulations. Of course much, very
much, of the credit is due to the faithful fellows who took an untried course
under an untried teacher, and worked manfully along under all the unfavor-
able conditions which environed them.

Thank you also for the mention of the article by Pom K Soh[8] (whom I do
not remember). I shall try to obtain the report, and give you what opinion I
can form of it.

It seems to me that my letter this time is one of thanksgiving, for I owe
you still—for your promise of your forthcoming book. I enjoyed greatly your
lectures, as we all did.

I am in town for the summer, putting Bishop Hurst's[9] (!) work through
the press. It is a Bibliotheca Theologica revised into the "Literature of

---

[5] Homer Bezaleel Hulbert (1863–1949).
[6] Homer B. Hulbert, *Omjee the Wizard: Korean Folk Stories* (Springfield, MA: Milton Bradley
Company, 1925).
[7] Katherine Lyra Stanton Griffis (1855–1898).
[8] Probably Sŏ Kwang-bŏm (1859–1897).
[9] John Fletcher Hurst (1834–1903) was appointed bishop of the Methodist Episcopal Church in
1880 and chancellor of American University (est. 1893) in Washington, DC, in 1891. He served
both positions until his death in 1903.

Theology."[10] And a nice time I've had with it for the last three years! Were it not for that, I should be enjoying the pleasant woods of Maine.

You have doubtless seen Hulbert's letter in the Independent[11] on Korea,—Appenzeller[12] had a short letter in the Xn. Advocate[13] to about the same effect.

Mrs. Gilmore desires to be most kindly remembered to you. By the way, you may be interested in knowing that Dr. Behrends is to be the next Bond Lecturer.[14]

Yours most cordially,
**Geo. W. Gilmore.**

## 3) Jan. 20, 1895

**Theological Seminary, Bangor, Me.** [location from letterhead]

My dear Dr. Griffis:

Thank you for your note & the information contained therein. We reciprocate most heartily the good wishes you express.

Of course I shall get your new book and I have no doubt it will not only be widely read but will do good. The narrowness is going out of our lives, and your book will beyond question correct some of the shortsightedness which comes out now & again, e.g., in those who cast objections & obstacles in the way of the Parliament of Religions[15] before it happens &, after the event, are still engaged in belittling the results.

I have published no new work on the subject, and did not know of the Nelson publication.[16] I shall look into it. Thank you ever so much for calling my attention to it. "I don't understand it a bit."

Yes, the Repository[17] is to appear again. I have been so busy I have not written for it—shall do so. You know I got tangled up five years ago in revising

---

[10] John Fletcher Hurst, *Bibliotheca Theologica: A Select and Classified Bibliography of Theology and General Religious Literature* (New York: C. Scribner's, 1883); *Literature of Theology: A Classified Bibliography of Theological and General Religious Literature* (New York: Hunter and Eaton, 1895).

[11] It refers to the journal, the *Independent*, published in New York.

[12] Henry Gerhart Appenzeller (1858–1902).

[13] The *Christian Advocate* (1866–1938) was a weekly magazine of the Methodist Episcopal Church, published in New York, New York.

[14] Adolphus Julius Frederick Behrends (1839–1900) was Bond Lecturer for 1895 at Bangor Theological Seminary. He was a pastor of the Central Congregational Church in Brooklyn, New York.

[15] Parliament of the World's Religions (or Parliament of Religions) is an interfaith conference that began in 1893 in Chicago, Illinois.

[16] George William Gilmore, *Corea of Today* (London: T. Nelson and Sons, 1894).

[17] The *Korean Repository* (Chosŏn Sosik; 1892, 1895–1898) was an English-language monthly journal published in Seoul.

## 114    LETTERS FROM MISSIONARIES

Bp. Hurst's Bibliotheca Theologica.[18] The publication of that is on my hands,—an enormous amount of labor. Consequently I have done no work for myself lately. Nous avons changé tout cela. Next year I shall be free & shall get to work again.

I have run across a number of article [*sic*, read articles] of yours lately—in fact hardly a batch of papers goes thro' my hands but I see your name prefixed or appended to something—& all is enjoyable. Keep it up. We want to hear from men who have something to say.

Your message to Prof. Sewall[19] shall be delivered.

Most cordially yours
**Geo. W. Gilmore.**

The Rev. Wm. Elliot Griffis D.D.
Ithaca, N.Y.

### 4) Feb. 11, 1895

**Theological Seminary, Bangor, Me.** [location from letterhead]

My dear Dr. Griffis

Thank you for remembering me with the tickets for your lecture tonight: I sent them to Brooklyn and hope that your appreciative audience will be increased. I wish I could hear you.

I enclose a few clippings—don't know that they will interest you.

Nelsons published my book[20] without my knowledge, doctored it, and took my name off the title page. That is all I know. Should not have known that if you had not written me.

Work here is going on well—we have 59 names on our roll this year!
With regards

Cordially yours
**Geo. W. Gilmore**

### 5) May 4, 1895

**Theological Seminary, Bangor, Me.** [location from letterhead]

My dear Dr. Griffis:

Yours of a month ago and the "Bulletin" do lie before me. Thanks for both.

---

[18] Hurst, *Bibliotheca Theologica*.
[19] John Smith Sewall (1830–1911) was a sailor, minister, and professor of homiletics at Bangor Theological Seminary.
[20] George William Gilmore, *Corea of Today* (London: T. Nelson and Sons, 1894).

Gilmore, George William (1893–1919)    115

As to Phallicism[21] in Korea, I recall nothing whatever which would indicate its existence there, and my impression is that the social and family economics are decidedly against the hypothesis that that cult ever dwelt in Korea.

I enclose a few more clippings, one of which, in all probability, you have not seen. Glad I can do you this service.

Bunker[22] goes back to Korea, sailing from Frisco[23] (I think) May 27th, or at any rate, about that time. He goes under the Methodist Board.

The year's work has used me up so that I am good for nothing. I go home soon for a rest, tho' I expect to read the proof-sheets of my "Resumé of the Johannean Problem"[24] this summer.

Very cordially yours
**Geo. W. Gilmore**

Rev. Wm. Elliot Griffis, D.D.,
Ithaca, N.Y.

### 6) Jan. 14, 1896

**Theological Seminary, Bangor, Me.** [location from letterhead]

My dear Dr. Griffis:

Let me thank you for the evidence of your remembrance of me in the shape of a copy of the Intelligencer[25] of the 8th instant.[26] There are two or three matters of interest to me which I am glad to see.

Though I have not written you for some time I have been glad at the work—literary and pastoral—which you are doing. Such work is needed and will bear its fruit.

We are getting along well at the Seminary, but we need, badly, $200,000. How I wish we could get it! My own work progresses, and I am quite at home, while what I have tried to accomplish has been well received.

With wishes for a pleasant and profitable issue of your work in the present year, I am

Most cordially yours
**Geo. W. Gilmore.**

---

[21] Worship of the generative principle, as symbolized by the sexual organs.
[22] Dalziel A. Bunker (1853–1932) was a Presbyterian missionary and physician in Korea from 1886 to 1926. He, Hulbert, and George William Gilmore (1858–1933) were dispatched to Korea in 1884 to teach at Yukyŏng Kongwŏn upon King Kojong's request. Bunker resigned from his teaching position in 1894.
[23] San Francisco.
[24] George William Gilmore, *The Johannean Problem: A Resumé for English Readers* (Philadelphia: Presbyterian Board of Publication and Sabbath-School Work, 1895).
[25] Newspaper in Lanhorne, Pennsylvania, founded in 1804.
[26] The eighth of this month.

116    LETTERS FROM MISSIONARIES

**7) Jan. 18, 1896** [Typed Letter]

**Theological Seminary, Bangor, Me.** [location from letterhead]

My dear Dr. Griffis:-

I fear that my reply to yours of the 11th must be brief and unsatisfactory. I am in such a rush that I am almost discourteous to my friends. The especial draft on me is the translation of the whole Zwinglian correspondence[27]—some 1300 pages of closely printed Latin and Swiss German. I have been at it not quite a year and am struggling to get the load off my back this school year. That with my school work makes me as busy a man as I want to meet.

The work here is going on all right. I suppose I may lay aside modesty sufficiently to say that the English course has taken its place and has approved itself so that I am now getting two thirds of the students.

Of course all has not been smooth sailing, and at times, like the monkey and the parrot, "we've had a h—l of a time." Aside from that, scrapping seems to do us all good and we are all in good health.

As to Korea, if you take the Repository, you have as much news as I have. The drift is clearly Russian, and personally I have no doubt that China and Korea both are in the Bear's hug by a secret treaty.[28] The talk about railroads gives the whole case away, in my opinion.

Japan has her hands full and the time has not yet come, as she backed down after the war,[29] to talk out in meeting. I am sending you my clippings on Korea, old & new, gathered from every source. If you can find anything that will help you use it, and after using kindly return the whole to me, unless there are any duplicates, in which case you are welcome to the duplicate. I do not want to part with the clippings or I would give them to you. But you will perhaps find something that will be useful. Sometime I may revisit the Orient and after that may do a little more writing about it. Just now I have another bee in my bonnet.

---

[27] Huldrych Zwingli, *Selected Works of Huldrich Zwingli,* ed. Samuel Macauley Jackson, trans. Lawrence A. McLouth, Henry Preble, and George William Gilmore (Philadelphia: University of Pennsylvania Press, 1901).

[28] The Sino-Russian Secret Treaty or Li-Lobanov Treaty, was signed on June 3, 1896, between Qing general Li Hongzhang (1823–1901) and Russian foreign minister Aleksey Lobanov-Rostovsky (1824–1896). It stipulated a Sino-Russian alliance against Japan, as well as Russian access to Chinese military facilities (such as railways and ports) in case of a Japanese invasion.

[29] The First Sino-Japanese War (1894–1895) was fought between Qing China and Japan over influence in Korea. Initiated by Chinese and Japanese military involvement in the Tonghak Peasant Revolution (1894), the war took place on Korean land and went on for nine months after the revolution itself ended. The war concluded with Japan's victory, China's cession of Taiwan, Penghu, and the Liaodong Peninsula to Japan, Korea's transferral into Japan's sphere of influence, and the signing of the Treaty of Shimonoseki (1895).

Gilmore, George William (1893–1919) 117

I suppose you have seen notices of Hurst's Literature of Theology.[30] I got that off my hands some time ago now I have this Zwingli,[31] the next thing that I hope to do is a text-book on O.Testament[32] Introduction that won't dodge questions. So I have my time laid out.

Of course you enjoy preaching to the students—they make the greatest audience in the world! If I were a preacher that kind of an audience would be my desire.

After you get all through with the clippings, kindly return them, and excuse my sending you such a mess as I suppose they are. But I have not time to sort them and you may want to send them back to me without looking at them. In that case pardon me and give me credit for at least the desire to be of service.

With cordial good wishes,

most sincerely yours
**Geo. W. Gilmore.**

**8) May 8, 1896** [Typed Letter]

**Theological Seminary, Bangor, Me.** [location from letterhead]

My dear Dr. Griffis:-

Thank you very much for the two reviews of my little book which you sent me. They were both from papers that I do not see, and consequently I was very glad to get them.

Things in Bangor are moving along very quietly now. Personally I am well, and am enjoying my work. The students seem very well pleased, and it looks as though I shall have to open some of my courses to the other students.

I find among my papers a notice of your last book but one which I was keeping till I should write to you.

I had a letter from Korea from Bunker a short time since. I thought I could find it and let you read it, but it has disappeared. You may like to read the enclosed letters from Hulbert even if they are very stale.[33] The latest news from the far East is rather disquieting. If Korea throws herself into the arms of Russia, it will be bad for Japan.

I was very glad to hear from you, and hope that as occasion offers you will let me hear from you.

Most cordially yours
**Geo. W. Gilmore.**

---

[30] Zwingli, *Selected Works*.
[31] Hurst, *Literature of Theology*.
[32] Old Testament.
[33] See Hulbert's letters dated April 29, 1894, and June 9, 1895.

# LETTERS FROM MISSIONARIES

**9) Apr. 29, 1919** [Typed Letter]

New York[34]
Rev. W. E. Griffis, D.D.,
240 Waverly Place,
New York City.

Dear Dr. Griffis:

I thank you for your letter and wish I had time to go into the matter of the Japanese treatment of Koreans. It is one of my curious experiences that from the time when I entered Japan the people who knew that we were going to Korea denounced the Koreans and lauded the Japanese. Now I have no bias against the Japanese, but I cannot shut my eyes to the fact that their treatment of Koreans has been in many respects as bad as the treatment of the Belgians by the Germans. I know, too, that their courts in Korea were used under administrative order for the despoiling of Koreans. I can give specific cases.

Furthermore, what I have noted in two letters to newspapers is an abiding fact, that the attempt has been made by the Japanese, and is still being made, to blackguard Christianity and put it under a cloud, and to persecute it so far as they dare. I know they have made charges against Underwood and against others of inciting the Koreans to insurrections,[35] and I know that these men were not guilty. I am hoping that I shall be able to see my way clear to bring the matter into such prominence as will give the Japanese reason to pause in their attribution of these acts to Christian missionaries who have at heart the best interests of the Koreans and realize thoroughly that the Japanese are only too eager to have capital made for them by such actions as they charge against the missionaries.

The fact is that the missionaries don't speak up loud enough to be heard in the courts. If I can I will put some backbone into them, so that they will not be afraid to come out with evidence of the way the Japanese are antagonizing Christianity and Christian Institutions. I think the time for patience has gone by.

With renewed thanks for your letters,

Cordially yours,
**Geo. W. Gilmore.**

---

[34] In letterhead: Publishing House of Funk & Wagnalls Company, 354–360 Fourth Avenue, New York.
[35] Horace Horton Underwood (1890–1951), son of Horace Grant Underwood (1859–1916) and principal of Chosen Christian College (est. 1885; now Yonsei University), wrote articles exposing Japanese atrocities during the March First Independence Movement (1919) against Japanese colonial rule. The U.S. *Congressional Record* published his description of the Cheamni Massacre (Apr. 15, 1919), a mass killing of Christian and Ch'ŏndogyo residents of Cheamni, Suwŏn, by Japanese troops.

Gilmore, George William (1893–1919)    119

10) [Event Flyer]

# Bangor Theological Seminary.

## ANNIVERSARY.

## May 19 and 20, 1896.

### Examinations at the Chapel.

TUESDAY.

9.00 a. m.  Junior Class in Hebrew,                                    PROFESSOR DENIO
10.30 a. m.  Senior Class in Homiletics,                               PROFESSOR SEWALL

3.00 p. m.  Junior Class in Greek Exegesis,                            PROFESSOR ROPES

7.30  "    Inaugural Address of Professor George W. Gilmore, at the Third
            Congregational Church.

WEDNESDAY.

10.00 a. m.  Literary and Business meetings of the Alumni.  Discussions:
            "Changes in Theology which make it imperative that the Church
            widen and deepen her work in human society," REV. D. A.
            EVANS, South Weymouth, Mass.
            "Retarding influence of a corrupt municipal life on the work of the
            church," REV. L. S. BEAN, Portland.

1.15 p. m.                   Alumni Dinner in the Gymnasium.

            Special addresses in memory of the late Professor D. S. Talcott, D. D.,
            by Professor H. L. Chapman, D. D., Rev. G. W. Field, D. D.,
            and Professor L. L. Paine, D. D.

7.30 p. m.  Graduating Exercises of the Senior Class, at Hammond Street
            Church.

### 8.00 p. m. Monday, Annual Meeting of the Trustees.

Senior Reception at the residence of Professor Beckwith, Monday evening, at 8
o'clock. Invitations are extended to the Trustees, Visitors, Alumni and their
wives.

Figure 20  "Bangor Theological Seminary Anniversary, May 19 and 20, 1896" (Box 59,
Folder 26, Griffis Collection)

# 17     *Griffis, William Elliot (1920)*

## WILLIAM ELLIOT GRIFFIS (1843–1928)

Born in 1843 in Philadelphia, Griffis served as a corporal in the Civil War. He attended Rutgers University and graduated in 1869. He was an English and Latin tutor for Taro Kusakabe, who was a Japanese student from Echizen and the first Japanese graduate of Rutgers. He also studied at the New Brunswick Theological Seminary, which at the time was known as the seminary of the Reformed Church in America.

Griffis taught English and science at Tokyo University, and his sister joined him later in Japan to teach at the Tokyo Government Girls' School. Griffis released *The Mikado's Empire* in 1876 and it became a widely accredited source in the English language on Japanese history and culture. He was a member of the Asiatic Society of Japan, the Asiatic Society of Korea, Meirokusha (an intellectual society in Meiji Japan), and the Historical Society of the Imperial University of Tokyo. Griffis was a prolific traveler, having visited numerous countries in Europe as well as Asia. Fascinated by the influence Korea had on Japanese history and culture, Griffis was instrumental in compiling sources and eyewitness accounts of the region into his book *Corea: The Hermit Nation*. Griffis's work did much in helping introduce Korea to much of the English-speaking world. He died in Florida on February 5, 1928.

### 1) Apr. 23, 1920[1]

**Until May 1, 1920, 100 Northern Avenue, New York City**

My dear Dr. Scranton

One who knows of your pioneer work, and long service in Korea, ventures to address you familiarly and ask help. Although it means loss of time, with no prospect of compensation in money, to an unsalaried (since 1903) minister. (I received nothing on two of my 4 missionary biographies), I intend to attempt a [one?]-volume history of Korea, showing, what I believe to be the fact, that, relatively, Korea was, from the 5th to the 15th Century, a highly civilized country, and Japan in civilization, for the first three centuries, after receiving [?]

---

[1] This letter, addressed to Dr. Scranton in Kobe, Japan, was returned to Griffis, as undeliverable.

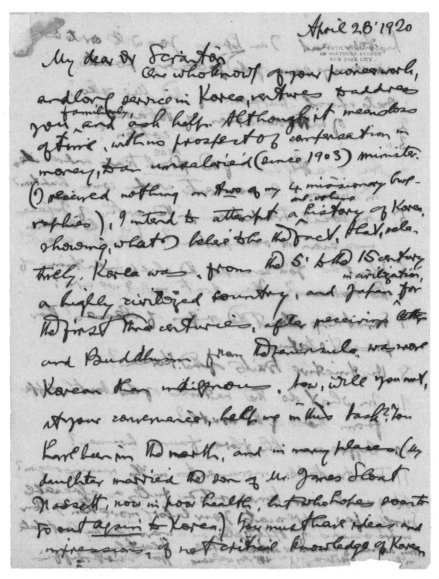

Figure 21 Griffis's letter to Scranton, dated April 23, 1920 (first page) (Box 59, Folder 27, Griffis Collection)

and Buddhism from the peninsula, was more Korean than indigenous. Now will you not, at your convenience, help me in this task? You have been in the north, and in many places. (my daughter married the son of Mr. James Sloat Fassett, now in poor health, but who hopes soon to go out again to Korea.) You must have ideas and impressions, if not critical knowledge of Korean history and I am hoping you will write me concerning some of the following points.

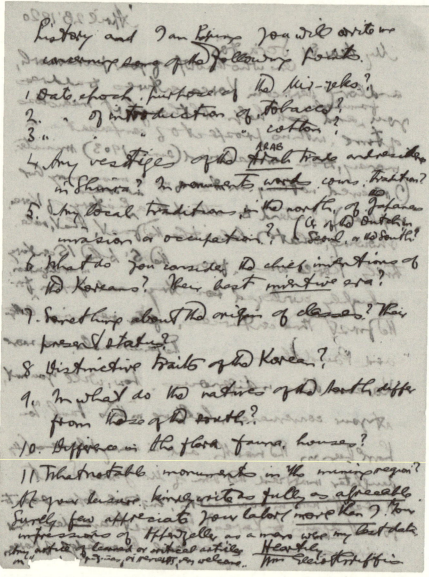

Figure 22  Griffis's letter to Scranton, dated April 23, 1920 (second page) (Box 59, Folder 27, Griffis Collection)

1. Date, epoch, purpose of the Mid-[yeks?]?
2. Date of introduction of tobacco?
3. Date of introduction of cotton?
4. Any vestiges of the Arab (ARAB) trade and residence in Shinto? In monuments, words, coms, tradition?
5. Any local traditions in the north of Japanese invasion or occupation? (As of the Dutch in Seoul, or the South?)

6. What do you consider the chief inventions of the Koreans? Their best inventive era?
7. Friendship about the origin of classes? Their present status.
8. Distinctive traits of the Korean?
9. In what do the natives of the North differ from those of the south?
10. Difference in the flora, fauna, houses?
11. What notable monuments in the mining region?

At your leisure, kindly write as fully as agreeable. Surely few appreciate your labor more than I. Your impressions of Appenzeller as a man were my last data. Any article of learned or critical articles in Korean literature, or [reviews?], very welcome.

Heartily,
**Wm Elliott Griffis**

# 18    *Hall, Rosetta Sherwood (1916)*

## ROSETTA SHERWOOD HALL (1865–1951)

After graduating from college, Rosetta Sherwood Hall worked as a local school-teacher in Liberty, New York. She decided to pursue a life in medicine and enrolled in the Women's Medical College of Pennsylvania in 1886. While working at a mission dispensary in New York City, Sherwood met her future husband, Dr. William James Hall, who was listed to leave on a mission to China. Sherwood joined the Women's Methodist Episcopal Church in 1890. In Korea Sherwood helped found many organizations, including the Baldwin Dispensary, which later became the Lilian Harris Memorial Hospital. In 1894 Sherwood began to teach people who are blind, beginning with teaching a blind girl her own modified version of braille. In 1909 she founded a school for the people who are deaf. A few years later she established the Women's Medical Training Institute with hopes of turning it into a women's medical school. After Sherwood's retirement, the institute was turned into a women's medical school in 1938. In 1933 Sherwood returned to the United States.

1) **Apr. 25, 1916** [Postcard]

**Pyng Yang, Korea**
Wm. Elliot Griffis, D.D.,
Ithaca, N. Y.
U.S.A

My dear Dr. Griffis,

Your request for pictures strikes us of a time when we have very few on hand and it is very expensive to get any. Here send you a few: any that you don't use please send later to my son, Sherwood Hall, at Mt. Union College, Alliance, Ohio.

I really appreciate your work of trying to move [*sic* have] Occidentals & Orientals understand each other better, since I have save a little along that line. The Lord bless you in this work: it truly spells Peace. Wish you might visit Korea in near future.

I had the pleasure of meeting you at a diamond Jubilee meeting in N.Y. City when I was last upon furlough—but I don't expect you remember me. Dr. Smith of China was also on platform that night.

I wonder if you knew my cousin Dr. [Sulman Peck?] of Ithaca.

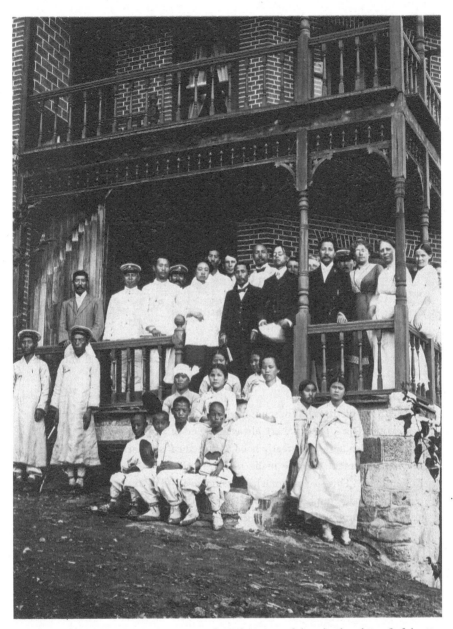

Figure 23 First Annual Convention on the Education of the Blind and Deaf of the Far East at P'yŏngyang,, Korea, held August 11 to 14, 1914. "Wishing Rev. and Mrs. D' Camp and family a blessed Xmastide! 1st Convention of the Far East Educators of Blind and Deaf 'The Sherwood Hall' at the time of the B.& D. Convention in Pyong Yang, Summer of 1914. In the foreground some of our B.& D. students who didn't go home during the summer vacation and a couple of blind students from the gov't school at Soul (Seoul) On the porch, Ms. Reiner of Daiku, Mrs. Sites of Forchow, Miss Carter and Mrs. Lan of the Girls' School for the Deaf Chefoo?, Vice counsel Chang of Chinnampo, Ms. Nakamura our blind chairman, recently from Youdan?, Rev. Billings, Rev. Shirvla and others" (from the back of the photo). Rosetta Sherwood Hall (with glasses) is in a white dress standing second from the right in the photo. (KP 8.2.15, Griffis Collection)

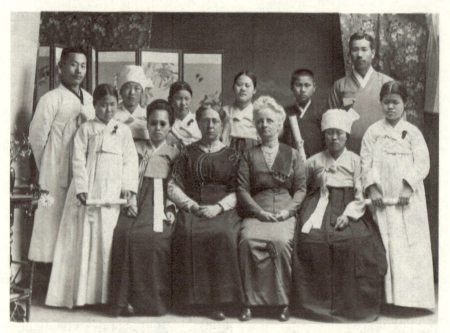

Figure 24 Rosetta Sherwood Hall (with glasses, sitting in the middle), Miss Denman, Korean teachers and the graduates of Pyongyang School for the Deaf and Blind for 1915 (KP 9.1.1, Griffis Collection)

With the pictures [I] am sending you considerable printed matter which I wish you might [?] use: we are always in need of $25, scholarships for Blind and Deaf; also, now we greatly need $50, medical scholarships for [Paking?] until arrangements can be made to qualify Korean women physicians in Korea again. This is very much pressing need—I'm suffering much from overwork, and begin to fear I'll die before I have any Korean successor, hard as I've tried for years—too little encouragement from other sources.

Sincerely,
**R. S. Hall.**

Figure 25 Rosetta Sherwood Hall's postcard to Griffis, dated April 25, 1926 (front) (Box 59, Folder 34, Griffis Collection)

Figure 26 Rosetta Sherwood Hall's postcard to Griffis, dated April 25, 1926 (back) (Box 59, Folder 34, Griffis Collection)

# 19     *Hulbert, Homer B. (1892–1917)*

## HOMER B. HULBERT (1863–1949)

After graduating from Dartmouth College, Homer B. Hulbert attended Union Theological Seminary, wherein he had the opportunity to visit Korea in 1886 with two other instructors, Dalziel A. Bunker and George William Gilmore. They went to teach English at the Royal English School (Yukyŏng Kongwŏn 육영공원), established by King Kojong. As an academic and journalist, Hulbert, along with independence activist Sŏ Chae-p'il and academic Chu Si-gyŏng, founded *The Independent* (*Tongnip Sinmun* 독립신문), the first Han'gŭl -only newspaper, in 1896. In 1889 Hulbert published the first Han'gŭl textbook, the *Samin P'ilchi* 사민필지, and as an advocate of the Korean alphabet published numerous essays about the excellence of Han'gŭl. In 1901 he established the magazine the *Korean Review*.

Although Hulbert initially viewed Japanese involvement in the peninsula as a positive force, he quickly changed his mind. He returned to the United States in 1905 as an emissary of King Kojong, to draw attention to Japanese oppression. He was secretly sent as part of a delegation to the Second International Peace Conference held in the Hague in 1907 but failed to secure an audience with the other nations. The Japanese Empire used this mission as an excuse for the forced abdication of King Kojong. Hulbert's criticism of Japanese colonial rule in *The Passing of Korea* (1906) caused his expulsion from Korea on May 8, 1907. Hulbert died in Seoul in 1949 during his visit to liberated Korea.

**1) May 10, 1892**

**411 7th Ave New York**
**Dr. W.E. Griffis**

Dear Sir

Your kind letter in reference to my work on the Korean folklore lies before me forwarded from Korea. I left that country in December returning by way of India and Europe. I only reached this City day before yesterday which explains the delay in answering your letter. I severed my connection with the Korean government because I saw plainly that under the present regime they desired nothing more than a school for interpreters. I had an engagement with them until '94, but at my request I was released.[1] As regards the matter

---

[1] Hulbert taught at Yukyŏng Kongwŏn (est. 1886) from 1886 until he resigned in 1891.

## 130  LETTERS FROM MISSIONARIES

that I printed in the "Mail"[2] I have all along had the intention of preparing it finally for publication in book form and what you kindly say confirms me in that determination. The "Mail" has not nearly finished the material of mine that they have on hand but as soon as they do, I shall begin to get the ms together and go over it again carefully eliminating a good deal and making numberless corrections. The form of the book as I had planned it is as follows. List a preface explaining the purpose of the work emphasizing the important position that Legends & folklore occupy among historical sources; not of course as being authentic history but as being corroborative testimony. Then will come a historical introduction in which I shall give a concise resume of Korean history from the earliest times. This I am prepared to do as I have looked into and translated a number of the best native Korean histories; among others the Tong Kuk Tong Gam[3] the one you mention in your list of works on Korea in "the Hermit Kingdom."[4] This historical introduction will be of value as giving the setting of the legends and tales. They would otherwise be, many of them, nearly unintelligible. Then will come the Legends and stories, after them will come a list of Korean proverbs and saws which compared with the Chinese will be found exceptionally pithy and readable. They are in the hands of the Editor of the "Mail" and will appear there first. They are accompanied with a running commentary which is often necessary to bring out the precise application. At the end I had thought of devoting one chapter to a general summing up of the subject bringing out clearly the peculiar characteristics of Korean Mythology etc and so massing them that one can use the work for a scientific comparison of the Korean Mythology with that of other peoples. You see I want to make it more than merely a popular readable book. I want it to mark a step in the working out the very mixed problem of the origin, and racial affinities of the Korean people. The whole would make an octavo volume of between two hundred fifty and three hundred pages. I have often thought of communicating with you in regard to it but I hesitated fearing to impose on your good nature. I would like to get your opinion of my plan and any strictures you may make will be most humbly received. I will spare no pains to make the book a success.

The general literary style of the stories as they appear in the "Mail" is very poor. They were thrown together hurriedly and must be entirely remodeled. I realize that the rhetoric is often execrable. These things you may

---

[2] After visiting P'yŏngyang with Presbyterian missionary Samuel Austin Moffett (1864–1939) in August 1890, Hulbert published his travelog "Korea As Seen From The Saddle" in *The Japan Weekly Mail*, in ten installments from June to October 1891. See Kim Tong-jin, *Hŏlbŏt'ŭ ŭi Kkum, Chosŏn ŭn P'iŏnarii! [Homer B. Hulbert: Joseon Must Bloom!]* (Seoul: Ch'am Choŭn Ch'in'gu, 2019), 68–69.

[3] *Tongguk T'onggam* (1485) is a history of Korea written by Chosŏn-Dynasty scholar Sŏ Kŏ-jŏng (1420–1488) and published by royal commission. It consists of fifty-six books in twenty-eight volumes.

[4] William Elliot Griffis, *Corea: The Hermit Nation* (London: W. H. Allen and Co., 1882)

depend upon will be rectified. I am going to work immediately to rewrite most of them entire.

Would you advise me to append many footnotes referring to the customs habits and history of the Koreans or would you make it an appendix for that purpose. Personally I prefer the footnotes.

Do you think it would be desirable to have illustrations for if so I can get up some. I sketch enough myself to give an artist who prepares pictures a fair idea of what would be wanted and I have some photographs that might come into requisition. As to a publisher, I had thought of applying to Houghton Mifflin & Co of Boston or to Scribner & Co of New York.[5] I thank you very heartily for the interest you have expressed in my work and I trust I shall not disappoint you. It is not improbable that I shall be in Boston shortly and I shall give myself the pleasure of calling upon you. Your aid, so kindly offered, cannot but be a great aid to me. I hope in a day or two to send you a geography of the world in Korean[6] which I published just before leaving Korea. I wrote it in the native character rather than the more scholarly Chinese because I wanted to help along the good work of popularizing the native character and weaning the people from their absurd prejudice in favor of the Chinese. This decision on my part insured the financial failure of the scheme but money has been well lost.

Pardon such a long letter but I could hardly have made it shorter & given you any idea of my plan.

Yours very sincerely
**H B Hulbert**

**2) Sept. 26, 1892** [Typed Letter]

**Zanesville, Ohio**
Dr. Wm. E. Griffis:

Dear Sir; -

There are one or two things that I want to get Your opinion on as regards Korea. I know that you are interested in whatever pertains to the advancement of Christian civilization both in that country and in Japan. It is true that those two races differ widely in many points but it is equally true that a Christian education is as necessary to one as to the other. During my six years of work in Korea I took pains to study the conditions underlying the intellectual life of that people and to examine just how far our ideas of education could be carried out there with beneficial results.

---

[5] Houghton Mifflin & Co. (est. 1832; now Houghton Mifflin Harcourt) and Scribner & Co. (est. 1846; now Charles Scribner's Sons) are American publishers.
[6] *Samin P'ilchi* was published in the Korean alphabet in 1889, and it was translated into Classical Chinese in 1895. In 1906 the English version was published as *Hulbert's Education Series. No II: Geographical Gazetteer of the World.*

132    LETTERS FROM MISSIONARIES

I arrived at one or two definite conclusions. The first was that we can never expect Korea and Koreans to carry on any extended system of education on the English basis as has been so largely done in Japan.

There is no likelihood of any overwhelming tide of liberal sentiment such as that which swept over Japan. Everything will go on more slowly, more conservatively and, it is to be hoped, with less reaction than has been felt in Japan. Of course I do not mean that there will be for many a decade any such progress as has been seen in Japan whether slow or fast but I do look for more rapid progress than China will enjoy. The work to be done in Korea is first and foremost to set in motion some sort of sentiment which shall point in the direction of popularising the true Korean alphabet as distinguished from the Chinese. That work has already been begun. Before I came away I saw a change begun in this particular. Koreans have told me that within two decades the Chinese character will be discarded in that country. That was a very sanguine estimate and yet I am sure it will come sooner or later. The reason of this is two-fold. In the first place the idea of literary culture can never be eliminated from the Korean mind. Nor would anyone desire to have it so eliminated for it is the one bright spot in the darkness of their lives. The second reason is that the Koreans are coming to see and will come more and more to see that they have not the leisure to prosecute the study of the Chinese character as they have always done. The increasing competition with outside peoples will drive them to some expedient whereby they can retain their literary standing and yet do it at a less expenditure of time and money. This will gradually drive them to their own alphabet and the question then arises; how can they be provided with the requisite material printed in their own character to satisfy their literary tastes.

The answer is found only in the willingness of those who are able to put into good idiomatic Korean various works in science, history, ethics and the like. Now there is a splendid opportunity just at this point to do a very influential piece of work. Efforts should be made to turn the current of the literary life of Korea into new channels. As I have said, the change from the Chinese to the Korean character is bound to come, and the direction it takes will be determined by the kind of works the Koreans find in their native character to betake themselves to. If they find none they will simply transpose the sterile literature of China into their own character and plod along as before but if they find, it may be, only a nucleus of a literature already at hand it will tend to give an impulse in a new and better direction. It was for this reason that I put my work on geography & c.[7] in the native character because while my so doing made it sure that the money invested would never come back it also made it sure that whatever influence the work did have would be in the right direction.

---

[7] Et cetera.

Not only so but this transition time that is opening before Korea is just the time when a thoroughly capable Christian college ought to be founded there on a firm basis. It would give just that much outlet to the literary aspirations of young men and it would be of course in direct line with the reform. It ought to be a practical college fitting men for professional or literary life. Of course the aim must be to bring as much Christian influence as possible to bear upon the students and to so direct their studies that Christian manhood shall always be held up before them as the model. There ought to be in connection with it a printing press from which shall go out a good strong Christian (although not exclusively theological or homiletical) literature. I have the best reasons for believing that such a school would commence its career with an attendance of nearly a hundred men.

You may ask whether the government school does not cover this ground and my answer is that the government school is composed of about twenty eight young men whom the government is training for interpreters.

The nature of that school has changed entirely during the last two years. The main idea is a utilitarian one, that of making interpreters.

That is one of the reasons that made me give up my work in it. The officials who had control of it had narrowed its power for good to that point where it became not worth my time engaging in it. At no time were we able to bring it anywhere near up to the standard that it ought easily to have maintained. We had no help from our government's representatives there. In fact we were more hindered than helped by them. When I came back to this country last May I went to Washington with the fixed determination to lay the facts before the secretary of state through whom I was sent out there but when I reached Washington I was dissuaded from so doing by Gen. Eaton[8] a friend of my father's. I am no less interested in education in that country, however. I feel sure that there ought to be founded in that city of Seoul a Christian college independent of the government and carried on in some such way as is Beyrout college or Roberts college of Constantinople.[9] The Presbytarian missionaries there are too short-handed to think of doing anything in that line. The Methodists who had a fairly good school there have practically abandoned it for various reasons mainly the lack of men. This is a matter that I have been thinking over for the greater part of a year and I am convinced that such a work ought to be begun there. I have estimated that the land and building that are needed would cost in the vicinity of forty-five thousand dollars. The endowment would need to be in the neighborhood of a

---

[8] John Eaton Jr. (1829–1906) was a Union Army colonel in the American Civil War (1861–1865) and U.S. commissioner of education from 1870 to 1886.
[9] The American University of Beirut (est. 1866) in Beirut (formerly Beyrout), Lebanon; The American Robert College of Istanbul (est. 1863) in Istanbul (formerly Constantinople), Turkey

## 134 LETTERS FROM MISSIONARIES

hundred thousand or more if possible. Three men ought to be sent to take charge of it and they ought to be carefully selected men.

I have hesitated a long time about broaching the subject for fear that some one might suspect that it was a case of special pleading on my part for an opportunity to go back to Korea in congenial work. I do not by any means deny that it would be congenial to me but I should work as hard in favor of the plan if I knew that I were to have no active part in carrying it out on the field. I want your candid opinion in regard to the whole matter. Do you know of any ways by which I could get the matter well before the public, especially before those who would be likliest [*sic* read likeliest] to give substantial aid toward its successful prosecution? Would there be any use in speaking about it to any Congregationalist seeing that the Presbyterian board has occupied the ground? I understand that the American Board[10] decided not to do missionary work in Korea. The question arises whether this would be considered encroachment being as it is a different line of work from that which the Presbyterians are carrying on there. I suppose the Christian men educated in the school would be likely to work with the Presbyterians in mission work and so I can see some reason why the Congregationalists might hesitate to give money for this purpose. But the Congregational church has done such splendid work in this line both in eastern Asia and in western Asia as well that I should like to have them start this school. Besides I am a Congregationalist myself and my sympathies are with them.

If there is a man of wealth who wants to put some of his money into a large benevolence this is a splendid opportunity. A nation of fifteen millions of people. A nation just starting out in the course of international life and growth. A nation that stands in the most important strategic position of any in Asia, with China on one side Japan on another and Russia on the third. It is almost if not quite the last great integral nation where there is an opportunity for a great leading school to be founded. Turkey, Syria, India, Siam,[11] China, Japan all have theirs. Korea has one and a half as many people as Turkey in Europe, almost twice as many as Persia and more than twice as many as Syria. Some one ought to be found who would be proud to give the whole sum that is necessary or twice the sum if need be. In presenting the matter of a college in Korea it would not be a favor that I was asking but an opportunity that I was offering. I should be glad to hear from you in regard to the matter.

Yours very sincerely,
**H. B. Hulbert**

---

[10] American Board of Commissioners for Foreign Missions (est. 1810)
[11] Siam was an archaic name for Thailand.

Hulbert, Homer B. (1892–1917)    135

### 3) Nov. 16, 1892 [Typed Letter]

**Zanesville, Ohio**
Rev W. E. Griffis D. D.

Dear Dr. Griffis:-

Your note today reminds me of what I had intended to a long time ago. I did not know that there was any need of haste in the matter or I would have attended to it at once.

My Korean notes were all put away and I was intending to look up the matter at the first opportunity but I hardly have a minute for my own private work so you must pardon my delay. I have been looking over my papers to find the names of certain men and I find only two that could be called great literary lights in Korea unless you include Ki Ja[12] (Ki Tz of the Chinese) who colonized Korea 1122 B.C. and introduced the literature of China. The two men to whom I refer are Say Jong[13] and Choe Chi Won.[14] The former was the fourth king of the present dynasty in Korea. Among his most important acts are the following not all in regard to literature but they will show you something of the man. He made the first copper type.[15]

He ordered the men who wrote his prayers for him not to write petitions for him but for his people.

He ordered the burning of all the books of superstitions and witchcraft.

He corrected with his own hand the Cha Chi Tong Gam[16] and published it in proper form for the instruction of the young.

He superintended the making of an alphabet and published the Hoon Min Chong Eum[17] in which the principles of the new alphabet were set forth.

---

[12] King Kija (pronounced "Jizi" in Chinese;?–?) was the founder of Kija Chosŏn (c. 1100 B.C.E.–195 B.C.E.), a kingdom speculated to have been founded during the late Kojosŏn (2333 B.C.E.–108 B.C.E.) Dynasty.

[13] King Sejong (1397–1450; r. 1418–1450), or King Sejong the Great (Sejong Taewang), was the fourth king of the Chosŏn Dynasty and a great supporter of Neo-Confucian, literary, and scientific scholarship. He invented the Korean phonetic writing system Hunmin Chŏngŭm, which was officially announced in 1446, was renamed Han'gŭl in 1908, and is today the official writing system of Korea.

[14] Ch'oe Ch'i-wŏn (857–?) was a politician, scholar, and poet of the Unified Silla Dynasty. He passed the imperial examination in Tang China before entering the Silla court as a reformist politician.

[15] The first copper type of Chosŏn (referred to as Kyemija) was developed not under King Sejong but under his predecessor, King T'aejong (1367–1422; r. 1400–1418), in 1403. King Sejong directed the development of later copper types such as Kyŏngjaja (1420) and Kabinja (1434).

[16] Zizhi Tongjian (in Korean, Chach'i T'onggam; 1084) is a history of China written by Song-Dynasty historian and politician Sima Guang (1019–1086) from 1065 to 1084 upon royal commission.

[17] Hunmin Chŏngŭm (1446) is a document explaining the purpose and structure of the Korean phonetic writing system of the same name. It was commissioned by King Sejong, inventor of the writing system, and written by eight scholars (Chŏng In-ji, Sin Suk-chu, Sŏng Sam-mun,

# 136    LETTERS FROM MISSIONARIES

The other man, Choe Chi Won, was a much greater man from a literary standpoint but he did not have nearly as good opportunities for benefiting the people as the other. He lived more than six hundred years earlier than Say Jong. At twelve years of age he went to China and prosecuted his studies and finished by taking the very highest honors in the civil examinations there. He then set out to see the world. He travelled through China, Thibet, Persia and is said to have even visited Arabia. When he returned to his native land he was immediately raised to the highest rank and the whole conduct of the educational department of the government was put into his hands. But his superior wisdom and refinement were so obnoxious to his envious fellow courtiers that he was finally compelled to leave the court and betake himself to the mountains where he lived a hermit life and spent his time writing histories. This is the man to whom educated Koreans look up as being their greatest scholar and literary genius. If you want two names these two, Say Jong and Choe Chi Won, are doubtless the ones to use. If you want only one the question is whether you want the one who did the most practical good or the one whom the Koreans consider the greater. For my part I should prefer to see the name of Choe Chi Won. The oe in the first part of the word is a diphthong and is difficult to pronounce but I could transliterate the sound in any other way. Very much thanks to you for suggesting my name to Mrs Basset of Chicago as a candidate for membership in the Folk Lore Society.[18] I am preparing a paper for them now as I get time.

Yours very truly,

**H. B. Hulbert**

P. S. Of course the Royal title Tai Wang[19] is put after the kings name So it is always written Say Jong Tai Wang.[20] It might be better to say, Sei instead of Say although the word is exactly our Say.

**H. B. Hulbert**

## 4) **Dec. 13, 1892** [Typed Letter]

**Zanesville, Ohio**

My Dear Dr. Griffs; -

I trust you received the letter giving the names of the celebrated Koreans and I hope too that you succeeded in getting one or more of them put on the building of which you wrote me.

---

Ch'oe Hang, Pak P'aeng-nyŏn, Kang Hŭi-an, Yi Kae, Yi Sŏl-lo) of Chiphyŏnjŏn, a royal research institute founded in 1420.

[18] Fletcher S. Bassett (1847–1893) was the founder and secretary of the Chicago Folk-Lore Society (est. 1891), and his wife, Mrs. Bassett, was its director.

[19] Taewang 대왕 means "great king."

[20] Sejong Taewang 세종대왕 is a title for King Sejong with an epithet meaning "great king."

I have prepared for the press all the MS. of my Korean legends that I have here and I am waiting to hear from the editor of the Japan Mail who has in his hands the rest, about one third in all. I have written him twice about it and asked him to send me either the copies of the Mail which contain the stories printed or else to kindly return me the MS. I do not know why he does not reply. I have every reason to believe the matter was all printed but I have not seen copies of the Mail since coming to this country and so am not sure.

I wonder if you take the Mail and if you keep the copies of it on file. If you do, would you be kind enough to turn to the issues of Nov. and Dec. and one or two following months of 1891 and see whether they contain any of my stories. I had a letter from the editor about that time saying that the news about the earthquake had crowded out all other matter for a short time but I inferred that he intended to continue as soon as that matter blew ever. You might find it more readily by referring to the index which they send once in six months or so, if you happen to have a copy of it. Would it be too much to ask you to let me take such issues as you have of the Mail subsequent to Nov. 7 1891 which contain any of my stories? I would take the best of care of them and return them with scrupulous care. I did not keep a copy of the MS. as I sent it to the Mail and now I find that unless I can get hold of those old copies I shall have to do the work entirely over. It would make me a great saving of time and labor.

I have been very kindly invited to read a paper before the congress of the Folk Lore society in Chicago next summer and have accepted the invitation. I do not forget that it is through your kindness that I enjoy these opportunities. I trust that I shall meet you at that time without fail.

Yours very cordially,
**H. B. Hulbert**

## 5) Dec. 19, 1892 [Typed Letter]

### Zanesville, Ohio

My Dear Dr Griffis:-

Your kind letter came today and I was deeply chagrined to learn that I was not in time with those names. It was al [*sic* read all] my fault and I am ashamed of myself for being so thoughtless.

In regard to the matter that you so kindly offer to look up for me in the mail I will say. If you find anything there of mine I should be deeply grateful if you would have it copied by a type-writer and sent to me. Can you have it done without great inconvenience to yourself? If you cannot, let it go and I will wait till I hear from Japan.

Let me know what the expense will be and I will send the money immediately.

# 138    LETTERS FROM MISSIONARIES

I trust that in leaving Boston you will be called to a position of still greater usefulness.

Your most sincerely,

**H. B. Hulbert**

When the sermon comes, I shall read it with great interest.

**H**

## 6) Dec. 11, 1893

### Seoul, Korea

My Dear Dr Griffis

Your pleasant letter came yesterday & I hasten to answer. In the first place I must thank you for your kind wishes which I appreciate.

I find some considerable changes here when I compare the present condition of things with that which prevailed when I left two years ago. The inevitable competition between the Koreans & their more energetic and business-like neighbors has worked out some rather sad results for the Korean. It is becoming daily more evident that the Korean must wake up and go to work. They must soon learn the lesson that large business on small margins is better than small business on immense margins. A Korean seems to think that any profit less than a one-hundred percent is not worth looking at. There is a growing discontent among all classes. One reason why the Koreans are not able to compete with the Chinaman and Jap is because the latter are exempt from all government taxation which seems to me to be quite unjust. Why should foreign merchants in Seoul not pay taxes as the Korean merchants do? This government is slowly learning in the hard school of experience that her neighbors, for all their expressions of friendliness are perfectly willing to tread the Korean nation under the feet if by so doing they can make elbow room for some of their superfluous millions.

I have as yet been able to do no independent work of any kind nor have I had time to write anything. The work of getting this press into running order has been a most arduous one but I begin to see my way out now and I shall soon get to work again.

Your suggestion as to a work on Things Korean strikes me as being a very valuable one and it will receive my early attention.

As to the Korean Repository[21] I intend to give some attention to it soon but it will be in the form of a quarterly probably. The last incumbent put the bulk of his time and energy into that to the neglect of his regular work which error I shall studiously avoid.

---

[21] *The Korean Repository* (or *Chosŏn Sosik*; 1892, 1895–1898) was an English-language monthly journal published in Seoul.

There are a hundred questions crowding up in my mind for consideration among which is a comparison between the Japanese pronunciation of Chinese with a view to discovering if possible whether the two derived their pronunciation from the same or from different provinces of China. I have also been wondering if the time would ever come when the "Story of the Nation" Series would include China Korea & Japan. It ought to do so and I should like to have a hand in it. Korean History is my special Fad. I am now having the Tong Kuk Tong Gam[22] copied. It is a heavy 27 volume work and gives a most thorough and interesting account of Korean history from the earliest times. I have already translated another Korean history of even greater value & these two together with others in my possession will furnish abundant material for a history of Korea. I am committed to that work and am fully determined to carry it out sooner or later.

I will try to get together a collection of things printed here which may interest you & forward them by the next mail. In fact I think I will send you by this mail some of the proofs of our mission report which will give you some idea of the work of our mission at least and it will be a fair indication of all mission work here.

Dr Underwood[23] is here and hard at work. He is quite indefatigable. Tracts come pouring in from him and others as well as quite a continuous stream which keeps us at high pressure all the time. All are well & I will remember you to them at first opportunity.

If you want a curious thing send to Rev. E. E. Rogers[24] for a photograph of a Korean Map of the World which I sold to the British Museum[25] & which they consider a treasure. These photos are for sale at something like a couple of dollars. There are only half a dozen or so but he will let you have one.

I assure you that I shall write to our Schmetz of Leyden[26] and do what I can to get a foothold there. Many thanks for the suggestion. I will write you as I have opportunity. If you take the Japan Mail you will see squibs of mine from time to time.

Yours most cordially

**H B Hulbert**

[Note at the end of letter:] Good for Noyes

---

[22] *Tongguk T'onggam* (1485).

[23] Horace Grant Underwood (1859–1916).

[24] Reverend E. E. Rogers (?–?) was the pastor of a Presbyterian church. He also appears in Horace N. Allen's September 26, 1912, list of persons interested in William Elliot Griffis's book *A Modern Pioneer in Korea: The Life Story Of Henry G. Appenzeller* (Box 59, Folder 2, Griffis Collection; see the chapter on Horace Newton Allen in this book).

[25] The British Museum (est. 1753).

[26] Possibly a photographer in Leyden, Massachusetts.

140    LETTERS FROM MISSIONARIES

### 7) Jan. 5, 1894

**Seoul, Korea**

Dear Dr Griffis

I have no time to write today but I send you a full set of the Repository as it appeared. There are but a few sets complete and I obtained this as a special favor. If you will you may send me the price ($2.80) to Rev. E. E. Rogers, Zanesville, Ohio. and tell him it is for me. I trust it will prove of interest to you.

Your very sincerely,
**H. B. Hulbert**

### 8) Apr. 29, 1894[27]

**Seoul**

My dear Gilmore—

By the time this reaches you your year will be about done and the long seminary vacation will be before you. I suppose you know more or less of what is going on here but I will recapitulate. In the first place Kim Ok Kiun[28] was decoyed out of Tokyo to Shànghai[29] by a paid assassin from here and went to Shanghai where he was instantly murdered and the Chinese of course immediately showed every courtesy to the murderer & gave him a gun boat to come over here on. The body of K.O.K.[30] was brought at the same time and has been cut up [to?] according to the delicate and civilized custom of 대조선.[31] It has caused a good deal of excitement but the result will be to fasten the Min[32] barnacles more firmly upon the bottom of the Korean ship of state. Things are in an awful condition here politically. The Koreans have borrowed money in small sums at 2½% a month mortgaging their customs receipts as security and so gradually throttling themselves.

---

[27] Gilmore forwarded this letter to Griffis.

[28] Kim Ok-kyun (1851–1894) was a reformist politician, bureaucrat, and diplomat who accompanied several Korean missions to Japan. After the Imo Soldiers' Riot (1882), he was an active proponent of radical military reform modeled after the Meiji Restoration (1868) of Japan, while politicians of the Yŏhŭng Min clan demanded gradual reform. He and other reformists led the Kapsin Coup (Dec. 4–6, 1884), a three-day coup d'état demanding domestic reform and independence from Chinese suzerainty. He was killed in Shanghai, China, by an assassin hired by the Min clan.

[29] Tokyo, Japan; Shanghai, China.

[30] Kim Ok-kyun.

[31] Taejosyŏn 대조선 means "great Chosŏn."

[32] Members of the Yŏhŭng Min clan (from Yŏju, Kyŏnggi-do) had a powerful political influence on late Chosŏn and the Korean Empire. Some figures from the Min clan include Empress Myŏngsŏng (1851–1895), Grand Internal Princess Consort Yeoheung (1818–1898; mother of King Kojong), and the politicians Min Ch'i-rok (1799–1858), Min Yŏng-hwan (1861–1905), and Min Yŏng-ik (1860–1914).

Seoul, Apr 29ᵗʰ 94.

My Dear Gilmore —

By this time this reaches you your year
will be about done and the long seminary
vacation will be before you. I suppose you
know more or less of what is going on here but
I will recapitulate. In the first place Kim Ok Kiun
was decoyed out of Tokyo to Shanghai by a
paid assassin from here and went to Shang-
hai where he was instantly murdered and
the Chinese of course immediately showed every
courtesy to the murderer & gave him a gun boat
to come over here on. The body of K. O. K. was
brought at the same time and has been
cut up &c according to the delicate and
civilized custom of 대왕님. It has caused
a good deal of excitement but the result
will be to fasten the _new_ barnacles more
firmly upon the bottom of the Korean ship of

Figure 27  Homer B. Hulbert's letter to Griffis, dated April 29, 1894 (first page) (Box 59,
Folder 30, Griffis Collection)

I suppose there are no less than 50,000 in Chullado[33] who have revolted and many of them are around. I look for developments all the time and expect that the old craft will soon go into dry dock & have her bottom scraped and at the same time she may be condemned & broken up for old iron. You know about how Bunker[34] went I suppose. I know that the reason he went was not simply because he wanted [then?] the school funds to be put in his hands but because he demanded a big use of salary & would not come down. As it is he has gone & Nienstead[35] who had left and was in Japan was sent for by cable & has taken the 육영공원[36] at $200. a month and contract to teach seven hours a day six days in the week. At the present exchange he is getting $95. gold a month. [He?] was talking with me & winking his other eye he remarked, "Nienstead's next step will be into a mission"! That idea tickled the old gentleman immensely.

Bunker has applied to our mission & we learn from N.Y. that in all probability his appointment will be confirmed. In that case he will take the 배재학당[37] and will have a house very near to mine.

Underwood is the same old fellow, a tremendous worker but jammed into the hole as hard as all the other members of the mission can jam him and they are a big crowd. You did not know Gale[38] did you. Well, he is a smart fellow but he is so furiously jealous of U.[39] that if U. says white is white he will swear it is black. At the same time I would give more for U. than all the rest of them put together so far as mission work goes. Mrs. Underwood[40] is badly off with rheumatism but seems about the same all the time. I do not see why she cannot hold on a number of years more. Appenzeller[41] is the same old boy, pugilistic as ever and knowing him well, I punch back at him good naturedly. There is not the least friction so far as I am concerned. One or two of the new men in our mission kick at having to be examined by Jones on the language every quarter. Well, I sympathize with them some, but if they would show just a little ability to get hold of the language, I should sympathize with them a great deal more.

Scranton[42] has changed a good deal. He has "sworn off" smoking, principally because his physician said his life depended on it somewhat I imagine

---

[33] Chŏlla-do is a province in southwestern Korea; Hulbert refers to the Tonghak Peasant Revolution (1894).

[34] Dalziel A. Bunker (1853–1932) was a Presbyterian missionary and physician in Korea from 1886 to 1926. He, Hulbert, and George William Gilmore (1858–1933) were dispatched to Korea in 1886 to teach at Yukyŏng Kongwŏn upon King Kojong's request. Bunker resigned from his teaching position in 1894.

[35] Ferdinand John Henry Nienstead (?–?) was an American military official dispatched to Korea in 1888 to teach at the military academy Yŏnmu Kongwŏn (est. 1888) upon King Kojong's request.

[36] Yukyŏng Kongwŏn (est. 1886).

[37] Pai Chai Haktang (now Pai Chai University; est. 1885). In the original script, the middle dot was used to spell "배재."

[38] James Scarth Gale (1863–1937).

[39] Underwood.

[40] Lillias Stirling Horton Underwood (1851–1921).

[41] Henry Gerhart Appenzeller (1858–1902).

[42] William Benton Scranton (1856–1922).

because he is the Supt.[43] of the mission. He wears a clerical coat & takes his time in the pulpit. But S.[44] is no man for a Supt. He is too changeable and too easily excited. I get along with him perfectly because I know how to take him but all our people do not know him so well as I do. Appenzeller and Scranton do not begin to know each other as well as I know either of them. Neither of them can see the others standpoint. But we are a harmonious body & are getting along finely. Mrs. M.F. is quite well & is doing a good deal of work among Koreans. I think she is better than most of the time when you were here. The Waebens are back & settled in the splendid mansion on the hill, a really magnificent place. We have a few good tennis players here. One in the customs & one in the English mission. I have played with them once or twice and these have all I want this spring.

Liang[45] is back in the Chinese Legation & has cut off his old time friendship with us as at least so far as tennis is concerned. I see him very seldom. Loy, I hear is over in Chefoo[46] in the customs, a fine fellow. I wish he was here.

Gifford[47] is getting to be something of a worker & is in the country about half the time. Mrs. G. is an exceedingly valuable worker I should judge.

The Bible Committee[48] have gotten to work at last and they have had a great old time on the term question. It has [been?] finally decided by a vote of 4 to 1 (this one being Gale) to adopt 텬주[49] the Roman Catholic term & all things considered I believe in it. Our mission has unanimously ratified that vote and there is little doubt that the scriptures will be printed with that term. The Catholics will immediately tack the 로마[50] to their name as they had to do in China when their term was adopted by others.

In my work in the press I was having good success. I have made it pay expenses which is fair success when you remember that last year it was behind some $800. Ohlingers[51] principle was that the press would pay expenses if it could get plenty of Onmoun[52] work to do but he charged such price that he could not get the work. I adopted the principle that we must get the work at any cost & I put my prices on a par with the Seishi Bunsha of Yokohama[53] and today I have work in hand. That will take two years to do & I have sent to U.S. for as fine a press as is made for foot power a 3200 pound machine. I have printed a million pages since November and have bound 220 books.

[43] Superintendent.
[44] Scranton.
[45] Liang Cheng (1864–1917) was Chinese ambassador to the United States from 1902 to 1907.
[46] "Chefoo" was an archaic name for Yantai, China.
[47] Daniel L. Gifford (1861–1900) and his wife Mary Hayden Gifford (1857–1900) were Northern Presbyterian missionaries in Korea from 1888 to 1900.
[48] The Korean branch of the British and Foreign Bible Society (est. 1804), of which James Scarth Gale was a member and president from 1917 to 1923.
[49] Chŏnju 천주 means "God" or "Lord."
[50] Roma 로마 means "Roman."
[51] Franklin Ohlinger (1845–1919).
[52] Ŏnmun 언문 was an alternate name for Han'gŭl, the Korean phonetic writing system.
[53] Seishi Bunsha was a publishing house in Yokohama, Japan.

144    LETTERS FROM MISSIONARIES

The Korean workmen like me and are willing to work fourteen hours a day if need be. Some of them do. Of course on job work. I took a series of lessons in a job office before coming out and the men know that I can appreciate the difficulties. It gives them confidence in me.

I have just sent for some new and handsome type to set up my work on Korean Folklore which one company at home rejected (and rightly too) because the ms. was not complete. I was going to have a considerable historical introduction but it was not finished. I shall stereotype it & wait til my new press comes before printing.

A Washington newspaper man Carpenter[54] is here writing syndicate letters & he says your book on Korea ranks Griffis', an opinion that others of us here share with him. My apple, pear, cherry, peach and apricot trees are all in fine feather. And my grape, strawberry and raspberry briers are going to bear heavily. I have some forty odd fruit trees. Rather a contrast to the place I used to live in here more satisfactory work in every way. I trust I have not bored you & that this letter will find you all well & happy with kindest regards to Mrs. G.[55] and your family I remain

Most sincerely
**H. B. Hulbert.**

### 9) Nov. 9, 1894

**Seoul**

Dear Dr Griffis,

As you have seen, we are about to go at work on the Repository again and as we believe at the opportune time, especially so far as the East is concerned. Might we hope to have an article from you sometime during the first four month of the new year on the significance of the new movement here. You could give us something on that line that would be of great value to us. These are great days for Korea. I am just printing a translation of the new Constitution of Korea gotten up by the Council of State under Japanese direction.[56] Will send you one.

Yours very truly,
**H. B. Hulbert.**

---

[54] Frank George Carpenter (1855–1924) was a journalist based in Washington, DC. Using his earnings from newspaper syndicate assignments, he later went on trips around the world and wrote the *Carpenter's World Travels* series, which includes a segment on his visit to Korea (*Japan and Korea* [Garden City, NY: Doubleday, Doran, 1925]).

[55] Katherine Lyra Stanton Griffis (1855–1898) .

[56] *Hongbŏm Sipsajo* (or *14-jo*; 1895) is a charter considered to be the first modern constitution of Korea. It was drafted by King Kojong and reformist politicians and declared on January 7, 1895, at the Chongmyo ancestral shrine. Written in fourteen clauses, the charter proclaims constitutionalism, reform of discriminatory social systems, and Korean independence from Qing China.

**10) June 9, 1895**[57]

**Seoul**

My Dear Gilmore -

Your note came today and I was delighted to hear from you. I am pleased to hear of your continued success there. I see your hours are full of work, as mine are. Well, old Seoul was the same as ever though you may imagine the new regime is making some radical changes. We see nothing of Yuan these days. His star is set. He is rusticating somewhere as are the numerous Mins.

By the way, Min Chong Muk[58] our quondam acquaintance is back in Seoul and sent me his card the other day. Yi Wan Yong[59] is now Minister of Education and Ko Mei Kiung is Chusa[60] at the F.O.[61] Hutchison & Halifax run the government School.[62] Bunker left just at the very wrong moment. Six months more of patience would have seen him the solidest of the solid, but so the world ways. Bunker & wife are now in mid Pacific on their way out to join our mission. They will occupy for a time the little house where Jones lived when you were here. The Koreans are about to start a newspaper and I am buying their material. I shall strike it off for them on my presses. I have a full set of matrices and type casting machinery. I am making my press a general printer's supply & bringing this estab. up to a paying basis. You would hardly know Seoul now for the new faces. Nice lot of people but more hold-offishness between the missions. Presbyterian mission had a great number of men in Seoul, and as of old, Underwood is always in hot water but he has a number of stout supporters among the number. He is the same old fellow and will "burn to the socket." Appenzeller has not changed a particle. Scranton has "sworn off" and is strong on evangelistic work. Mrs. M. F. is feeble and cannot hold on much longer. Jones is settled at Chemulpo[63] & is doing a splendid work, the only man in our mission who gives his main time to pastoral work.

---

[57] Gilmore forwarded this letter to Griffis.

[58] Min Chong-muk 민종묵 (1835–1916), a member of the Yŏhŭng Min clan, was a politician who held various government positions including vice minister of civil service affairs, minister of penal affairs, and mayor of Seoul. A pro-Japanese collaborator during the Japanese occupation of Korea, he was given the title of baron by the Japanese House of Peers.

[59] Yi Wan-yong 이완용 (1858–1926) was prime minister of Korea in 1910. A pro-Japanese collaborator, he is known as one of the "Five Thieves of 1905" (*ŭlsa ojŏk*) responsible for the Japan-Korea Treaty of 1905, which deprived Korea of its sovereign status and accelerated the Japanese colonial occupation. He also played an instrumental role in King Kojong's forced resignation (1907) and the signing of the Japan-Korea Treaty of 1907 and Japan-Korea Annexation Treaty (1910).

[60] *Chusa* 주사 was an administrative post under the office of *p'animguan* 판임관, the lowest of the three levels of government offices after *ch'igimguan* 칙임관 and *chuimguan* 주임관. These designations were created in a government structure reorganization in March 1895 following the Kabo Reforms (1894–1895).

[61] Foreign Office?.

[62] W. F. Hutchison (?–1901) and Thomas E. Halifax (?–?) were appointed as professors at Yukyŏng Kongwŏn (est. 1886) in 1894.

[63] Chemulp'o (now Inch'ŏn).

# 146 LETTERS FROM MISSIONARIES

The Korean Repository is booming. We have more than enough subscribers to cover expenses and a good lot of advertisements which of course pay best. I am publishing in the June & July numbers my article on the origin of the Korean people. I will try to think to send you copies.

I have nearly finished my history of Korea and Macmillan of London has offered to examine it with a view to publication.[64] By the way your book has entered its second edition I hear. Great Stuff! I have heard many friendly comments on it. Didn't I hear that some firm in Europe had stolen it? I am sure I did.

Great tennis now-a-days. We have five hard players here and when Bunker comes it will be six. B. has come up fast in tennis and is a strong player. I wonder if you have kept your hand in. I am getting so fat I keep up my tennis from hygienic purposes if for no other. My regards to Mrs. G.[65] and the children. I have two girls[66] now.

Yours,
**Hulbert**

## 11) **Nov. 30, 1896**

**Seoul**
[on top of the first page:] I am publishing now in Shanghai a history of this dynasty in Chosen[67] 600 pp. 5 vols.[68] Also am printing here a history of Korea in native character for schools.
HBH
Dr Griffis—

Dear Sir,

When I returned to Korea in 1893 I immediately plunged into the interesting field of Korean History. I found a man who for 6 years was a secretary to His Majesty and who had spent fourteen years in working up the history of the present dynasty. I have also had access to some rare manuscripts which help me to carry the ancestry of Kija back some thirteen generations and which give a detailed account of the Kija dynasty. This is a ms that has just come to light in Pyeng Yang[69] among descendants of Kija himself. This work is now being copied for presentation to His Majesty and I have been able through my teacher to see advance sheets of it. But the most interesting part is the light which these Korean manuscripts cast upon the Japanese Invasion in 1592–

---

[64] Homer B. Hulbert, *The History of Korea* (Seoul: The Methodist Publishing House, 1905). Macmillan (now Macmillan Publishers Ltd; est. 1843) is a publishing house that was founded in London, UK.

[65] Katherine Lyra Stanton Griffis (1855–1898); Stanton Griffis (1887–1974) and John Elliot Griffis (1893–1963).

[66] Helen Hulbert (married name Blague; 1891–1939) and Madeleine Hulbert (1894–1910)

[67] Chosŏn (1392–1910).

[68] It is unclear which book this is referring to.

[69] P'yŏngyang.

1598.[70] In the History of Korea[71] which I hope soon to publish I have about a hundred pages devoted to that war and I am sure it will be of intense interest to all who know anything about Japanese history. For instance the fact that Hideyoshi[72] met his death at the hands of a Chinaman, by poison, and that a Korean slave at Hideyoshi's court was the only one cognizant of it and brought the details of the event to Korea later, where it has remained ever since hidden in the native mss.

What I am very anxious to find out is the exact relation that the Colony of Japanese in Fusan[73] held to the Korean government. From the end of the Invasion, say 1600 till 1868 a colony of 300 Japanese lived at Fusan, supported by the K.[74] government and called "The Frontier Guard."[75] The Koreans claim, and with apparent reason, that this was a colony of hostages held by Korea. I would like to know what the Japanese believe and hold on this subject. Why should the govt have supported them unless they were hostages? If it had been a Japanese garrison the Japanese govt would have supported them & if it had been a colony of traders they would have supported themselves. It is impossible to conceive that for three centuries Japan could have made Korea support a Japanese garrison in Fusan. Again, the moment the K. Govt ceased to feed them they were withdrawn. This also looks as if Japan felt justified in withdrawing her hostages when the K. govt ceased to provide for them.

Have you ever come across the absurd tradition that after the invasion Korea demanded and received from Japan annually for a time 300 skins of Japanese unmarried girls. The Koreans here offer to show me three hundred of them stowed away in one of the arsenals of Seoul. I am going to keep them to their promise. The tradition goes on to say that Japan asked to be let off from this and in lieu of this tribute offered to put 300 hostages in Fusan permanently, to be reviewed every year or two. The idea of taking the skins of unmarried girls was, so tradition says, to keep down the population of Japan as [to] make another invasion unlikely.

With many regards,

Yours

**H. B. Hulbert**

[70] The Imjin War (1592–1598) was a Japanese invasion of Korea by Toyotomi Hideoyoshi(1537–1598) and his army, during the reign of King Sŏnjo (1552–1608; r. 1567–1608). The term "Imjin War" commonly refers to both the first invasion in 1592 (the year *imjin*) and the second in 1597 (the year *chŏngyu*). The campaign was concluded by the death of Hideyoshi and the withdrawal of Japanese forces in 1598.

[71] Hulbert, *The History of Korea*.

[72] Toyotomi Hideoyoshi (1537–1598), born Hiyoshimaru, was a Japanese samurai and feudal lord (daimyo) who united Japan via military conquest in the late sixteenth century. His plan to conquer Korea and China was thwarted by his death from an unspecified illness.

[73] Pusan.

[74] Korean.

[75] Japanese expats were able to trade and settle in areas called *weguan* 왜관 in Chosŏn Korea. The *weguan* in Pusan was closed during the Imjin War (1592–1598) and reopened in 1607.

148    LETTERS FROM MISSIONARIES

**12) Apr. 29, 1897**

**Seoul**

Dear Dr Griffis.

Your note with check came some days ago and has remained unanswered too long. I am sending you herewith a full set of the Independent[76] from the beginning. The first numbers are very rare but I fortunately have several full sets. For the first few months I wrote all the editorials for Dr. Jaisohn[77] but he gradually got into harness and save for an occasional snag in this most elusive language (English) he gets along nicely. As the subscription price is $6.00 a year from Jan. 1897 your check will not cover it but I went in time to have him put your name down for the paper regularly. I will ask him to mail it to you weekly, three numbers together.

Day after tomorrow I enter upon the duties of a five year's contract with the Korean government with a view to the establishment of a national system of education.[78] For the first two years it will be mainly the preparation of a series of textbooks in the vernacular and the training of a corps of teachers, then will come the establishment of schools in the country; at first in the provincial capitals and gradually in the rural districts. There is a life work in it. I already have two of the text books nearly finished and have others on the stocks. I have the full run of the Gov't Printing Office and so can publish any of these text books as soon as the ms is ready. I am also getting other foreigners to work up text books in their special branches, such as physics, physiology, chemistry and the like—natural sciences in which I have never taken any particular interest and I shall confine myself to Mathematics, History, Geography, and Political Science. Eventually we want to bring in civil service ideas and make an education along these lines a sine qua non of official position.

We are all very well but a month ago we lost our little boy 13 mos. old. It was a heavy loss to us.

I will look up the other matters which are covered by your check & report. The Repository is $3.84 silver The full file of Independent is $1.00 for 1896 and $2.00 for 1897 to date. Postage will be a few cents. I will reckon it all out.

With best regards to yourself & family

Yours
**H B Hulbert.**

---

[76] *The Independent (Tongnip Sinmun*; 1896–1899) was Korea's first privately owned daily newspaper, founded by Philip Jaisohn and published both in Seoul and in regional offices (Inch'ŏn, Pusan, Suwŏn, P'yŏngyang, and others). It was published both in Korean and in English, the latter of which Hulbert helped edit.

[77] Philip Jaisohn (Sŏ Chae-p'il; 1864–1951).

[78] In 1897, Hulbert signed a contract with the Korean government to help organize, and teach at, the teacher-training college Hansŏng Sabŏm Hakkyo (est. 1895).

## Hulbert, Homer B. (1892–1917) 149

**13) Feb. 18, 1900** [Typed Letter]

**Seoul, Korea**
Wm. E. Griffis, D. D.

My Dear Doctor:-

Your note came the other day and was very welcome. I had been thinking of writing you for some time, but I fear that total depravity works out in me in the form of procrastination. Hence the result of my good resolutions. As to the Repository[79] it was suspended at the end of 1898 but was kept up for a short time in a sort of leaflet that was sent out weekly during a part of 1899. It did not amount to much however and would have been of little value to you I imagine. I have every reason to believe that it will be resumed again some time this year, probably about June. When I went home in the Fall of 1898 Appenzeller[80] asked me to take the chief editorship of it when I came back and I promised to do so but when I returned things did not look cheerful and the thing was dropped for the time being. My active connection with the magazine ended in 1897 when I left the mission and reentered the government service.[81] When the time comes to resume, however, I shall be on the editorial staff. At least I have so arranged with Appenzeller. There is a good deal of call for the paper, especially from Russians. These northern neighbors of ours are deeply interested in us here and the time will soon come when we will see more of them than we have. I only hope Japan will wake up in time.

I have had a long hard time getting the history of the present dynasty in Korea printed in Chinese in Shanghai but it is almost done now and will be out this Spring. It is in five volumes and will circulate somehow in Korea and China. Possibly in Japan too. Dr Allen[82] urges me to publish my history of Korea (English)[83] immediately. He has examined the MS[84] and is greatly interested in it. A firm in Shanghai will do it in good shape and at a very small figure and I have about concluded to do it. If so it will be by subscription. You will receive notification of it. It will be 800 pages, I fear, with illustrations and all, but I have no time nor inclination to cut it down. It will have to go as it is.

I am in charge of the Government Normal School[85] intended to fit men of positions in schools throughout the country but the utter collapse of all decent government gives little hope of anything in the near future and Japan and Russia fill the more remote future so completely that I am in doubt as to

---

[79] *The Korean Repository* (*Chosŏn Sosik*; 1892, 1895–1898) was an English-language monthly journal published in Seoul.
[80] Henry Gerhart Appenzeller (1858–1902).
[81] In 1897, Hulbert signed a contract with the Korean government to help organize, and teach at, the teacher-training college Hansŏng Sabŏm Hakkyo (est. 1895).
[82] Horace Newton Allen (1858–1932).
[83] Hulbert, *The History of Korea*.
[84] Manuscript.
[85] Hansŏng Sabŏm Hakkyo (est. 1895).

150 LETTERS FROM MISSIONARIES

the value of my work. Its greatest value will be in textbooks that I am preparing. The people will be here at all events. I have remembered you to friends and they return the compliment. Kindly give my regards to Mrs Griffis.

Yours very sincerely,
**H. B. Hulbert**

**14) Dec. 20, 1900**

**Seoul, Korea**[86]

Dear Dr Griffis—

I am sending you in a day or two the prospectus of our new monthly illustrated magazine—The Korea Review.[87] It will be much along the same lines as the Repository but I shall have rather less to say about politics. To my mind the Repository was never particularly happy in its political talk. One needs to have some inside knowledge to talk on such matters to edification. My attitude will be one of friendliness to the government while not trying to excuse its faults. My position of course demands this. I trust that if you take the magazine you will find it no less interesting than the Repository was. If you could conscientiously give a word of commendation in our new venture I should appreciate it very highly. You will notice that I am making a special department for the answering of any questions about Korea. This is specially for foreign subscribers and I hope you will send me very soon some questions that you want answered. I can promise that your questions will be submitted to those who are best qualified to answer them.

I am going to print my History of Korea serially in the Review[88] and as it is the first work of its kind I trust it will be not without interest to the people who keep Korea in mind, as I know you do. I was glad to shake hands with you across the pages of the Bulletin of the Am. Geog. Soc.[89] even though it is a far cry from the Heather and Hollows of Holland to those of Korea. The Japan Mail selected your article and mine for quotation in their columns.

The first number of the Review will be mailed late in Jan. for I have only just learned that the Repository is, for the present at least, defunct.[90] I solicit for my new venture the same generous patronage and support that you gave

---

[86] In letterhead: The Korea Review.

[87] The *Korea Review* (1901–1906) was an English-language monthly journal on Korean culture and affairs, edited by Hulbert and published in Seoul.

[88] Hulbert published *The History of Korea* in forty-eight installments in the *Korea Review*, from January 1901 to December 1904.

[89] William Elliot Griffis, "The Heaths and Hollows of Holland," *Bulletin of the American Geographical Society* 32 (1900): 308–321; Homer B. Hulbert, "Korea's Geographical Significance," *Bulletin of the American Geographical Society* 32 (1900): 322–327.

[90] The *Korean Repository* (Chosŏn Sosik; 1892, 1895–1898) was an English-language monthly journal published in Seoul.

Hulbert, Homer B. (1892–1917) 151

to that publication. I trust this letter will find you and your family in good health. Wishing you the compliments of the 20th Century. I remain

Yours very sincerely
**H. B. Hulbert.**

I now hold a double position under the government that of Head Master of the Normal School and Professor of English in the new Middle School.[91]

### 15) Apr. 9, 1901

**Seoul, Korea**

Dear Dr Griffis

Your note came by todays mail and I was very glad to hear from you in regard to the Review. You were very kind to mention the magazine in the Nation and elsewhere. Of course all these things help. Evidently you had not received the first number of the magazine when you wrote but it must have reached you soon after for it was mailed the latter part of January. I trust you will find it interesting. I am laboring under several disadvantages. In the first place, I suffer for lack of room. The history takes up twenty pages in each number which is not too much if I am ever to finish it. Even so it will take these years to complete it. I may have made a mistake in putting it in but I hope not. I am limited to 48 pages for the reason that the probable circulation at the price I am charging is not enough to stand more than this. If I find that my circulation runs up to 400 or so I shall enlarge the magazine to 60 pages. I have noted your suggestions carefully and some of them, you will notice, I have already carried out. A second difficulty is that I cannot afford to illustrate freely. This is a severe drawback. I have overcome it somewhat by the publication of the Review Album[92] of which you will find notice in the February number. I am having good success with it. The pictures are very special ones and I think are excellently gotten up (by Japanese) but they are expensive. I have to charge 10 cents (Japanese) for them but if the subscription to the Album should run up to 300 I could reduce the price by ½. You see I am trying merely to meet

---

[91] Hulbert was principal of Hansŏng Chunghakkyo (now Kyunggi High School; est. 1899) from 1900 to 1905.
[92] "As the KOREA REVIEW is gotten up with the view of furnishing information about Korea we do not see how we can get along without illustrating. On the other hand we do not see how on our present modest financial basis we can furnish illustrations to our subscribers. The result of this dilemma is that we have decided to publish what we shall call The Korea Review Album, of Korean pictures. We have secured a goodly number of choice pictures on Korean scenery, customs, superstitions, monuments, architecture, punishments, etc. etc. which will be developed into half-tone plates and printed on a heavy quality of paper of a size suitable for insertion in an album of good proportions or for mounting in frames if so desired." Homer B. Hulbert, "Editorial Comment," *Korea Review* 1, no. 2 (1901): 69–70.

150	LETTERS FROM MISSIONARIES

expenses, not to make any money out of it. In time it may become a paying concern but for a year or two I am content to make ends meet.

I have so much matter on hand and the space is so small that I am almost compelled to enlarge the magazine. I shall probably add four pages to the April number. But of course I have to go rather slow on extras. I shall be glad to mention the work of which you speak—"Verbeck of Japan."[93] G. E. Stecher[94] of 9 W. 16th St. N.Y. is my agent in the U.S. and as he is an importer of foreign works and periodicals he will doubtless know about where to place the Review so far as libraries are concerned but if there are any special places where you think it would be worthwhile to send sample copies I should be glad to get a list of them and in sending mention that it is at your suggestion. This would be of material advantage to me. I think you will find that in many points the Review is an improvement on the Repository. They are doing better press work now though of course far from perfect. If I go home in 1903 as I hope I shall bring back the necessary outfit to do my own printing. I want the magazine to be gotten up in really first class shape. At present halftone pictures and photogravures cannot be printed in the body of the magazine. The presses here cannot do fine enough work for that. It has to be done separately in Japan. I inclose with this a sample picture from the Album which will give you an idea of the style. The paper is heavy and fine (American). I rather think you will approve of them except the price, which I grant is very high. I am going to print your suggestions in the April number in order to stir up any correspondents to answer some of your questions.

Yours very sincerely,

**H. B. Hulbert**

These pictures will be spoiled by creasing but they are only samples.

### 16) June 22, 1901

**Seoul**

Dear Dr Griffis,

Your interesting and kindly letter came the other day and I take the first opportunity to answer. I am especially interested in what you say about the history and am grateful for any suggestions you have to make. Now I agree with you in part but I think there are one or two things that should be explained and which I think will modify your opinion. In the first place there is practically one single source of historical information about ancient Korea. All the various accounts are variations on the ancient Sam-guk-sa, or "History of the

---

[93] William Elliot Griffis, *Verbeck of Japan: A Citizen of No Country; A Life Story of Foundation Work Inaugurated by Guido Fridolin Verbeck* (New York, Chicago, and Toronto: Fleming H. Revell Company, 1900).
[94] G. E. Stecher and Co. was a publisher based in New York, New York.

Three Kingdoms."[95] It is not a fact that there are various historical records that can be compared. There is no possibility of cross-examination and verification. We have a simple straightforward story of ancient times, the mythical, legendary and historical elements all being blended into a single narrative. In giving an English setting of this narrative would you expect me to leave out the account of the legends and myths which encompass as swathe the beginning of Korean history. I would as soon think of dropping the the [sic] mention of King Arthur from English history of Wm. Tell from Swiss history, of Homer and Helen from Greek history.[96] You will observe that at the very start I guarded myself against the charge by stating that I give the legends and myths for what they are worth. They are essential to a clear view of the Korean mental standpoint. To my mind so far from being a blemish to the book they are quite indispensable.

You may say that I should have been more careful to separate them from the body of the work and give them in the shape of footnotes etc. In this my taste may have been at fault. No one would surely get the impression from my pages that I believed in the historicity of these fabulous events. What then is the use of cutting up your pages and breaking the continuity of the reading by throwing these things with foot notes? In nearly every case I note in the text that these supernatural events are mere traditions. The first two or three chapters, dealing with the Tangun, Kija,[97] etc are purely traditional, but could a true history of Korea be written without mentioning them? In the book I clearly tell at what point actual history begins to take the place of legend.

My history of Korea is gotten up not on the analytical method but on the narrative method. The single source of information permitted of us synthesis from different points of view.

Now in Japanese history, if I am rightly informed, the Kojiki[98] gives all we can find in regard to the earliest times. I have been reading it with great care

---

[95] *Samguk Sagi* (1145), a history of the Three Kingdoms (Koguryŏ, Paekche, Silla) written by Koryŏ-Dynasty scholar and politician Kim Pu-sik (1075–1151), and/or *Samguk Yusa* (1281), a history of Korea from Kojosŏn to the Later Three Kingdoms (Koryŏ, Later Paekche, Unified Silla) written by Koryŏ-Dynasty Buddhist monk Iryŏn (1206–1289).

[96] King Arthur of Camelot, a legendary British king who inspired various medieval English texts; Wilhelm (or William) Tell, a Swiss folk hero and archer; Homer (?–?), Greek epic poet and author of the *Iliad* and *Odyssey*; Helen of Troy, a Greek mythological figure said to have been the most beautiful woman in the world.

[97] Tan'gun (?–?; r. 2333 B.C.E.–1122 B.C.E.) was the founder of Kojosŏn (2333 B.C.E.–108 B.C.E.), the first kingdom known to have existed on the Korean Peninsula. Mythological accounts such as that of *Samguk Yusa* identify him as the the the son of Hwanung (son of the heavenly god Hwanin) and Ungnyŏ (a bear-turned-woman). King Kija (pronounced "Jizi" in Chinese; ?–?) was the founder of Kija Chosŏn (c. 1100 B.C.E.–195 B.C.E.), a kingdom speculated to have been founded during the late Kojosŏn Dynasty.

[98] *Kojiki* (712) is a collection of Japanese foundational myths, hymns, semihistorical accounts, and oral traditions compiled by Ō no Yasumaro (?–723) upon the commission of Emperor Tenmu (c. 631–686; r. 673–686).

of late. Compared with it the ancient history of Korea is entirely credible. There is hardly a line of the Kojiki that you can put your finger on and do more than guess that it may refer to an historical occurrence. Take the Empress Jingu and her supposed conquest of Korea. She and all her doings are buried in supernatural lore to such an extent that no one would dare to affirm the possibility of those events being historical unless the comparatively sane and matter of fact annals of ancient Korea verified them. And yet you and many another has accepted Jingu's conquest of Korea as a settled fact that is practically beyond dispute.[99]

The grand difference between the ancient records of Korea and of Japan is that in the Korean records the supernatural is the exception & not the rule, while in the Japanese records it is only once in a while that you meet anything that could even be guessed to be history.

Each month I am having the pages renumbered and 300 copies [struck?] off which are laid aside to be bound with a volume at last. I have biographical and geographical indexes, seven maps, chronological tables and over fifty-full page illustrations for the history. I shall have it gotten up in a thoroughly scientific way so as to be of use to the student. There is no use in my trying to find a publisher in the U.S. for I am unwilling to cut the book down to dimensions that would make its publication a financial success. As I am doing now I shall have three hundred copies of the history made up complete at a price which will enable me to sell them at $2.00 gold and still clear quite a profit. It is the only way to get a complete history of the country on the market.

I have given you my views here very frankly as I know you would prefer. I value your opinion very highly and want to get as much light as possible on the subject. I do not know whether I have met your objection in the above. If not then I am not aware of your exact meaning. I think I have served the public better by giving a straightforward narrative of events without drawing other than the most obvious inferences than if I had spent my time trying to generalize. I should be pleased if you had time to give me a more particular word as to your meaning. It may be I have misunderstood you.

You are very kind to help me by reviewing the Review. I have no access to the Nation[100] but should be very glad to see what you have been so kind as to say. My mailing list is growing and I shall at least not be out of pocket at the end of the year. Mr. Appenzeller[101] returns from the U.S. in Sept. & I am told he wants me to suspend the Review in Dec & let the Repository start up again. There was a hiatus of two years in the Repository & no present prospect of resuscitation so I started in with the Century.[102] From the standpoint

[99] The overall popularity of the Jingū theory has been declining since the 1970s due to concerns raised about available evidence.

[100] *The Nation* (est. 1865) is a weekly progressive magazine published in New York, New York.

[101] Henry Gerhart Appenzeller (1858–1902).

[102] *The Century Magazine* (1881–1930) was a monthly magazine published in New York, New York.

of editorial or journalistic courtesy am I under obligation to suspend? I should like an unbiased judgement on this point from you. I noticed with pleasure what you say of your new literary ventures. All success to you.

Most truly
**H. B. Hulbert.**

### 17) **May 26, 1902**

**Seoul, Korea**[103]

Dear Dr Griffis,

Your pleasant note has just come and I hasten to acknowledge receipt of $10 gold. Your subscription to the Review for 1902 will be $2.25 including postage and the pictures will be $1.50 with .30 extra for postage, so your total bill is $4.05. The remaining $5.95 are in my hand for the purchase of photos, etc.

As for the specific things you mention I fear there will be no picture of the Puyu[104] monument for many a long year to come. I wish I could get a picture of it. Everything about here is photographed by the Japanese and is on sale at the shops. If any special pictures are taken they are by private parties who want to use them exclusively and so it is next to impossible to get them. There are plenty of fine pictures to be taken but the cost of taking a photographer to them and getting them taken is prohibitive. What you want is just what we all are on the look out for but never seem to be able to get. Some of the rarest pictures among my set of photographs were taken from plates loaned me by friends as a special favor but such opportunities are few and far between.

The town of Puyu is about a hundred miles directly South from Seoul and the monument lies in the ground in the town, or rather under it.

My history of Korea is about one third done. I have finished the medieval period up to 1390 and from now on I shall give the history of the present dynasty in detail. The account of events that have taken place since 1863 alone would make a respectable volume but this I have of course condensed within reasonable limits. Some day I may attempt something on "The Opening of Korea" of which I have obtained all the material from eyewitnesses. The history will run through this year and next so far as I now know.

Many thanks for noticing my paper in the Nation.[105] It should be of substantial benefit to me. I find that the second year shows very few falling from

---

[103] In letterhead: The Korea Review.

[104] Puyŏ was the capital city of Paekche (18 B.C.E.–660 C.E.) from 538 to 660, during which time it was called Sabi. Today, Puyŏ-gun is a county approximately eighty-nine miles south of Seoul, in Ch'ungch'ŏng-namdo, southwestern Korea.

[105] "The other side of the shield is shown in the paper on 'Korean Survivals,' by Prof. H. B. Hulbert, who declares that, so far from Korean life being a replica of that in China, 'the points of similarity with the Chinese are the exception, and that the survivals of things purely native and indigenous are the rule.'" "Notes," *Nation*, September 19, 1901.

156 LETTERS FROM MISSIONARIES

my mailing list while many are being added. On the whole I think I may venture to call it a financial success, perhaps because the public thinks that anything is better than nothing. I must be acknowledged that it is a one man paper. Appenzeller and Jones[106] are in a sense my colleagues on it but they do no writing being both overburdened with other work. Everybody is consumedly busy and would rather read what I write than help me write it. But even this severe handicap does not seem to affect the circulation much. I am just finishing a ms on "A Search for the Siberian Klondike"[107] with copious illustrations. It relates the curious experiences of a friend of mine for two years in far northern Siberia who handed his notes and pictures to me to work up. I think it will "go", myself though such things are always problematic. I wish you all success in your many and important literary ventures. I have a story coming out in the Century shortly which you will see.

Yours very sincerely,
**H. B. Hulbert.**

I will do my best for you about photographs.

### 18) Aug. 29, 1902

**Seoul, Korea**[108]

Dear Dr Griffis

Your card is before me. The summer vacation and consequent disorganization of my study table has worked havoc with my mail. I shall begin now to keep my promises, I trust. I send herewith the Jan. Review and the photogravures. I thought the latter had been sent. There are several daily papers published in Seoul. Two by Koreans and one by the Japanese.[109] Also one in Chemulpo.[110] Dr. Jaisohn[111] resumed medical practice in U.S. & is living at Primos, Del. Co. Pennsylvania.[112] It would be hard to tell how many Korean students are abroad now. There may be a dozen in U.S. and half that number in Europe. In Japan there are thirty or more. Portraits of all the sovereign of the present dynasty exist but are not visible by the public. Your suggestion as to article on extant memorials of Korean art is a good one but as Korean art is

---

[106] George Heber Jones (1867–1919).

[107] Homer B. Hulbert and Washington Baker Vanderlip, *In Search of a Siberian Klondike* (New York: The Century Co., 1903).

[108] In letterhead: The Korea Review.

[109] *Hwangsŏng Sinmun* (1898–1910) and *Cheguk Sinmun* (1898–1910) were Korean-language daily newspapers published in Seoul. *Hansŏng Sinbo* (1895–1906) was a Japanese- and Korean-language newspaper run by the Japanese government and published in Seoul.

[110] Chemulp'o (now Inch'ŏn).

[111] Philip Jaisohn (Sŏ Chae-p'il; 1864–1951).

[112] Primos, Delaware County, Pennsylvania.

at best a 16th rate affair, I deem it better to wait till subjects of greater actual interest are disposed of. You will be surprised to learn what a dearth there are of contributors to the Review. Nor am I the only sufferer. The Korea Branch of the R.A.S.[113] can get no articles from anybody. The only people here competent to handle subjects exhaustively are all missionaries and they put other duties first. My magazine has not an enemy in Korea and all support me heartily in subscriptions. I shall clear a thousand or more this year; but they won't write. So I do it myself as you see. I have a ms of my own on the relics of Kyöngju (capital of Silla)[114] in my drawer over a year waiting for Mr. Engle to write me something better on the same subject but I receive nothing as yet. I have a long article on treaty relations with Japan taken from a rare work on that subject. It settles the question as to Japans supposed superiority. I have not been able to tuck it in anywhere yet. You say, of course, that such would be much better than some of the weak stuff I put in but there are many tasks to consult. I have frequent appeals for more folklore or for more news or more this and that. I make a monthly hodge-podge and let it go at that. Anybody that is willing to give the time is welcome to the job. I could spend the time much more profitably writing for some periodicals. I hope by the time you get this my story will be out in the Century. They have held it three years and have just paid for it. So I hope it will not be posthumous after all. My brother Archer[115] has published a novel "The Queen of Quelpart"[116] which you may see. He was out here a year.

I trust you will not consider my review of your New England article of Korea unfair.[117] The honest reviewer must eliminate the personal element, otherwise I should have said only the pleasantest things. After all my strictures were only incidental points.

I am still holding that money you sent but I have not struck anything would care much for. I wish you could give me a little more explicit directions as to what you want. I shall be happy to get what I can provided I run some chance of pleasing you with my choice. I can tell you in advance that there is mighty little to get here in the way of photos outside the regular trade pictures that everybody has.

I shall be in America next June in all probability to accompany my father to Dartmouth[118] to attend his 50th Anniversary of graduation. I am thinking

---

[113] The Korea Branch of the Royal Asiatic Society (RASKB; est. 1900).

[114] Silla (57 B.C.E.–935 C.E.) was a kingdom located in southeastern Korea, one of the Three Kingdoms along with Koguryŏ and Pakeje. Its capital city was Kyŏngju, now a city in Kyŏngsang-bukto.

[115] Archer Butler Hulbert (1873–1933) was a historian, geographer, and writer. He was in Korea to help edit *The Independent* (*Tongnip Sinmun*; 1896–1899) from 1897 to 1898.

[116] Archer Butler Hulbert, *The Queen of Quelparte* (Boston: Little, Brown and Company, 1902)

[117] Homer B. Hulbert, "Review," *Korea Review* 2, no. 7 (July 1902): 304–306; William Elliot Griffis, "Korea, the Pigmy Empire," *New England Magazine* 26 (1902): 455–469.

[118] Dartmouth College (est. 1769).

158     LETTERS FROM MISSIONARIES

of preparing a model of Yi Sun-Sin's Tortoise boat[119] the first ironclad (1592) for exhibit at the St. Louis Fair.[120] I have all the specifications pictures etc. etc. I should rather like to be appointed foreign Secretary to the Korean Commission to that exhibition. Little hope of it tho.

I would like to be living in the U.S. while these stirring days are passing but I keep track of what you are all doing. I seem to be fixed here for another five years. I shall probably not stay it out.

With many regards,

Yours sincerely
**H. B. Hulbert.**

### 19) **Oct. 22, 1902** [Postcard]

**Seoul**
Rev. W.E. Griffis D.D.
Ithaca, N.Y.
U.S. America

Dear Dr Griffis

Your card came some time ago. I fear I have been negligent about the pictures but nothing new has turned up lately and as some of the pictures of my set of photogravures were sold out I have sent to Japan to get some more & will forward them as soon as I can.

Dr. Baelz[121] of Tokyo gets it back at me very neatly for saying that you spell Korean names in a Japanese way by charging me with spelling Japanese names in a Korean way! I fear the stricture is just. He handles my Dravidian original theory pretty roughly as you will see in the October Review.[122] One of these days I shall publish a careful comparison of Korean and the Dravidian languages. Have you seen my brother's novel "The Queen of Quelpart" just out by Little Brown & Co of Boston?[123]

Yours cordially,
**H. B. Hulbert.**

---

[119] Yi Sun-sin (1545–1598) was a Korean admiral and military general who led successful battles against the Japanese Navy during the Imjin War (1592–1598). The *Kŏbuksŏn* ("turtle ship," named for its characteristic deck cover, spikes, and dragon-shaped head) was a warship used in his battles.

[120] The Louisiana Purchase Exposition (Apr. 30–Dec. 4, 1904), or St. Louis World Fair, was an international exposition held in Forest Park in St. Louis, Missouri.

[121] Erwin Otto Edward von Baelz (or Bälz; 1849–1913) was a German ethnographer, physician for the Japanese imperial family, and professor at Tokyo Imperial University (now the University of Tokyo's Faculty of Medicine; est. 1877).

[122] Erwin O. E. von Baelz, "Correspondence: The Origin of the Korean People," *Korea Review* 2, no. 10 (October 1902): 440–446.

[123] Archer Butler Hulbert, *The Queen of Quelparte* (Boston: Little, Brown and Company, 1902)

## 20) Dec. 5, 1903

## Seoul

Dear Dr Griffis

I have no good excuse to offer for not writing to you before but I will do the best I can. In the first place about the money of yours that I hold. I have had no opportunity to get hold of any special photographs. You see from the Review that I can procure for myself only the regular line of pictures. Now if you want me to make as good a selection as I can of the pictures on the market let me know and tell whether you want pictures of scenery, public buildings, prominent individuals, costumes, customs, industries or what not and I shall be glad to get them but as for very special or unique pictures they are so hard to get that I am discontinuing illustrations in 1904. If I cannot get them for myself of course then I cant get them for you much as I should like to. I was in America during June and July and passed your place on the N.Y. Central three times but could not stop. While at home I read the proof of "A Search for a Siberian Klondike" Century Company, which you may have seen. I had a little story in the July Century and am now at work on a Serial story at the request of Mr. Gilder.[124] It will be located in the island of Quelpart[125] and will bring in more or less Korean life customs & superstitions.

I am also ready to make the final copy of my Comparative Grammar of Korean Japanese and the Dravidian languages of India.[126] But time flies and it is almost impossible to get things done. The Century Co has asked me for a book on the Far East in general but I am not well qualified to write such a book even if I had time. Have you seen Gulicks book on Japan?[127] I call it a masterpiece.

I hear that you have left the pastorate and are devoting your time to literature pure and simple. I am horribly tempted to do the same but have no such qualifications for it as you have. Korea seems to be doomed to fall into Russian hands sooner or later and that will end my career here. I shall be glad if I have succeeded in giving the world a little information about this country. I have just published the history of the present Korean dynasty in Chinese 5 vols. 547 pp or rather leaves.[128] It sells here like hot cakes. The first lot of 100 sets from

---

[124] Richard Watson Gilder (1844–1909) was the editor of *The Century Magazine* (1881–1930) from 1881 to 1909.

[125] The "Isle (or Island) of Quelpart" was a European name for Cheju Island on the southwest coast of Korea.

[126] Homer B. Hulbert, *A Comparative Grammar of the Korean Language and the Dravidian Languages of India* (Seoul: Methodist Publishing House, 1906).

[127] Sidney Lewis Gulick, *Evolution of the Japanese: Social and Psychic* (New York and London: Fleming H. Revell, 1903).

[128] Hulbert arranged the publication of *Taedong Kinyŏn* (Shanghai: The American Presbyterian Mission Press, 1903), a history of the Chosŏn Dynasty in five books and five volumes, written by Yun Ki-jin (?–?) of the Foreign Office of Korea.

160     LETTERS FROM MISSIONARIES

Shanghai[129] went off in 48 hours and dozens of applications are filed waiting a new invoice for which I have cabled to Shanghai. I have heard some extravagant words about it all of which must be heavily discounted. You know the Koreans have absolutely no history of the last 120 years. I bring the history down to 1896.

I trust you and Mrs. Griffis[130] are well and your family. Kindly give them my best regards

Yours very sincerely
**Homer B Hulbert.**

**21) Jan. 8, 1904 [Typed Letter]**

**Seoul, Korea**

Dear Dr Griffis:-

Your nice note containing check for 1904 Review came this morning, for which many thanks. The copy of the Times that you mention has not come yet but will be along in a few days probably. I have word that an Angus Hamilton has published a book on Korea in London.[131] He was here about two weeks! He writes me that he has used material from the Korea Review but has given me credit in his preface. I shall be anxious to see just how much he has used the Review, for he could have gotten very little material at first hand. I rather think it will be a recasting of Review matter in which case no acknowledgement in the preface would be a valid excuse, and after looking it over I shall tell the truth about it. You gave no indication in your note as to what the World that you were sending contained. I wonder if it was a review of that book. I suppose you have not seen My "In Search of a Siberian Klondike" yet. Mr George Kennan[132] has said some very pleasant things about it which the Century Company have forwarded to me. We are in the midst of exciting times out here and today is something of a culmination. I hear that the King[133] is coming around and that the government will soon assume a friendly attitude toward Japan. If so all will go well for Korea, I believe. I have been in consultation with the many of the Korean officials and with the Japanese Minister and there are good days ahead for Korea yet. Reports from Tokyo this morning indicate that war is practically inevitable unless Russia backs down completely. Japan will consent to no arrangement that gives her power in Korea but still leaves the Russian fleet in Eastern waters and Manchu-

[129] Shanghai, China.
[130] Sarah Frances King Griffis (1868–1959).
[131] Angus Hamilton, *Korea* (London: W. Heinemann, 1904).
[132] George Kennan (1844–1923) was an American correspondent of the Russo-Japanese War (1904–1905) for *The Outlook* (1893–1928), a weekly magazine published in New York, New York.
[133] King Kojong (1852–1919; r. 1864–1907).

ria in the grip of Russia.[134] I believe Japan has better backing in this than is generally suspected. But I believe that Russia will back down at the last moment. It is just a game of bluff and Russia loses. Her officers have gone a step too far in the bluffing process and Japan has "called her hand" which is a distinct diplomatic defeat for such a country as Russia. I have seen a good deal of Russian dealings and methods out here and I consider them to be distinctly Asiatic. Many thanks for your suggestion about proposing my name as one to write about Korea. I have not traveled in the country as much as some but I think I have a fairly accurate knowledge of country conditions. Perhaps I have absorbed this during the long years of my banishment to these regions. With the change that is now imminent in the Korean government will come a much larger opportunity to do something for this people in a sphere rather higher than that in which I now move. But I will let you know of these things later. I am sorry to say that this change can hardly be effected without some violence on the part of Korean officials. Two men in power today are doomed and can hardly escape the doom which they have merited. I have said all I could to avert trouble for them but it is generally felt that they must either secretly get out of the country or the Korean people themselves will mob them. They have sold themselves to Russia and now that Russia has no more use for them she throws them off. That has always been Russia's way here. That is the way she treated Kim Hong-nyuk[135] and Kim Yong jun[136] and that is the way she will treat any oriental. Well, I have wandered on unconscionably but you will excuse my garrulity. Whatever telegrams you see in the papers from Korea and coming through the Associated Press are from me.

With best regards to yourself and your family,

Yours very sincerely

**H. B. Hulbert.**

---

[134] The territorial dispute between Japan and Russia over Korea and Manchuria (the northeastern region of China bordering Russia and Korea) was among the causes of the Russo-Japanese War (1904–1905), declared on February 8, 1904, following a Japanese attack on the Russian Far East Fleet at Port Arthur (now Lüshunkou), China.

[135] Kim Hong-nyuk 김홍륙 (?–1898) was an interpreter (Korean and Russian) for the Korean government from 1894 to 1898. In 1895, he interpreted during treaty negotiations between Russian diplomat Karl Ivanovich Waeber (1841–1910) and Yi Pŏm-jin (1852–1911), Korean minister to Russia. In 1896, he interpreted for King Kojong and Waeber during the king's exile to the Russian legation. He was executed in 1898, accused of involvement in an attempted poisoning of the king.

[136] Kim Yŏng-jun (?–1901) was executed for illegally selling the construction rights of Wŏlmido (an island in present-day Inch'ŏn) to Japan. Hulbert writes of him in the *Korea Review*: "This year 1900 was the heyday of another parvenu in the person of Kim Yung-jun. He was a man without any backing except his own colossal effrontery.... Even the fate of Kim Hong-nyuk did not deter him, though his case was almost the counterpart of that victim of his own overweening ambitions.... [I]t was not until the opening of the new year 1901 that he was deposed, tried and killed in a most horrible manner. After excruciating tortures he was at last strangled to death." Homer B. Hulbert, "Korean History," *Korea Review* 4, no. 10 (October 1904): 467.

## 162 LETTERS FROM MISSIONARIES

**22) Jan. 18, 1905**

**Seoul**

Dear Dr Griffis

Your note has just come and also from G. P. Putnam's Sons.[137] I feel very much complimented by this proposal. They do not say that they really want a book on Korea but ask if I would furnish it in case they do decide to print one. I am at work on a book on Korea for the Century Co which they have already accepted and so of course I am not at liberty to accept the proposition of the Putnam Company much as I should like to do so. I am grateful to you for your recommendation of me to them and am only sorry that I cannot respond.

I am getting to the end of my "Comparative Grammar of Korean and the Dravidian Languages," and shall put it out this year. The work that I have already done in Korean Folk-lore will be thrown together revised and supplemented by some comparative studies and appear, if I can find a publisher. I am so crowded with work "on the stocks" that there is danger of not being able to launch any of them. The Korea Review is to continue after all. I am putting out 300 sets of my History of Korea in 2 vols 800 p. for circulation in the Far East only. I shall send a copy home and ask some publisher if he would like to have it condensed for publication there in a single vol. Libraries ought to take such a book I should think and there are enough libraries to make it pay. I should like your advice on this point. I gave your note about the new edition of your book complete in the last Review. I have just been over the Seoul Fusan R.R.[138] and am sending an account of it to "Worlds Work"[139]

I have sent a long article on Quelpart to the Am. Geog. Soc. which would perhaps interest you.[140] I do not know when I shall be able to finish the Serial Story which Mr. Gilder has asked for but it is partly done & will come out in the Sweet bye & bye. I live in a state of chronic literary congestion. I wish I knew some remedy for it.

With very many thanks and with best wishes

Yours sincerely
**H. B. Hulbert**

---

[137] G. P. Putnam's Sons (est. 1838) is a publisher based in New York, New York.
[138] The Seoul-Pusan Railroad, or Kyŏngbu Railroad.
[139] *The World's Work* (1900–1932) was a probusiness monthly magazine published in New York, New York..
[140] Homer B. Hulbert, "The Island of Quelpart," *Bulletin of the American Geographical Society* 37, no. 7 (1905): 396–408.

## 23) July 3, 1905

### Seoul

Dear Dr Griffis,

Your note came a few days ago and I hasten to reply. I rejoice with you in the victory of Japan over Russia but I am sorry to say that with all my admiration for the Japanese I cannot take such an optimistic view of the situation as you do. You will read in the June Review some of my views on the situation. To sum it all up, I have been compelled to conclude, after a careful study of the Japanese, that however powerful they may be in war they are almost totally unable to undertake such a work as that which is now on their hands in Korea. The trouble is that they are still far too near the Koreans in the quality of their genuine civilization. It is wholly impossible for more than the very cream of the Japanese to look upon the Korean with the magnanimity with which an Englishman looks upon the Indian or the Egyptian. I tell you what is strictly and demonstrably true that the average Japanese who have come to Korea are far below the average Korean in enlightenment. I thoroughly believe that the Japanese officials in Korea, with hardly an exception, are constantly taking large bribes from the most corrupt Koreans to prevent justice taking its proper course.

I know that there is no possibility of redress for a Korean against a Japanese. I could quote you case after case with particulars in which Koreans have been kicked out of the offices of Japanese Consul and justices when they have appealed for justice. If it were merely that thousands of Japanese ruffians had swarmed into the country and that the Japanese are unable to cope with them as yet there would be some excuse but the fact is, a fact which I have demonstrated personally, that even in cases where it would be easy to give justice no attempt whatever is made to do so. Within the past fortnight Min Young-jun,[141] the most corrupt official here, who has fattened off the people and gorged himself with stolen wealth, has paid ¥20000 to secure [immunity?] and today it is impossible for Koreans who have been robbed by him and who hold in their hands prima facie evidence of his guilt, even to obtain a hearing of their cases. The authorities have been bribed.

The trouble is that Japan is judged in America solely on the merits of a few high statesmen who have received a liberal education abroad. Those men are powerless to secure the accomplishment of their better purposes in Korea or elsewhere simply because there is no considerable body of middle class officials

---

[141] Min Yŏng-hwi (born Min Yŏng-jun; 1852–1935), a member of the Yŏhŭng Min clan, was appointed minister at five of the Six Ministries (Civil Service Affairs, Rites, Penal Affairs, Military Affairs, Public Works) and mayor of Seoul between between 1890 and 1894. He requested military intervention from Qing China during the Tonghak Peasant Revolution (1894) and was a pro-Japanese collaborator during the Japanese occupation of Korea, holding the title of viscount in the Japanese House of Peers.

## 164  LETTERS FROM MISSIONARIES

enlightened enough and brave enough to call their own people to account. I say "brave" advisedly, for if the Japanese consuls and other officials in Korea should begin to bring the rascals to justice they would be murdered within forty eight hours. You can form no idea of the state of things here. Imagine ten thousand desperadoes from Texas let loose upon the streets of New York with us one who dared to tackle them or keep them within bounds and you will have some idea of things here. The missionaries throughout the country are a unit in saying that the common people are treated abominably by them. A gang of ten or more will come into a man's fields and stake out ten acres or more and say "these are mine" and if the Korean objects he is beaten insensible. If he appeals to the Japanese authorities he is told that "the matter will be investigated" but it never gets any further. You will think that I am prejudiced but I assure you that my attitude is mild compared with that of some of the more sensible and cool headed man have. Ask Underwood, ask Avison[142] and you will elicit replies far more radical than anything I have said. It is a well known fact that [better?] officers are likely to be the greatest martinets. So with the Japanese. They are not high enough above the Koreans to know how to treat them.

Well I must stop. Your many questions have not been answered but I will keep them in mind.

Yours Sincerely,
**H.B. Hulbert**

PS. My History of Korea 2 vols is out but there are only 300 sets in all and I shall dispose of all of these in the Far East except in the case of a few friends like yourself. When I dispose of these 300, as I soon shall, I shall revise and condense into a single vol. and try to publish at Home or at least publish for sale to libraries etc in Europe and America. I will send you a set shortly and you may remit the $5 to my Father Rev C. B. Hulbert D.D. South Dennis, Mass.[143]

These are great times here in spite of all. The Koreans are waking and taking hold. The attitude I assume in the Review will coin the hatred of the Japanese—at least those in Korea for they will listen to nothing but adulation. What an ass Pres. Jordan of Leland Stanford Univ.[144] made of himself when he said there is no such thing as "graft" in Japan!

Yours,
**H**

---

[142] Oliver R. Avison (1860–1956) was a Canadian Northern Presbyterian missionary and physician who founded and organized Severance Hospital (now Yonsei University Severance Hospital; est. 1885).

[143] Calvin Butler Hulbert (1827–1917) was a Congregational pastor and the president of Middlebury College (est. 1800) from 1875 to 1880. He lived in Dennis, Massachusetts, from 1904 to 1912.

[144] David Starr Jordan (1851–1931) was the founding president of Stanford University (est. 1885), whose official name is Leland Stanford Junior University.

## Hulbert, Homer B. (1892–1917)

### 24) Nov. 8, 1906

**Seoul**

[Note at top of the first page:] Do not take my word for it alone. Write to Johnston for his view of the situation. Write to Bishop Candler of the Southern Methodist Church.[145] Write to Mr James one of the Presbyterian Mission Board.[146] They have all been here and they know. They went all over this country.

Dear Dr Griffis—

Your note and your card came together. I am indeed pleased that you can speak so pleasantly about my new book.[147] I knew that my exposition of matters Japanese does not coincide with yours but I assure you that out of the whole body of missionaries in this country I have still to find one who does not agree with me in every essential point. And more than that a number of the missionaries in Japan have visited this country and without exception they have been forced to accept my view of the situation. Korea has been made a mere spoil of war and the world is beginning to find it out. If my book helps in disclosing the facts of the [?] I shall consider it a success. It is not pleasant to sit in the seat of the scornful but there are times when to keep silence is a crime. I was enjoying a fine position under the Korean government and if I had been complacent and had spoken nicely of the Japanese I could have enjoyed advantages that would have netted me a fortune. A partisan advocacy of the Japanese or even a quiescent attitude would have made me "solid" with them. The day before I left for America on my fruitless mission the Japanese Minister[148] came to me and offered me the most tempting prospect if I would give up my trip for he anticipated what my object was—I could not accept his offer, of course. The journey was undertaken at enormous personal sacrifice so far as mere money is concerned but it will be a lifelong satisfaction to know that I did what I could to help along the cause of what I believe to be justice. I am working night and day now trying to get some show of justice for Koreans who have been horribly wronged by Japanese. I have just succeeded in saving some $6000. worth of land for an aged widow lady of good family. It was being taken from her by Japanese trickery. Yesterday I succeeded in frustrating a $60,000. swindle that a Japanese was playing on an old gentleman seventy five years old. I am in the midst of a case where a Japanese has seized hundreds of acres of rice land in the country on the strength of forged deeds.

---

[145] Warren Akin Candler (1857–1941) was bishop of the Methodist Episcopal Church, South, from 1898 to 1934. In 1906, he had episcopal responsibility for Korea, Japan, and China.

[146] Perhaps James Scarth Gale (1863–1937)?.

[147] Homer B. Hulbert, *The Passing of Korea* (New York: Doubleday, Page and Company, 1906).

[148] Hayashi Gonsuke (1860–1939) was the Japanese minister to Korea from 1900 to 1906 and played a leading role in the signing of the Korea-Japan Treaty of 1905, which deprived Korea of its sovereign status and accelerated the Japanese colonial occupation.

The missionaries cannot touch these cases of course, but I am entirely independent and can injure no one but myself. Of course the Japanese hate me. They hate exposure and publicity. They hate all who do not speak smooth words about them. But I do not anticipate molestation of any kind. The Japanese know that any trouble they cause me will stultify them. I still affirm that Japan has no friend that wishes her greater success along all legitimate lines than myself. I do not have the least rancor against them. I fully believe they are laying up trouble for themselves by thin contempt of their own treaties. I look forward confidently to the time when Japan will be forced to hand over Korea to the Koreans. She never will do it voluntarily but she will be forced to do it.

We who live out here know something of the real feeling of the Chinese toward Japan and unless history belies itself Japan will sometime suffer the same humiliation that France did under Napoleon I and for identically the same reason. You say you hope I will not confine myself to political topics. Well, Dr. Heber Jones is back now & is going to give me some aid along general lines but I am frank to confess that the sole mission of the Korea Review today is to expose the heartless treatment of Korea and the Korean people by Japan. If you have the chance to meet Dr. Howard Agnew Johnston[149] ask him how things are going here. You will hear sharper things from him about the Japanese than you have ever read in the Korean Review. I am anxious that you should see things as they are. I look forward to the time when every honest man who has condoned the acts of Japan in Korea will be compelled to confess his error. I beg of you to examine the facts and do what you can to correct the wildly erroneous attitude of the American people toward Korea.

Pardon me if I spill over to another sheet of paper. You will be interested to know I am publishing the Hulbert Series of School Text books in Korean.[150] The first two will be out in a week or two. They are an elementary geography 5000 vols, a higher geography 5000 volumes, a history of Korea 5000 vols, a botany 2000 vols, a manual for study of English 5000 vols. All these are in press or under way, so you see I am not doing an entirely "kicking" business. I have come to the relief of the Korean Religion Tract Society[151] with an offer of Yen 10,000 to use in publication, which sum is not a gift, but is to be returned. I become, as it were, the publisher of the society. This I am able to do because of fortunate investments in real estate which I made years

---

[149] Howard Agnew Johnston (1860–1936) was a Presbyterian missionary, member of the Presbyterian Church U.S.A. foreign mission board, and pastor at Seventh Presbyterian Church in Cincinnati, Ohio.

[150] In 1906, Hulbert published the second edition of *Samin P'ilchi*, or *Geographical Gazetteer of the World*, a Korean-language social studies textbook. Its first edition was published in 1889, during which Hulbert was an instructor at Yukyŏng Kongwŏn (est. 1886).

[151] The Christian Literature Society of Korea (est. 1890) was a Protestant missionary publishing institution based in Chongno, Seoul. It was initially named "Korean Religious Tract Society" but changed its name in 1919.

ago and which, curiously enough, became valuable through the Japanese seizure of Korea. If I can help Korea in any measure with the money, it will be a case of compensation. I shall be pleased to see your review of my book. The critic will doubtless find flaws in the matter and in the style, but I will admit of no criticism of the motive.

Yours most cordially
**H. B. Hulbert**

**25) Jan. 2, 1911**

**Springfield, Mass.**

Dear Dr Griffis:-

Many thanks for your little brochure on the [Sage?] Memorial window and for the kindly thought which inspired it.

In regard to Korean historical material, the trouble is that it is far harder to get anything about the last 100 years than about any other portion of the country's history. I worked very hard to get hold of private ms histories of the 1392–1909 dynasty[152] and I am certain that no one else has had the time or the interest to do anything in Korean history. So far as I know I am entirely alone so far as any original research in that field is concerned. Not one word, so far as I am aware, has been written about the last 100 years of that dynasty except the Dallett's "Histories A'Eglise de Corea"[153] and of course, that says little about anything but church matters. A few weeks ago I got out my history of Korea (reprinted from the Korean Review)[154] intending to begin a condensation of it and to bring it down to a date for publication but libraries would be the only purchasers excepting for a few personal acquaintances. But I feel as if the history should be written out complete down to the end of things. Of course I do not think Korea is finished. She has just begun. She has taken hold of Western ideas by the opposite handle to that which Japan grasped and it is by no means certain that the future may not vindicate her in this choice nationally as well as socially. However, I feel that she has chosen the "better part" whatever her political future may be. I am sorry that I cannot indicate any possible historical sources. If I know of any I should be eager to get hold of them myself. In a French library there are many Korean works that ought to be read and digested but I have neither the time nor the money to do it—If I hear of anything I will be glad to let you know.

---

[152] Chosŏn (1392–1910).
[153] Claude Charles Dallet, *Histoire de l'Eglise de Corée* (Paris: Librairie Victor Palmé, 1894)
[154] The *Korea Review* (1901–1906) was an English-language monthly journal on Korean culture and affairs, edited by Hulbert and published in Seoul.

# 168    LETTERS FROM MISSIONARIES

I may be going to the Pacific Coast this winter for a lecture tour & if so I shall see Gen. Foote[155] again in San F.[156] and shall get from him what details I can about his brief incumbency at Seoul as U.S. Minister. Any help that I can give you in regard to events within my own observations I shall be glad to give.

Most Cordially
**H. B. Hulbert**

[At the end of the page:] (Over)

P.S. I see upon rereading your note that you ask for anything medieval & early Korea. I suppose you mean the dynasties preceding 1392. Nothing has been done nor can be done except by translating the ancient histories, the best one of which is the Tong-sa Chan-yea[157] a work in 9 vols in Chinese which I sold to the British Museum Library[158] in 1898. It is a perfect Thesaurus, but beside this there is the splendid Encyclopedia the Mun-hon Pi-go[159] in 112 huge volumes which I sold there in 1903. There is a perfect mine of information about almost everything Korean antedating 1500 A.D. If I had leisure & means I should like nothing better than to ransack that remarkable book. If translated entire it would equal the Encyclopedia Britannica in bulk! In Seoul I have a number of other works in Chinese that have not been looked into, Korean books of great value. Korea has had a great history. I suppose you have what I published in the Korea Review.

Yours,
**H.B.H.**

## 26) Oct. 20, 1917[160]

**Canaan Corn Farm**

Dear Dr Griffis:-

I was pleased to get your note and I wanted to call on you the other day when I was in N.Y. but did not get around to it. I should have liked to talk things over

---

[155] Lucius Harwood Foote (1826–1913) was the first U.S. minister to Korea, serving from 1883 to 1885. His appointment changed in 1884 from envoy extraordinary and minister plenipotentiary to minister resident and consul general. He and Allen resided in the U.S. legation behind Tŏksugung Palace in Seoul, in a traditional Korean house purchased from the Min family (family of Empress Myŏngsŏng). He was replaced by George Clayton Foulk (1856–1893).
[156] San Francisco.
[157] *Tongsa Ch'anyo* (1606) is a history of Korea written by Chosŏn-Dynasty civil minister O Un (1540–1617). It consists of eight books in eight woodblock-printed volumes.
[158] The British Museum Library (est. 1753).
[159] *Chŭngbo Munhŏn Pigo* (c. 1903–1908) is a compilation of documents on Korean customs, which was published by royal commission. It consists of sixteen treatises in 250 volumes.
[160] Date not written on the letter; it is from a memo by Griffis on the envelope arranged right after this letter in Hulbert's folder.

Hulbert, Homer B. (1892–1917)    169

with you. Some things were done at the Conference in Washington that have never been given publicity.

I printed privately 300 sets of the history of Korea and they were all gone years ago. You can find it in the N.Y. Public Library[161] but I fear there is no way to buy one. I want to take that book, condense it, bring it down to date & print it but fear no publisher would risk his money on it now that Korea is politically extinct; but I have reason to believe that this extinction will not be permanent & some time I may carry through my plan.

With very best wishes

Cordially

**H. B. Hulbert.**

I am away all the time & so out of touch with things in Springfield[162] that I cannot say now whether an opening can be made for you there but I will look into it.

H

## 27) Oct. 25, 1917

**Springfield, Mass.**

Dear Dr Griffis—

I was glad to hear from you. I agree that the lecture business is in a bad way unless one has had the chance to be in the war zone. I have been doing some lecturing at Army Camps under the Y.M.C.A. without pay! I had a pretty full summer in Chautauqua[163] work but have practically nothing for the winter. I trust that in the South you will be able to find some work—In these days one may well envy the day laborer who has more work to do than can be done. I see that Japan has declared a Monroe doctrine for the Far East.[164] Well, time will tell whether she can carry through the program. For my part it looks like unmitigated presumption.

In regard to the foreigners who helped Japan I shall be very glad to help you. I do not know much about some of them but will tell what I can.

You are well aware that Von Mollendorff[165] was the first Commissioner of Customs. He left Korea before I went there. He organized the Service[166] as an

---

[161] New York Public Library (est. 1895).

[162] Springfield, Massachusetts.

[163] The Chautauqua Movement promoted adult education, self-improvement, and civic involvement. It grew into a nationwide movement in the mid-1910s, then saw its decline in the 1930s.

[164] The Monroe Doctrine was a U.S. foreign policy opposing European and U.S. interference in affairs in the Western Hemisphere. The doctrine was articulated in 1823 under U.S. president James Monroe (1758–1831) and invoked in 1865.

[165] Paul Georg von Möllendorff (1847–1901) was a German linguist, commissioner of Korean Customs, and founder of Tongmunhak (1883–1886), Korea's first interpretation and translation school.

[166] Korean customs service (Chosŏn Haegwan).

170 LETTERS FROM MISSIONARIES

independent one—independent from China but Yuan Shi-Kai[167] managed to get that changed and the Chinese Customs Service took over the whole business, with Henry F. Merrill[168] at its head. Associated with Von Mollendorff were a number of English and Germans. These gentlemen mostly remained in Korea after Von Mollendorff left and occupied themselves in various ways. A Mr. Hallifax[169] had charge of a school for English interpreters for two or, three years and did very charitable work.

Judge O. W. Denny,[170] formerly U.S. Consul Gen'l in Tien-Tsin was made advisor to the foreign office in 1885 and was an able and conscientious friend of Korea. He was hampered at every turn by Yuan Shi-Kai and his entourage who were sent [sic. read have set] upon undoing the mistake that China felt she had made in recognizing the independence of Korea. It is very unfortunate that Judge Denny received little if any support in his work from the U.S. Legation. There was always an intense jealousy between him and the occupation of the Legation which left him single-handed to accomplish an impossible task. The Chinese finally succeeded in securing the dismissal of Judge Denny. He was succeeded by Mr. Greathouse[171] whose powers were somewhat curtailed compared with Judge Dennys. He was not able to do anything for the Korean Gov't. although he was an able man. Later he fell into such an alcoholic condition that his usefulness was gone and he died of the effects. (I am telling you these facts—not for publication—of course but for your own information). In 1886 Messrs Gilmore, Bunker & Hulbert[172] went to Korea to start the gov't school. At first it handled young men of the nobility but this proving unsatisfactory the school gradually took on views of less political prominence but of more enterprise. After two years Mr. Gilmore, for family reasons, returned to America. In 1891 Mr. Hulbert, because of the reactionary character of the gov't and its neglect of educational interests resigned and returned to America.

[167] Yuan Shikai (1859–1916) interfered in Korean diplomatic affairs as commissioner of the Qing dynasty in Seoul from 1885 to 1894. He was president of the Republic of China from 1912 to 1915 and from March to June of 1916, and emperor of China from 1915 to 1916.
[168] Henry F. Merrill (1853–1935), an American customs officer, succeeded Paul Georg von Möllendorff as the second commissioner of Korean customs.
[169] Thomas E. Halifax (?–?) was a British telegraph operator and sailor prior to his teaching appointment at Tongmunhak.
[170] Owen Nickerson Denny (1838–1900) was an American lawyer, U.S. consul general in Tianjin and Shanghai, China, between 1877 and 1884, adviser to the Korean ministry of foreign affairs from 1886 to 1891, and author of China and Korea (Shanghai: Kelly and Walsh, Ltd. Printers, 1888).
[171] Clarence Ridgley Greathouse (1846–1899) was an American legal adviser to the Korean government. He led the investigation of the assassination of Empress Myŏngsŏng on October 8, 1895.
[172] George William Gilmore (1858–1933), Dalziel A. Bunker (1853–1932), and Homer B. Hulbert were American educators and missionaries dispatched to Korea in 1884 upon King Kojong's request. They taught at the royal academy, Yukyŏng Kongwŏn (est. 1886).

## Hulbert, Homer B. (1892–1917)    171

Meanwhile three American military men—Gen Dye, Col Nienstead & Col Cummings [*sic* read Cummins],[173] were employed to drill the Korean Army. They did good work but were badly hampered by the unprogressive character of the gov't and lack of active support by the U.S. gov't.

Another American had charge of a gov't farm but little was seen of him. I never met him and the project failed for the same reason. I think his name was McKay or something like that.

About 1892 Gen LeGendre[174] came to Korea as adviser to the household. He had participated in Japan's expedition to Formosa.[175] What he did in Korea or what his work was no one seems to know.

In about 1894 Mr. Bunker resigned from the Gov't School and Messrs Frampton, Hutchison and Halifax[176] took over the school. They were English.

In 1897 Hulbert reentered the gov't services in charge of a normal school. This was during the time when I [went?] Brown had charge of the Customs Service and was doing much to rehabilitate the Country. Philip Jaisohn,[177] a naturalized American Citizen of Korean birth, had returned to Korea and am publishing the first newspaper there and, as adviser to the gov't., was doing much to get things on their feet. Mr Brown[178] had the finances of the country well in hand and things looked bright for Korea—but the Russian influence was strong because of the Japanese assassination of the queen and the King's flight to the Russian Legation.[179] Later Mr. Hulbert was transferred to the Gov't College[180] from which he resigned in 1905 to go into the diplomatic service of the Emperor.[181] During the Russian period of influence a number of Russian and French were employed. A Mr Gorschalki[182] had charge of a mulberry plantation but it failed. A Russian[183] had charge of a glass proposition

---

[173] William McEntyre Dye (1831–1899), Ferdinand John Henry Nienstead (?–?), and Edward H. Cummins (?–?) were American military officials dispatched to Korea in 1888 upon King Kojong's request. They taught at Yŏnmu Kongwŏn (est. 1888), a Westernized military academy.

[174] Charles William Joseph Émile Le Gendre (1830–1899) was a French-American diplomat and military officer, an assistant in Japan's Taiwan expedition (1874), and an adviser to the Korean government from 1890 to his death in 1899.

[175] "Formosa" was an archaic Portuguese name for the island of Taiwan.

[176] G. R. Frampton (?–?), W. F. Hutchison (?–1901), and Thomas E. Halifax were appointed as professors at Yukyŏng Kongwŏn (est. 1886) in 1894 after Dalziel A. Bunker resigned.

[177] Philip Jaisohn (Sŏ Chae-p'il; 1864–1951).

[178] John McLeavy Brown (1835–1926) was the commissioner of Korean customs and financial adviser to the Korean government from 1893 to 1905.

[179] From February 11, 1896, to February 20, 1897, King Kojong was in internal exile at the Russian legation after the assassination of Empress Myŏngsŏng.

[180] Yukyŏng Kongwŏn (est. 1886).

[181] In 1905, Hulbert returned to the United States as an emissary of King Kojong.

[182] Albert Friedrich Gorschalki (1856–1917) was a German merchant who lived in Korea from 1884 to 1917 and ran a silkworm farm and mulberry plantation in Chemulp'o from 1889 to 1892.

[183] Government official and politician Yi Yong-ik (1854–1907) founded the National Glass Manufactory (Kungnip Yuri Chejoso) in 1902. The manufactory, supervised by a Russian technician (name unknown), was closed in 1904 during the Russo-Japanese War (1904–1905).

172 LETTERS FROM MISSIONARIES

that was foisted on the gov't—There was no glass sand in Korea. A Frenchman[184] took charge of the post office and did very good work considering his limitations.

A German school flourished for some years under the management of Mr. Bolljahn and a French school under Mr Martel. There was also a Chinese language school and a Japanese.[185]

All these schools went on with moderate success until the Japanese occupation but were never properly financed nor managed.

One of the most successful men under the gov't was a German[186], long in the employ of Japan as a band master, who came to Korea and in an extraordinarily short time equipped and trained a first class band—I cannot remember his name.

A Dane named Muhlensteth[187] was one of the first foreigner in Korea. He was engaged in building telegraph lines throughout the country. He lived in Korea upward of 32 years. He committed suicide in Seoul about two years ago.

For a short time, between 1899 and 1902 or 3, Mr. Sands,[188] upon retiring from the position of U.S. Secretary of Legation, was Adviser to the Household Dept. What he did, if anything, is not known.

For some time, a Mrs. Joly,[189] widow of a Brit. Consul in Korea, acted as tutor to the Prince, son of Lady Om[190]—but it is not known that she even performed the function of the office.

Collbran Bostwick & Co built the Electric Tramway[191] in Seoul in conjunction with the Emperor but as the latter failed to pay his proportion of this capital the Company took over the road.

---

[184] J.V.E. Clémencet (?–?), a French postal official, was hired by the Korean government in 1898 to organize a modern Korean postal service. In 1900, Korea became a member of the Universal Postal Union.

[185] Six foreign-language schools were established in Korea in the 1890s: Japanese (1891), English (1894), French (1895), Russian (1896), Chinese (1897), and German (1898) were taught in their respective schools, which were later merged into Hansŏng Oegugŏ Hakkyo (1906–1911). Johann Bolljahn (1862–1928) was an instructor from Germany who taught at the German school. Emil Martel (1874–1949) was an instructor from France who taught at the French school from 1895 to 1911.

[186] Franz Eckert (1852–1916).

[187] H. J. Muhlensteth (1855–1915) was a Danish engineer who helped build Korea's first telegraph system (between Seoul and Chemulp'o) in 1885.

[188] William Franklin Sands (1874–1946) was the first secretary of the U.S. legation in Seoul from 1897 to 1899, then adviser to King Kojong from 1900 to 1904.

[189] Clara Agnes Lillie Wilkin (1860–1928), wife of British consul for Korea Henry Bencraft Joly (1857–1898).

[190] Lady Ŏm, the highest-ranked concubine of King Kojong (1852–1919), was the mother of Yŏngch'inwang (1897–1970), Yi Ŭn. In addition to King Sunjong (1874–1926) by Empress Myŏngsŏng, King Kojong had the following children: Wanhwagun (1868–1880) by Lady Yi (1849–1928), Ŭich'inwang (1877–1955), Yŏngch'inwang (1897–1970), and Princess Tŏkhye (1912–1989).

[191] In 1898, U.S. businessmen H. Collbran (?–?) and H. R. Bostwick (?–?) of Collbran & Bostwick Co. acquired the construction rights to electricity distribution facilities (Hansŏng Chŏn'gi Hoesa; est. 1898) and waterworks in Seoul and built an electric tramway.

An English Company[192] was employed to build the water works for Seoul at a cost of $7,000,000 and their work was thoroughly successful.

These are all that I can think of at the moment. If you should look up the file of Korean Repository[193] and the Korea Review you would find out most of what you want to know.

I do not know whether this that I have written is what you want. If I can do more, let me know.

Very cordially
**H. B. Hulbert.**

---

[192] The waterworks company initially acquired by Collbran & Bostwick Co. in 1898 was sold in 1905 and became restructured as the British international syndicate Korean Waterworks Limited (Taehan Sudo Hoesa; est. 1905), founded by British civil engineer Hugh Garrat Foster Barham (1867–1954).
[193] *The Korean Repository* (or *Chosŏn Sosik*; 1892, 1895–1898) was an English-language monthly journal published in Seoul.

# 20 *Jones, George Heber (1894–1912)*

### GEORGE HEBER JONES (1867–1919)

George Heber Jones is known best as the first Protestant missionary to approach the study of Korean religions as an academic subject. Jones arrived in Korea in 1887, as the third missionary after Henry Gerhart Appenzeller and William Scranton. He started a number of academic journals, including *The Korean Repository* (or *Chosŏn Sosik*), the *Korean Review*, and *Sinhak Wŏlbo*. He compiled a Korean-English dictionary and wrote extensively about Korean history, culture, and religion. In 1892 he published the first Korean hymnal. From 1892 to 1903 he was in charge of forty-four churches in the Chemulp'o (today's Inch'ŏn) region. Jones encouraged many Koreans to move abroad to sugar plantations in the Hawaiian Islands. In 1907 he assumed the directorship of the Union Biblical Institute (or Hyŏpsŏng Sŏngkyŏng Hagwŏn 협성성경학원). Jones had a negative view of Korean society and was almost murdered after he praised the Japanese police's use of force on Koreans during the March First Independence Movement (1919).

### 1) June 18, 1894

**Chemulpo, Korea**
Rev. Wm. Elliot Griffis, D.D.
Ithaca, N.Y.

Dear Sir:—

Your kind letter of Mar 26th to hand. Please accept my best thanks for the words of appreciation it contains concerning my article on Japanese invasion of Korea in 1592.[1] Apropos it may be in order to say that Korea is the object at this writing of another Japanese invasion,[2] there being now in this port 3600 troops, in Sŏul 1200, in Fusan 2000 and in Gensan[3] 1000. It is also said that 5000 more are to come to this section. And no one outside of Japanese author-

---

[1] George Heber Jones, "The Japanese Invasion," *The Korean Repository*, January 1892, 10–16.
[2] In June 1894, the Japanese government dispatched troops to Korea to quell the Tonghak Peasant Revolution. Japanese and Chinese military involvement in this revolution would lead up to the First Sino-Japanese War (1894–1895).
[3] Wŏnsan, a port city in present-day Kangwŏn-do, North Korea (pronounced "Gensan" or "Genzan" in Japanese).

ities knows the reason of it all. I can simply say that the troops are here or still pouring in, and that one and all we are anxiously awaiting their next move trusting it will reveal the object of this mysterious visitation.

You may be interested in learning that the Korean Repository[4] will be resumed from January 1895 under the joint editorship of Mr. Appenzeller[5] and myself, provided of course no unexpected arises to interfere with this plan.

In reply to your questions I would state that 1) The historical literature is quite full & complete but outside certain common and printed works is hard of access. It is preserved in written or mss copies in private libraries. 2) The historical novel exists and is very popular in Korea. In the place of circulating libraries we have reading guilds. 3) The Koreans know little concerning the art of book illustration. 4) No signs whatever of a literary revival. 5) One of the last of the latest pamphlets on Korea is a short synopsis of the Decennial Customs report. It is expensive though—$11.50 = Yen.

I greatly hesitate to express opinions on most of the questions you send me for having looked into them somewhat from time to time I am convinced that it is very hard for even an expert to say much that is definite & trustworthy concerning Korea,—let alone myself.

With kindest regards

Believe me

Sincerely yours

**Geo. Heber Jones**

**2) May 10, 1895**

**Chemulpo, Korea**

W. E. Griffis, D. D.,

My dear Sir:-

I have long promised myself the pleasure of writing to you, but have been hindered by other pressing engagements. We are in the midst of exciting developments at the present, and hardly know as yet but another and far more severe storm of war and desolation may break over us. This grows out of the condition of affairs due to the Japanese Chinese war.[6] Japan has done

---

[4] *The Korean Repository* (1892, 1895–1898) was an English-language monthly journal published in Seoul.

[5] Henry Gerhart Appenzeller (1858–1902).

[6] The First Sino-Japanese War (1894–1895) was fought between Qing China and Japan over influence in Korea. Initiated by Chinese and Japanese military involvement in the Tonghak Peasant Revolution (1894), the war took place on Korean land and went on for nine months after the revolution itself ended. The war concluded with Japan's victory; China's cession of Taiwan, Penghu, and the Liaodong Peninsula to Japan; Korea's transferral into Japan's sphere of influence; and the signing of the Treaty of Shimonoseki (1895).

176 LETTERS FROM MISSIONARIES

far more than simply conquer a small span of Chinese territory. She has dragged China out of the obscurity of brag and arrogant and baseless presumption into this light of day. The China of one year ago, a monster in size, inexhaustible in resource, terrible in military array, and the dominant power of the Far East has been completely destroyed. The China of today is a nation without spirit, without prestige and almost I might say without hope, on the eve of being partitioned probably among foreign powers.

But as to that cloud of which I speak. As you know Japan has secured among other things Formosa and the adjacent islands, the Leau Tung Peninsula and Wei Hai Wei and announces her intention of holding the latter place and Port Arthur as military and naval bases, and proposes to erect an Asiatic Gibralta [sic read Gibraltar] at the Pescadores.[7] Russia, backed by the moral support of most of the European Powers objects in a most threatening manner, giving out that she does not want Japan in Manchuria.[8] Personally I am convinced that this is all a pretense and that the real reason lies in a feeling of alarm as to the possible future. The stipulations of Peace give Japan the military command of all China.

From Korea, Manchuria lies at her mercy; from Port Arthur & Wei Hai Wei she commands China, from Peking to the Yangtse,[9] for these places are the military gate to that great plane. From the Pescadores South China lies at her mercy. Her attitude as well as her frame of mind is a military one: China is going to pieces; insurrection and anarchy are sure to succeed the [cessation?] of actual hostilities, and the nation which holds the strongest position vis-a-vis China stands the best chance of falling heir to the powers of the Dragon Throne.[10] I therefore believe that Europe is alarmed, not so much at the amount of territory taken as at the the [sic] stratigetical [sic read strategical] position, military attitude and frame of mind the Stipulations put Japan in. She seems to be willing to brave everything, and Young Japanese would not hesitate at even national hari-kiri.[11] But we shall see in a short time. A telegram was posted here yesterday that the ratification of the Peace Stipulations, which should have occurred in Chefoo[12] on the 8th has been postponed until the 13th; what does it mean?

As for Korea the prospect is very bright. I am sanguine as to the future in store for the country under the present Administration. Japan is doing nobly

[7] The Leau Tung (now Liaodong) Peninsula on the northeastern coast of China; Weihaiwei (now Weihai), a port on the northeastern coast of China; Port Arthur (now Lüshunkou), on the tip of the Liaodong Peninsula; Gibraltar, a British Overseas Territory on the Iberian Peninsula; Pescadores (now Penghu), an archipelago on the Taiwan Strait.
[8] "Manchuria" is a loosely defined exonym referring to the northeastern region of China that borders Russia and Korea.
[9] Peking (now Beijing); the Yangtse (now Yangtze or Yangzi) River.
[10] The Dragon Throne (longyi) is a metonym for the Chinese monarchy.
[11] Hara-kiri, or seppuku, is a form of Japanese ritual suicide.
[12] Chefoo (now Yantai, China).

for the country; she is committing occasionally a couple of errors viz., she brings too much pressure to bear on the Gov't. at times i.e. carries measures by threat; and forbids the employment of American and European experts in the Dep'ts. of State. From these two positions she will have to back down eventually.

The Korean Repository is now an accomplished fact. It will give you in homeopathic quantities, facts concerning Korea. As editor I am naturally solicitous that it should please. I hope it does.

I shall be very happy to exchange personal photographs with you. The last picture of myself was taken about two years ago at the time of my marriage. I send you one of these for I have not changed materially since then, and it will serve to introduce you to my dear wife.

With kindest regards and best wishes, and trusting soon to see your "counterfeit presentment."

I beg to remain, my dear Dr. Griffis

Yours to command
**Geo. Heber-Jones**

**3) May 24, 1911** [Typed Letter]

**New York, N.Y.**[13]
Dr. William Elliot Griffis,
Ithaca, New York.

My dear Dr. Griffis,-

Continuous absence must account of for my delay in replying to your card inquiry of May 10th.

Rev. Mark Napier Trollope[14] severed his connection with the Church of England Mission in Korea some years ago, and is now settled in London as pastor of one of the parishes there. I do not know the name of the Church of England missionaries now located at Kangwha, but any inquiry concerning affairs there addressed to Rev. Mr. Badcock,[15] Church of England Mission, Seoul, Korea, would certainly reach its destination.

Cordially yours,
**Geo. Heber Jones.**

Mr. Badcock was stationed in Kangwha for a number of years.

---

[13] In letterhead: The Korea Quarter Centennial Movement, Methodist Episcopal Church, 150 Fifth Avenue, New York.
[14] Mark Napier Trollope (1862–1930) was a British Anglican missionary, chaplain to the Bishop of Korea from 1890 to 1902, vicar general from 1896 to 1902, and bishop from 1911 to 1930.
[15] J. S. Badcock (?–?) was a British Anglican missionary to Korea.

# 178    LETTERS FROM MISSIONARIES

**4) July 19, 1911** [Typed Letter]

**New York, N.Y.**[16]
Dr. William Elliott Griffis,
Ithaca, New York.

My dear Dr. Griffis,-

I am both surprised and delighted to learn that you plan to get out a book on "Appenseller [*sic* read Appenzeller] and Korea"[17] and shall be very glad to co-operate with you to the fullest possible extent. As you know, Appenzeller was a very dear friend of mine, and we spent years of the very closest intimacy. I shall be glad to put at your service anything and everything that I have. Will give the matter some thought and you will hear from me a little later. As you know, I am very much involved in the details of the present campaign in America in behalf of Korea, but will try to find time, and as things occur to me will jot them down, and send them on to you.

Just recently I wrote an article for the Epworth Herald,[18] giving an account of a trip which Appenzeller and I took to Wonju,[19] Korea. I enclose carbon, which you can keep for reference.

Most cordially yours
**Geo. Heber Jones.**

Enclosure.[20]

**5) Aug. 16, 1912** [Typed Letter]

**150 Fifth Avenue, New York City** [location from letterhead]

My dear Dr. Griffis:

Just a line to explain the great pleasure with which I have dipped into "A Modern Pioneer in Korea."[21] A copy reached me yesterday, and I have not had a chance in the midst of the busy engagements which have crowded the day to glance through it, but I have seen enough to know there is a rich feast ahead.

---

[16] In letterhead: The Korea Quarter Centennial Movement, Methodist Episcopal Church, 150 Fifth Avenue, New York.

[17] William Elliot Griffis, *A Modern Pioneer in Korea: The Life Story of Henry G. Appenzeller* (New York, Chicago, and Toronto: Fleming H. Revell Company, 1912).

[18] *The Epworth Herald* (1890–1940) was a weekly newspaper published by the Epworth League (est. 1889), a Methodist association for young adults.

[19] Wŏnju, a city in present-day Kangwŏn-do, South Korea.

[20] The enclosed article is not with the letter.

[21] Griffis, *A Modern Pioneer in Korea*.

*Jones, George Heber (1894–1912)* 179

Thank you for giving Korea the benefit of your facile and enchanted pen. More later.

As ever yours,
**Geo. Heber Jones.**

Rev. William Elliot Griffis, L.H.D.,

Ithaca, New York.

# 21     *Kerr, Grace Kilbourne (1916)*

## GRACE KILBOURNE KERR (1887–1985)

Grace Kilbourne Kerr was the wife of Reverend William Campbell Kerr, a missionary in Korea.

### 1) June 29, 1916

**Sorai Beach,**[1] Korea

My dear Dr. Griffis,

It was a great pleasure to hear directly from one with whom I have already been in closer touch than you evidently imagine. It is not infrequently that I hear parts of Alice Appenzeller's letters from home, and references to your various kindnesses are by no means lacking.

If you had not lived in the Orient yourself, you might find it hard to believe that I really started out to secure photographs such as you might use, very shortly after your letter came, but as it is, I trust that you will understand the number of obstacles and delays that have made this reply so late.

It was only about ten days ago that I received the prints that I am enclosing, (I'm sorry not to be able to command the corresponding negatives, but they are not mine) and it was yesterday that these other two in negative form were handed to me. Though I started the search for them, by letter, months ago.

I am relying on the fact that you gave no date for the article for the Missionary Review, to give me hope that these may still be of use to you,—if not for the purpose you had in mind,—at least at some future time.

I am very sorry to have to ask that the two negatives be returned, as they are not mine. They were both taken in Chai Ryung,[2] and you will readily recognize one as that of a woman, washing at a spring, and the other as two ironing women, who came out by request, into the street in front of their house, so that we could get the picture. You will find me standing at one side in this, and also in both pictures of the sight-see-ers in front of our house.

---

[1] Sorae P'ogu 소래포구 in Inch'on.

[2] Chaeryŏng 재령 in Hwanghae-do where a Presyterian church was built in 1895 by W. B. Hurst, C. F. Sharp, E. W. Koons, W. C. Kerr, H. C. Whiting, A. M. MacKee, and C. A. McCune.

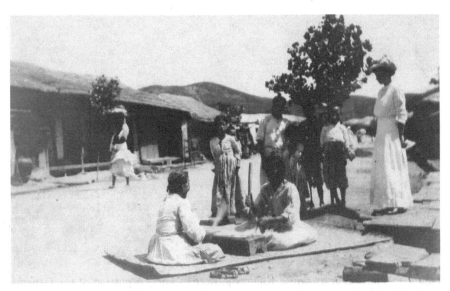

Figure 28 Photo sent by Grace Kilbourne Kerr in 1916. Two ironing women in front of their house, who were photographed on the street by request. Grace Kilbourne Kerr is standing on the right (KP 8.1.3, Griffis Collection)

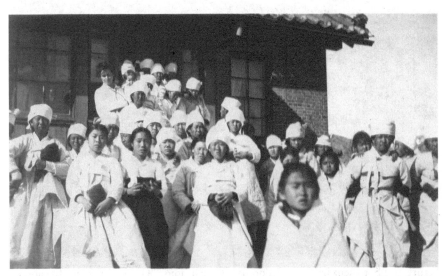

Figure 29 Photo sent by Grace Kilbourne Kerr in 1916. "Coming out after having 'seen heaven'- namely a foreigner's house from the inside and the baby!, Chairyung, Korea, 1916" (from the back of the photo) (KP 8.3.4, Griffis Collection)

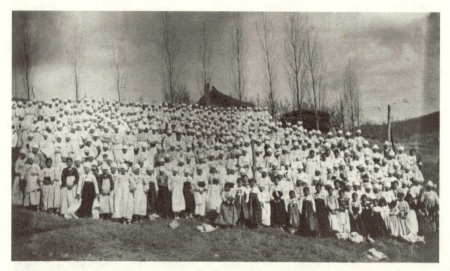

Figure 30 Photo sent by Grace Kilbourne Kerr in 1916. "A portion of the General Women's Bible Class in Chairyung, Korea, Spring of 1916" (from the back of the photo) (KP 8.3.5, Griffis Collection)

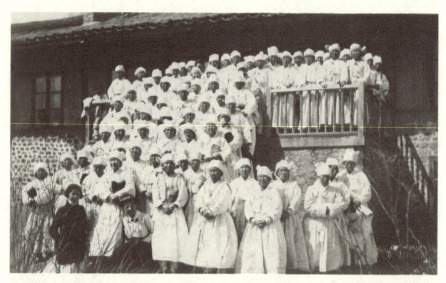

Figure 31 Photo sent by Grace Kilbourne Kerr in 1916. "The 'Old Ladies' division of the General Women's Bible Class in Chairyoung, Korea, 1916" (from the back of the photo) (KP 8.3.8, Griffis Collection)

*Kerr, Grace Kilbourne (1916)* 183

> Sorai Beach, Korea.
> June 29. 1916.
>
> My dear Dr. Griffis,
>
> It was a great pleasure to hear directly from one with whom I have already been in closer touch than you evidently imagine! It is not infrequently that I hear parts of Alice Appenzeller's letters from home, and references to your various kindnesses are

Figure 32 Grace Kilbourne Kerr's letter to Griffis, dated June 29, 1915 (first page) (Box 59, Folder 45, Griffis Collection)

It was most kind of you to give me encouragement toward writing, as you did. Though as yet it seems presumptuous for me to think of anything more than an occasional short article, whenever one is assigned to me!

We are building a small summer cottage here, on the West Coast and when that is completed, there will be more chance of the nurse's working,

## 184 LETTERS FROM MISSIONARIES

than in Chairiyung, where anything that I write is more apt to deal with the home, life of the missionary than of the people among whom she is supposed to be working! Here one gets away from the heavier housekeeping cares, and one's soul has an opportunity to expand.

My warmest appreciation of your kindness in writing as you did.

Very sincerely,
**Grace Kilborne Kerr.**

# 22     *Kerr, William Campbell (1921)*

### WILLIAM CAMPBELL KERR (1883–1976)

William Campbell Kerr was a missionary in Korea through the Presbyterian Mission at Seoul. Kerr became the pastor of the Seoul Union Church in 1928, following the footsteps of Henry G. Appenzeller and Horace G. Underwood.

1) **Apr. 29, 1921** [Typed Letter]

**On the train for Seoul**

My dear Dr. Griffis:-

You must have thought that you made a poor investment when you sent me that copy of Dr. Speer's[1] book last year. I had no idea that I should be so dilatory about sending you material. Doubtless the trouble was that of waiting until I could prepare something elaborate. An occasional sending of something less pretentious would have been a wise way.

Even now I have nothing elaborate to send you. I am on my way home from an extended itinerating trip in the south, and so I am free from interruptions for a while as I shall not be after I get home. So let me just write you an ordinary letter, and see if I can tell you something that may be of help to you.

Last spring, when your letter came, I was very busy getting ready for my last language examinations. Then came a busy summer in Karuizawa,[2] complicated by a bad case of whooping cough on the part of our little boy. This was followed by a return to Chosen, and moving from Chairyung up to Seoul. It was the first time we had seen our own household effects for almost four years. Settled in Seoul, we were immediately face to face with the work and opportunities of the new position. I had made it my policy to undertake nothing to which I had not had at least a tacit invitation. There was plenty of time for allowing circumstances to shape themselves, for I still had language study to do. But the invitations came in such a hurry that the time for language study was narrowed down more and more. The moderator of Presbytery asked me to go with him to an itinerating trip among some of the country churches which were having no regular supervision, and so that opened up

---

[1] Robert Elliot Speer (1867–1947), an American Presbyterian leader and an expert on missions.
[2] A town in Nagano Prefecture, Japan.

186    LETTERS FROM MISSIONARIES

itinerating work to me. I am now finishing the trip which has taken me to the last of the places where the work of the Nihon Kirisuto Kyokwai is carried on in this country.

One trip is hardly enough to base very extensive conclusions upon. But one is that the country is quieter than it has been for some time, tho surface indications are not sufficient to tell about what lies underneath. In the south there was less trouble than in the north from the very first, and there I found the relations between the two peoples more advanced than elsewhere. The opinions of the Japanese Christians were rather freely expressed, and they were not by any means sympathetic toward some of the policies that have been carried out in the country before this. It does seem to me that a spirit is abroad, and, while there are still many things to correct, the higher officials are certainly desirous of correcting the wrong conditions as much as possible. It is with the under officials that much of the present trouble lies, and it is the Korean policemen, even more than the Japanese who keep doing the little things that keep up the friction. As the chief of the Police Bureau told me, it is not an easy thing to make perfect men out of the 20,000 men on the force. Many of them had the ideas of the old regime pretty well ground into them, and it is hard to get them away from that attitude to something better. Of course, the Koreans' hopes have been raised so high and their demands have gone so far that it will be almost impossible to satisfy them. But, while the desire still remains deep-seated, these Koreans at home realize conditions as they are, much better than do the malcontents on the outside.

The moderator of Presbytery, who is pastor of the principal church in Seoul, while out on that trip to the country churches, had in his baggage a well-thumbed and marked English edition of the Confessions of St. Augustine. He pointed out some of the passages, and told me that they fitted in so well with his own experience that he had read them over and over. Then he told me his story.

He was the son of a physician whose thinking was largely materialistic. The son was an apt scholar, and the praise bestowed on him by teacher and parents was enough to turn his head. He rather slacked up on his studies, and began to go in fast company. After a time he realized that this sort of life was not getting him to anything useful, and so he tried Buddhism and Confucianism in turn, finding each of them unsatisfactory. The unsolved problem of the universe was weighing heavily on him by that time, and he felt that if there was no solution to be had there was nothing for him but suicide. About that time one of his friends in Tokyo (he himself was studying in Kanazawa) became a Christian and urged him to do likewise. But he was prejudiced against the new religion, and rather urged his friend to give it up. This the friend agreed to do if he could show him anything in the religion itself which made it worthy of being discarded. So just to find this point he began to study, and before he knew it the appeal of the Gospel message was making itself felt in his own heart. He came under the influence of some of the local missionar-

ies, and made his decision. When it came to the matter of his life work, he had another hard battle. One of the missionaries handed him a pamphlet by Dr. Pieters,[3] and it was that which made him decide for the ministry. But he had already started on the law course of study, and could not well change over, so he continued with that course until he graduated, and then began on his theological training. Now he is in the ministry, in one of the influential churches. He and his friend are married to sisters; but the friend, who had brought him to Christianity, became a successful businessman and in his success has lost the faith which had lasted long enough, at all events, to change the destiny of the other. This pastor has been sending me his copies of the British Weekly, with suggestions as to the articles which he has found most helpful. He has also loaned me a volume of sermons by Dr. Alexander Whyte,[4] and this is almost as much marked as the copy of the Confessions. The marking shows the interest which is felt in the matter of individual sin. This marks the man off in a day when it is rather the sin of society which is receiving attention. Yet with all his reading, this man cannot converse at all in English!

After my experience with Korean workers, who have only a very limited library in their own language from which to draw, it has been very impressive to follow the experience of this Japanese pastor. Some day the Korean will rise to the point where the same advantages will be his. But, both of them, with far less than the American pastor has, and all manner of things in their environment to pull them down, are accomplishing a work of which the man of the West might well be proud.

Enough for the present. Perhaps you may take this as the earnest of more to come. I greatly enjoyed Dr. Speer's book, even if I did not tell you so at the time.

Very sincerely yours,
**William C. Kerr.**

---

[3] Albertus Pieters (1869–1955), an American missionary in Japan.
[4] Alexander Whyte (1836–1921), a Scottish preacher.

# 23 Loomis, Henry (Date unidentified)

## HENRY LOOMIS (1839–1920)

In 1861, while attending Hamilton College in New York, Loomis enlisted in the Union Army.[1] After the U.S. Civil War was over, Loomis decided to transfer to Auburn Theological Seminary in 1866. In his last year there, he decided to devote his life to mission work in Asia. In 1871 he traveled to Japan with his wife, Jennie Greene. They arrived in Yokohama, then a small harbor town. At a time when Christianity was banned and foreigners were≠ viewed negatively, Loomis was able to establish the first Presbyterian church in Japan in 1874. After Empress Myŏngsŏng (also known as Queen Min) was assassinated in 1895, Loomis was one of the two missionaries invited to the royal palace in Seoul.

1) [**Date not identified**] [Letter/Manuscript]

[**Location not identified**]

Corean Converts.

In the month of December, 1884 an attempt was made by the leading members of the Progressive Party in Corea to overthrow the Pro-Chinese or Conservative Party and establish a new and independent regime.[2] To accomplish their plans, the leading men in power were assassinated, and the scheme would probably have been successful had not the Chinese troops interfered and killed or driven away the Progressionists. Such of them as escaped fled to Japan, and arrived at Yokohama in January 1885.[3]

They sought the advice and help of some of the missionaries, and in April following three of the members went to America. One has returned to Japan and the other two still remain in the U.S.[4]

---

[1] A letter from Henry Loomis dated February 10, 1887, sent from Yokohama, is in the digital archive.

[2] The Kapsin Coup (Dec. 4–6, 1884) was a three-day coup d'état demanding domestic reform and independence from Chinese suzerainty. Led by Kim Ok-kyun (1851–1894), Pak Yŏng-hyo (1861–1939), Philip Jaisohn (Sŏ Chae-p'il; 1864–1951), and other progressive politicians of Kaehwadang, the coup began with the assassination of conservative and pro-Chinese figures at the Ujŏngch'ongguk opening ceremony, and the Qing Chinese military cracked down on it in three days.

[3] Nine Kaehwadang politicians, including Kim Ok-kyun, Pak Yŏng-hyo, Philip Jaisohn (Sŏ Chae-p'il), and Sŏ Kwang-bŏm, sought political asylum in Japan after the Kapsin Coup failed.

[4] Pak Yŏng-hyo, Philip Jaisohn, and Sŏ Kwang-bŏm left Japan and moved to the United States in 1885. Pak Yŏng-hyo returned to Japan afterwards, while Philip Jaisohn and Sŏ Kwang-bŏm remained.

On reaching Yokohama they knew nothing of the English language, and as to Christianity it was regarded in their own country as an uninvited evil and a curse to any land. Those of their own people who embraced it were put to death and its continuation in the country was only means of the greatest caution and constant deception on the part of the Jesuit Missionaries.

The leader of the party[5] had been twice to Japan and had learned that the strongest and most enlightened nations were Christians, and so had come to look upon the religion of Christ with favor and approval. His influence disposed the others to inquire into the subject and to look upon Christian teachers as friends.

Those who went to America took letters to a prominent Christian man in San Francisco[6] and through his kind assistance they have been cared for and instructed.

The youngest of the party[7] had studied military science in Japan and was placed at the head of a military school in his own country. I have received letters from him very frequently and the following are some extracts. At the time of writing he had been in America only about one year and had studied English a little longer.

"Dear Mr. Loomis,[8]

I received your letter of March 10th on yesterday. I am glad you are healthy and I pray to our Lord for you and some other workers of God all they are happy and well done their work in everywhere. I am same as usual, and our friends all well, and I wants to thank you for all your kindness.

I am believe my Lord will make happiness for me in this world and next world but if I do not trust him he may not do so.

You heard we had sent a letter to the King of Corea[9] and had advised the killing of the officers which is certainly a rumor. It is not true. We never offered such unkind and unwise speaking though we are very dark hearts and we have no special intelligence; but from since we reading Bible and learning the idea of Christian then moreover obtain such continuance and diligently to getting application of peace and philanthropy and keeping the commandment of our Lord and obey the will of God what is our object and duty. We positively do not so. Please you believe we are different from former

---

[5] Kim Ok-kyun traveled to Japan in 1881, to observe the effects of the Meiji Restoration (1868) on Japan's industrialization and modernization, and again in 1882, to accompany Pak Yŏng-hyo in a diplomatic mission.

[6] John Wells Hollenbeck (1829–1885) was an investor and philanthropist based in California. He financially supported Philip Jaisohn's study at the Harry Hillman Academy in Wilkes-Barre, Pennsylvania.

[7] Philip Jaisohn (Sŏ Chae-p'il; 1864–1951) went to Japan in 1883 to receive his military education at Rikugun Toyama Gakkō (or Toyama Military Academy; est. 1873). Upon his return to Korea in 1884, he established and directed the royal military academy Choryŏn'guk.

[8] This is the letter Loomis received from Philip Jaisohn.

[9] King Kojong (1852–1919; r. 1864–1907).

190   LETTERS FROM MISSIONARIES

mind as broken the commandments of Lord. We think we are quietly con-
verted (from) bad deeds and unpleasant thoughts which is mercy of our
Savior.

I desire my Savior forgive my sin but if I do not perform his will and love
him he may not redeem my sin as white as snow. So I will do baptist (be bap-
tized) on next Sabbath day in our church, and I hope my Lord give me strong
power for abstain from my sin and forgive my many sins then I shall be happy
in the land and I shall rejoice in the kingdom of Jesus Christ in future world.
We trust ourselves to Jesus and these are our supplications.

I am intending to go to Theological Seminary[10] and to study ministry
and if I more understand about knowledge of Christ I will translate the Bible
and some other religious books into Corean characters for Corean people and
by and by go back to Corea I will preach the gospel of Jesus Christ to Corean
people for his sake. I think it is very benefit for my life and the lives of the
Coreans. How do you think about it?

I thank God (who) loves the Corean people and send his servants to there
and let them do such great work in Corea. I hope God may continually help
the missionaries there that it may be encouraged.

I do hope Judge Denny[11] reform the Corean Government and make her
independent and Christian and civilized country. May God abide with you
forever.

Sincerely Yours,
S__ J__ P__."[12]

The penmanship of this letter is good, the spelling almost uniformly correct,
and I have made but a few and very slight alterations in the construction.
A generous Christian gentleman[13] has prepared to give this Corean a com-
plete education and thus fit him to become a missionary to his own country.
Thus his prayer will be answered.

One of his companions is also a Christian. He is not so far advanced in his
knowledge of English, but he is pronounced by those who know him to be a
man of most excellent spirit and judgement; and what is rare among the ori-

[10] Possibly at Lafayette College (est. 1826) in Easton, Pennsylvania, a Presbyterian-affiliated
institution that Philip Jaisohn attended briefly between 1889 and 1891 and then left due to
lack of funds.
[11] Owen Nickerson Denny (1838–1900) was an American lawyer, U.S. consul general in Tian-
jin and Shanghai, China, between 1877 and 1884, adviser to the Korean ministry of foreign
affairs from 1886 to 1891, and author of China and Korea (Shanghai: Kelly and Walsh, Ltd.
Printers, 1888).
[12] Suh Jai-pil, alternate transliterated form for Sŏ Chae-p'il (Philip Jaisohn).
[13] John Wells Hollenbeck (1829–1885).

entals, is thoroughly honest and reliable. The conversion of such men is reason for profound gratitude to God.

**H. Loomis**

Agent A.B.S.[14]

P.S. Perhaps this had better not appear in print at present. It might not be best for the young man to see it.

H.L.

---

[14] The American Bible Society (or ABS; est. 1816) is a New York-based organization that promotes, distributes, and translates the Christian Bible.

# 24      *Ludlow, Alfred Irving (1926)*

### ALFRED IRVING LUDLOW (1875–1961)

Alfred Irving Ludlow was the first fellow of the American College of Surgeons to come to Korea in 1912. Three years prior, he had traveled to Korea and realized the urgency for medical attention and expertise in the country. Ludlow returned to Korea to begin his medical missionary work, becoming a professor at Severance Union Medical College (now part of Yonsei University). Ludlow performed Korea's first appendectomy and went on to perform more than 1,000 operations. In 1914, Ludlow established a research department at Severance Union Medical College and worked on relapsing fevers and amebic liver abscesses. For his academic contributions he was recognized with an honorary degree of master of arts from Case Western Reserve University in 1926. During his time at Severance Union Medical College, he trained forty-five Korean surgeons, many of whom continued their studies in America or worked at Severance Union Medical College.

**1) Nov. 23, 1926** [Typed Letter]

**Severance Hospital, Seoul Chosen (Korea)**
Dr. William E. Griffis
Tokyo

My Dear Dr, Griffis,-

A few days ago the notice of your expected arrival in Japan appeared in one of the newspapers. This note is written with the hope that you may be able to include Korea in your visit to the Orient. It has never been my pleasure to meet you but I am reminded of the fact that you are a loyal Delta U.[1] and as a fraternity brother it gives me double pleasure to invite you to Seoul. We have three Delta U. men in Korea who represent the three phases of mission work. Rev. Stacy L. Roberts[2] is Pres. of the Presbytarian Theological Seminary. He is a member of the Layayette [*sic* read Lafayette] Chapter. The second is Dr. Horace Underwood[3] a son of the Rev. H.G. Underwood D.D.[4] a

---

[1] Delta Upsilon Fraternity (est. 1834).
[2] Stacey L. Roberts (1881–1946) was a Northern Presbyterian missionary in Korea from 1907 to 1941 and the president of Pyongyang Chosun Jesus Presbyterian Seminary (est. 1901; later Pyongyang Theological Seminary) from 1924 to 1938.
[3] Horace Horton Underwood (1890–1951)
[4] Horace Grant Underwood (1859–1916)

member of the New York Chapter. He is a professor on the Chosen Christian College.

I am a member of the Western Reserve Chapter and have been connected with the surgical department of the Severance Union Medical College and Hospital[5] for the past fifteen years.

If you find it possible to visit Korea you will no doubt find much of interest and we would be very glad to have the opportunity of entertaining you in our home. My wife joins me in very best wishes and may you have a most happy visit after your long years of absence from the country in which you have had such great interest.

Fraternally yours
**A. I. Ludlow**

---

[5] Severance Hospital (est. 1885), which developed out of Chejungwŏn, Korea's first Western hospital

# 25     *Macdonald, D. A. (1920)*

### D. A. MACDONALD (?–?)

D. A. MacDonald arrived in Korea in 1912. In general, Canadian missionaries, such as Rufus R. Foote, Duncan MacRae, and D. A. MacDonald, received less press coverage than their American counterparts.

### 1) July 29, 1920

**Kainei, Korea**
Rev. William Elliot Griffis, D.D. L.H.D.
Ithaca, N.Y.

Dear Dr. Griffis:-

Your letter, sent first to Union Seminary,[1] and afterwards forwarded to me here, was duly received. Needless to say, it was a great pleasure to have a letter from you. Although whomever had the privilege of [?] you, your name and writings are known, I presume, to all students and lovers of Korea.

I am afraid I cannot give you much information of interest on the subject you mentioned. No, I was not born in Korea. I only came here in 1912 and have been on furlough for the last year and a half. I belong to the Canadian Presbyterian Mission, whose territory, as you probably know, extends from Wonsan[2] northward, comprising the whole of South and North Ham Kyung Do,[3] and also across into Manchuria where a great many Koreans have emigrated into the district known as Kando.[4] Kainei is the Japanese name for Hoiryung,[5] which is a city of about 10,000 situated right on the Tumen River.[6] There is a

---

[1] Union Theological Seminary (est. 1836).
[2] Wŏnsan, a port city in Kangwŏn-do, central Korea.
[3] Prior to 1946, Wŏnsan was within the jurisdiction of Hamgyŏng-namdo (south Hamgyŏng).
[4] Kando (pronounced "Jiandao" in Chinese) refers to the northeastern region of Jilin, China, with a large Korean population.
[5] Hoeryŏng 회령 (pronounced "Kainei" in Japanese), a city in Hamyŏng-bukto, northwestern Korea, that borders the Tumen River.
[6] The Tumen River (or Tuman-kang) is a river that flows along the boundary shared by present-day North Korea, China, and Russia. It originates from Mount Paektu and flows eastward.

good railway[7] now connecting Hoiryung into Chongchin,[8] the seaport about 60 miles distant, and construction work is now in progress all along the coast to Wonsan. So it will not be very long before we can take the train from Hoiryung to Wonsan & Seoul.

I don't know of any recent historical matter on Korea. Indeed, although I have always been interested in Korea, I have found it difficult to find much good historical data. You will have to read F. A. MacKenzie's latest book "Koreans Fight for Freedom"[9] and a book by a Korean named Chung(?)[10] which deals largely with treaties and diplomatic history. I am afraid I know very little about Korean History. My work has taken me over the whole of the northern half of this province a good deal but the pressure of church work has left very little time for independent study or research. I have heard an occasional interesting local legend but have no record of them. Perhaps your letter will act as an incentive to do more along this line. I have often felt that the missionaries did not do this duty along the line of historical research.

Politics is the subject of all absorbing interest now. I was in Canada during the Independence Movement[11] and so am getting my impressions now. Up here in this farthest north corner, there were comparatively few disturbances and no atrocities such as characterized the repressive measure in the South.

One cannot speak in detail of these matters in a letter but the future has infinite possibilities for both good and evil. No one knows what will happen. I hope to make a trip to Russia in the interests of the Korean church either this fall or next spring. There are a great many Koreans between Vladivostok and Harbin[12] and north. There are several churches but no foreigner is in charge.

If there is anything I can do at any time, I shall only be too happy to do it as far as my limited knowledge will avail.

With kindest wishes

I am, Yours most sincerely

**D. A. Macdonald**

---

[7] The Hamgyŏng Line was a railroad line in northwestern Korea connecting Wŏnsan and Hoeryŏng. It was built by Chosen Government Railway (Chosŏn Ch'ongdokpu Ch'ŏlto), a Japanese colonial railway company. Construction began in 1914 along two separate lines (Wŏnsan-Munsan to the south, Hoeryŏng-Ch'ŏngjin to the north) that were connected in 1928. Today, the Hamgyŏng Line is divided into the Kangwŏn, Pyŏngan, and Hambuk lines.

[8] Ch'ŏngjin, a city in Hamyŏng-bukto, northwestern Korea.

[9] Frederick Arthur McKenzie, *Korea's Fight for Freedom* (New York: Fleming H. Revell Company, 1920).

[10] Henry Chung, *The Oriental Policy of the United States* (New York: Fleming H. Revell, 1919) or *Korean Treaties: Compiled by Henry Chung* (New York: H. N. Nichols, Inc., 1919).

[11] March First Independence Movement (1919).

[12] Vladivostok, Russia; Harbin, China.

# 26     *McCallie, Henry Douglas (1910)*

## HENRY DOUGLAS MCCALLIE (1881–1945)

Henry Douglas McCallie graduated from Baylor University, the University of Virginia, and the Princeton Theological Seminary. McCallie married Emily Cordell in 1909 in Pusan, where they were both stationed.

1) **May 18, 1910**

**Molp'o, Korea**

Dear Dr. Griffis:

Both of your letters have been received and were greatly appreciated. I have read your first book on Korea and know of your great interest in this land.

When your first letter came I knew so very little that I had nothing to say. My knowledge is still extremely deficient as to the people and as well to their language. There are so many localisms not to say dialects on the islands that it is a struggle to even get the sense of what is said.

There are many old inscriptions in various places but of course all in Chinese and very difficult to decipher. Some of the islands show signs of very ancient civilizations. No doubt among the country people there is a folklore but I haven't succeeded in finding out anything yet.

Different types among the Koreans are very noticeable especially the Indian cast of features and dull copperish color. Many in foreign or Japanese clothes are indistinguishable from the Japanese something that is not true of the Chinese.

The Japanese are doing wonders for this land in the way of material improvements but no one is so foolish as to think it is being done for the sake of the Koreans. Their lands and houses are being taken and what is to become of them no one knows.

It looks as if they mean to do with them as we did with the Indians. Man's extremity however is God's opportunity hence a great religious work is going on. We extend you a most cordial invitation to visit us.

Very sincerely yours,
**H. D. McCallie**

# 27 *McCune, George Shannon (1921)*

## GEORGE SHANNON MCCUNE (1872–1941)

George Shannon McCune was a Presbyterian missionary who arrived in Korea in 1905. McCune primarily worked in P'yŏngyang from 1905 to 1936. He and his wife, Helen McAfee, held the "Syen Chun Bible Class for Women" in April 1912, which witnessed phenomenal attendance by both Korean and non-Korean women. His son, George McAfee McCune (1908–1948), was a linguist and Koreanist who codeveloped the McCune-Reischauer romanization system of Korean. George S. McCune was recalled to the United States, like all missionaries from North America, during the Pacific War.

1) **June 23, 1921** [Typed Letter]

**1536 Arch St., North Side, Pittsburgh, Pa.**
Rev. Wm. Elliot Griffis,
Ithaca, New York.

Dear Rev. Griffis,

To-day I have read your review of THE CASE OF KOREA by Henry Chung in the New York Evening Post, June 18, 1921[1]

   There is one point that I wish to call your attention to particularly, and that is the so-called reforms introduced into Korea by the Japanese which so many friends of both Korea and Japan in America believe to be true. As you perhaps know I have lived in Korea for sixteen years and am intimately acquainted with the people. I have returned to this country just about three months ago, so I know all about the kinds of reforms the Japanese have introduced into Korea in the year 1919.[2] Japan claims she has introduced reforms in Korea, but her acts do not warrant her statement. The only change in

---

[1] Unable to locate this article in the June 18, 1921, *New York Evening Post.*
[2] Cultural Rule (*Munhwa T'ongch'i*) refers to the reform of Japanese colonial policies in Korea under Governor-General Saitō Makoto (1858–1936), in response to international criticism against the Japanese military's brutal crackdown of the March First Independence Movement (1919). These appeasement policies, largely nominal, conversely led to the expansion of colonial rule. For instance, the abolition of the military police was accompanied by increased investment in the regular police force, and reforms that opened government positions to Koreans only benefited those who were pro-Japanese collaborators.

## 198 LETTERS FROM MISSIONARIES

Korea after Baron Saito[1] came into authority is that the name military was changed to civil and the uniforms of the gendarmerie changed to those of policemen. It is true that the Japanese school masters no longer wear swords in the school rooms, but they carry on the policy of ruthless "assimilation" as rigidly as ever. In fact, the country is run by the same man with the same brutal policy under a different name—that of civil administration.

Conditions in Korea to-day are worse than those under the military regime of Governor-General Terauchi.[2] I have seen with my own eyes the marks of torture inflicted upon the boys of my own school, Hugh O'Neil Academy at Syen Chun.[3]

It must be remembered that it is nearly two years since the so-called reforms were brought into Korea, but tyranny and oppression are going on as much as ever. I personally know Baron Saito, and I wish he would carry out the policy he advocates to foreigners. His actions, however, are diametrically opposed to his statements. All this tends to show that reforms introduced into Korea by the Japanese are for effect only and not for execution in that unfortunate land.

I am writing this letter knowing that you are a sincere friend of both Korea and Japan and that you would want to be correctly informed on the present-day situation in Korea.

Very sincerely yours,
**Geo S. McCune**

George S. McCune.

---

[1] Saitō Makoto (1858–1936) was the colonial governor-general of Korea from 1919 to 1927 and from 1929 to 1931.

[2] Terauchi Masatake (1852–1919) was the colonial governor-general of Korea from 1910 to 1916.

[3] Hugh O'Neill Jr. Academy (the Boys Academy of Syen Chun; Sinsŏng Hakkyo; est. 1906; now Shinsung High School) in Sŏnch'ŏn.

# 28 · *McGill, William B. (1895)*

## WILLIAM B. MCGILL (?–?)

William B. McGill was an American missionary stationed in Wŏnsan, a city in northeastern Korea. He was part of the American Methodist Episcopal Church Mission, and he was sent to Korea by the Northern Methodists as a medical missionary in 1892.

### 1) June 27, 1895

**Yuensan (Wonsan),[1] Korea**
Rev. Wm Elliot Griffis

My dear Sir.

I have the pleasure to try to reply to yours of April ult.[2] My knowledge is too limited to be of any use to you on the subjects you ask for.

The words for yes and to drive [a?] horse is remarkably like Eng. for the same thing. As we have no equivalents in Korea for The, Z, S, V, R, F in sound it is difficult for Koreans to learn to make such sounds. But I know of no sound or combination in Korean that Eng. people—Americans cannot excel the native in their efforts to acquire a foreign language.

I have visited several temples and have seen no large images of stone except one not far from Seoul. There are some large images near here in a temple which are the four spirits who guard the Buddha which are not granite but paper.

There is very little cut stone in the country. A few stone bridges a few arches in the gates of large cities. The boundary stones are not images but only a square block. As you know the mileposts are all wood and carved roughly to represent abstraction. There is very much demon-worship. I think nearly every house has a Spirit Shrine which is separate from ancestral.

They do expose the sick who are supposed to have evil disease such as Typhoid fever and relapsing also typhus. But Small pox, Chicken pox, Scarlet fever, diphtheria, Whooping cough, Leprosy are not considered contagious. Today I went to my dispensary and found a Leper with 12 or more persons in

---

[1] Wŏnsan.
[2] Past month.

a small room. I have seen very kind attention given to cases who were expected to die.

I first saw your book Corea The Hermit Nation on my way out here. Bishop Andrews was reading it and loaned it to me for a few days. I think there are some errors but on the whole I think it a remarkable book for one who has not visited the country.

My work is just taking root in this place. I was in Seoul 3 years and have been here nearly 3 years. Have done a good deal of traveling. [Treated?] many [?], Have seen some who were interested in the Gospel and I think some who are saved. But the no. is not large.

The war seemed to have turned the Korean native towards the Gospel. They seem to be looking around to find where they are and there is more hope for them. I shall be happy if I can be of any service to you in the future. With best wishes for your work

I am yours Fraternally
**W. B. McGill, M.D.**

P.S. I was first lead [*sic* read led] to think of Korea by Secretary Leonard who said he wanted a man for this place and said he thought I was the man.

Dr. Pearson of Phila did much in his sermons to incite me to missionary work.

# 29 *Moffett, Samuel Austin (1901, 1913)*

### SAMUEL AUSTIN MOFFETT (1864–1939)

Samuel Austin Moffett attended Hanover College and studied at McCormick Theological Seminary in Chicago. In 1889 Moffett was appointed as a missionary to Korea. Moffett was one of a few early Presbyterian missionaries in Korea, most of whom were inspired by John Nevius (1829–1893), a prominent missionary in China. Moffett founded Pyongyang Chosun Jesus Presbyterian Seminary (Chosŏn Yesugyo Changnohoe Sinhakyo 조선예수교장로회신학교; est. 1901; later Pyongyang Theological Seminary) in P'yŏngyang. Moffett served as president of the institution for seventeen years. After forty-six years in Korea, Moffett was forced out by the Government-General of Korea in 1936.

1) **Dec. 16, 1901**

**Pyengyang, Korea**
Rev. Wm. Elliot Griffis D.D.
Ithaca N. Y.

My Dear Dr. Griffis:

Doubtless you think that from my long delay in answering your letter that your request has been ignored and forgotten. I assure you we all appreciate what you have done for us and for Korea in your "Korea, the Hermit Nation" and I am far from unwilling to either neglect or ignore your request.

When your letter was received I could secure no photographs such as I thought you might wish, but since then I have been making efforts to have such photographers—mostly amateurs—as visited Pyeng Yang take photos of several of the objects which I think will interest you.

The monument to the Chinese General, Tso Pao Keni[1] of which you ask a photograph was merely a squared pine host with India ink Chinese Characters written on it and surrounded by a small haling fence. It remained for only some five or six months—if I remember correctly, and I have no recollection of anyone ever having taken a photograph of it. Mrs. Bishop or the Japanese may have done so, but I have never seen one. I am sending you with this 26 photographs with an index & the same. Not all the photographs which

---

[1] Possibly Su Dingfang; 蘇定方 소정방 (591–667) who led the Tang Army in 660 to help the Silla Kingdom to unify the Korean Peninsula.

# 202 LETTERS FROM MISSIONARIES

were taken this summer have been developed or if developed have not yet been sent to me. I shall hope to have a few more to send you later on. I trust some of these at least may be such as you want.

Pyeng Yang has now regained it former appearance—all the great vacant spots in the city where the houses were torn down or burned during the war, have filled up with houses, and I should say the population is fully as large if not larger than it was before the war.

The chief differences comes from the presence of Christianity and the presence of the Japanese. The most conspicuous as well as the largest building in the city is now the Presbyterian Church where every Sabbath from 1200 to 1400 people meet to worship God. The Methodists also occupy another hill with a smaller church—while the Presbyterian Academy just beyond the City Wall to the West is the largest two story building in the North. Christianity is now a great factor in the life of the city. The Japanese occupy the best shops on the main street of the city and on the river front, the Japanese flag flying over the Consulate inside the East Gate, while the Japanese run small steamers between here and Chemulpo.

I have no question but that the Japanese are to be the dominant factor in the commercial life of the people for some years to come.

I am sending you also a copy of the first printed report for work here and a copy of the last one. If you have the time to read the two you cannot fail to be impressed with the great strides Christianity has taken here in the last seven years.

I am glad to be able to send you the photographs and this little information and do not look for any return other than to know that it will be used in some way for the good of Korea and the glory of God in the advancement of His work in this land.

An exceedingly busy life in the midst of most abundant opportunities and a rapidly developing work prevent me from writing you at further length.

With respect and very sincerely Yours
**Samuel A. Moffett.**

**2) Jan. 15, 1913** [Typed Letter]

**Seoul, Korea**
To Rev. Eliot Griffis D.D.
Ithaca N.Y.

Dear Sir:

The enclosed paper was prepared for a Japanese statesman in response to the question, Why do you believe the stories of torture in the Korean "Conspiracy Case"?[2]

---

[2] Japan's "105-Man Incident" refers to the 1912 Japanese arrest of 105 men, mostly Christians from Sonch'on in northern Korea, in an attempt to suppress the Korean national movement

We are sending copies of it to several people and papers because we believe they are interested and should be kept informed in the interest of justice.

After the Trial is over you are at liberty to publish this if you wish. We have very great hopes that the Appeal Court will give justice in this trial, and thus vindicate the reputation of the Courts, and then we hope for a reform of the Police Administration which will make impossible such tortures as this paper shows to have taken place. If you have read the reports in the Japan Advertiser which have been ssent [*sic* read sent] you, you will the more readily understand this paper.

Yours Sincerely,
**Samuel A. Moffett.**

[Typed Report]
(Not to be published until after the trial is over.)

### CREDIBILITY OF THE STORIES OF TORTURE TOLD BY THE ACCUSED IN THE KOREAN CONSPIRACY CASE.

In studying the question of the truth of the torture stories the a priori probability that they may be true must first be considered. Torture was common in Japan until forty or more years ago. It was common under the Korean law. It is almost universally practiced in China. It is thus a natural thing in the Far East, where the legal prohibition of it is recent and not yet strongly supported by public opinion. Hence complaints in regard to it are not uncommon in criminal cases in Japan proper.

In Europe and America, although formal torture was abolished by law much longer ago, cases of cruel treatment of prisoners, amounting almost to torture, occur frequently; and every now and then such a case is investigated and found true.

Other things being equal, torture is employed more readily when there is a difference of race between the governing powers and the governed, and still more so when the administrative power over a subject people is in the hands of the military, wholly or in part. Under such circumstances charges of torture have been established against Americans in the Philippines, the British in India and elsewhere, the Belgians in the Congo, the Spanish in all their colonies, etc.

This probability is increased wherever there is a difference of religious belief, as seen in Russian treatment of Jews, Turkish treatment of Armenians, etc. The educated classes in Japan have probably but little ill feeling against Christianity, but among the common people, from whom the police and gendarmes are recruited, "Yasokyo" (Christianity) is still feared, despised, and hated, and "Yaso" is a term of contempt and insult.

---

under the pretext of investigating several 1910 assassination attempts on Terauchi Masatake, the governor-general of Korea.

## 204   LETTERS FROM MISSIONARIES

Judging from the ordinary experience of mankind, therefore, it is not antecedently improbable that torture was used in this Korean affair, for it presents in combination all the circumstances that commonly tend to produce it.

That torture actually was employed, may reasonable [*sic* read reasonably] be concluded from two kinds of evidence, Direct Evidence and Circumstantial Evidence.

### I. Direct Evidence

This consists of the testimony of nearly one hundred and [fifty?] divided into three classes, as follows:-

(1)  Men examined by the police but released without trial
(2)  Men tried in the Court of First Instance but accused
(3)  Men now on trial (Dec. 17th) in the Court of Appeals

In general the evidence of each of these men is direct only as to his own case, although some of them testify that they witnessed torture of others. The combined testimony, although individual in each case, is cumulative as to the fact of torture [?] used, it is rare to have such a mass of direct testimony [. . . half of line faded]

In regard to this direct testimony it [. . . half of line faded] [there?] is no direct testimony in rebuttal. The [. . . half of line faded], but not by men who had personal knowledge of the [?] [?] have been denied by the Procurator and other officials, who do not even assert that they have investigated the matter. The testimony to the fact to torture is open and public; in court; the testimony against it is secret and not produced in court. (b) That some of the testimony to torture may have a powerful motive behind it, but not all. It is true that the prisoners have a powerful motive to falsehood since if their stories are believed they must be acquitted, and may thus escape long terms of imprisonment. No such motive exists, however, in case of the men never put on trial, and this motive is weakened in the case of those now in the appeal court, inasmuch as they have experienced the fact that a plea of torture does not necessarily produce acquittal. (c) That the denial of torture may have an equally powerful motive behind it, for if the police are found guilty of torture, they are liable to disgrace and severe punishment. They have therefore as much reason to deny as any of the prisoners have to assert torture.

Finally, it is necessary here to be on one's guard against race prejudice. In the case where the question is one of veracity between Americans and Japanese, Americans would be likely to believe their own people more readily than the Japanese. So also when Japanese have to judge of a case that turns on a question of veracity between Japanese and Koreans, they will naturally think that the Koreans are liars; A fair-minded man will put away such prejudice as far as possible.

*II. Circumstantial Evidence.*

The above powerful direct evidence is supported by the most impregnable circumstantial evidence. We give here a list of twelve circumstances, each of which is capable of being readily explained on the supposition that torture was used to force assent to confessions dictated by the police, and can not be explained on any other theory.

(1) First Circumstance. The Existence of More than One Hundred Confessions.

The crime to which more than one hundred men confessed was a capital crime, punishable in any case by a long term of penal servitude. Under such circumstances it is not uncommon for one or two of the accused to confess under promise of pardon, that is, to turn "State's evidence", but no such promise has been heard of, except in the testimony of the accused. It is also not uncommon for men to break down and confess when shown unanswerable proof of their guilt, but no such proof has been produced, apart from the confessions themselves. Even in such cases as those now mentioned, however, confessions are rare. We have here the unparalleled circumstance that more than one hundred men out of one hundred and twenty three put on trial in the Court of First Instance confessed their guilt. If they were tortured then this is easily explained, if they were not, then it is beyond all explanation.

(2) Second Circumstance. The Withdrawal of the Confessions.

If the existence of so many confessions is unusual, the withdrawal of every confession is not less so. Whatever motive one may assign for a genuine voluntary confession: repentance for the wrong done, as the Procurator says; hope of a lenient [?]; or what not, it is evident that the same motive should have continued to [?]

The prisoners in the trial as at the preliminary examination [?] if a few might change from mere fickleness, this would not be [?] in the case of so many. This withdrawal of all the confessions, with a single exception is a very peculiar feature of this trial. We doubt if a parallel for it can be found. How is it to be explained? If the original confessions were false, and extorted by torture or the fear of torture, then the motive would be removed as soon as the prisoners saw themselves in an open court. Upon this basis the circumstances is readily explained. Upon what other supposition could this phenomenon be accounted for?

All the more is this the case when we notice that the motive for withdrawing the confessions, as already pointed out, is weaker in the present trial than in the first one. The Procurator, in his speech, accounted for the withdrawal of the confessions by saying that the Koreans were very ignorant of law and fancied they would not be convicted if they only retracted their

# LETTERS FROM MISSIONARIES

confessions. That may have been their idea in the first trial, but certainly not in the second, for they know that they were convicted. Not only that, they know that if the present court finds them guilty they may receive a severer penalty than that imposed by the lower court. If their stories against the police were investigated and found false they would deserve heavier punishment, and probably would receive it. Yet knowing this danger they continue to withdraw their confessions and to make the most serious charges against the police.

(3) Third Circumstance. The Harmony between the Testimony of Released Men and of the Prisoners on Trial

A number of men were examined by the police and were set free without trial. These men, returning to their homes, told circumstantial stories of torture. These stories were written down at the time and the paper was privately circulated long before the present trial. The men who told these stories had no communication with the prisoners now on trial, for the latter are debarred from all private communication with the outside world. Yet the stories told outside the court, in private, by men for a time in the hands of the police, and the stories now told in open court by the prisoners, are exactly similar as to method of torture and instruments employed. This is the more remarkable as some of the methods of torture described were not known previously in Korea. The harmony between these two entirely independent kinds of testimony is natural if both stories are true, but is impossible upon the supposition that they are false.

(4) Fourth Circumstance. The Mortality and Insanity among the prisoners.

Of about one hundred and fifty men examined by the police, men in the prime of life, it is to be noted that in the space of less than a year four died and three are said to have become insane. The insane men have since recovered. This mortality is altogether abnormal. Among so many men of that time of life death is rare, unless the men are engaged in a dangerous occupation or some epidemic of contagious disease breaks out. Insanity also is rare. Yet in the short space of a few months three men became insane and four died, two in prison and two shortly after being released. How is this to be accounted for? If the torture stories as told in court are true, it is natural that is should be so. If the stories of torture are false, this circumstance must find some other explanation. Where can that be found?

(5) Fifth Circumstance. The Character and Standing of Many of the Accused.

We can not speak for all of the accused. Among them are some as to whose character and course of life we have no reliable source of information. On the other hand, many of them have for years been daily companions and intimate acquaintances of the missionaries, some of these are pastors, elders, deacons, teachers, etc., holding positions for which three things are required.

Moffett, Samuel Austin (1901, 1913)    207

First, a profession of the Christian faith, second, an established reputation for high moral character, third, careful abstinence from political activity. We place no emphasis in this connection upon the mere fact of their profession of faith in the Christian religion, but the other two circumstances are of great importance.

A man who holds the position of pastor or elder in a Christian church must be a man well known as a man of unblemished character. Even a slight charge or a general suspicion of immorality would be sufficient to make it impossible for him to be elected or to retain his place, moreover, since the relations between Japan and Korea began to be delicate, it has been the practice not to allow a pastor or elder to retain his position if he engages in any political activity.

Now, the previous character of the accused is always taken into consideration in a criminal trial. If he is from the criminal class, or is known to be an untruthful or immoral man, the charge is believed with less evidence, and his complaints against the police are more readily discredited. If, on the other hand, he has a high reputation for truthfulness and honor, it requires more evidence to establish criminal charges against him, and if he makes counter charges against the police they are entitled to a more respectful hearing.

This presumption in favor of a man of unblemished reputation however, is not decisive in the case of a single individual, for such men have occasionally been found guilty of all kinds of crimes, including murder.

The presumption is greatly strengthened, however, when two such men are alleged to have agreed together to commit a heinous crime, it is obviously far less probable that two such men should thus agree to murder than one should commit such a crime in secret. When the number of men of high character who are accused of conspiring together to act in a manner contrary to all their usual course of life is increased to three, or four, or five, and still higher, the presumption of innocence becomes stronger and the difficulty of believing the accusation becomes greater with every additional man. When as in the present case, twenty or thirty such men are alleged to have conspired together to commit murder, the presumption against the truth of the accusation, based upon their previous life and established character of each one, becomes overwhelming. We doubt whether any case can be quoted from criminal annals where any such charge has been made or proved against such a number of such men.

Yet in this case, there are twenty or thirty of such pastors, elders, and teachers among the prisoners who have confessed such a crime. If the explanation they give, that they were forced to confess by intolerable torture, is true, this circumstance is not surprising. On any other theory it is incredible. If there was no torture, we must suppose that these men of peaceful habits and unblemished reputations all first tried to commit murder, then all repented voluntarily and confessed, then all, hardening their hearts took back their true confessions, and finally all agree in the most disgraceful lies to

## 208 LETTERS FROM MISSIONARIES

hide their crimes. Such a process is difficult to believe in the case of one man. That it should take place simultaneously in the cases of so large a number of men is impossible.

In the above discussion we have confined ourselves to the cases of pastors, elders, and teachers, as men in public positions whose high reputations for moral excellence are attested by the very fact that they have been chosen to fill such positions and have retained them for many years. The argument, however, is not limited to them, but may be extended to a great many more of the accused. Neither is it confined to the consideration of moral excellence. When we consider that many of the accused are men of wealth and position, habitually averse to taking part in risky political undertakings, or men with large families, etc., the difficulty of believing the confessions to be genuine and the consequent logical necessity of finding some other explanation of the circumstances is greatly accentuated.

(6) Sixth Circumstance. The Vivid and Detailed Nature of the Torture Stories and the Artless Manner in Which they are Related.

There is a remarkable verisimilitude about these stories. This appears (a) In their variety. No two are alike. Every day's proceedings gives us more new forms of torture. Men state that they have been strung up, beaten, slapped, burned with irons, burned in the private parts with cigarettes, blindfolded, gagged, doused with ice cold water for hours, kept crouched under a shelf, ditto under poles arranged in some way, starved, struck on the ears, held by the throat, had their arms seriously injured or dislocated, injured internally so that blood flowed from the rectum, etc., etc., The Stories are in great detail and variety, and yet are told by simple countrymen. (b) The manner in which the prisoners related them. Neither their gestures nor their tones are in the least unreal looking. Either they are wonderful actors or else they are telling the truth. Their depositions are given in an ordinary tone until they reach the account of their torture experiences. Then, unconsciously, as it seems to a spectator, the memory of cruel and brutish indignities leads them to raise their voices and speak in a manner that demands attention and belief. There may be a fraction of exaggeration in some cases—it would be strange if there were not—but the stories have every appearance of being ninety per cent or more the pure truth.

(7) Seventh Circumstance. The Eagerness of the Prisoners to Furnish Material for Investigation.

In the case of deliberate falsehood, a man avoids, so far as possible, all mention of details and specifications that would make it possible to examine the truth of his story. Such a man prefers to speak in general terms, to give no names, or to mention times and places that cannot be easily investigated.

The attitude of the prisoners as they tell their stories is the precise opposite of this. They take pains to give circumstances that can aid the investiga-

tor in finding out the truth or falsity of the charges. The following are some such details. The prisoners assert that they have scars upon their bodies caused by the torture, wounds in the private parts still unhealed, broken wrists, etc., and invite an inspection of such scars and mutilations. They mention details in regard to the officers who examined and ill treated them, such as the number of stripes of gold braid upon the uniform, the fact of teeth with gold fillings, having a beard, speaking Korean well, etc., In Many cases the police interpreter Watanabe has been pointed out in court as the man who conducted or was present at the examination with torture. They also describe the place where the examination carried on. One prisoner asserted that a hole would be found in the plaster where the poker missed him and struck the wall. Repeatedly, also, the prison doctor has been spoken of as having attended them, and they have asked that he should be called to testify. In short, the prisoners have named abundant material for an investigation. Can this circumstance be explained on the theory that they are lying? It requires no explanation if they are telling the truth.

(8) Eighth Circumstance. The Lack of Confirmatory Evidence.

A genuine confession must necessarily lead to the discovery of confirmatory evidence—a false confession is known by the contrary. Supposing these confessions to have been voluntary and genuine, they should have led, among other things, to the discovery of the weapons used by the conspirators. A man who makes a voluntary confession has no longer any motive to hide the weapons he used. On the contrary, whatever advantage he hoped to gain by the confession will be better secured if he confirms the truth of his confession by revealing the hiding place of his weapons. In the present case a large number of revolvers were certainly in the hands of the prisoners who confessed, if their confessions were true, yet only four or five have been found. It should have been easy for the detectives to show where these pistols were purchased, how much was paid for them, how they were smuggled across the border, where they were concealed, etc., but none of these things have been shown by independent evidence. This circumstance, again, is natural and inevitable if the confessions are false ones, extorted by torture, as prisoners say. It can not be explained in any other way.

(9) Ninth Circumstance. The Inactivity of the Police during 1910.

This is one of the most remarkable features of the present case. If the theory of the prosecution is true, attempts upon the life of the Governor General were made at Pyeng Yang, Syen Chun, Chung-ju, Kawksan, Cha Ryu Kwan, and New Wiju[1]. At most of these places there were three or four attempts, viz, in September, October and November of 1910, when the Governor

---

[1] P'yŏngyang 평양, Sŏnch'ŏn 선천, Chŏngju 정주, Kwaksan 곽산, Sinŭiju 신의주; Cha Ryu Kwan is unknown.

210    LETTERS FROM MISSIONARIES

General did not come, and in December, when he did. In this latter case two attempts were made treach [*sic* read at each] station, except Pyeng Yang, where there were three. In 1911, two attempts were said to have been made at New Wiju and two at Pyeng Yang. The number of separate attempts is therefore as follows:-

One attempt at each of six stations upon three occasions when the Governor did not come. .................................................................................... 18
Two attempts at each station, Dec. 1910, one when going to New Wiju and one when returning. ................................................................................. 12
One extra at Pyeng Yang when stopping over night.          . . . . 1
    Two attempts at New Wiju and two at Pyeng Yang in 1911............................ 2
TOTAL 35

Here we have thirty five separate occasions when bands of men up to thirty or forty or even more in number, armed with deadly weapons, assembled in broad daylight at public places to kill the Governor General of the country. To prepare for these attempts it was necessary to collect much money, often by violence, to hold many meetings, some in public places like school class rooms; to take into the plot hundreds of men; to send messengers hither and thither; to smuggle and conceal unlawful weapons; and to do many similar things. Yet, wonderful to tell, not a shot was fired at the Governor General, not a hand was raised against him, not a man was taken with a weapon on his person, not once did the presence of such a band of men excite the suspicions of the police or gendarmerie, no unlawful meeting was discovered by the police, and no suspicion of all this crossed the minds of the secret service men until nearly a year later when it came out incidentally while the police were examining men on another charge.

If this is all true, then the Japanese police and gendarmerie are the most incompetent, useless, and inefficient guardians of the peace on the face of the earth—which we know they are not. If the confessions are genuine and truthful statements, voluntarily made by repentant conspirators, then all this went on under the noses of the police in 1910 and 1911. If, on the other hand, the confessions were forced by torture, and are false, the reputation of the Japanese police for efficiency is saved.

(10) Tenth Circumstance. The Existence of False and Absurd Confessions.

Somewhat more than one hundred confessions were made, and a large proportion of these, (thirty, more or less) have already been rejected by the court as false or can easily be proven to be so. (a) These are, in the first place, the confessions of the men who were acquitted. These are seventeen in all. The court, by its verdict of acquittal, recognized their confessions as false. (b) There are, further, the cases of Pak and Chang, emphasized by the counsel for the defense in the first trial. These men confessed like the others, it

was found, however, that although they confessed that they had gone to the station of a certain date to kill the Governor General, they were already at that date in prison, undergoing examination on other charges. This was admitted by the Procurator. (See Japan Chronicle Pamphlet, p.88) They were therefore set free. Yet they had confessed falsely a crime for which they might be put to death and would at least have a long term in prison. Why did they confess in this way falsely against their own interest? Were they not forced to do so?

A second thing, however, must be here carefully noted. Not only is it strange that such men should confess, it is still more strange that they should know what to confess. Their confession agreed with those of other prisoners as to dates, places, and other circumstances. Yet they had certainly not been at those places upon those dates, and had had no communication with those who made similar confessions. How is this strange circumstance to be explained? If what the prisoners say is true, and the police forced assent to confessions which they dictated to the prisoners then it is easy to explain, otherwise not. (c) There is further the case of Kil Chin-hyeng.[2] This young man, according to his own confessions, travelled about with Ok Kawn-pin[3] from Dec. 14th to Dec. 25th, 1910, to Syen Chun, Wiju, and other places, holding many meetings and encouraging the conspirators to commit murder. Yet is it well known to many missionaries that this is entirely untrue. Kil was at that time a student in Pyeng Yang College, and the Rev. Dr. Baird and many other teachers, American as well as Korean, are ready to testify that Kil never left the college at all during that time.

(d) Take again the case of Yang Chong Miun, the merchant of Syen Chun. He confessed that at his store and at his house, large meetings were held, numbering seventy or eighty persons, to consult in regard to the plot. Yet the house is well known to the missionaries, and the plans have been produced in court, showing that such statements are absurd. No more than fifteen men at most could crowd in. Dr. Hanai made a strong point of this in court.

(e) There is another case of a man flat on his back with typhoid fever during the whole period when he is said, by his own confession, to have gone about with the other conspirators. He was then under treatment by Dr. Sharrocks, who is ready to testify to these facts.

(f) Some of the prisoners confessed that they had conferred in regard to the plot with Mr. Bernheisel and Mr. Becker, and others, who were in America at the time.

(g) Finally, we quote the case of the men who confessed that they had travelled by rail between Chung Ju, Kwaksan, Syen Chun and other stations,

---

[2] Kil Chin-hyŏng 길진형 (1891–1917), educator in Sinsŏng School in Sŏnch'ŏn.
[3] Ok Kwan-bin 옥관빈 (1891–1933) worked for the Korean Provisional Government.

212   LETTERS FROM MISSIONARIES

in bands of thirty or forty at a time, although the railway records, when examined, were found to show the total of all passengers on those days averaged only five or six a day. (See Japan Chronicle Pamphlet, p.82).

Besides the seven cases here enumerated there are many others that have been shown or can easily be shown by documentary—and other evidence to be false. The seven specified cases disprove between twenty and thirty of the confessions. In the trial on appeal, man after man has arisen and offered to prove an absolute alibi by incontrovertible documentary and personal evidence, in other words to prove his confession false.

Now all of these confessions were contrary to the interest of those who made them. How is it to be explained that so many men made false confessions, if they did it voluntarily? On the other hand, if torture was employed until the resolution of the men was broken down, this circumstance is not difficult to understand.

(11) Eleventh Circumstance. The allegations Against the American Missionaries.

Nearly or quite twenty American missionaries were asserted to have been concerned in this conspiracy. The acts attributed to them are such as these:- Taking charge of revolvers, distributing them to the conspirators, making speeches urging the murder, agreeing to give signs to show who must be shot, etc.. How came these stories to be told? The Koreans would have no object in telling them, for even if believed by the police it would not result in any help to them, only in the arrest and punishment of the missionaries. They would have all the less motive for telling them, inasmuch as the missionaries were in many cases intimate personal friends. Even if they might have wished to tell stories of missionaries to hide their guilt, they would have spoken of missionaries who were in Korea at the time, not, as in many instances, of missionaries who were in America. If the confessions were voluntary, the confessions were dictated by Japanese policemen who did not know much about the character and standing of the missionaries or about their movements; but only knew their names and that they were important men in the church, this circumstance, also, is readily explained.

(12) Twelfth Circumstance. That the Charges of Torture have not been Investigated.

The charges of torture are not made now for the first time. They were brought to the attention of the authorities Dec. 16, 1911 in a letter addressed by Dr. Alfred M. Sharrocks (M.D.) to Mr. M. Komatsu,[4] Director of the Bureau of Foreign Affairs. They were tentatively made a second time in a memorial addressed to Governor General Terauchi by five American Missionaries

---

[4] Komatsu Midori 小松 緑 (also romanized as Komatz) (1865–1942). See the letters from Komatz Midori to Griffis dated October 30, 1893, and May 22, 1906.

Jan. 8, 1912. In this memorial they were supported by presumptive evidence of their truth. Yet up to date we have not heard that any investigation has been made. The charges of torture were made the third time in the Court of First Instance. The prisoners there withdrew their confessions and stated that they had made them under torture. They were eager to describe the torture in detail. That statement had a vital bearing on the question of their guilt or innocence. It was the duty of the Court of First Instance to listen to the charges of ill treatment, as the present Judge is doing, and to investigate the truth of what the prisoners said. This was not only the duty of the judge, but it was in accordance with his professional education and honor. Yet he refused to hear the evidence and made no investigation. How can this circumstance be explained? In whatever way it may be explained in Japan, the world at large will explain it on the theory that the torture charges are true and that the judge refused all investigation in order to hide from the world the disgraceful methods of the Japanese police in Korea. Unless this question of torture is properly investigated at the demand of Japanese men of patriotic spirit, this great disgrace will rest not only upon the Japanese police in Korea but upon the entire Japanese nation.

We have now enumerated twelve separate and distinct sets of circumstances, each of which can be explained only upon the theory that the "confessions" in this case were forced from the prisoners under torture by the police. Each circumstance by itself already raises a strong presumption that this explanation is the truth. When they are taken together, and are seen to converge upon one point, their evidence is overwhelming. When further, this circumstantial evidence is added to three distinct forms of direct evidence, involving the convergent testimony of one hundred and fifty men, the whole is conclusive.

Prepared for the information of a Japanese Statesman.

By Albertus Pieters, with the assistance of five other missionaries from Japan and Korea.

Dec. 17, 1912.

# 30     *Morris, Charles David (1911–1916)*

## CHARLES DAVID MORRIS (1869–1927)

Charles David Morris was born on a farm in Ballyhupahaun, Ireland. After his parents died, he left Ireland for the United States and settled in Paterson, New Jersey, serving a church in Newark. In 1900 Morris traveled to P'yŏngyang, where he met his wife, Louise Ogilvy. They married in 1903 in Kobe, Japan. In 1917 the family was assigned to Wŏnju. Morris was the head of seventy-five Sunday schools and seventy churches; both the schools and the churches had thousands of members.

### 1) May 22, 1911

**Yeng Byen, Korea**
Rev. Dr. William Elliot Griffis
Ithaca, N.Y., U.S.A.

My dear Dr Griffis:

We have reviewed your "China Story,"[5] and Mrs. Morris and I thank you most sincerely for your kind thoughtfulness in sending it to us. We will thoroughly enjoy its perusal, and it will enable us to get better acquainted with our [faith?] neighbors.

Our work moves on most encouragingly. Our Annual Conference[6] will meet in Seoul, June 21th, and from all that I can learn we will be able to report the best year we have had in the more than a quarter of a century of our mission history.

There is just one thing I want to call your attention to: You will probably see from time to time adverse criticism of the Korean Church in some of the home papers. The Japanese yellow press is, as you know, always opposed to missions, and papers of that character published in Korea are more fierce in their attitude than those printed in Japan proper. We pay no attention to the criticisms of such papers, but when reliable journals at home copy such reports and give them out to the American public it becomes a matter of some consequence. Even such a careful journal as the New York Independent was

---

[5] William Elliot Griffis, *China's Story in Myth, Legend, Art and Annals* (Boston: Houghton Mifflin, 1911).
[6] The Korea Annual Conference of the Methodist Episcopal Church (June 21, 1911).

led astray some time ago, and published a report that after the annexation[7] the membership of the Church at Chemulpo[8] fell off one half. Every person here knows that it was absolutely false, but people who see such statements in the home papers are liable to be led astray. The annexation has made no difference in the growth of the Church, and the reason it did not is that the Christian Church in Korea is built on a spiritual basis, and has always kept aloof from politics.

As I said above, we do not think it worth while to notice the falsehoods that continually appear in the Japanese papers that correspond to our yellow journals at home, but we regret that such a paper as the Independent and others will publish such statements without first making inquiry as to their truth from those who are in a position to know the facts.

Mrs. Morris has instructed me to also thank you for "Truth in Mosaic" that you sent to her some months ago. She says she is trying to get some purely Korean things for you, but it is slow work. She will however do the best that she can.

Thanking you again, I am

Yours very Sincerely
**C. D. Morris.**

2) **Feb. 5, 1912** [Typed Letter]

**Yeng Byan, Korea**
Rev. William Elliot Griffis, D. D.,
Ithaca, N. Y., U. S. A.

My dear Dr Griffis:-

Mrs Morris and myself did greatly appreciate your sending us that charming book of yours: "The Unmannerly Tiger and other Korean tales".[9] I should have written our thanks sooner, but I have been trying to secure for you a set of the drawings made by the Koreans of their arts and industries. I have not been able to secure them in Yeng Byen,[10] and I have tried a couple of times in Pyeng Yang[11] without success, but when I go up to Seoul I will try there, and will surely secure them for you if at all possible. It may be that the newer science of photography has made it more difficult to secure these drawings, but I am sure that I will be able to secure them for you. In one of your letters you said that you did not care if they were somewhat crude.

---

[7] Japan-Korea Annexation Treaty (1910).
[8] Chemulp'o (now Inch'ŏn).
[9] William Elliot Griffis, *The Unmannerly Tiger and Other Korean Tales* (New York: Thomas Y. Crowell Company, 1911).
[10] Yŏngbyŏn, in P'yŏngan-bukto, northwestern Korea.
[11] P'yŏngyang.

216    LETTERS FROM MISSIONARIES

The tales in your book are certainly very charming, and you have done us a real service by their publication. This is one of the volumes that will be carefully preserved for our little girls to enjoy after they learn to read. Please accept our sincerest thanks for your so thoughtfully remembering us.

With our kind regards. I am

Most sincerely yours
**C. D. Morris.**

### 3) Nov. 9, 1912

**Pyeng Yang, Chosen, (Korea) Japan**
Rev., Wm. Elliot Griffis, D.D.,
Ithaca, N.Y. U.S.A.

My dear Dr Griffis:

At last, after long waiting, we found a man who was able to make the pictures of the industries, etc. of old Korea. Most of them however continue as of old. I am forwarding by parcel post, and I hope you will receive them safely.

We much appreciate your faithful portrayal of our Brother Appenzeller. I saw him the day he purchased the ticket for the fatal trip, and I was, I believe, the last of our missionaries who had the privilege of seeing him. I also knew the Mr. Bowlby you refer to very well, as he was employed for some time by the Oriental Consolidated Mining Company in Unsan, North Korea.[1] You have done our cause a real service by putting into permanent form the facts of our Appenzeller life. He was a knightly soul, and we have never ceased to mourn his loss.

We miss him more and more as the years go by. We are rejoiced to know that some of his children expect to return to this field.

Hoping that the drawings we are sending will be of service to you. I am, with kind regards,

Yours very Sincerely,
**C. D. Morris.**

### 4) July 11, 1916

**150 Fifth Avenue, New York, c/o Board of Foreign Missions**

My dear Dr. Griffis:-

Your interesting letter came to hand sometime ago. I will write to Korea and see if I can secure any recent photos that will illustrate women's work among our people. I note you would like some of buildings with pupils or anything

---

[1] Oriental Consolidated Mining Company was an American enterprise that ran gold mines in Unsan, P'yŏngan-bukto, northwestern Korea, from 1898 to 1939.

that will illustrate women's life in our part of Korea. I hope that I can secure some that will aid you in your work.

Now, I will try to answer some of your questions: You ask about the naming of girls, and the kind of names they take, Biblical or English Christian names. As you no doubt know, according to old Korean custom, the Korean girl did not receive any name except perhaps a pet name that applied to her when a child. Later she was known as somebody's sister, some man's wife, and especially as the mother of some boy if she was blessed. No name was given to her in her own right. When we received women into our congregations we gave them names. For a time we gave them in some cases foreign names and Biblical ones, but the custom has probably given over to one of giving the woman a name purely Korean that has some meaning. For instance many a woman is baptized "Chinsil"[2] which means sincere. You can make up any number of such names from the Korean language, and such names are much appreciated by our Christian women. Effort is made to give a woman a name that will mean much to her.

You ask "if native names are customarily adhered to, is there any elevation or improvement in the meaning, appropriateness or hopefulness of names of girls in the 20th Century." I think the above covers all that. There is a complete revolution as you can see.

You ask if we "keep any record of the alumni, or of girls that have received training or scholarship at Pyeng Yang." In addition to the primary schools of the Presbyterian and Methodist Missions in that city we have a union school for the older girls and young women. This school has a course equivalent to part of our home high school course, but is specially adapted to fit the young girls for its home making. I believe a full record is helping all the alumni, and from all I have learned the graduates, as a whole, have proved well worthy of the hope and confidence of their teachers.

You inquire, "Are the evidences clear that Christian girls make better wives and have more attractive homes." Yes indeed this evidence is clearly seen. The home made by the Christian girl is cleaner and far more attractive than be found among the non Christian population. In fact, you have to look to its Christian women to find a home in its deep sense understood by us.

I am sorry that I cannot here give you any native problems about women. Wives in Korea could do it easily. The geisha or dancing girl is still Korean informally, but I feel that there is[sic read has] gradually been created a sentiment against her.

Recently I have not known of direct opposition to the idea of educating girls and women from Buddhist priors or monks. As you probably know Buddhism (that is the Korean Buddhism) is of a very low type and has very little influence on the people—especially the more intelligent. I do not think the Confucian Conservatives favor the education of women but they see the trend of

[2] Chinsil 진실 means "truth" in Korean.

## 218 LETTERS FROM MISSIONARIES

the times and I do not think there is much direct opposition. The fortune teller or exorcist would of course oppose, but their influence is small and is becoming more and more so. I believe that the Japanese Government regulations will when fully enforced, encourage its education of women & girls, especially along political lines. I do not anticipate any hindrance, but rather help along the lines of education that are practical.

I do not know of any Japanese Christian women who as yet have definitely identified themselves with the uplift of Korean women. There may be such, but I do not know of any.

I think I have now answered your questions as far as I am able. Hope what I have said may be helpful.

If I get up your way it will be a real joy to call on you and if I can serve you further

do unto to me at any time.

With kindest regards, I am

Most Sincerely Yours,
**C. D. Morris**

P.S. Mrs Morris and our two children are in California. I am hoping that they may be on in the Fall. She is improving in health I am happy to say.

I saw Henry Appenzeller[3] a couple of weeks ago. He hopes to go to Korea next year.

---

[3] Henry Dodge Appenzeller (1889–1953).

# 31  *Morris, Clara Louise Ogilvy (1902)*

### CLARA LOUISE OGILVY MORRIS
### (1881–1943)

Clara Louise Ogilvy was engaged and had plans to study in college when she was a high school senior in Kansas. When a missionary couple passing through Kansas were looking for teachers to travel to Korea and teach missionary children, Ogilvy dropped everything and applied for the educational missionary position. In 1900 she set sail for Korea and started to work in P'yŏngyang, where she met her future husband, Charles Morris. The two married three years later in Japan. She is known to be the first teacher of American children in Korea. After her husband's passing in 1927, Ogilvy remained in Korea under the Women's Foreign Missionary Society until 1940, when missionaries were forced to leave Korea by the Japanese authorities.

1) **Feb. 25, 1902**

**Pyeng Yang, Korea**
Rev. William Elliot Griffis,

Dear Friend:-

It is hard to find words to tell you the pleasure your kind letter and your book have brought to me. We have gotten acquainted and in a strange way and I am very glad to know you. Rev. Stanton has been such a helpful and kind friend to me and I count it a privilege to have thus had our acquaintance pass on to others, and especially to those who are so much interested and who can understand the work here as well as I feel you can.

I have not read your interesting book through but am enjoying it very much indeed. Not only will I know much more about Pyeng Yang[1] by the time I have finished it but will have a much higher opinion of both the Japanese and Chinese people. I have of course seen very little of either of these peoples and those I have seen were of a class to lower ones opinions rather than improve them.

Our work here in Korea and especially here in the north, you of course know is very wonderful in its results. The Father is calling these people to himself in a most wonderful way. The work is immense of course and the

[1] P'yŏngyang.

220     LETTERS FROM MISSIONARIES

workers few. Our church here in the city has a weekly audience of attentive, earnest, believers numbering from twelve to fifteen hundred. Can you imagine how our hearts jump for joy and how we are inspired by a Prayer meeting each Wednesday of six or seven hundred souls?

The people in this part are so earnest, so eager, so hungry for the truth. It just seems as tho they are waiting only to hear and they believe and their lives show so plainly and so quickly the change of heart.

I have forwarded to you our last years reports which I trust you may find interesting. You can get from them ideas of the way the Lord is carrying on this work here. Just at present I have no pictures of things interesting here. I have ordered a number however some of which are there which you would like. It will give me much pleasure to send some of them when they come to me altho' it may be some time before they are ready. You know how things move in the East.

Please remember me to Dr. Stanton. I am expecting to hear from him soon. Also, please accept my sincerest thanks for your kindness to me in sending the Book and the kind letter. I appreciate them much. It would give me much pleasure to hear from you again and to do anything in my power for you here during the time of my stay. I expect to return home, for a time at least, about the middle of next year.

Thanking you again, I remain

Very Sincerely Yours
**(Miss.) C. Louise Ogilvy**

Pyeng Yang,
Korea,
Asia.
Via Chemulpo.

## 2) Sep. 13, 1910

**Yeng Byen, Korea**
Rev. Wm. Elliot Griffis,

My dear Dr. Griffis,

Among my letters for the past eight years there has been the letter you wrote to me at that time asking for some pictures of interesting subjects in Pyeng Yang. I wrote at the time thanking you for the work you sent me, and promising to send you any pictures which I could get hold of. In those days there were no photographers in Korea, and very few missionaries who had Kodaks and it seemed impossible for me to get hold of any of the pictures you especially wished. So your letter has always been among my unanswered letters waiting for me to keep my promise. It does not seem so long, but I notice the date is 1902, so I realize that the years have indeed rolled by, and yet every

time I see that letter I feel that there is a duty undone. So I thought I would write to you now if a letter can find you, and ask if there is anything that you would like to have now, or am I too late to be able to be of any assistance to you? Now we have photographers in many places and it is very easy to get pictures of any thing and every thing. Or if not pictures, is there anything else I might do for you?

If you remember my name at all you will see that it is now added on to. We are now living in Yeng Byen,[2] the most northern of the Methodist Episcopal Church Stations. The work is growing constantly, and is very encouraging in every way.

This will suffice as a note to try to find you, and ask if I can be of a service to you. My conscience will feel happier anyway that I have attempted to fulfil that promise made so long ago.

With all good wishes for the fullest success of your work, I remain

Sincerely yours,
**Louise Morris (Mrs. C.D.)**

Louise Ogilvy Morris.

### 3) Jan. 24, 1911

**Yeng Byen, Korea**

My dear Dr. Griffis,

Your letter came some time ago, and I have been trying to secure some of the pictures which you wanted before answering. The picture of the Pyeng Yang Gateway with the chain from General Sherman's vessel, is no longer as it was a few years ago. After the Japanese came in the upper part of the gate was enclosed with glass, and made into a bazar. That did not seem to be a success so it was deserted and left with much of the glass broken, and then used as a stone house, so it is now full of dirt and dark inside. The piece of chain still hangs inside this part, and the photographers all say that it would be impossible to get a picture of the chain. I am sending you the photo of the Gate itself, but am sorry not to be able to get the picture as you wished it. It is the "Great Hole Gate" named from the Tai-Tong or Great Hole River.[3] You can see the Chinese Characters on the Gate. I am numbering the pictures and will state briefly what they are—

No. 1—Gateway in Pyeng Yeng.

No. 2—A very ancient arched bridge north of Pyeng Yang. Noted because of its architecture.

[2] Yŏngbyŏn, in P'yŏngan-bukto, northwestern Korea.
[3] They might refer to the Taedonggang River and Taedongmun Gate in P'yŏngyang.

222 LETTERS FROM MISSIONARIES

No. 3—Peony Point—north of Pyeng Yang Buddhist Temple.[4]

No. 4—The old telegraph Office of Pyeng Yang. Used before war.

No. 5—Korean store.

No. 6—Plowing with a cow.

No. 7—Plowing when there is no cow.

No. 8—Making Bread—(Rice Bread) The woman wets it with water and the men pound.

No. 9—Beating out grain with flail.

No. 10—A corner store—notice roof made of pieces of wood held in place by stones. Old man, young man, semi-foreign youth, and little boy.

No. 11—Beasts of burden in Korea.

No. 12—City water supply.

No. 13—Taking pork to market.

No. 14—Wood for sale.

No. 15—Buddhist Nun.

No. 16—A wayside Devil House, showing idols prayed to, and scraps of cloth from the clothes of those seeking blessing on health.

No. 17—Newly made child's grave.

No. 18—Gateway in the oldest wall in Pyeng Yeng. Built in the days of David. Now all destroyed.

No. 19—Helping.

No. 20—Stopped for a moment to take a picture. All proud of their badges of motherhood.

No. 21—Little girls—alike the world over.

No. 22—Dishes for sale.

No. 23—Leech Pond in Yeng Byen. Every spring people come in from far and wide, to take the leech cure. Wherever pain is, there the leeches are stuck on. Dinners are eaten in the little Pavilion and the leeches know enough to come to the top of the water, so worship of spirits and the cure of disease is united.

No. 24—Hat or covering worn by young women to keep them from being seen by the men.

No. 25—Wash day.

I will send these twenty five pictures to you now, and will send some things later as I get hold of them. I have ordered some work done by an artist here, and will forward when finished. Are the pictures on the Post Cards all right? There are so many of those now days [sic read nowadays] and many of them are very fine. Little by little I may be able to get some of those you have asked for—I will try.

Our Mission had its twenty-fifth anniversary celebration this year, and it was most gratifying to have every missionary, without exception report that

[4] Moranbong ("peony hill"), a park in central P'yŏngyang; Yŏngmyŏngsa Temple.

not one Korean had fallen away from the Church because of the Annexation of Korea to Japan. Indeed never has one Church been so full of new members, never have the people come in with such a true understanding of sin and a personal need of a Savior as they are all now coming in. They seem to feel that for them politics are a thing of the past, and the life to come is all there now is for them to think of and prepare for. While Korea is having her chance at home in the Church this year, on the field special Campaigns are being held everywhere, with remarkable results. We believe every thing is all right, will work out to the glory of God, altho the articles that appear in many of the papers these days are very absurd; but so long as they say what the world wishes to hear, and even those who have the best of opportunity of knowing the true condition of many things, are thought to be prejudiced and therefore not believed, it is far better to keep still, and work ahead in a quiet way, believing that all will be well in the end. The inevitable has happened, and the Japanese Official Class are anxious to do all they can to help Korea and their own country, but they have many hard problems ahead of them. Every country in the same position as either Korea or Japan has its problems, and trials.

We are expecting that this year's work in our Home Churches will put our mission force just where it ought to be, and then it will not be so hard to keep things going, and to meet the demand for teaching and preaching, which is so very great.

If I can be of service to you in any way, please, let me know, and I shall be glad to serve.

Sincerely yours,
**Louise Morris.**

(Mrs. C. D.)

# 32     *Pieters, Albertus (1914)*

### ALBERTUS PIETERS (1869–1955)

Albertus Pieters was an American missionary who served in Japan. He was one of the most well-known members of the Reformed Church in America. Pieters was born in Wisconsin and raised in Holland, Michigan, where he earned his bachelor's degree from Hope College. In 1891 Pieters married Emma Kollen. The two traveled together to serve as missionaries in Japan, where they remained for thirty-two years. While in Japan, Pieters's most notable accomplishment was his program "Newspaper Evangelism." This work made Christianity accessible to a number of Japanese citizens, including people in the countryside. Pieters published many writings during his lifetime that were translated into Japanese, and many of these writings are still in print today.

1) **Jan. 30, 1914** [Typed Letter]

**Oita, Japan**
Rev. Wm. Elliot Griffis, D.D.,
Ithaca, New York.

Dear Sir and Brother:-

Your letter of the 29th ult.,[1] inquiring in regard to graduates of Rutgers College in Japan, has come to hand. I regret very much that I am not able to give you the slightest information on this subject. Not being a graduate of Rutgers myself, I have not come into touch with any of them. Indeed, to show you how impossible it is for me to be of any service to you in this regard, I may say that I do not know of a single graduate of Rutgers College in Japan at present, either American or Japanese. I presume that some of our North Japan missionaries, such as Mr. Booth or Mr. Miller, may be from that college, but I have no knowledge of it. I feel sure there is no one of that kind in the South Japan Mission.

    May I take this opportunity of offering you authentic information on the subject of Japanese authority and judicial proceedings in Korea? The facts are such that the friends of Japan have been very slow to believe them, but it is becoming impossible any longer to deny or conceal the truth that the administrative measures adopted both in Formosa and in Korea, with much that

---

[1] Past month.

makes for the material prosperity of the people, contain also a great element of ruthless injustice and almost incredible cruelty. Even the Japanese papers are denouncing the injustice and cruelty that forced the recent premature rebellion in Formosa, and the history of the Korean Conspiracy Case[2] is one of the most remarkable in the annals of injustice for the refined cruelty of the tortures employed on the unhappy victims, and the callous injustice of the courts.[3]

I am sending you herewith my review of the case, and I shall be glad to furnish you with other facts as required. It seems to me that a clear and brave article from you in one of the leading magazines would do much to impress it upon the leading men that things must change or the credit which Japan has so laboriously built up will be lost, and the sense of intellectual and moral kinship which underlies American friendship and the Anglo-Japanese Alliance will be so impaired that the loss will be well nigh irretrievable. You are well known as an enthusiastic friend of Japan, and the words of such a friend will be heeded where those of critics like the "Kobe Chronicle"[4] have no effect.

Very sincerely yours,
**Albertus Pieters**

[2] It refers to Japan's "105-Man Incident" (1912) when Japan arrested 105 men, mostly Christians from Sonch'on in northern Korea, in an attempt to suppress Korean national movement under the pretext of investigating several 1910 assassination attempts on Terauchi Masatake, the governor-general of Korea. See Arthur Judson Brown, *The Korean Conspiracy Case* (New York, 1912).

[3] See Pieters's report, "Credibility of the Stories of Torture Told by the Accused in the Korean Conspiracy Case," which was enclosed with Samuel Moffett's letter dated January 15, 1913.

[4] *The Kobe Chronicle* (1891–1904) was an English-language daily newspaper published in Kobe, Japan.

# 33     *Swearer, Lillian May Shattuck (1911)*

Lillian May Shattuck Swearer (1872–1955), wife of Wilbur Carter Swearer (1871–1916), a Methodist missionary who served in Seoul and Kongju from 1898 to 1912

## 1) Aug. 10, 1911

**Kong-ju, Korea**
Dr Wm Elliot Griffis,
Ithaca, N.Y.

My dear Dr. Griffis,

Your very kind letter of May tenth was received in due time. My late reply is not due to the fact that I was not pleased to get it for it pleased me very much, but rather to the fact that we have been away from home a good part of the time since receiving it. We were at Seoul attending our Annual Conference and after that we attended a Bible Study Class conducted by Dr. White of New York City. The latter was a great treat as we so rarely have such an opportunity. Out here we miss as greatly the intellectual and spiritual help that one gets at home, but of course that is to be expected. The only thing is that we are in danger of dropping down along short lines unless we are very careful.

We have read of "The World in Boston", and I think it must have been well worth seeing. Korea was fortunate in landing such an able representative as Homer Hulbert. He is very well known to us both, and of course very much liked by us as he is by everybody—except the Japanese. This we consider no discredit to him.

We are glad to hear you are to add a chapter to your book, "Corea: The Hermit Nation" but as to letting it drop out of public view, I hardly think other people will let it. It is read by all the missionaries for it is in the second year's course of study. I have often thought and have heard others express the same, that it is quite remarkable that one who has never been in this land could depict the life and customs so accurately. The history is most instructive and interesting. The book may have cost you much time and labor. We thank you for it.

You have a very large collection stereopticon slides. We are very glad to know that you use them in lecturing on Korea. We also welcome the news of any book from your pen for public interest needs to be sourced in that way. People often ask why the missionaries do not write more but it is almost

impossible for some to get the time and then again all are not gifted in that line.

I have never met any of the Appenzellers but Mr. Swearer bonded with them when he first came to Korea. It would seem very fitting if one or more of the children could come to work here where their father laid down his life.

Now for your questions: As to the Japanese rule, many things have been improved by it; as roads, postal service, railroads and such things, but the outlook of the Koreans does not seem bright. The cost of living is very much increased while the Koreans are being crowded out of all paying positions, even the educated Koreans. The Japanese are coming in great numbers and of course the Koreans have to be crowded back. Worst of all, the Japanese skepticism and unbelief is beginning to influence the Koreans and we have a great desire to push the work on as fast as possible to keep ahead.

No, we have no little folks in our home.

I think that Kong-ju is not peculiar in any of its ways. It is a city of about ten thousand, small as we reckon cities but Korea has few large cities; none really large except Seoul. There is nothing in Kong-ju in my opinion of which you would care to have the picture. I am sending the picture of the In Chin Buddha.[5] I don't know whether or not you might like it. It is located about thirty miles from here, and is the best one in Korea. The picture of the devil post made entirely from a tree is rather interesting. It was found near here and has been cut down since the picture was taken. The tall pole affair is twelve miles from here and is made of things that look like sewer piping, sort of round tiles. The group is the Kong-ju pastor and family. You will find them named on the back. The street scene is typical of Korean villages, but you may have one like it. If you want to get pictures to illustrate any special things and will let me know, I should be glad to get them for you. Please do not consider these that I am sending at all in the light of a "favor" there are not enough for that. I only wish we had something of special interest to send you.

We are happy in our work and consider it a great privilege to be permitted to have a part in it.

I shall always remember with pleasure the few times I had the privilege of listening to you in Ithaca. I wish it might be repeated. Are you not going to visit Korea someday? My husband sends his kindest regards. Thanking you for your letter I am

Yours most sincerely,
**Lillian May Swearer**

---

[5] The eighteen-meter stone statue of Mireuk Buddha in Nonsan, which was built during the Koryŏ Dynasty.

# 34 — *Underwood, Horace Grant (1900–1909)*

## HORACE GRANT UNDERWOOD
### (1859–1916)

Horace Grant Underwood was a British-born American missionary who spent most of his life in Korea. A graduate of New York University and the New Brunswick Theological Seminary, Underwood arrived in Korea along with fellow missionary Henry G. Appenzeller on Easter Sunday in 1885. Underwood took on many endeavors during his time in Korea, including teaching, translating, and serving as university president. He taught physics and chemistry at Gwanghyewŏn (est. 1885), the first Western-style hospital in Korea, whose name was later changed to Chejungwŏn. Underwood also took on the task of translating the Bible into Korean with a group of missionaries. They completed the New Testament in 1900 and the Old Testament in 1910.

He founded a Christian orphanage in Seoul in 1886, the Korean Tract Society in 1888, and the Chosen Christian College in 1915, today's Yonsei University. He also helped establish the Seoul branch of the YMCA and the Pierson Bible Institute. In 1889 Underwood married Lillias Stirling Horton and they had one son, Horace Horton Underwood, who continued his father's missionary work, as did his children after him. When Underwood's health deteriorated in 1916, he returned to the United States seeking treatment and died on October 12. In 1999 his body was transferred to Korea to be buried in Yanghwajin Foreign Missionary Cemetery in Seoul.

1) **July 14, 1900** [Typed Letter]

**Seoul, Korea**

Dear Dr. Griffis:-

Your kind invitation to be present at your wedding on June 28th,[1] did not reach us until nearly a month afterwards and the ceremony had, I presume, been performed. It would have given Mrs. Underwood[2] and myself great pleasure to have been present on that occasion, but you will see circum-

---

[1] Griffis married Sarah Frances King (1868–1959) in 1900, after the passing of his first wife, Katherine Lyra Stanton (1859–1898).
[2] Lillias Stirling Horton Underwood (1851–1921).

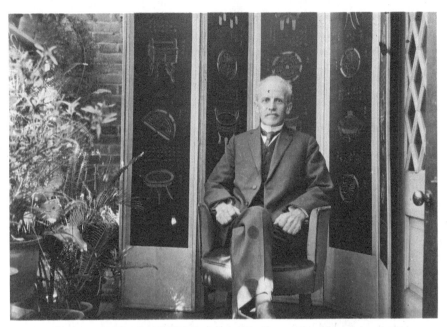

Figure 33 Portrait of Horace Grant Underwood. "taken in Seoul, April 1916" (from the back of the photo) (KP 4.1.2, Griffis Collection)

stances forbade. It was a great pleasure to once again to see the familiar handwriting and we desire to extend to you and Mrs. Griffis our heartiest best wishes. We have as far as we have been through the papers watched for your name and tried to note what you were doing. We always feel as though you were part of Korea for your book has done so much to acquaint people with this distant land. Things in Korea are more disturbed than ever, tho we have no difficulty from the Chinese boxers,[3] politically no one in Korea can be trusted and we cannot tell what will happen. While, politically there has been no progress, in other ways hover [sic read however] there has been advances. Railroads are coming in,[4] mainly however for the benefit of foreign investors and the greatest advances that we find is in the work of the gospel, here and here mainly appears the hope of Korea. You and Mrs. Griffis ought to visit Korea, make a study of the people and everything that there is here and then write a new book. Our furlough comes next year but if health

---

[3] The Boxer Rebellion (1899–1901) was a late Qing-Dynasty movement led by the Yihequan ("Righteous and Harmonious Fists," or "Boxers"), a nationalistic organization that demanded the withdrawal of European forces occupying Chinese territory.
[4] Railroads constructed during this period include the Seoul-Chemulp'o Railroad (or Kyŏngin Railroad; completed July 8, 1900), the Seoul-Pusan Railroad (or Kyŏngbu Railroad; completed Dec. 27, 1904), and the Seoul-Ŭiju Railroad (or Kyŏngŭi Railroad; completed Apr. 28, 1905).

230     LETTERS FROM MISSIONARIES

permits we shall stay a year or two longer. When we return we shall endeavor to have the pleasure of meeting you face to face again.

With kindest regards from us both, believe me,

Yours sincerely,
**H G Underwood**

**2) Oct. 16, 1909** [Typed Letter]

**Seoul, Korea**
Dr. William Elliot Griffis,
Ithaca, N. Y.

My dear Dr. Griffis:

I have been back in Korea now for a month or so and I am sending to you by this mail a copy of the Report of the Korea Mission, and I want to inclose you at the same time a copy of a letter that I have just written to Rev. E. F. Hall.[5] You felt that there was progress in the work in Japan and that things were going along at a marvelous rate when you were there, and I thought that affairs in Korea had been progressing at a tolerably fair rate of speed when I came home to America, but when we look at the progress in this land during the past three years the special progress this year is something almost beyond thought. The increase of speed at which everything is going forward is getting greater and greater in more than geometrical proportion. The thought of a million for Christ this year mentioned in my letter to Mr. Hall was staggering for the moment to a great many who were there. They looked at it as simply a possibility in God's sight but that was all. Then when they came to consider it further and saw that if each professing Christian secured five converts during the year, or if each recorded member should secure one convert a month the million would be brought in the possibility became apparent to everyone. The missionaries and a great many of the foreigners are praying earnestly for this.

I wish you could realize the spirit of prayer that runs through the whole church just now, and makes a special call to prayer on the part of the church at home asking that in a peculiar way the missionaries and the Korean Christians may be fitted for the work that they have to do and may have the faith to believe that the work can be accomplished.

I am writing to you at this time in order that you with your facile pen may enter a campaign to secure a volume of prayer from God's people all over the United States for truly it is only as we wait upon him that we can secure that for which we are asking.

Very sincerely yours,
**H G Underwood**

[5] E. F. Hall (?–?) was a minister of First Methodist Church. See Underwood's letter dated November 16, 1909, for the enclosed copy.

### 3) **Nov. 16, 1909**[6] [Typed Letter]

**Seoul, Korea**
Rev. E. F. Hall
Western Secretary, Bd. of Foreign Missions
c/o Occidental Board, 920 Sacramento St.,
San Francisco, Cal., U. S. A.

My dear Mr. Hall,

You missed it this year in not being out here in Korea. Not only can we say that the past year has been the very best year Korea has ever seen, but in every line and in every way the tide reached higher than ever before. The general spirit of union and harmony and Christian love has been more marked this year than at any Annual Meeting That I ever attended, and in addition to this the same spirit was marked at the Evangelical Council.[7]

I wish you could have been present at the Twenty-fifth Anniversary of Mission Work in Korea as held in Pyeng Yang.[8] The papers were not numerous but the progress during the first twenty-five-years, the way in which God has so evidently been leading the Work, and the way in which we have plainly seen that the result have been only such as Almighty God could accomplish thrilled the hearts of us all. I wish you could have heard Mr. Clark's[9] report on statistics. Some people, you know, say that those figures and statistics are dry, but as Mr. Clark brought those out there was nothing dry about them at all, and he showed us clearly how the Koreans are earnestly pushing forward the Work themselves. You will of course soon receive a copy of the papers that were prepared for this occasion, and it will do you good to read them, especially Mr. Clark's remarks on the statistics and the interesting comparisons that he has made. The following are a few facts culled from the Twenty-Fifth Anniversary Exercises which have been taken from a little leaflet prepared by Mr. Bernheisel,[10]

"Protestant Missions began work in Korea twenty-five years ago.[11] The Presbyterian Mission (North) alone reports this year 25057 communicants, or more than 1000 for each year of work.

---

[6] This is a copy of Underwood's letter to Rev. E. F. Hall. Underwood enclosed this letter with his letter to Griffis dated October 16, 1909.
[7] Possibly a council of the World Evangelical Alliance (WEA; est. 1846), an international organization founded to promote evangelical Christianity.
[8] P'yŏngyang.
[9] Charles Allen Clark (1878–1961) was a Northern Presbyterian missionary in Korea from 1902 to 1941. He taught at Pyongyang Chosun Jesus Presbyterian Seminary (est. 1901; later Pyongyang Theological Seminary) from 1908 to 1940, and he was banished from Korea by the Japanese colonial government in 1941, after his participation in an anti-imperialist World Day of Prayer (Feb. 28, 1941) service.
[10] Charles F. Bernheisel, "Some Gleanings from the Harvest in Korea," *Korean Mission Field* 5, no. 11 (November 1909): 182.
[11] In September 1884, Horace Newton Allen (1858–1932) of the Northern Presbyterian Church became the first Protestant missionary in Korea.

## 232    LETTERS FROM MISSIONARIES

"There are nearly 24000 catechumens enrolled while the total number of adherents is 96668.

"There are 107 missionaries in the Presbyterian Mission.

"The church contributions for the past year amounted to $81075.00 Gold, or about $3.25 for each communicant when the daily wage ranges from 20 to 40 cents.

"There are 57 organized churches and over 900 places of regular meeting.

"138 students attended the Theological Seminary[12] the last year. Two years ago the first class of seven was graduated, one of which was sent as a missionary to the Isle of Quelpart[13] off the S.W. coast of Korea, where [he] has been laboring faithfully since with the result that a flourishing work has commenced there. This year one of them has been sent as a missionary to the Koreans in Siberia.

"There are 300 students in the Academy at Pyeng Yang and 45 in the College.[14] Three other academies are conducted by the Mission, one each at Seoul, Taiku and Syon Chyun.[15] There are also three academies for girls in the Mission enrolling last year 230 students.

"Plans are being made to open two new stations beside the eight already in existence.

"In connection with the Mission there are 589 primary schools enrolling 10916 boys and 2511 girls.

"In the Pyeng Yang field 176 Bible classes for men were held during the year with an attendance of 4513. Those classes last from five to ten days, and the attendants pay all there expenses.

"All the Missions in Korea have united in the publication of a hymn book. Within a year of its issue the whole of the first two editions of 120000 was sold."

In connection with the Annual Report of the Mission I wish you would read the remarks on Pages 31 and 32. I think I will quote them,-

"As for spiritual growth the following may be noted: 1st. The regular attendance at Sabbath Morning Bible Classes with their pastors has given an opportunity of development of spiritual life. 2nd. The missionary society has grown till most of the students are active members. 3rd. The students on their own initiative, feeling that Sabbath Day preaching was not enough in forward work for missions raised $125 and sent one of their own number as

---

[12] Pyongyang Chosun Jesus Presbyterian Seminary (est. 1901; later Pyongyang Theological Seminary).

[13] The "Isle of Quelpart" was a European name for Cheju Island on the southwest coast of Korea.

[14] Pyongyang Chosun Jesus Presbyterian Seminary (est. 1901; later Pyongyang Theological Seminary); Union Christian College (1905–1938) in P'yŏngyang.

[15] Presbyterian University and Theological Seminary (est. 1901) in Seoul; Keisung Academy (est. 1906; now Keisung Middle School and Keisung High School) in Taegu (Taiku); Hugh O'Neill Junior Academy (est. 1906; now Shinsung Middle School) in Sŏnch'ŏn (Syon Chun).

Underwood, Horace Grant (1900–1909)    233

their missionary to Quelpart.[16] 4th. A prayer -circle for special objects met weekly. 5th. In the Tuesday evening prayer meeting the students took part very earnestly. 6th. The conduct of the students in their boarding houses and in public has brought forth comments of praise for the school. 7th. The graduates without exception have shown that they are thinking of the welfare of the Kingdom in their decisions for future work. 8th. A great many students are taking up church work or assisting in schools without compensation during the summer. 9th. Two of the Academy graduates finished the first year of the Theological Seminary during the spring."

When you find schools that can report such spiritual results as these I think the strongest evangelistic worker must favor such a school.

We are in great need at the present time of a proper equipment for Pyeng Yang and Seoul Colleges as outlined in our propaganda list. In fact I do not know what we shall do with them.

The Annual Meeting passed off very harmoniously and since the Annual Meeting the Executive Committee have been visiting the various stations.

Dr. C. H. Irvin[17] has felt moved to hand in his resignation and the Executive Committee of the Mission have recommended that the Board accept the same. This will of course leave Fusan[18] Station rather crippled, but we hope that some good physician can be found speedily to take up Dr. Irvin's work.

Soon after the Annual Meeting we had a meeting of the Evangelical Council of Missions, which has been followed by the Bible Conferences by the Chapman-Alexander[19] party. They have just left.

During the past year there was a manifestation of the presence of God's power among the missionaries at Song Do,[20] a more detailed account of which you will get from the "Korea Field".[21] After much prayer and conference the Methodist Mission South[22] decided this year to ask the Lord for 200,000 converts in their Mission, and when the Council of Missions heard of this they appointed a committee to wait upon the Lord asking him to reveal His will as to what the Missions in Korea should ask for all Korea, and after

[16] Cheju Island.
[17] Charles H. Irvin (1862–1933) was a Northern Presbyterian medical missionary in Pusan, Korea from 1893 until 1911, when Pusan became part of the Australian Presbyterian mission. He stayed in Pusan to practice at his private medical clinic until his death in 1933.
[18] Pusan.
[19] The "Chapman-Alexander Simultaneous Campaign" was an evangelistic performance team led by Presbyterian evangelist John Wilbur Chapman (1859–1918) and gospel singer Charles McCallon Alexander (1867–1920). The campaign visited Seoul as part of its worldwide tour between 1907 and 1909.
[20] Songdo is an archaic name of Kaesŏng.
[21] The Korea Field (1901–1905) was a monthly magazine published by the Presbyterian Board of Foreign Missions in Seoul. In 1905, it merged with The Korea Methodist (1904–1905) into the Korean Mission Field (1905–1941).
[22] The Methodist Episcopal Church South (1895–1930) oversaw missions in southern Korea. In 1930, it merged with the Methodist Episcopal Church North to form the Korean Methodist Church.

234    LETTERS FROM MISSIONARIES

waiting upon the Lord for hours the Committee brought in a resolution that we unite during the year in asking the Lord for a million souls for Christ this year. You can readily understand that the missionaries, very many of them, staggered for the moment at such a request but they felt that God had given the suggestion and that the only thing that could keep us from receiving the full answer to our prayer would be our lack of faith. Just after this has been adopted the Chapman-Alexander Conference began and we had a most blessed season. It was by all odds the best conference that I have ever attended. The numbers present I do not know, but a large majority of the missionaries in Korea of all denominations was in attendance. The conference closed in a consecration service.

Mr. Harkness[23] of the Chapman party wrote a special hymn in connection with the million souls for Christ and composed music for the same. This will be translated into Korean and will be largely used. At the same time steps were made looking toward the organization of a personal workers' league to develope [sic read develop] and carry on the work that is now done by the Koreans in Korea. You and Mrs. Hall[24] can readily understand how our hearts have been stirred by these things, and at the same time you can understand how we wonder what we will do with the million souls when they are in the church. At the present time we have not sufficient force to cope with the Christians that we have to develop and train them aright, and what shall we do with a million? The faith of the missionaries who were present at the conference steadily rose and at the present time that the great bulk here are believing and working for the million, and it is our duty to plan for the means for the proper training and development of leaders for these. More and more do we feel the need not simply of the institutions as we have them here but of the enlarged institutions as planned, and the further development of our educational plans to meet these needs and the changed conditions. There seems to be resting on us and upon the church at home a great burden and a still greater responsibility. I know that we have your constant prayers that we may be able to live up to this responsibility and to bear this burden and we want that you in your work at home shall do your best to get everybody praying for the missionaries and for the Korean Christians. Personally as I look over the field now I think there will be need for us to at once develop Bible Institutes of the Moody Institute[25] type for this need. Our present machinery is absolutely inadequate for even the present and we must do something of this kind. Just exactly what to be done I can not say but certainly more than ever do I realize that if the church will put the men and means into Korea now this land can be won for Christ. Dr. Chapman says that he himself feels

[23] Robert Harkness (1880–1961) was a performer and composer who wrote hymns for the "Chapman-Alexander Simultaneous Campaign."
[24] Probably wife of Reverend E. F. Hall.
[25] Moody Bible Institute (est. 1886) is an evangelical Bible college founded by Dwight Lyman Moody (1837–1899).

that Korea can be won now and that the church can nothing better than put the men and money into Korea now.

I do not know whether this little outline will have given you any real conception of the condition of affairs here, but you yourself have been on the field and can in some small way gain an idea of the work that is before us.

Trusting that God will help you in your work to stir up interest and to secure some of the men and means that are needed,

Yours most sincerely,

236 LETTERS FROM MISSIONARIES

## 4) [Newspaper Clipping]

**BOOKS, SUNDAY, AUGUST**

stages of Egyptian, Hindu, Greek and Jewish cultures.

### Korean Schools

*MODERN EDUCATION IN KOREA.*
*By Horace Horton Underwood.*
*New York: International Press.*

Reviewed by
VERA KELSEY

"HUMOR," said Mark Twain, "is out of place in the dictionary." He was speaking of a carbuncle on the back of his neck. The dictionary had defined it as "a kind of jewel."

And since education, in the class room at least, consists largely in re-arrangements of the dictionary, the remark seems timely here in connection with Professor Underwood's book on "Modern Education in Korea." It, too, is "a kind of jewel," and as irksome in its own way to the reader as was the carbuncle to Mark Twain. To attract the eye of even long enduring readers, it should be cut and recut.

Although "modern" education was introduced into Korea only a little over forty years ago, the Chinese system was imported into the country during the quasi-historical Kija dynasty, a thousand years before Christ. And both new and old forms have proceeded after the manner of a Shakespearean drama, comedy tumbling on the heels of tragedy, tragedy stalking comedy. They have both had their villains, their heroes and heroines, mob scenes, choruses and Falstaffs.

Professor Underwood, confining himself to the modern period, chooses to neglect the drama in the interest of presenting all the facts and figures, which seems a pity. Beginning with the first "wedge," an English language school for interpreters, started in 1883 by an American telegrapher, he proceeds to construct the vast and complicated educational structure of Korea to-day.

This includes Bible schools, elementary and secondary schools, industrial schools, colleges and special schools, such as the theological seminaries, the institutions for the blind and deaf, the schools for foreign children, private schools, and government schools. He describes the work and scope of each detail, and since education in Korea is largely in the hands of the missions, he describes not only the part each denomination plays, but the different divisions of each denomination. Under the Presbyterian, for example, there are the northern, southern, Australian and Canadian Presbyterian schools. *etc.*

He amplifies each, with painstaking graphs, tables of statistics, copious notes, and concludes with an enlarged appendix and index. Altogether the book is a monument to his industry and zeal, but in its present form it can be of little interest to many outside the workers and boards of the churches and organizations engaged in missionary and educational work in the Orient.

Yet, if it was his purpose to compile a handbook for only those interested in this field, why was he not more accurate and even more complete? A missionary teacher, for example, is introduced in the text as "Miss Haydn," and a footnote explains that she is "Mrs. Gifford." And again and again comes the phrase, "there is not space here to tell."

Perhaps for the missionaries, it is not necessary to develop the very sentences that arouse the interest of the reader not connected with their work. Yet the reader senses beneath the mass of facts and tables an heroic story of courage, perseverance, defeat, success. The Korean Queen, who because she was too enlightened and advanced for the good of the political parties within the country, and the greedy powers without, was assassinated almost on the eve of signing a bill to establish a school for the nobility, the village boy with three years common school education, who taught his thirty pupils to read and write from an equipment of old newspapers and some India ink tablets, the missionaries who persisted, even though but one pupil enrolled in their schools, and finally and most interest-provoking of all, the part Japan has played in the drama of modern education in Korea, are all subjects which, if developed beyond a sentence or a paragraph, could tell the story more vividly and convincingly than any table or graph.

Figure 34 Korean schools; this review is on Horace Horton Underwood's *Modern Education in Korea* (Box 60, Folder 13, Griffis Collection)

# 35     *Vinton, Cadwallader C. (1903)*

## CADWALLADER C. VINTON (1856–1936)

Cadwallader Vinton served as a medical missionary in the royal hospital Chejungwŏn in Seoul and founded a leprosy hospital in Pusan. As secretary of the Presbyterian Church in the United States, he left behind detailed reports of mission achievements during his tenure. He retired in 1908 and returned to the United States.

1) **Nov. 30, 1903**[1] [Typed Letter]

**Seoul, Korea**

Dear Dr. Griffis:

Twenty years ago I know that you were looking across to the shores of this country and praying for an opening through them for the Gospel messengers. That is not a long period in the World's history, but it has proved a period of momentous changes in Korea. As the workers here plan to gather in celebration of the passage of that amount of time since the first of them entered here and in conference to rehearse the facts of the work and thank God for it, we think of you as a fellow-worker, though you have never come among us here, and it is only fitting that we should extend you a special invitation to join with us in September next. I am sure I need use no arguments to attract you, but that you will be glad to come if you can. I very much hope that you can, even if it requires a disarrangement of other plans and a forming of wholly new ones. If you can do so, you may be assured of a very warm welcome among us and of the greatest appreciation of anything you may come prepared to say to us, in the Conference or elsewhere.

Yours very sincerely,
**C. C. Vinton.**

[Printed Public Invitation][2]
Dr. Wm. Elliot Griffis;[3]

---

[1] In letterhead: Conference of Missionaries in Korea, September 18–25, 1904.
[2] In letterhead: Conference of Missionaries in Korea, September 18–25, 1904.
[3] Only "Dr. Wm. Elliot Griffis;" is handwritten.

238    LETTERS FROM MISSIONARIES

The month of September, 1904, will mark the completion of a period of twenty years since the arrival of the first English-speaking missionary in Korea. In this interval the diffusion of the Gospel in this peninsula has been wonderfully blessed, so that now nearly two hundred missionaries are engaged in the work and the converts are numbered by thousands. In commemoration of this event it has been decided to hold a Conference during the week from Sunday, September 18th., 1904, to Sunday, September 25th., on Mission Work in Korea. A copy of the programme will be mailed to you when completed and a synopsis is herewith enclosed. It is designed to cover a wide range of topics in missionary effort, each taken in its especial relation to Korea. Historical papers are to be presented detailing the progress and development of each of the Missions engaged here; and special efforts are being made to secure papers upon problems of theory and practice in missionary work by eminent speakers from Europe and America, as well as from Korea and the neighboring mission lands.

Your presence is desired with us at that time. Will you be so good as to take the matter into consideration in connection with your other plans for work and travel and inform us at your early convenience whether you can make it possible to spend this season with us. If unable to come, we should be glad to receive a paper from you, to be used at our discretion, upon any phase of the work.

The General Committee who are calling the Conference is composed of members of the Methodist Mission (North), the Methodist Mission (South), the Presbyterian Mission (North), the Presbyterian Mission (South), the Canadian Presbyterian Mission, and the Australian Presbyterian Mission. Committees upon Finance, Programme, Transportation, Hospitality, Press, Local Arrangements, and Museum Exhibit are already at work, and others are expected to be created as needed.

The Conference will meet in Seoul, the capital of Korea, and suitable arrangements will be made to obtain lodging and board for as many visitors as are expected. Facilities will be arranged for the practical display of the mission work as it exists in Seoul, and for as many as can give time to visit the wonderfully progressive work in the north. Concerning travelling facilities, route, accommodation while in Seoul, and other practical details you will receive specific information when your reply reaches us. Korea is close to the beaten lines of constant travel and little time need be lost in making connection with steamers at Kobe, Nagasaki, or Shanghai; while it is expected that rates can be arranged favorable to those planning to make the trip. Ladies and other members of travelling parties will receive the same welcome as yourself.

It is expected that the Presbyterian Council will meet in Seoul during the week preceding the Conference and that the various missions will hold their Annual Meetings during the week following.

A series of wall maps, accurately representing all sections of the field, is being prepared; and a committee will gather a museum of Korean objects in illustration of life and missionary work among the people.

The Conference is to be undenominational in all its bearings, representing the harmony of relation that has always existed between various workers in Korea. It is expected that its proceedings and the principal papers read will be published in a volume after the close of the Conference: those wishing to acquire this record are invited to make the fact known at an early date to the committee in charge.

In replying to this invitation please address

**C.C. VINTON,**

SEOUL, KOREA, ASIA

# 36 *Walter, Jeannette (1919)*

### JEANNETTE WALTER (1885–1977)

Jeannette Walter sailed to Korea in 1911, where she taught at the Ewha Mission School (or Ewha Haktang; today's Ewha Womans University) for fifteen years, until her return to the United States in 1926. Walter then took up teaching in Kansas, a job she held for twenty-five years before retiring to Boulder, Colorado. In 1969 Walter published her autobiography, titled *Aunt Jean*.

1) **Jan. 9, 1919** [Circular]

**Ewha Haktang, Seoul, Korea**

Dear friends.

As you have been struggling in America with the influenza all these weeks, we can only be thankful that we have escaped so well. When we last wrote the epidemic here[1] was almost over and then came the problem of the pickle making, which is outdoor work and would be a great exposure to the girls who were still weak. For days we tried to plan to exclude them, and still have money enough to hire help to do the hard work. At last we decided to send every girl who could possibly go, to her home and use the money that would pay for her board for the help needed. No girl who stayed in the dormitory had a relapse although some who went home were sick again, there were no complications and no deaths.

One day during the epidemic an old woman came and called me to her home to see her granddaughter. She left before I had even time to see her and I had difficulty finding out who she was and where she lived. I found it was a home where I had called once and all were healthy except this little girl. She was very sick and in her distress she called for the foreigner to sing. When I got there I found the little life almost gone and the fever raging. I cared for her and the next day she seemed better. Her people were so grateful and said "Oh if you only make her well, we will believe." I tried my best but the little girl never came back to consciousness and we were not able to sing for her the songs that she had learned in the Christian School, and so longed for, but her last words were words pleading for her people to believe in the Jesus she had

---

[1] The influenza pandemic of 1918–1920 affected both the United States and Korea.

learned to love and she told them she felt sure God would make her well if they would only love Him.

The missionary society had their usual fall mite box opening as last year and received about $9.00. It was used to buy rice and wood to give to the poor on Christmas day and I wish you could have seen the poor people who had gotten tickets coming and going away with their gifts, a little bag of rice and wood enough to cook one meal. Theirs was a Christmas dinner long to be remembered.

There were the usual Christmas trees and programs like we told you about last year, but the inspiration we all received, from the program of Christmas music given by the girls on Sunday evening, will never be forgotten. The church was crowded with Koreans and foreigners. The new pipe organ began to play and from out in the yard we heard "Joy to the World" and the two choruses dressed in white, marched down the aisle singing the good news.

Whether it was the pipe organ which inspired the girls or whether it was because special attention had been given to the translation of the songs, the girls seemed to have unusual freedom and sang to the hearts of the people. In a crowded house usually we have much disorder, but as the girls sang, one could have heard a pin drop and the little boys on the floor, in front sat with wide open mouths. The American Consul general's mother, an old woman of 81 years said "I don't know a word they are saying but I seem to understand. How it must please the Lord Jesus to have people sing His praises like that."

As a result of this program, Mr. Cynn,[2] the principal of PaiChai school came and asked for Miss Wood[3] and two of the girls to go with him to hold a revival meeting in one of the Southern Methodist stations. As singing heretofore has been more for entertainment and evangelistic singing has not been done, it was a new adventure. But knowing that Mr. Cynn would know how to use such singing to advantage the girls went and the people were touched. As Helen Kim[4] sang, "He was not willing that any should perish," an old man sobbed and later rose and told how that song had touched his heart. Now the girls are interested in finding the songs that will appeal at such times and getting them into their own language. One of the teachers in the Southern Methodist school said "the influence of these two little evangelists in our dormitory has been felt and it is a proof to me that Higher Education is worth while and I'm going to try to plan for some of our girls to have the opportunity of college life at Ewha."[5]

[2] Hugh Heung-wo Cynn (or Cyn; 1883–1959) was the president of Pai Chai Haktang (est. 1885; now Pai Chai University).
[3] Lola A. Wood (?–?) was a vocal music instructor at Ewha Haktang.
[4] Helen Kim, or Kim Hwal-lan (1899–1970), was the founding president of the National YWCA of Korea and the first Korean president of Ewha Haktang from 1939 to 1961.
[5] Ewha Haktang (est. 1886; now Ewha Womans University).

242  LETTERS FROM MISSIONARIES

As Christmas presents were not plentiful this year we gave packages only to the girls who did not go home. The girls seemed to understand that there would be little coming from Santa this year and all were unusually grateful for what they did get. To give up getting a nightgown that you have been waiting for for years is not only putting aside a Christmas sentiment but is a real sacrifice. We are so thankful to you all for the effort you have made this year when there have been so many other demands. When the girls gathered around the tree, they gave a little program and then a play which represented a post office scene and people calling for their mail. Some grumbled because they got so little even tho their arms were full but one who got only a post-card telling of the improvement of her mothers health, went away glad and happy. So you see we too have gotten the spirit of a giftless Christmas.

The tree for the school helpers and their families was one of the happiest events of Christmas day to me. The boys and their children gave the program and as the house boy stood to read the Christmas story (he had just learned to read with great effort), his little five year old daughter looked up and said, "My, can't my papa read good!" One twelve year old boy, while singing his solo became a little shaky and his anxious father sitting near by tried to help him. But the father never once hit the tune. Each man was bursting with pride as he showed off his little family.

This fall our school became registered and is now under government regulation. This sounds all very well to put down on paper but it means much anxiety on our part. All the work is done in Japanese now and even the tiny tots are learning it so well they never seem to notice a change when one speaks in Japanese to them. The great problem is that the teachers must be qualified and that means salaries doubled and more teachers must be hired. With the salary of every helper raised, because of the high price of rice, which has been more than doubled, we can only go on having faith that help will come from some place, for we know that the school belongs to the Lord and He will care for it.

Three years ago, one of our Ewha High School graduates went to the Higher Government Normal School of this city.[6] She was the only real Christian there and as she was a H.S.[7] graduate it was very hard for her to have to go back and study in the grammar grades in the Japanese. But she did it willingly after she had a vision one day that perhaps God would use her there. We felt that to get in touch with one of these schools was an opportunity, so we had Sukcha bring a list of names of the girls most interested in Christianity. Each one of our King's Daughter's[8] leaders took a name and began to pray for that girl, first of all that she could be influenced to go to

[6] Hansŏng Sabŏm Hakkyo (est. 1895).
[7] High school.
[8] The International Order of King's Daughters (est. 1886) is an interdenominational Christian service organization established by women from Episcopal, Methodist, and Presbyterian churches.

church. As they went one by one, our girls were delighted. In the Spring Sukcha organized a Bible Class asking a Mrs. Pak to teach. After the first meeting at which only three girls were present, each girl decided that she would bring in five girls, for the next meeting. That day 17 were present, then came the summer vacation after which the girls returned with the same enthusiasm. One day Sukcha saw a notice in the paper of a girl in a near by town, whose mother had been sick a long time and then died and left a great debt for which the girl was obliged to sell herself to the manager of a house of ill fame. The girl did this unwillingly but she had no one to help her. When Sukcha told the dormitory girls about this, their hearts were stirred and they told their teacher the next Sunday. He merely asked a few questions as—"What would you want done if you were that girl?" The girls broke down and cried and he dismissed them with the words: "Weeping will not help, you will have to work and sacrifice." The girls went to their dormitory but there was no peace for them, then they prayed and began to give out of their poverty as only the Koreans know how to do. There was little money but there were silver spoons, clothes and the embroidered things they had made. These they all gave. The thirty girls who had become Christians all gave much and best of all every girl in the school gave at least 25 cents each, and altogether they raised $50.00. It required $110.00 to buy this girl from her life of shame and when they reported the result of their effort to the church, the Aid Society did the rest and the girl was sent for and put into the home of Mr. Pak, the teacher, who has now adopted her and put her in school. The day of her arrival, every non-Christian girl was present to see her and at that time heard a strong message from one of the pastors. Sukcha does not claim any of the credit, she says it was all because the girls here prayed. Last year at this time there were three Christian girls in that school, now thirty are working earnestly for the other thirty.

What a wonderful opportunity to train a leader and live to see her accomplish things that you could not possibly do! What a wonderful privilege of having a little part in preparing a seed and seeing it planted in a place where conditions seemed unfavorable and finding it to grow and multiply even thirtyfold.

Sincerely yours,
**Jeannette Walter.**

### 2) Aug. 18, 1919 [Typed Letter]

#### On board the Asia

Miss Appenzeller[9] has asked me to write a note to you about the conditions in Korea at he [*sic* read the] present time. I feel that there is little to tell that you

---

[9] Alice Appenzeller (1885–1950).

244    LETTERS FROM MISSIONARIES

have not already seen in the papers in America. In our personal letters we can say very little. While things seem a little more quiet in some ways, the feeling on the part of the Koreans is just as intense. Japan is sending a new Gov. General[10] into Korea now and I heard as I left that there was to be another demonstration of some kind to welcome? him. Japan promises some changes for the better but she gives none. The latest is that the police is to wear a different kind of uniform nut [sic read but] that wont mean much to the Korean if his heart is the same. Just before I left Korea they were letting many of our people out of prison.[11] Most of them on bail for a hundred yen each. Our school girls were all out except one or two who were arrested at their homes and were beginning to serve out their sentences. One for three years. They come out weak in body but mighty in spirit. Our girls are nervous and have lost much in weight, the men are terribly bloated so that many cannot be recognized. Just why they are releasing them now I do not know unless it is to get a good feeling so that the Koreans will consent to go to school this fall. It is doubtful now whether there will be school in the fall or not for they are still arresting students and teachers and as long as they do that it will not be safe for them to come in from their homes. We tried to get a written statement that they would let the girls alone if we called them back but they would not give it to us. We will open the Primary school at any rate and the Higher school if at all possible.[12]

I think that it is safe now for any one in Korea altho this spring all country work had to be shut down. The hatred that the Japanese have for the foreigners is felt everywhere and one never knows what they will demand if you are in a country place alone. Many Koreans are running away to Chine [sic read China] and there joining up with the Chinese troops and expect some happy day to come back and fight.

The Japanese people are kept ignorant of all the truth about Korea for they can only read what is officially written and most of that is a lie. When Japan herself really knows she will demand better things not so much for Korea but for herself. We had hoped that they would do away with the military system but their new man is military man so we have little hope.

The people of Korea expect their Independence as much as anything for have they not prayed for it and will God not hear the prayers of his many children. But often in these days of awful suffering and agony of mind they become disheartened and they look to the missionary for help and encouragement but often do not find us as hopeful as they I fear.

---

[10] Saitō Makoto (1858–1936) was the Japanese governor-general of Korea from 1919 to 1927 and from 1929 to 1931, during the Japanese colonial occupation of Korea. He was a viscount in the Japanese House of Peers.
[11] Most likely the release of protesters arrested during the March First Independence Movement (1919) against the Japanese colonial occupation.
[12] Primary and higher schools under Ewha Haktang.

The stories of the burnt villages are true.[13] A boy who came from there to work for us was besides one other boy the only men to escape with their lives. The picture of the fear and the suffering in that boys face will never leave me. His father and his mother were both shot down but he escaped by hiding in the hills.

I am sure that you will not forget Korea in these days and please pray that the God who so wonderfully took care of His children in times of old will work out that which is best for this people who love Him so.

Sincerely Yours
**Jeannette Walter**

---

[13] The crackdown on March First Independence Movement (1919) by the Japanese military involved multiple village burnings and shootings. The Cheam-ni Massacre (Apr. 15, 1919), for instance, was a mass killing of Christian and Ch'ŏndogyo residents of Cheam-ni, Suwŏn, by Japanese troops.

# PART II

# LETTERS FROM KOREANS AND JAPANESE

# 1   *Cho, Hi-yŏm (조희염) (1923)*

## CHO HI-YŎM (조희염) (1885–1950)

With help from a Canadian missionary, Cho Hi-yŏm studied at Dalhousie University in Nova Scotia and the University of Toronto before he enrolled in a PhD program at the University of Chicago in 1923. He was actively involved in the Korean Student Federation of North America (북미대한인유학생총회 Pungmi Taehanin Yuhaksaeng Ch'onghoe) and its magazine, *The Rocky* (Urak'i 우라키), until 1927. At the request of the Canadian Mission, he returned to Korea and served as principal at a theological school in Hamhŭng. In 1940, he was appointed to the faculty of Chosŏn Sinhakkyo (now Hanshin University) in Seoul. He remained in Hamhŭng after the division of the Korean Peninsula (1945) and died as a result of torture during the Korean War (1950–1953).

1) **June 20, 1923**

**Lucan, Ont.**

Dear Dr. Griffis:—

I have received your favour of June 7th and I thank you for all what you have done for my home country in your prayer and your congratulation on what little success I have made in oratorial contest.

I would have been very good minded to send you the copy of the speech if I had it with me. As you notice my present address I am not in the city of Toronto but in the county quite distant from Toronto and I left most of my belongs in Toronto and the copy of the speech is one of them.

If you really care for it and some time in the fall is not too late to send you I will do it when I go back to that city again. I will be at the University of Chicago next winter for my degree of doctor of philosophy.

Sincerely yours,
**H. Y. Cho**

# 2     *Cynn, Hugh Heung-Wo (신흥우) (1922)*

### HUGH HEUNG-WO CYNN (신흥우)
### (1883–1959)

Hugh H. Cynn (Sin Hŭng-u 신흥우) was an active member of the Korean independence movement during the period of Japanese oppression. In his early years, Cynn attended Pai Chai Haktang, a boys' school founded by Henry G. Appenzeller. Upon Appenzeller's recommendation, Cynn studied English and German. In 1901 he was imprisoned on charges of radical political thought, during which he befriended other Korean independence advocates and missionaries, who inspired him to study in the United States. After returning to Korea in 1911 with a degree from the University of Southern California, Cynn became the dean of his alma mater, Pai Chai Haktang. Throughout the next decade, he was an active member of the Methodist Church and the YMCA. Cynn published a booklet titled "The Rebirth of Korea: The Reawakening of the People, Its Causes, and the Outlook" (1918) and became the president of the YMCA in 1920. However, in the 1930s, Cynn espoused fascist ideas and formed a faith group advocating fascism. This led to his resignation from the YMCA in 1935 and the decrease of his visibility in Korean history. After Korea's independence from Japan (1945), he ran for president and the National Assembly without success and served as an advisor to the Democratic Party in 1957.

**1) Nov. 27, 1922** [Typed Letter]

**New York**[1]
Rev. Wm. Elliot Griffis, L.H.D.,
Pulaski, New York.

My dear Dr. Griffis,-

You were good enough to write me after I returned home and asked me to get some historical material from Korea for your new books, but on purpose that you could appreciate to some degree I have kept absolute silence so far as my foreign correspondences were concerned. Now, however, I am in this country for a visit, and I have the material with me, which I had a Korean scholar compile

---

[1] In letterhead: The Union Committee of Korean Young Men's Christian Associations, Chong-no, Seoul, Korea.

for me per your request and that of Bishop Welch[2] with whom you had correspondence on the matter. I will be in the city for about a week, and I shall be very happy to see you whenever it is convenient for you. You can drop me a card, telling me where and how I can best see you. My address is 347 Madison Ave. (YMCA Hdqters), or the hotel Madison, opposite the Madison Square Garden.

Hoping to hear from you soon, I am,

Yours most respectfully,
**Hugh H. Cynn**

---

[2] Herbert George Welch (1862–1969) was a bishop of the Methodist Episcopal Church, Methodist Church, and United Methodist Church. He also served as a bishop of the Seoul episcopal area.

# 3        *Harada, Tasuku (原田助) (1915)*

### HARADA TASUKU (原田助) (1863–1940)

Born into the samurai class, Harada received his early education in Kumamoto Yōgakkō under the Christian guidance of Captain Leroy Lansing Janes. In 1880 he began his study at Dōshisha English School, a Congregational school in Kyoto. Harada was baptized in 1881 and ordained in 1885. He studied at the University of Chicago Divinity School and Yale University and then in England and Germany before returning to Japan in 1896. As pastor of major Congregational churches, Harada was active in the YMCA movement and interdenominational cooperation. In 1910 he represented Japan at the Edinburgh World Missionary Conference. From 1907 to 1920 he served as president of Dōshisha University. Harada was invited to the University of Hawaii to set up a department of Asian Studies and served as its dean until 1932. He wrote numerous books, notably, *The Faith of Japan* (1914).

### 1) Oct. 10, 1915

**The Chosen Hotel, Keijyo (Seoul), Chosen** [location from letterhead]

Dear Dr. Griffis:

You may remember Ichihara[1] who was at New Haven[2] at the same time with me, became a professor in Doshisha and lately the president of the Bank of Chosen, died a few days ago. I came here to attend his funeral which took place the day before yesterday, at the large Y.M.C.A. Hall. Dr. I[3] was one of the Kumamoto band[4] who were the first graduates of Doshisha. All his friends deplore his sudden passing away.

---

[1] Ichihara Morihiro (1858–1915) was the first president of the Bank of Chōsen (1909–1950), the central bank of colonial Korea, from 1911 to 1915. He graduated from Kumamoto Yōgakkō (1871–1877) and Dōshisha English School (est. 1875; now Dōshisha University) and taught at the latter. He also held a doctoral degree in economics from Yale University (est. 1701).
[2] New Haven, Connecticut.
[3] Ichihara.
[4] The Kumamoto Band was a group of Protestant Christian students who attended Kumamoto Yōgakkō, an academy of Western studies founded by American missionary and educator Leroy Lansing Janes (1838–1909). The closing down of the academy in 1877 led many students, possibly including Ichihara Morihiro, to transfer to Dōshisha English School.

This morning Dr. Underwood,[5] a Presb.[6] missionary and the president of the new Union Xn College[7] (teaching in Y.M.C.A. rooms at present), took me riding out to the new site of the college outside of the city, with Prof. and Mrs. Nichols[8] of Cornell who are visiting here.

The Exposition[9] is going on in the old palace ground, to celebrate the fifth Anniversary of the Japanese rule since the Annexation. It concretely shows the success of the rule. This is my third visit to Seoul. Every time it is simply a wonder to see the changes & improvement evident everywhere. Seoul is completely new! I wish you could see this.

Sending you a pamphlet, "The Progress of Five Years" with cordial regards to Mrs. Griffis[10] and yourself I am

Ever faithfully yours,
**Tasuku, Harada.**

---

[5] Horace Grant Underwood (1859–1916).
[6] Presbyterian.
[7] Chosen Christian College (est. 1885; now Yonsei University).
[8] Possibly referring to Edward Leamington Nichols (1854–1937), who was a professor of physics at Cornell University (est. 1865) from 1887 to 1919.
[9] The Chosŏn Industrial Exhibition (Sep. 11–Oct. 31, 1915), held in Kyŏngbokkung Palace, Seoul, was a fair held by the Japanese colonial government to publicize its fifth anniversary of colonial occupation in Korea.
[10] Sarah Frances King Griffis (1868–1959).

# 4     *Itō Hirobumi* (伊藤博文) *(1908)*

### ITŌ HIROBUMI (伊藤博文) (1841–1909)

Itō, born Hayashi Risuke, attended University College London, where he studied Western governments. He helped draft the Meiji constitution and established the bicameral national Diet of Japan. He became the first prime minister of Japan in 1885 and the first governor-general of Korea in 1905, following the Russo-Japanese War. Itō advocated that the Korean Peninsula be treated as a protectorate in order to prevent it from falling under China or Russia's growing sphere of influence. The Japanese cabinet voted to annex Korea, and Itō was forced to resign by the Imperial Japanese Army on June 14, 1909. Itō was assassinated in Harbin, China, by a Korean independence activist, An Chung-gŭn (1879–1910).

1) **May 6, 1908** [Typed Letter]

**H.I.J.M.'s Resident General's Mansion, Seoul**
Dr. W. Elliot Griffis,

Dear Sir:-

Your note dated 20th, March last has been duly received by Resident General Prince Ito. Recollecting his old friendship with you, the Prince read the note with much interests and highly appreciated your undertakings in America, which have been done so devotedly and sincerely for the honor and interest of Japan.

As you requested, the Prince directs, herewith to send you photographs of the Korean Government buildings, court house, new prison compound, hospital, industrial and agricultural model farms, various schools, etc. Several English pamphlets attached hereto, would give you some general ideas concerning the progress and reforms done in Korea under the guidance of Resident General. The prince trust that these photographs and pamphlets should help your interesting undertaking.

I am specially ordered by the Prince to convey his best wishes to you.

Very respectfully and sincerely, yours
**H. Furuya.**

The Private Secretary
To the Resident General.
[Typed Document]

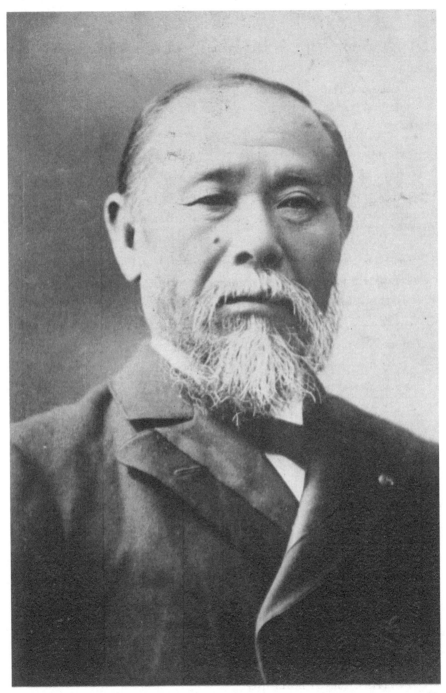

Figure 35 Portrait of Itō Hirobumi, taken between 1900 and 1909 (KP 1.3.10, Griffis Collection)

## LETTERS FROM KOREANS AND JAPANESE

H.I.J.M's. Resident General's Mansion,

Seoul, May 6, 1908.

Dr. W. Elliot Griffis,

Dear Sir:-

Your note dated 20th, March last has been duly recei-
ved by Resident General Prince Ito.   Recollecting his old friendship
with you, the Prince read the note with much interests and highly
appreciated your undertakings in America, which have been done so
devotedly and sincerely for the honor and interest of Japan.

As you requested, the Prince directs me herewith to
send you photographs of the Korean Government buildings, court house,
new prison compound, hospital, industrial and agricultual model farms,
various schools, etc.   Several English pamphlets attached hereto,
would give you some general ideas concerning the progress and reforms
done in Korea under the guidance of Resident General.   The prince
trust that these photographs and pamphlets should help your interes-
ting undertaking.

I am specially ordered by the Prince to convey his best
wishes to you.

Very respectfully and sincerely, yours

H. Furuya.

The Private Secretary
to the Resident General.

Figure 36  Itō Hirobumi's letter to Griffis, dated May 6, 1908 (Box 59, Folder 36, Griffis Collection)

*[front:]*

*A. List of Photographs*[1]

I   THE CABINET BUILDING
II   THE SEOUL PRISON BUILDINGS[2]

[1] The Korean photographs (KP) are a subseries of the Griffis Collection's Photographs series.
[2] Kyŏngsŏng Kamok (est. 1908; now Sŏdaemun Prison History Hall) in Sŏdaemun, Seoul. Sŏdaemun is Korean for "West Gate."

III  THE COURT HOUSE (SUPREME COURT & SEOUL APPEAL COURT)[3]
IV  A  THE PRINTING BUREAU
    B  THE BOOK BINDING SECTION
V   A  THE SEOUL NOMAL [*sic* read NORMAL] SCHOOL[4]
    B  A CHEMICAL LABORATORY OF THE SCHOOL
VI  A  A SEOUL PUBLIC SCHOOL
    B  A CLASS ROOM OF THE SCHOOL
VII  THE FOREIGN LANGUAGE SCHOOL[5]
VIII  THE SEOUL Y.M.C.A.[6]
IX  A  THE SEOUL HOSPITAL
    B  A WORD [*sic* read WARD] FOR THE THIRD CLASS PATIENTS
    C  AN OPERATION ROOM
X   A  THE INDUSTRIAL TRAINING SCHOOL[7]
    B  THE POTTERY AND PORCELAIN SECTION
    C  THE MANUAL TRAINING SECTION
    D  THE WEAVING SECTION
    E  CHEMICAL EXPERIMENTARY SECTION
    F  THE IRON WORK SHOP
    G  THE DRAFT & DRAWING SECTION
XI  A  AGRICULTURAL AND INDUSTRIAL EXPERIMENTING MODEL
       PLAN
    B  THE SECTION OF NATURAL HISTORY ATTACHED TO THE
       FARM
    C  THE AGRICULTURAL SCHOOL ATTACHED TO THE FARM

[*back:*]

*B. List of Pamphlets*

I.  Administrative reforms in Korea.
II.  Summary of the Financial affairs of Korea.
III.  Report of the Progress of the Reorganization of the Finance of Korea, November, 1905.
IV.  État du progrès de la Reorganization des Finances de Corée, Juillet 1906.

**2.** [*Typed Article*]
   NEW PRISONS FOR KOREANS.
   Great improvement made under the present administration.
   Will be ready very soon.

---

[3] Hansŏng Chaep'anso (1895–1907).
[4] Hansŏng Sabŏm Hakkyo (est. 1895).
[5] Hansŏng Oegugŏ Hakkyo (1906–1911).
[6] Seoul YMCA building (est. 1908) in Chongno, Seoul.
[7] Kyŏngsŏng Kongŏp Chŏnsŭpso (est. 1895; now Seoul National University College of Engineering).

## 258 LETTERS FROM KOREANS AND JAPANESE

Codes being completed by Experienced lawyer.—Present System is Necessarily Only Temporary

(From Japan Advertiser,[8] Sept. 28th, 1908)
Seoul, September 20

The president of the newly established high court of justice in Korea, Mr. Noboru Watanabe,[9] one of the renowned Japanese lawyers who converses in French quite fluently, speaking of the financial reforms in Korea says, the following courts are provided for:-

(1) One high court of Justice in Seoul. (2) Three courts of appeal in Seoul, Pyang Yang (north) and Taiku (South K.)[10]
(3) Eight provincial courts in Seoul, Kongchu, Hamheung, Pyong Yang, Haiku, Taiku, Chinchu and Kwangchu.[11]
(4) 16 district and local courts opened and 99 others to be opened gradually, divided amongst the 13 Korean provinces. For the present these 16 districts courts are in course of formation.

The court of first instance can punish criminals up to 10 months' imprisonment with or without hard labor, corporal punishment, commutation punishment, viz., money or liberation under caution. All the laws even newly introduced from Japan are of only a temporary character. The new codification is undertaken by Prof. Dr. Ume[12] of the Tokyo University who has been called here by Prince Ito in order to study the customs and habits of the Koreans. Dr. Ume has returned to Japan in order to prepare the Civil Code, Commercial Code, and the regulation of the Civil Procedure.

The Penal Code will be worked out by a committee of 8 Japanese and 3 Koreans under the guidance of the Vice Minister of Justice, Kuratomi,[13] who has thirty years' experience behind him as advocate, public procurer and judicial official. He is considered in Japan as an authority.

It is hoped that all the new Codes will be ready at the end of 1910. Mr. Watanabe states that prison reform is under investigation. According to

---

[8] *The Japan Advertiser* (1918–1940) was an English-language daily newspaper published in Tokyo.

[9] Watanabe Noboru (1838–1913) was the first chief justice of the court of the Government-General of Korea from 1910 to 1923.

[10] P'yŏngyang (in northwestern Korea); Taegu (in southeastern Korea).

[11] Kongju (in Ch'ungchŏng-namdo, southwestern Korea); Hamhŭng (in Hamgyŏng-namdo, northeastern Korea); P'yŏngyang; Haeju (in Hwanghae-namdo, northwestern Korea); Taegu; Chinju (in Kyŏngsang-namdo, southeastern Korea); Kwangju (in Chŏlla-namdo, southwestern Korea).

[12] Ume Kenjirō (1860–1910) was a Japanese legal scholar, professor at Tokyo Imperial University (est. 1886; now University of Tokyo), and founder of Hosei University (est. 1903). Itō commissioned him to codify the Korean law in 1906.

[13] Yūzaburō Kuratomi (1853–1948) was a Japanese prosecutor, bureaucrat, and politician. He was appointed vice minister of justice of Korea in 1907.

the Korean prison regulations there are now only 8 big prisons, established in connection with the 8 provincial courts in Seoul, Kongchu, Hamheneg, Pyong Yang, Haiku, Taiku, Chinchu, and Kwangchu.

The present prisons are all in a bad state and old-fashioned, but the plan for the new prisons now under construction outside the West Gate are exceedingly elaborate.[14] Prince Ito, in granting permission for the newspaper men recently to make an investigation at the Seoul Prison, said: "Yes, let them see them, for afterwards, when the new prisons are ready, foreigners will appreciate what we have done in improving the prisons."

The prisons are under the supervision of the three Chief Public Procurators of the three courts of appeal at Seoul, Pyong Yang and Taiku.

The stuff [*sic* read staff] of the 8 prisons consists of one general-prison director, 8 prison directors, one for each, 54 chief jailors, 216 jailers and 16 female jailers, 9 interpreters and 12 medical doctors.

The Seoul Prison contains in 30 cells, each of about 4 cubic meters, 582 male and 6 female prisoners—about 20 in each cell. At the end of this month they will be removed to the larger prison.

Undoubtedly all the prisons are overcrowded, but no sensible man will hold the Japanese responsible for it and surely it won't be many years before we shall see adequate prisons in Korea.

[14] Kyŏngsŏng Kamok (est. 1908; now Sŏdaemun Prison History Hall) in Sŏdaemun, Seoul.

# 5  Jaisohn, Philip (서재필) (1919–1922)

## PHILIP JAISOHN (서재필) (1864–1951)

At the age of 18, Philip Jaisohn (Sŏ Chae-p'il 서재필) passed the Korean civil service examinations. After studying at the Youth Military Academy in Japan, he was appointed as the commandant of the Korean Military Academy. Jaisohn participated in the Kapsin Coup (1884) to initiate political reforms. Its failure forced him to leave Korea as a political refugee bound for San Francisco. With the help of the American industrialist John W. Hollenback, Jaisohn began his study at the Harry Hillman Academy in Wilkes-Barre, Pennsylvania. He enrolled at Columbian Medical College (now George Washington University) and became the first Korean to receive an American medical degree. In 1894, he married the daughter of the U.S. postmaster general, the first interracial marriage on record between a Korean and a citizen of the United States. He returned to Korea in 1896 and initiated a series of reforms. Although offered the position of the foreign secretary, he rejected the offer, instead focusing on reform movements. One of Jaisohn's major achievements in this period was founding *The Independent* (Tongnip Sinmun 독립신문) (1896–1899), the first newspaper written entirely in the Korean alphabet, which allowed a wider stratum of Korean society to access information.

In 1898 Jaisohn returned to the United States under pressure from conservative factions in the Korean government. In the United States, he operated a stationery shop and a furniture store in order to promote the Korean independence movement. He organized the First Korean Congress and established the Korean Information Bureau. He also founded the League of Friends of Korea and published a political journal called the *Korea Review* to inform the public of the situation in Korea. Jaisohn declared bankruptcy in 1925, due to the burden of his active engagement in the Korean independence movement. He then returned to medical practice. He received commendations from presidents Franklin D. Roosevelt and Harry Truman, and from the U.S. Congress in 1946.

1) **July 30, 1919** [Typed Letter]

**Bureau of Information for the Republic of Korea, 825 Weightman Building, 1524 Chestnut Street, Philadelphia, PA.** [location from letterhead]
Dr. William Elliot Griffis,
Glen Place,
Ithaca, N.Y.

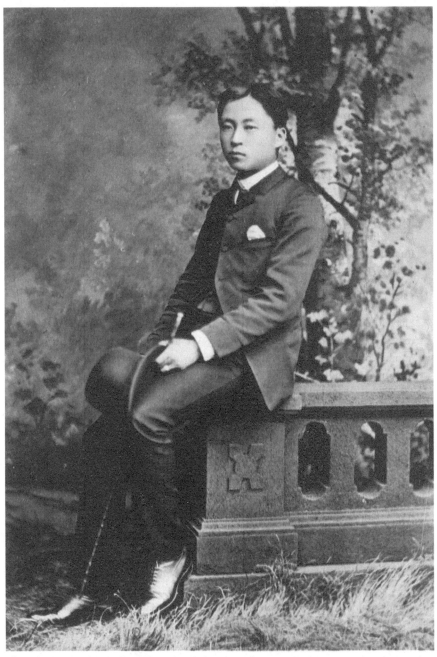

Figure 37 Portrait of Philip Jaisohn (Sŏ Chae-p'il 서재필) (KP 4.1.1, Griffis Collection)

262    LETTERS FROM KOREANS AND JAPANESE

Dear Dr. Griffis:

I am sending you under separate cover a copy of the proceedings of the First Korean Congress, held in Philadelphia, April 14, 15, and 16, 1919.[1]

This may be of some interest and information to you.

Yours sincerely,
**Philip Jaisohn**

PJ*DEC

**2) July 18, 1921** [Typed Letter]

**Korea Review, 825 Weightman Building, Philadelphia, PA** [location from letterhead]
Dr. William Elliot Griffis,
Pulaski,
Oswego Co., N.Y.

Dear Dr. Griffis:

I have the letter of Dr. Lovett to you, which you kindly sent me. I think your review of Chung's book[2] was very fine. We are reproducing it in the July number of the KOREA REVIEW.[3] I am returning Dr. Lovett's letter to you, and am also sending Dr. Lovett some literature on Korea.

We are very much interested in the coming international conference in Washington. I hope you will write an article for some publication, such as the "New Republic",[4] setting forth the reasons why the Korean problem should be discussed and justly solved at that conference. Not only for the sake of justice to the Koreans but for the general welfare of the world, specially to those nations who are interested in the Pacific, including Japan herself. It is obvious if Japan refuses to solve the problem she will be isolated among nations of the world, which will not do her good.

If you write an article along the line of promoting the real welfare of Japan by proper action at this conference, the Japanese may take the hint and

---

[1] The First Korean Congress (Apr. 14–16, 1919), held at Plays and Players Theatre in Philadelphia, Pennsylvania, was a convention publicizing both the March First Independence Movement (1919) and the establishment of the Provisional Government of the Republic of Korea (Imsi Chŏngbu). The event was organized by Philip Jaisohn and Syngman Rhee (1875–1965).
[2] Henry Chung, *The Case of Korea: A Collection of Evidence on the Japanese Domination of Korea, and on the Development of the Korean Independence Movement* (New York: Fleming H. Revell, 1921).
[3] The *Korea Review* (1919–1922) was a monthly magazine published in Philadelphia, Pennsylvania, by the Korean Students' League of America, under the auspices of the Bureau of Information for the Republic of Korea.
[4] *The New Republic* (est. 1914) is a weekly magazine on politics, contemporary culture, and the arts, published in New York, New York.

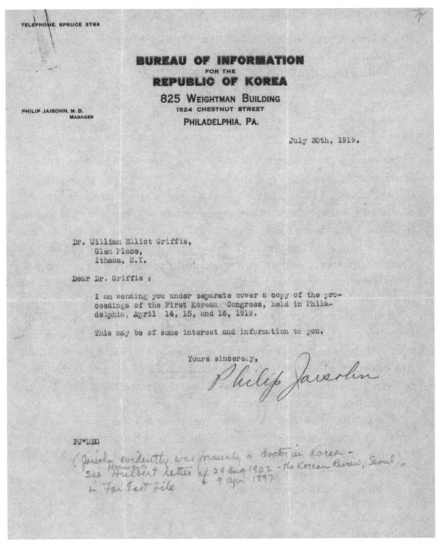

Figure 38 Philip Jaisohn (Sŏ Chae-p'il 서재필)'s letter to Griffis, dated July 30, 1919 (Box 59, Folder 37, Griffis Collection)

do something. If you send me the article I will certainly publish it in my magazine, but if it was published in some other paper also, and then I copied from that, it will have double publicity. I hope you will have time to do this for Korea and for Japan.

With kindest regards, I am,

Sincerely yours,
**Philip Jaisohn**

## 3) July 25, 1921 [Typed Letter]

**Korea Review, 825 Weightman Building, Philadelphia, PA** [location from letterhead]
Dr. William Elliot Griffis,
Pulaski, Oswego Co.,
New York,

Dear Dr. Griffis:

I have yours of the 22nd inst., enclosing articles, for which please accept my sincere thanks.

As I wrote you before, I hope you will write an article on Korea in reference to the coming international conference in Washington.[5] The world owes Korea a chance to plead her case before such a tribune, especially when the conference is held in America for the specific purpose of settling the Far Eastern questions. The only way to eliminate possible causes of war and future disturbances is to deal with every unit of the nations of that region, so that the world will obtain the co-operation of all the peoples in Eastern Asia.

If the conference should overlook the case of Korea, because Korea is an impotent and negligable [*sic* read negligible] quantity, Korea may become the means of defeating the very purpose for which this conference is called. America ought to remember her treaty stipulations with Korea at this time and give her a chance to lay her case before this international body for its consideration and just adjudication.

I would like an article from you along these lines for either the New Republic or some other well known periodical, to be published in either the September or October issue. Will it be asking too much of you to give your services to Korea in this matter?

Thanking you in advance, I am,

Sincerely yours,
**Philip Jaisohn**

---

[5] The Washington Naval Conference (1921–1922) was an international conference held to negotiate the limitation of naval armaments in the Pacific Ocean. Several treaties were signed, including the Four-Power Pact (United States, Great Britain, and Japan) and the Five-Power Naval Limitation Treaty (United States, Great Britain, Japan, France, and Italy).

## 4) Apr. 17, 1922 [Typed Letter]

**Korea Review, 825 Weightman Building, Philadelphia, PA** [location from letterhead]
Dr. William Elliot Griffis,
344 West 56th St.,
New York, N.Y.

Dear Dr. Griffis:

I have yours of the 15th inst., enclosing manuscript. At the bottom of your article I am going to add the enclosed information. This gives some of the historical facts.

You will notice that I have mentioned two co-reformers came with Secretary Soh; I was one of the two the other was Prince Park,[6] who is still living in Korea. The Japanese gave him the title of Marquis. He is very much feared by the Japs and they would have done away with him long ago but for the great popularity and affection he enjoys among the people.

As per your suggestion I have written to Dr. Corwin and sent him a copy of Hansu's Journey[7] with my compliments.

With kindest regards, I am,

Very truly yours,
**Philip Jaisohn**

## 5) May 26, 1922 [Typed Letter]

**Korea Review, 825 Weightman Building, Philadelphia, PA** [location from letterhead]
Dr. William Elliot Griffis,
Pulaski, N.Y.

Dear Dr. Griffis:

I have yours of the 20th inst., enclosing article which is an advance copy of your book of Korean Fairy Tales.[8] I will be very glad to use it as it will interest a good many of our readers.

Thank you very much for same, I am,

Sincerely yours,
**Philip Jaisohn**

---

[6] Pak Yŏng-hyo 박영효 (1861–1939) was the husband of Princess Yŏnghye (1858–1872) and a reformist politician involved in the Kapsin Coup 갑신정변 (Dec. 4–6, 1884) and Kabo Reforms 갑오경장 (1894–1895). In July 1895, he emigrated to Japan after being accused of treason. A pro-Japanese collaborator, he was a colonial officer during the Japanese occupation of Korea and was given the title of marquess by the Japanese House of Peers.

[7] Philip Jaisohn, *Hansu's Journey: A Korean Story* (Philadelphia: P. Jaisohn and Co., 1922).

[8] William Elliot Griffis, *Korean Fairy Tales* (New York: Thomas Y. Crowell Company, 1922).

# 266 LETTERS FROM KOREANS AND JAPANESE

6) **Dec. 29, 1922** [Typed Letter]

**Korea Review, 825 Weightman Building, Philadelphia, PA** [location from letterhead]
Mr. William E. Griffis,
Pulaski, New York.

Dear Mr. Griffis:

I hope you have had a pleasant and enjoyable holiday and that you are enjoying your usual good health.

I am writing you these few lines to wish you a very happy and prosperous New Year.

Yours very sincerely,
**Philip Jaisohn**

# 6    *Kim, Ch'ang-hŭi (金昌熙) (1927)*

KIM CH'ANG-HŬI (金昌熙) (?–?)

Kim Ch'ang-hŭi wrote to Griffis after he attended Griffis's lecture in Seoul on April 16, 1927. In this letter written in Japanese, Kim pays high respects to Griffis's scholarship regarding Japan and its relation to the United States and quotes a phrase, "please have the anti-Japanese law come to an end," from Griffis's lecture. In his journal entry on April 16, 1927, written during his visit to Korea (March 22–April 4 and April 9–April 19, 1927), Griffis entered, "Y.M.C.A. Koreans and Japanese. Lecture on Japan Past & Present 大."[1] (We are grateful to Dr. Haruko Wakabayashi for transcribing the handwritten letter.)

### 1) Apr. 16, 1927[2]

**Hunjŏng-dong 69, Korea** [location from the location at the end of the letter]

私は今晩八時から、私にとっては二度と耳にする事
の出来ない御高徳なる先生の講演を拝聴し
た者の一人であります。先生の講演に依りまして日
本の維新時代の事を一層よく知り、誠に先生の
日本に対する御研究と精神的、又肉体的に御
壮健にあらせらるる事を感敷 [sic read 激]しました。
願がはくば今後、吾々人生をして明き平和の道、
神の近境まで導かれん事を切にお祈りす
るのであります。殊に、日米両国の国際的親密を
とお励[3]み下さいませ。現時こそはでは語学不充分の為
先生の御講演を皆聴き入る事は出来ませんで
したが先生が書かれた本が出来上がる迄には
と思って一層の努力を以って勉学するつもりであ
ります。御著の本を完全に拝読する事が出
来ればと思って今から喜んで居ります。何を
缺いでも、御著だけはと思って今から資産の積
立を始める心積であります。もう一言申

---

[1] See S. Park and Y. Cho, "William Elliot Griffis and His Visit to Korea in 1927: From His Journal and Korea Letters" in *The Photographs of Korea in the William Elliot Griffis Collection*, ed. S. Yang and Y. Yu (Hanbit Publishing, 2019), 368–388.

[2] We followed the line breaks in the original letter. The date is from the date at the end of the letter.

[3] 励 is the simplified kanji that corresponds to the kanji used by the writer.

添えますが、御講演にもあった通り、あの「排日法案
をして、死んだ文字にして下さいませ」。御遠路
御健康にあらせられん事をお祈りして居り
ます。さようなら
一九二七、四月十六日

薫井洞 六九,
金昌熙 [Kim Ch'ang-hǔi]

グリフィス博士

# 7   *Kim, Frank Yongju (김용주) (1927)*

FRANK YONGJU KIM (김용주)
(1890?—1940?)

Frank Yongju Kim (Kim Yong-ju 김용주) was the son of Kim Yu-jŏng, who was a diplomat in the Korean legation in Washington. He was educated in the United States from 1897 and served as the editor in chief of *The Seoul Press* (1907–1937), Japan's flagship Korean newspaper printed in English, whose mission was to validate Japanese rule in Korea. He was also a correspondent for the Associated Press and the founding member of the Rotary Club.

1) **Mar. 3, 1927**[1]

**The Seoul Press**
Dr. Griffis,
Beppu, Japan.

Dear Sir:

Kindly pardon me for writing to you direct without a formal introduction. Realizing that you are so well known here in this remote part of the world I take this liberty of writing to you.

    I have been asked by the members of the University Club of Chosen, of which I am the secretary, to extend their invitation to both Mrs. Griffis and you to meet them on one of the days of your sojourn in Chosen. I understand you are planning to stay in this country several weeks. If the above report is true would it be too much to ask you to set aside an hour or so on some day when you are not too busily occupied? If possible I would like to know what date you can reserve for us by return mail. This advance information is necessary because some days are needed to send notices to members.

    Hoping you will overlook my shortcomings in approaching you in this abrupt way,

Yours truly,
**F. Yongju Kim.**

---

[1] On the envelope, it is written, "If not delivered in 5 days, kindly return to F.Y. Kim c/o The Seoul Press, Seoul, Chosen."

# 8     *Kim, Henry Cu (김현구) (1914–1920)*

### HENRY CU KIM (김현구) (1889–1967)

Henry Cu Kim (Kim Hyŏn-gu 김현구) emigrated to the United States in 1909, where he founded the Korean Student Alliance (est. 1912), *The Korean Students' Review* (1914–1916), and *The Young Korean* (1919). He participated in the First Korean Congress (1919), began serving in the North American headquarters of the Korean National Association (Taehanin Kungminhoe; est. 1909) in 1920, and represented Hawaii during the Korean Conference Abroad (1941). He earned his B.A. at the Ohio State University and a doctoral degree at the University of California. Kim became the editor in chief of *The New Korea* (*Sinhan Minbo* 신한민보), a popular Korean American newspaper, publishing articles advocating Korean national independence. He also contributed to the Korean National Association's articles from 1919 to 1927. As a fierce critic of Syngman Rhee, the first president of the Provisional Government and the first president of the Republic of Korea, Kim published *Biography of Woonam Syngman Rhee*. Kim promoted diplomacy for Korean independence through his publication, "Eight-Year Plan for Independence Movement." Kim was posthumously recognized with the Order of Merit of National Foundation and Patriotism Award by South Korea. Although Kim died in the United States, his remains are buried in the Daejeon National Cemetery.

### 1) July 19, 1914

**Gananoque, Ont. Canada**
Dr. Wm E. Griffis
Ithaca, N.Y. U.S.A.

My dear Sir:—

With greatest pleasure and many thanks I have received the most esteemed letter from you. The thanks, the pleasure, and all are far, far more than what any writing can express.

The questions you have asked me, I will answer in order:

(1)  "How and why Hastings College is so largely attended by Koreans?"
Some years ago one of our leaders (who was a young man of twenty-two, or three then and well known as a scholar of Chinese, Japanese and our own languages, and as an enthusiastist [*sic* read enthusiast] among fellow

countrymen) came to San Francisco and found that he could not stay there for some reason. Then he came eastward not [?] any particular place for aim. But when he reached Nebraska he settled there somehow though with great difficulty, with his followers of six or seven people in accompaniment. After a year or so the settlement was getting somewhat better. Finally we found a great and helpful friendship in Mr. Johnson and many others who were and are helping us so much. That is about all the reason.

(2) "Were they directed by missionaries?" No such influence whatever. Of course most of Koreans in Nebraska rather in America are Christians and "good" many of them are Presbyterians.

(3) "How many Korean students in America?" All together about 270–280 in number—including those from 5th grade in Primary Schools to Graduate schools in Colleges. Among those about [50?] are working in colleges.

(4) "What other American colleges have one or more Koreans?" Following colleges and universities have Korean students—varying in number from one to three: California, Pennsylvania, Virginia, Ohio State, Yale, Chicago Universities and few other colleges. But it is our plan that we may be scattered all over into every well-known colleges if there will be any possible opportunity for us.

About Korean history I do not know what to say in answering your inquiry. First place, I do not think I have the ability yet. In the second place I do not have—it is a shame to say—any references now to refer to, nor I have the possibility of getting them; for the field is too wide and time is too short, rather lacking. Seven Koreans including me have planned and agreed that we will engage ourselves to historical research when we go back. It may be a foolish and unprofitable plan; but we will try. I do not have any book about Koreans and Korea at present and I am sorry to say I can not do now what you ask me to do.

Your suggestion on the best historical writings by foreign authors is very interesting to me. Foreigners are usually free from prejudice and therefore see the features more clearly. I beg your pardon and want to say that if anyone of our foreign friends, you for example, may write a good history for us, it would be much much better than we do; for we do have some trouble in writing certain things so that we may not be free not only from prejudice, but from being hindered to state the facts, by some people or law who is stronger in power than the Koreans. After all, all these what I have said are shame but nothing more.

I am going back to Ithaca by first part of September, and will come to you. I would like to answer your further questions, if you have.

With best wishes to you and Mrs. Griffis,

Very sincerely yours
**Henry C. Kim**

272 LETTERS FROM KOREANS AND JAPANESE

**2) Apr. 1, 1916**

**Columbus, Ohio**
Rev. William E. Griffis,
Ithaca, New York.

My Dear Sir:—

Your kind letter, which has been received a couple of weeks ago, has made me exceedingly pleased and very much obliged to you. Further I am really delighted to hear that you are writing your contributional articles, especially on "Korea" among several; I hope that you will produce the first impartial statements on my native country, so little until yet known to the world and so often unfairly looked down by the learned people. I have read the present article in the Encyclopedia, and will read yours as soon as the new edition will appear.

About your questions, I had made inquiries to the Editor of our Student Review and to others, but failed to get any adequate account. Finally I have just written to the President of our Student Alliance,[1] (Mr. Earl K. Paik[2]) who is in San Francisco and asked him to write you directly. I am quite sure he will do so; I beg your pardon for my boldness of having done it this way,—I thought the sooner it will reach you, the better it will be for you to have it ready in hand.

With many thanks and sincere wishes to you and Mrs. Griffis,

Very faithfully yours
**Henry C Kim**

**3) Oct. 5, 1916**

**104–15th Ave., Columbus, Ohio**
Dr. Wm E. Griffis,
Ithaca, New York.

My Dear Sir:—

Your kindest letter has brought me your hearty advice to me to work for my country, dead and gone in a sense. In reading this I cannot check the tears of thanks and hope. What is more, is that, I sincerely confess, I really appreciate more and more as time passes by, your most scholarly work both in aim and in composition of "Corea The Hermit Nation." I knew you are doing still more for Koreans in the articles you are writing on the Oriental peoples. We,

[1] In 1913 Henry C. Kim, having already founded the Korean Student Alliance, enrolled at Cornell University, where he began publishing *The Korean Students' Review*.
[2] See his letter to Griffis dated April 14, 1916.

Koreans, are so much indebted to you; and your gratitude will be ingraved for eternity on the innermost of our heart's monument.

As for me, I see in myself a radical change—especially as to the attitude toward orientals problems of the day, international morality, philosophy of humanity and even of life itself. Once until a short time ago, I had been a subject to deadly despair, unreasonable hatred, and too narrow a point of view. Now I am, at least I sincerely desire to be, a thorough-going pacifist: perhaps that is the only and safest position I can take. At any rate, I have submitted to that universal ideal through pure and simple conviction rather than mere utilarian [sic read utilitarian] sense of necessity. Now I honestly acknowledge the Japan's leadership in the East. I have great hope of them and for them. Sooner or later as the time arrives for me, I will go to Japan and tell her what sort of ideal a leader must have; and I will fight for the eternal laws of right and wrong—of course, as far as I can see and only that far—and I will take the risk as the consequence may be.

Consequently, I have formed a plan since March of this year to write a little paper, which will probably be about a hundred pages or so in which I try to show in a round-about way the ideals and ideas of the East and West compared in such a way as to point toward the unity of East and West: There I mean to emphasize if possible the typically Korean Points of View, "in a non-political and non-sectarian way."

Sadly enough, however, I am checked by my own nature and situation. Several chapters had been written but then thrown into waste basket, for I must get some one's help in preparation, which is unfair of me to ask so much burden from anyone, for so insignificant a writing as mine. But I wish to finish it some how sometime, of course then to ask your aid first of all before it takes any definite form at all.

I have named this prospective something "An Oriental Dream": it will deal with some such problems as religious, social, educational setting of the East present and future, in the first half—about 8 or 10 chapters or 80 to 100 printed pages—and other problems such as the relation of East and West, Relation among eastern countries themselves, Korea as such, in itself and as to the world in the last half—about equal in length with the first. I will try to approach these from philosophical points of view rather than practical-political view, so that I may introduce the oriental philosophical ideas and racial characters. But to be scientific is not my attempt, with the name "political" or "idealistic," I will be satisfied since my life model is a dreamer, an Optimistic Fool. Again if that be done, I will beg you to give a recommendation with the world for the book.

Of things strictly Korean I do not think the world think much. Some scholarly works though few have been appearing time and again; but they were not very welcomed. So I thought it to be better for me to get to it indirectly and at same time to present some ideals typically oriental and Korean

274 LETTERS FROM KOREANS AND JAPANESE

and my notions of world unity. After all I do not know yet whether I will succeed or not. At any rate I will ask further advice from you, my dear Master.

With best wishes to you and Mrs. Griffis, I am

Very sincerely yours,
**Henry C. Kim**

P.S. I thank you very much for the autobiographical sketch, you have given me. I will treasure it above all.

### 4) July 1, 1917

**Columbus, Ohio**
Dr. Wm. E. Griffis,
Ithaca, New York.

My dear Sir:—

The manuscript and your kind letter therewith both have been received. I am so much obliged to you for your aid with me & and [sic] your kind encouragement and advice for my picture. I understood, I fancy, what you meant by your letter with all its true embodiment of the Ideal Christian Love.

To define my position is the worst difficulty of my life. I must confess to you, my most impartial teacher, that I cannot say either that I am a loyal subject of Japan or that I am not. If I profess to be loyal to Japan, I am an outcast from Koreans; if not I can not do any thing of my plans to help out Japan from her future political troubles that will come from her present short-sighted political ideals. In either case I am a useless creature. For this reason, I have chosen a course in which I will willfully refuse to say anything about politics whatever, and will take the ethical stand and that only. But this too is equally hard; for the problems of our life are so intricately interwoven that one can [sic cannot] treat one thing without touching another or all. So in brief, I do not know yet what to do about it.

Furthermore, I am a runaway from Japanese law who has come in the country without a passport. And my former connection with Choy Ik Heun[3] my beloved teacher who died in disgrace for his foolish rebellion against Japanese rule of Korea makes it even worse. All these things together may hinder me to come back to Korea yet my honest desire is however I want to go back to Korea or Japan or somewhere else in the East where I may tell the Orientals, as far as I can see, the moral necessity of the Union of the East and of the World. I do not yet really know where I will be when I get through with the so-called studies of mine.

[3] Ch'oe Ik-hyŏn 최익현 (1833–1907), leader of the Righteous Army. Informal civilian militias called the Righteous Army were formed to fight for Korean independence during the period of Japanese intervention and annexation.

Therefore I can not ask you to call me any practical name. But you may call me anything that you think would fit my life and work so insignificant as this. I hope you know best. I am not really against any person or any nation. If I were against Japanese rule over Korea at all, it is not against the rule itself but against the method of rule. But even against the method, if any, I will try all my best and hardest to keep myself totally dumb about it. There is one thing I want to ask your favor. This is that, if you choose to name me as a loyal subject of the Emperor of Japan, please do not forget to duplicate this with another name, a lover of Korea. At any rate all I can do is to beg you to consider and judge of my situation and intention and give me any name you please. I will submit you the rest of MS and the contents [upon?] the middle of August or earlier.

 With very best wishes to you and Mrs. Griffis, I am

Very sincerely yours
**Henry Kim**

P.S. With all my heart I thank the Appenzellers the true servants of God; I wish them great success in their work of rescue.

 I have started now this summer my graduate work for doctorate; I am going to choose my thesis topic: A Critical Examination of Yi-King or the Book of Change. What could you advise me about it?

### 5) July 19, 1917

**Columbus, Ohio**
Dr. Wm. E. Griffis
Ithaca, New York

Dear Sir:—

The front part of the M.S. has been finished some time ago, but on account of the condition of my teacher who has promised to help me with correction and then has been too busy with her work, (in Red Cross, food conservation, woman's auxiliary and teaching), to carry out her promise, finally I failed to get her corrections; and here I am sending the raw scraps to you. I beg your pardon. First of all, I wish get your word of forward; and besides if you can possibly spare any time for me now or sometime later I wish to get your corrections on these pages also. If you can not, I will have to let this part go. My purpose of putting this part in is that, in the first place, the words I started with in the original first part is too much a shock to a reader, because it is socialistic in its tone, and that, in second place, I wish to complete my plan (for future work in any language) which is to put my writing in four parts consisting of structure, functions, relation, and purpose. I hope you will help me again.

 With best wishes

Very sincerely yours
**Henry Kim**

## 276 LETTERS FROM KOREANS AND JAPANESE

### 6) May 5, 1920

San Francisco, Cal.
Dr. William Elliot Griffis
Ithaca New York

My Dear Sir:—

Both of your kind letters dated May 10th have been received with the greatest pleasure. I would almost weep for joy to learn once more of your unlimited love to Korea. God and man may bless your great love!

I planned to work out a theory—of course, within and despite my natural limitations—of evolution, not by struggle or victory of the fittest, but by cooperation of all. I found the possible origin of this new theory in the "Book of Changes." Although knowing that this is something more than my talent permits, I have not yet given up that notion yet. But I have stayed out of schools for the last three years and could not start the work on it. I will, however, go back to college by the next term provided the conditions at home do not get worse. And then I will tinker with it again.

About the thesis called "The One and the Two," I will send you the manuscript if you mean that. I can see now many points need to be altered.

Your suggestion about the novel or fiction—especially human interest type,—is an excellent one. Popular novel will surely do much better work than a historical treatise. Besides a well plotted story can embody practically whole setting of Oriental or at least the Korean History, while it will be heartily received by the public without much antagonism.

In this line I have thought of a plot for a novel or novelet. I could not, however, develop in myself; nor could I make any suggestion to any writer yet about it. I am writing it down on a separate sheet and enclosing it herein.

If you will communicate with the girls, named below, you will likely find out something about their [temperament?] and about Korea history: Miss Soonie Choy[4] 1307 Fort St of Honolulu, T.H.; Miss Marcella Syn[5] 732 Woodward Bldg, Washington, D.C., Miss Asther Kim (whose address I do not know, but can be reached through her brother Y. S. Kim, Madison, NJ; Miss Nodie Dora Kim,[6] Oberlin College, Oberlin, Ohio.

With best wishes for your health and success, I beg to remain

Yours sincerely
**Henry Kim**

P.S. The imaginary plot of novel is written down on the following sheets.

---

[4] Soonie Choy, the president of the Korean Girls' League.
[5] Marcella Syn's letters to Griffis, dated August 26, 1920, and December 16, 1920, are found in the Griffis Collection. Her letters are found in the digital archive under Korean Relief Society.
[6] Nodie Kimhaekim Sohn (1898–1972), Korean American church and community leader in Hawaii.

*[Manuscript]*

Great Contest (Symbolistic)

*Personnel:—*

Cora Halen (Korean Girl, from old illustrious family, proud of her family name, an orphan adopted and brought up by a missionary; her father executed as member of the "Righteous Army," her mother becomes a Christian, but died before Cora reached her age

Herold Sihn (Korean young man, an accomplished young lawyer but defeated in career by his Japanese competitor, a Christian, then suffered from the persecution for his faith; which persecution was made severer by his rival in love affair about Cora; then sole and faithful lover for Cora

Peter Wright (an American missionary, adopted father of Cora, honest, upright, loving; at first dubious of Cora's ability to be independent in thought and action, but later became more and more convinced of her ability and the bond of fatherly love became stronger; always best friend and protector of Cora

Mrs Wright (loving mother to Cora, but she favors the Japanese suitor for Cora not because she has any evil intention against Cora or Herold but because she thought Kato would be better businessman as he is polite and diplomatic and strong and would get better or preferential protection from the strong Japanese government and consequently be a better husband for Cora

Kato (T) (Successful young Japanese lawyer, rather of limited means, polite, smooth, active hustler—lover of Cora, rival of Herold, hated by Mr. Wright and admired by Mrs. Wright; Kato extremely attractive to Cora and polite to Wrights, but his love for Cora is really love for her beauty and wealth but not at all a true love; he is polite to Cora's guardians and adopted parents because they are the trustee on Cora's wealth entrusted by the will of Cora's mother to Wrights for Cora's interests. Kato is the head of Secret Service, later judge.

Yamagata (M) (Japanese judge, a Christian, straight, friend of Koreans, In many cases he decided the case in favor of Herold and Cora against Kato; later defeated by Kato in politics:

*Kato's many intrigues*
1. Against Cora (masking love with treats open and secret; attempt to force her; attempt to ruin her name by circulating a false story; kidnapped her to a prostitution house; later accused her of conspiracy; then attempt to confiscate her property
2. Against Herold (Threatening him to stay away from Cora openly and secretly; Criminal case against Herold as if Herold, as a local court judge for brief time, have received some bribery, or killed some innocent people; case against Herold as peace maker; case against Herold as "traitor" etc. etc.

## 278  LETTERS FROM KOREANS AND JAPANESE

3. Against Wrights (mild yet far reaching threats; accused as helper of Korean agitators

*The Conclusion*

1. Cora was separated from Herold as the latter had to flee to America
2. Cora fled to China
3. Herold studied in American University and became specialized in law,
4. Cora graduated from Nanking University—and became a teacher in a Christian College in Shanghai in Oriental philosophy and history
6. Herold came to Shanghai after the Korean Provincial Gov't formed
7. Cora went to Korea as secret messenger and was imprisoned and tortured; somehow escaped death and coming back to China
8. Herold dispatched to Peking as gov't agent
9. Met in a hotel by mere chance after a two year separation.
10. Formation of Korean revolutionary army was announced; Herold enlisted and received commission and Cora registered as Red Cross Nurse.

\* As for the real conclusion, one may choose either the tragic or comic as he pleases.

As it seems to me, a story like this would cover the whole history and will represent all points of view on the Korean question, symbolically as well as historically.

I hope you would kindly give me your opinion about the plot as is suggested above. Though of course I do not really know whether I will ever be able to write it myself or have some one to write it for us, but I would like to know your opinion on it.

Again thanking you in advance,

Respectfully,
**Henry Kim**

# 9    *Komatz, Midori (小松緑) (1895–1906)*

### KOMATSU MIDORI [ALSO ROMANIZED AS KOMATZ] (小松緑) (1865–1942)

Komatsu graduated from Keio University in 1887. After obtaining degrées in political science from Yale and Princeton, he began working as a diplomat in Korea in 1896 and as secretary of the Japanese legation at Washington in 1901. In 1906, he accompanied Itō Hirobumi and led the Foreign Office of the Government-General in Seoul until 1916. Among his many publications, Komatsu is known for an influential article, "The Old People and the New Government," published in 1912.[1]

### 1) Oct. 30, 1895

**Japan**

Rev. Dr. Griffis,

Dear Sir:—

Since I wrote you of my arrival here and of my mother's sad death, I am still staying here in Yokosuka, a suburb, about 18 miles from Tokio[2] where I visited only once since I came back home. My Father is here to take care of my sister and her children as my brother-in-law is at Port Arthur[3]—Perhaps he must stay until he shall come back.; but I am only here to finish my books—As soon as my first book[4] is finished, I shall go to Tokio and stay there to look after a chance of establishing my long-cherished enterprise—the magazine of which I told you so often. Many of my friends advised me to serve in the government or teach in the College[5] as Imperial professor, that is, as a professor commissioned by the Imperial Government. I have not either accepted or refused, so what way is laid before me by Providence—But at all events, I cannot abandon my enterprise of magazine publishing—If I should teach in some private school, I might prepare the journal at the same time. I trust God will

---

[1] Midori Komatsu, "The Old People and the New Government," *Transactions of the Korea Branch of the Royal Asiatic Society* 6, no. 1 (1912): 1–12.

[2] Tokyo, Japan.

[3] Port Arthur (now Lüshunkou) in Dalian, China.

[4] Komatsu Midori wrote many books, including *Meiji Shijitsu Gaikō Hiwa* [The secret history of Meiji diplomacy] (Tokyo: Chūgai shōgyō shinpōsha, 1927).

[5] Tokyo Imperial University (est. 1886; now University of Tokyo).

280     LETTERS FROM KOREANS AND JAPANESE

show His way, and I will follow whatever course by which I can do my duty to God and men.

In Tokio, Christian Churches are everywhere and full of attendants. The Congregationalists declared that

1. Repent sins and obey the Heavenly Father.
2. Fulfill the great principles of love, as we are all children of God.
3. Uphold principle of one man and one wife and purify the home.
4. Glorify the State and magnify the Happiness of the people.
5. The hope of everlasting life should be fulfilled by the truth and justice (or by righteousness).

We have made great mistake in Corea. Our soldiers assisting Coreans attacked the palace and killed the Royal consort, and Tai on Kun[6] took the government by force. Our minister at Keijo General Miura[7] is said to be complicated with this barbarian action. He and his assistants and many other private persons, numbering in all about 25, are recalled and they arrived at Hiroshima where all of them (of course except their servants) arrested and they are now imprisoned, and a special court will be opened as soon as their guilty has been proved. The whole people, together with the government, are exceedingly chagrined.

I do not know what become with Japan.

I will write again after. Please give my best compliments to all.

Yours in the Lord
**Midori Komatz.**

c/o Lieut. Y. Takasaka,
No. 253 Henmi,
Yokosuka, Japan

**2) May 22, 1906**[8]

**Tokio**

Dear Sir:

This letter will probably take you by surprise, coming from one whom you may have almost forgotten, though he always remembers you with grateful

---

[6] Hŭngsŏn Taewŏn'gun (1820–1898), or Taewŏn'gun 대원군.

[7] Miura Gorō (1847–1926) was a lieutenant general in the Imperial Japanese Army, viscount in the Japanese House of Peers, and Japanese minister to Korea. He assassinated Empress Myŏngsŏng on October 8, 1895, and was put on trial at the Hiroshima District Court.

[8] In the Japan Letters subseries in the Griffis Collection, there are two folders under Komatz Midori: "Komatz Midori, 1896–1900" and "Komatz Midori, 1901–1906." This is the last letter in the second folder. In addition, there is a separate folder, "Komatsu M. 1897," but we believe Komatsu and Komatz are two different versions of romanization of the same person, 小松緑, a common practice before standardization.

feelings. I returned home just one day before the declaration of the war from Siam where I had stayed a little over one year since my transfer there from Washington. During the war, I was sent to the front as Counselor on International Law to the Liaotung Garrison, and had a good opportunity to visit Port Arthur, Liaoyang, Newchang, etc. With the conclusion of peace, I again returned to the Foreign Office where I have been serving till today. I am now appointed a Secretary to Resident General Ito, with whom I am to leave here for Korea in a few days. The Marquis tells me he has received a letter from you and understands that you are intending to write another work on Korea. I shall be glad to be at your service in any way while my tenure of the office continues at Seoul.

Yours most sincerely
**Midori Komatz**

# 10     *Niwa, Seijiro (丹羽清次郎) (1927)*

### NIWA SEIJIRO (丹羽清次郎) (1865–1957)

Niwa Seijiro was baptized in the Congregational Church. As an elder of the Christian movement in Japan, he supported the Japanese invasion of Korea with a religious fervor. Niwa is best known for promoting the YMCA movement. In 1909, shortly before the annexation of Korea, he visited Korea and established the Kŏngsŏng Christian Youth Association (Japanese YMCA in Seoul) and served as its first general secretary until 1931. When the Korean YMCA was absorbed by the Japanese YMCA in 1938, Niwa served as its honorary director. He became the president of the Chosun Christian Organization, which declared itself a pro-Japanese group. Following Japan's surrender on August 15, 1945, Niwa returned to Japan.

1) **Mar. 27, 1927**

**Y.M.C.A.**

Dear Miss Appenzeller:[1]

The reception luncheon for Dr. & Mrs. Griffis[2] will be given at the Kejio Station[3] restaurant on Wednesday, 30th, at 12.30 PM. Some of us will go to the school to take the guests to the place, and we shall be very happy if you would join the company.

Yours Sincerely,
**S. Niwa**

S.P. Please deliver this message to Dr. and Mrs. Griffis

---

[1] Alice Appenzeller (1885–1950).
[2] Sarah Frances King Griffis (1868–1959).
[3] Keijo Station, or Kyŏngsŏng Station (est. 1900; now Seoul Station), a station on the Seoul-Chemulp'o and Seoul-Ŭiju railroads.

# 11     *Paik, Earl Ku (백일규) (1916)*

EARL KU PAIK (백일규) (1880–1962)

Earl Ku Paik (Paek Il-gyu 백일규) was an active politician who had international influence in the 1910s. As the second in command at the Korean National Association (Taehanin Kungminhoe; est. 1909), he led the Korean independence movement not only domestically, but in America and Mexico. This movement included advocating for Korean census registration and rejecting Japanese currency, among other things. Paik also spearheaded efforts to raise eighty thousand dollars for the Korean Provisional Government in Shanghai, China. As a writer for *The New Korea* (*Sinhan Minbo* 신한민보), a popular Korean American newspaper, Paik wrote anti-Japanese articles. With a graduate degree in economics, Paik paid attention to economic issues in addition to political problems of the time. He published *The History of Korean Economics* (1920), which was incorporated into the curriculum for Korean American education. Paik served as president of the Korean National Association in North America for nine years. The South Korean government posthumously awarded him with the Order of Merit of the National Foundation and Independence Award, recognizing his efforts for Korea during the Japanese colonial rule. His remains have been buried in Daejeon National Cemetery since 2002.

## 1) Apr. 14, 1916

**359 Pacific Blg., San Francisco, Cal.**
Rev. W.E. Griffis,
Ithaca N.Y.

Dear sir:—

Mr. Henry C. Kim,[1] a friend of mine, wrote me a week ago and asked me to write you something about the Koreans in Hawaii and in America. Herewith you will find something about them. I do not know whether it will answer your request or not. But I will be very glad to answer you if you have anything

---

[1] Henry Cu Kim (Kim Hyŏn-gu; 1889–1967) emigrated to the United States in 1909, founded the Korean Student Alliance (est. 1912), *The Korean Students' Review* (1914–1916), and *The Young Korean* (1919). He participated in the First Korean Congress (1919), began serving in the North American headquarters of the Korean National Association in 1920, and represented Hawaii during the Korean Conference Abroad (1941).

284 LETTERS FROM KOREANS AND JAPANESE

more about to know. I thank you very much, for you are favoring us, the poor Koreans on earth. Thank you as ever I remain

Yours very sincerely
**Earl K. Paik**

[Manuscript]

### Koreans in Hawaii

The Korean immigrants have come to Hawaii in 1904 and 1905.[2] Some of them have come in the previous years but they are very few in number. These immigrants have been collected and shipped from the different ports of Korea—Wonsan, Füsan, Mokpo, Masan, Chemulpo, Chengnampo, Daiku and Pyung Yang.[3] These Koreans are scattered in hundreds of sugar plantations in the principle [*sic* read principal] islands of Hawaii,—namely, Hawaii, Maui, Kauai, and Oahu. Their number is about 8,000 including less than a hundred women and fifty or more children. Their ages are varying from 18 to 35 years. None of them in 1905 is more than 35 years old. These immigrants have formed many small groups of community in the "Pacific Paradise," living by their own customs. Some of the conservative men are kept in their top-knots which show their nationality at first sight of any Westerners.

The economic conditions of Koreans in Hawaii is somewhat favorable. In addition to wages every laborer is provided free of cost a house, all tools, fuel, water and medical treatment. During the past years the housing arrangements have been greatly improved at a cost to the plantations of hundreds of thousands of dollars. Statements from Korea working men show that while the minimum earnings for a year—receiving only day wages—amounts to about $200, the total expenses of living for a single man amounts to about $125, leaving thus a clear profit of $75. A man and wife with two or three children at the minimum, earns about $280 and spends about $250, leaving only a small balance. Where a contract is taken the laborer still receives house, fuel, etc. free and his income and savings depend on his energy and skill. A man and his wife can earn as much as from $50 to even $80 per month. Exceptional cases run high. The highest earnings reported were those of two men who took a contract for the cultivation of a 25 acre field. The work was completed in 235 days and for that period they received $1,856.50, being $3.95 per day each.

Each Korean community, numbering about 70, has a little church or a chapel where they may come together on every Sunday and worship their God. This little churches have its headquarters at Honolulu, and each provides for its own

---

[2] The first group of Korean immigrants in Hawaii arrived on January 13, 1903.
[3] Wŏnsan (in Kangwŏn-do, central Korea); Pusan; Mokp'o (in Chŏlla-namdo, southwestern Korea); Masan (in Kyŏngsang-namdo, southeastern Korea); Chemulp'o (now Inch'ŏn); Taegu (near Kyŏngsang-bukto, southeastern Korea); P'yŏngyang.

preacher and own Bible. Mr. H. C. Song,[4] a past graduate of the Princeton University is now in charge of its headquarters and develops the evangelical work among the Koreans in the islands. In addition to the churches there are some sort of political organizations in each locality. The organization elects its headman of "Dongchang,"[5] whose duty is to look after the social welfare of the community. It has a common council, composed of seven or eight members; by whom the ordinance and business of the community are made and carried. If any one breaks the law he is immediately punished or banished from the society. Wherever he goes he cannot get any job since each community does not receive any man coming from its neighboring place without a certificate. Thus develops a strong self-governing society among the Korean colonies.

Until 1908 there was no central organization among the Koreans in Hawaii. Each small colony enjoyed its own privilege and interests, and they did not act together as a unity. There are once forty different organizations, loosely or closely organized. They are somewhat similar to the "city-states" of the ancient Greeks with less population and less power. They are, however, awaken by the "civilized tide" of the Pacific Ocean, and begin to think about a civilized institution under which they could live together. In the year 1908 Messers P. K. Yoon,[6] S. K. Kim[7] and a few others, observing the common sentiment of the very moment, have worked together and brought the various organizations into one strong institution. This is then called "the Korean National Association."[8] The association has its headquarter firmly established at Honolulu, where 800 Koreans engaged in various occupations. The government of this association is much similar to that of a modern democratic country. It has a law-making body, executive

[4] Song Hŏn-ju (or Hŏn-su; 1880–1965) emigrated to Hawaii in 1904, where he organized Hanin Sangjohoe (1905–?), a Korean American mutual aid society. He was educated at Roanoke College and Princeton University, became a member of the Korean Commission to America and Europe (under the Provisional Government of the Republic of Korea) in 1919, and was elected president of the North American headquarters of the Korean National Association in 1939.

[5] It is unclear if this *dongchang* (alumni) is a person or the name of an organization.

[6] Yun Pyŏng-gu (?–1946) emigrated to Hawaii in 1903, where he cofounded the Korean American political organization Sinminhoe (1903). He represented Korea at the Portsmouth Peace Conference (1905) and was elected president of the Korean National Association (Taehanin Kungminhoe; est. 1909) in 1912. In 1949, he returned to Korea to serve as an adviser to the Ministry of Foreign Affairs and Ministry of Public Information.

[7] Kim Sŏng-gwŏn (1875–1960) emigrated to Hawaii in 1904 as a plantation laborer. He was an active member of various diasporic Korean independence organizations including the Mutual Cooperation Federation (Kongnip Hyŏphoe; 1905–1908), Korean National Association, Young Korean Academy (Hŭngsadan; est. 1913), and Korean National Revolutionary Party (Chosŏn Minjok Hyŏngmyŏngdang; 1926–1947).

[8] The Korean National Association was founded by independence activist An Ch'ang-ho (1878–1938), in a merger between the Mutual Cooperation Federation in San Francisco and the United Korean Federation (Hanin Hapsŏng Hyŏphoe; 1907–1908) in Hawaii. The association represented diasporic Koreans during the Korean independence movement against the Japanese colonial occupation. Notable members included Syngman Rhee (1875–1965), Henry Chung (Henry Chung De Young or Chŏng Han-gyŏng; 1890–1985), and Pak Yong-man (1881–1928).

officers, and judiciary officers. The duties of the said functions are, of course, observed as are indicated. It has a weekly news, "The Korean National Herald,"[9] published for the interests of Koreans in Hawaii as well as of those elsewhere. The expenses of the association are maintained by collecting a membership fee, five dollars each, and by a special contribution when it is necessary.

In August 1913 Mr. Y. M. Park,[10] a graduate of the State University of Nebraska was called by his countrymen in Honolulu, taking care of the Korean affairs over there. He has done and is doing great work for the poor Koreans. Through his editorship of the Korean National Herald increases its volume and subscription. He also establishes the "Young Men's Military Academy"[11] outside of the city of Honolulu. The cadets of this academy is numbering about 180 men. In November of the same year Dr. Syngman Rhee[12] came to Honolulu from New York, and took a professional work with few other educated men. A man of most influential both among the Koreans and American communities as Dr. Rhee is, let me tell you a brief account of his life. Dr. Rhee, as a Korean Reformer, tried to modernize the Korean government in 1884. Naturally he was, by an Imperial edict, imprisoned in jail about seven years.[13] Shortly after the Russian-Japanese war,[14] he was released and came to America for his high education. He post graduated at Harvard University and obtained his degree of philosophy at Princeton in 1910. He then returned to Korea and tried to do something for his country. But he failed to accomplish his purpose, for Korea was then controlled by the Japanese who did not allow him to do anything for the sake of his country.

As [a] very intelligent man he was, he realized that he could no longer stay in Korea under the Japanese yoke, and leaving his fatherland once more in 1911, reached America in the following year. He visited many churches and institutions in the New England states and in the Middle West, where he delivered many lectures to them. While he himself found great interests in such undertakings, his countrymen in Honolulu invited him to come over there.

---

[9] The Korean National Herald (Kungminbo; 1913–1962), also known as the Korean Pacific Weekly (T'aep'yŏngyang Chubo), was a weekly newspaper published in Honolulu, Hawaii, by the Korean National Association (Taehanin Kungminhoe; est. 1909). The association also published the weekly newspaper The New Korea (1909–?).

[10] Pak Yong-man (1881–1928) emigrated to Nebraska in 1904, where he founded Hanin Sonyŏnbyŏng Hakkyo (1909–1914), the first military school for Korean Americans. He moved to Hawaii in 1912, where he was a member of the Korean National Association, editor of The New Korea, and founder of the military school Taejosŏn Kungmin Kundan (1909–1917) and the Korean school Usŏng Hakkyo (1927–?). He was assassinated in Beijing in 1928.

[11] Taejosŏn Kungmin Kundan (1909–1917) was a military school in Oahu, Hawaii, established by Pak Yong-man. It trained young Korean American soldiers (approximately 120 to 300 in number) in preparation for militant resistance against the Japanese colonial occupation.

[12] Syngman Rhee (1875–1965).

[13] It is highly unlikely that Rhee was involved in the reform efforts (Kapsin Coup) of 1884. He was imprisoned from 1899 to 1904, accused of involvement in the poisoning and attempted assassination of King Kojong (1852–1919; r. 1864–1907), and was released by special pardon.

[14] Russo-Japanese War (1904–1905).

Dr. Rhee accepted this invitation and went to Hawaii, where he remains until today. He has done and is doing great work for the Korean churches and schools. The Pacific Oriental School,[15] a Methodist mission school, which had been found [*sic* read founded] by the Methodist people, come through his influence to its full development. The Korean Girls' Boarding School,[16] in which Mrs. Stocks, a lady of Chicago, is the Principal, is his gift. "The Korean Pacific Magazine,"[17] a monthly magazine and only one published in Hawaii; "The Hawaiian Korean Weekly Advocate,"[18] a weekly paper published for the interests of Korean church and society; the "Korean Church Persecution,"[19] a book described the most terrible scene of 125 Korean children persecution which occurred shortly after the annexation of Korea—all these publications are his splendid work and are enormously sold and eagerly read.

Today the Koreans in Hawaii are reduced to little more than 5,000 souls, since some of them have returned to their native land, some have come to the Mainland, and some were dead. Among these 5,000 people, about 300 are professional men and students. More than eighty percents are Christians, and more than ⅘ of the entire community are male inhabitants. Recently the number of Females are increased by the so-called "Picture bride" marriage. As has been proved that the married man worked constantly and honestly, the Hawaiian authorities permit these "Picture brides" to be brought in from their native land.

### Koreans in America

Since the treaty between the United States and Korea was signed in 1882,[20] Korean students began to come to America for studying the Western civilization; but they were very few in number, not exceeding five up to 1890. As years pass by, the number is gradually increasing to over 1,000 people in 1915. Some of them came directly from Korea, some were re-immigrated from Hawaii, and some came from Manchuria and Siberia, where they found a refuge from the Japanese cruel persecution. Of about 250 are students including more than twenty girl-students. This figure is including all students from those in grammar schools to those in colleges. The college students in 1915 are only 45 young men

---

[15] The Korean Methodist School for Boys and Girls merged with three other schools (Kawaiaha'o Seminary for Hawaiian Girls, Mills Institute for Chinese Boys, and Okumura Japanese Boarding School) into the Mid-Pacific Institute in 1908.

[16] The Korean School for Girls (or Hanin Yŏhagwŏn; 1915–1918) was an all-girls boarding school founded by Syngman Rhee in Honolulu, Hawaii. It was reorganized as a coed school (Hanin Kidok Hagwŏn) in 1918.

[17] *The Korean Pacific Magazine* (*T'aep'yŏngyang Chapchi*; 1913–1970) was a monthly magazine published in Honolulu, Hawaii, by Tongjihoe (1921–1943), a Korean American society organized by Syngman Rhee and Min Ch'an-ho.

[18] The *Hawaiian-Korean Weekly Advocate* (*Hawai Hanin Chubo*; ?–?) was a weekly published in Honolulu, Hawaii.

[19] *Han'guk Kyohoe Pakhaesa* [The history of Korean church persecution] was written by Korean minister and independence activist Ch'oe Sang-rim (1888–1945).

[20] Corean-American Treaty of Amity and Commerce (1882).

288 LETTERS FROM KOREANS AND JAPANESE

and two girls. The rest of Koreans are mostly working men, including about thirty women and more than forty children. Most of the Korean working men are engaged in fruit raising farms, since they live mostly in the state of California where man produces all kinds of fruits. About half hundred Koreans raise rices in the valley of Sacramento, where the soil is rich and wet, and the irrigation of river is possible.

The Koreans historically known as the descendants of agriculturists are very skillful in raising rices. Therefore many white men who own such rice-fields hire them with large amounts of wages. Very few Koreans, as Chinese do, are engaged in house work, such as cook, laundry, waiter, dish-washer, and others.

The biggest wages of Koreans are from $3.00 to $5.00 per day, while the lows is about a dollar per day. The average earnings of Koreans reported are about $1.50 per day. There are many Koreans out of work specially during the winter months. Thus they could not save money unless they are very intelligent and skillful laborers.

The Korean National Association with its headquarters at San Francisco has been established in 1907, which was little earlier than that of Hawaii. Later it was firmly established under the state law of California. Its member is approximately 2,000, including Koreans in Mexico. It collects from its every member a membership fee of $5.00 as do the Koreans in Hawaii. It has built a students' "Club House" at Claremont, California, costing about three thousand dollars. It maintains a weekly news, "The New Korea,"[21] while the Korean Students Body publishes a semi-annually magazine, "The Korean Students' Review,"[22] which is the only English press produced by the Koreans in the United States.

The religious work among the Koreans in America is only found in California. It is divided into two sections, namely the Northern and Southern section of California. In the Northern section the Korean worshippers are the South Methodists, while in the South they are the Presbyterians. The South Methodists establish its headquarters at San Francisco with its various branches at Sacramento, Stockton, Manteca, Oakland, and Mountain View. Rev. David Lee[23] takes

[21] *The New Korea* (1909–?) was a weekly newspaper published in Honolulu, Hawaii, by the Korean National Association. The association also published the weekly newspaper *The Korean National Herald* (*Kungminbo*; 1913–1962), also known as the *Korean Pacific Weekly* (*T'aep'yŏngyang Chubo*).

[22] *The Korean Students' Review* (*Miguk e Innŭn Han'guk Haksaengbo*; 1914–1916) was a biannual magazine founded by Henry Cu Kim and published by the Korean Student Alliance U.S.A. in Nebraska.

[23] David Dae Wei Lee (Yi Tae-wi; 1878–1928) was a Methodist minister and independence activist. He emigrated to San Francisco in 1903 and became the first Korean graduate of the University of California at Berkeley in 1913. He was the president of the Korean National Association, pastor of the San Francisco Korean United Methodist Church, interpreter at Angel Island, and inventor of a modernized Han'gŭl keyboard that was first implemented by *The New Korea*.

charge of the San Francisco Mission, while Rev. S. Y. Whang[24] and few others preach gospel to the Koreans in the different places referred to above.

The entire congregation is numbering about 300 Christians. The Presbyterian mission in the Southern California has its headquarter at Los Angeles, where Rev. C. H. Min[25] is in charge of it. This mission has many branches in the neighboring places of the city of Los Angeles—namely, Riverside, Upland, Claremont, Dinuba, and Redlands. Its member is altogether about 250 persons.

Among Koreans in California, in addition the Korean National Association, there has been found a peculiar institution," the so-called "Young Korean Academy."[26] Anyone who desires to become a member of this institution must take an oath that he would, at last, accomplish a branch of education, such as a science or an art, that any American colleges may well prove of. Besides its member must acquire a physical training and must read every morning a page or more of well authorized books. Everyone must make his daily record with reference to his exercise and reading, and report the same three times in a month to the main office which was established for a purpose to scrutinize the reports. If any one fails his duty he must be obliged to be punished with heavy penalties. Its member stands today about sixty strong, and most of them are young men who are hungry and thirsty for American education.

Its leader is a most influential man among Koreans. He is Mr. C. H. Arhn.[27] He had been arrested by the Japanese at the time of annexation of Korea, and was

[24] Hwang Sa-yong (1882–1964) emigrated to Hawaii in 1905 as a plantation laborer and then moved to San Francisco, where he played an instrumental role in the merger between the Mutual Cooperation Federation (Kongnip Hyŏphoe; 1905–1908) and the United Korean Federation into the Korean National Association. He served as a community organizer for Korean immigrants in Mexico in 1910, was elected president of the North American headquarters of the Korean National Association in 1911, and worked as a member of the Korean National Revolutionary Party (1926–1947) until his return to Korea.

[25] Min Ch'an-ho (1877–1954) helped establish the Korean American mutual aid society Hanin Sangjohoe (1905–?) and the Korean National Association (est. 1909) and was a founding chairman of the Young Korean Academy. In 1921, he and Syngman Rhee cofounded the Korean American society, Tongjihoe (1921–1943) in Hawaii.

[26] The Young Korean Academy was founded by An Ch'ang-ho (1878–1938) in San Francisco to provide anticolonial education to young diasporic Koreans. Today, it is an international educational institute with twenty-five domestic and eight international branches.

[27] An Ch'ang-ho (1878–1938) was an activist, nationalist, educator, and leading figure of the Korean independence movement. In 1897, he became a member of the Independence Club (Tongnip Hyŏphoe; est. 1896) and organized the anticolonial congress Manmin Gongdonghoe in 1898. He founded the New People's Association (Sinminhoe; 1907–1911; not to be confused with the Hawaiian organization of the same name established in 1903), a clandestine organization for both domestic and international independence activism. In the United States, he founded various independence organizations and Korean American societies such as the Mutual Cooperation Federation (Kongnip Hyŏphoe; 1905–1908), the Korean National Association (est. 1909), and the Young Korean Academy (est. 1913). He was imprisoned for orchestrating the assassination of Itō Hirobumi (1841–1909) and a bombing in Hongkou Park, Shanghai, that targeted Japanese colonial officials (1932).

290 LETTERS FROM KOREANS AND JAPANESE

about to be killed. But a Japanese statesman as Prince Ito,[28] seeing that if he kills such a man like Mr. Arhn whom every Korean loves, it would create the most bitter public resentment against Japanese policy in Korea, released him after some sort of trials. Mr. Arhn then escaped from his farther danger by coming to America. He established his residence in Los Angeles until today. He is an orator, an organizer, and a patriot. His aim to organize the Young Korean Academy is to produce a "better" men for the future Korea.

End.

[28] Prince Itō Hirobumi (1841–1909).

# 12     *Park, Eun Sic (박은식) and Lee, Kwangsoo (이광수) (1920)*

## PARK EUN SIC (박은식) (1859–1925)

Park Eun Sic (Pak Ŭn-sik 박은식) was a historian and a fierce patriot. Although he was initially trained as a Confucian scholar, he was greatly influenced by Korean independence movements. In 1898, Park joined the Independence Club (Tongnip Hyŏphoe 독립협회) (1896–1898), which was founded by Phillip Jaisohn to implement new social and political ideas. He served as an executive for the Ministry of Education. Following the forced disbandment of the Independence Club, Park turned to teaching and writing. An advocate for national sovereignty, he criticized ideologies of the past and advocated for national enlightenment. Park's most notable role was that of the second president of the Provisional Government of the Republic of Korea in Shanghai. Following Syngman Rhee's impeachment in 1925, Park took office, ultimately resigning after his successor, Yi Sang-nyong, was elected as the third president.

## LEE KWANGSOO (이광수) (1892–1950)

Lee Kwangsoo (Yi Kwang-su 이광수) was one of the pioneers of modern Korean literature. In 1914, he was appointed as the main contributor to *The New Korea* (*Sinhan Minbo* 신한민보), a popular Korean newspaper published in the United States. When the First World War broke out, Lee returned to Korea and in 1915 went to study in Japan. In 1917, Lee serialized in *Maeil Sinbo*, a daily newspaper, a novel titled *The Heartless* (or *Mujŏng* 무정), considered to be the first modern novel in Korean literary history. In 1918, he fled to China and began writing critically against the traditional patriarchy, espousing new ideas on life, children, and marriage. After his return to Korea, Lee dedicated himself to the cause of Korean independence. However, from the 1930s to the end of the Japanese rule, he transformed himself into an active Japanese collaborator, urging Korean men to volunteer for the Japanese war efforts. After Korea's independence, Lee was charged for his role as a Japanese collaborator and published a confessional writing. As a high-profile figure, Lee was abducted by North Korea during the Korean War and died in 1950.

292　LETTERS FROM KOREANS AND JAPANESE

1) **June 23, 1920**[1] [Typed Letter]

**Shanghai, China** [location from the location at the end of letter]
Dr. W. E. Griffis,
Ithaca, New York.

My dear Dr. Griffis:

We are very delighted that you have decided to write a historical sketch of the Korean civilization.

It is an undisputed fact that your former work "Corea, the Hermit Nation",[2] although seriously mistaken in minor details in certain places, is one of the best, if not the best, records of Korean history existing. We are afraid that we can not be of very much assistance to such a great scholar as you are, but we will do our best to furnish you in so far as possible all the data and facts that you care to incorporate into your new book.

We wish also to take this opportunity to express our heartfelt gratitude for the stand you have taken in regard to the Korean question. We are fully confident that if all the Americans were as fully informed as you are on the Korean question, then there would be little question on their part in regard to the justice of the Korean cause. By your fearless stand you have captivated our hearts and have inspired us to a renewed sense of our duty and obligation to the preservation of a once glorious civilization which the vandal is inscrupulously attempting to extinguish.

Respectfully,
**Eun Sic Park.**

**Kwangsoo Lee.**

Shanghai, China, June 23, 1920.

[1] Date from the date at the end of the letter.
[2] William Elliot Griffis, *Corea: The Hermit Nation* (London: W. H. Allen and Co., 1882).

Dr. W. E. Griffis,
Ithaca, New York.

My dear Dr. Griffis:

We are very delighted that you have decided to write a historical sketch of the Korean civilization.

It is an undisputed fact that your former work "Corea, the Hermit Nation", although seriously mistaken in minor details in certain places, is one of the best, if not the best, records of xxx Korean history existing. We are afraid that we can not be of very much assistance to such a great scholar as you are, but we will do our best to furnish you in so far as possible all the data and facts that you care to incorporate in your new book.

We wish also to take this opportunity to express our heartfelt gratitude for the stand you have taken in regard to the Korean question. We are fully confident that if all the Americans were as fully informed as you are on the Korean question, then there would be little question on their part in regard to the justice of the Korean cause. By your fearless stand you have captivated our hearts and have inspired us to a renewed sense of our duty and obligation to the preservation of a once glorious civilization which the vandal is inscrupulously attempting to extinguish.

Respectfully,

*Eun Sic park.*
*Kwangsoo Lee*

Shanghai, China, June 23, 1920.

Figure 39 Park Eun Sic (Pak Ŭn-sik 박은식) & Lee Kwangsoo (Yi Kwang-su 이광수)'s letter to Griffis, dated June 23, 1920 (Box 60, Folder 1, Griffis Collection)

# 13       *Rhee, Syngman (이승만) (1919)*

### SYNGMAN RHEE (이승만) (1875–1965)

In 1896, Syngman Rhee (Yi Sŭng-man 이승만) joined a group advocating for Korean nationalism, which led to his imprisonment from 1898 to 1904. After his release from prison, Rhee went to the United States and ultimately earned a PhD from Princeton University in 1910. When the Provisional Government of the Republic of Korea (Imsi Chŏngbu) was established in 1919 in Shanghai, he was elected as the first president. His time in office was not peaceful, as he had many opponents and was impeached only a few years into his presidency.

Until Korea's liberation from Japan in 1945, Rhee stayed in the United States to garner Western support for Korean independence. He was elected the first president of the Republic of Korea in 1948. Unfortunately, his leadership proved to be dictatorial, leading to political turmoil in the country. He had the National Assembly amend the constitution to allow no term limits, despite protests from the opposition. The rigged election in March 1960 led to the April 19 Student Revolution, and he was forced to resign. Rhee went into exile in Hawaii.

**1) Apr. 19, 1919** [Typed Letter]

**Korean Independence League, 811 Weightman Building, 1524 Chestnut Street, Philadelphia, PA** [location from letterhead]
William E. Griffis, Esq.,
New York, New York.

Dear Dr. Griffis:

Your telegram of the 15th of this month has been received, but I was surprised to learn that you have a hurt by an accident. I sincerely hope that you will recover rapidly and completely. Wish to learn how you are getting along.

I want to thank you for your telegram of greetings. It was read at the Congress,[1] and received a great applause.

---

[1] The First Korean Congress (Apr. 14–16, 1919), held at Plays and Players Theatre in Philadelphia, was a convention publicizing both the March First Independence Movement (1919) and the establishment of the Provisional Government of the Republic of Korea. The event was organized by Syngman Rhee, Philip Jaisohn (Sŏ Chae-p'il; 1864–1951), and Henry Chung (or Henry Chung De Young or Chŏng Han-gyŏng; 1890–1985).

The Congress has been a great success. The situation here is very favorable.

I am sending you herewith literature relative to the Independence of Korea.

Thanking you again for your kind expressions of friendship, I am

Most sincerely yours,
**Syngman Rhee**

SR-BCL.
Enc.

## 2) May 21, 1919 [Typed Letter]

**American Headquarters of the Republic of Korea, Office of the Secretary of States, Washington, D. C., Continental Trust Bldg. Fourteenth and H Streets Northwest** [location from letterhead]
Dr. Wm. E. Griffis,
240 Waverley Place,
New York City.

My dear Dr. Griffis:

I wish you to know how much you encouraged us when Mr. Chung[2] and I saw you in New York City last time.

We are arranging for a large meeting here in Washington. Dr. Floyd Thompkins[3] and Dr. Philip Jaisohn[4] of Philadelphia have promised to speak for us. You will be the principal speaker in the evening. The date suggested is June the third, and I hope it will be perfectly convenient for you to spare that day for us and for Korea.

I will pay your travelling expenses, and three of you gentlemen will be entertained over night at The Washington or at the New Williard,[5] unless you desire to stay in some other hotel, kindly let me know, as I will be glad to make arrangements for you.

---

[2] Henry Chung was a Korean American scholar and an activist for the Korean independence movement. He and Syngman Rhee assisted independence activist An Ch'ang-ho (1878–1938) in founding the Korean National Association (est. 1909) in San Francisco, California. In February 1919, Chung and Rhee submitted a petition to U.S. president Woodrow Wilson, demanding support for Korean independence from Japan, as well as a League of Nations Mandate in Korea until the stabilization of an independent government. He also co-organized the First Korean Congress (Apr. 14–16, 1919) with Rhee and Philip Jaisohn.
[3] Floyd Williams Tomkins (1850–1932) was an Episcopalian minister in Philadelphia, Pennsylvania. He delivered an opening address to the First Korean Congress (Apr. 14–16, 1919).
[4] Philip Jaisohn (1864–1951).
[5] The Hotel Washington (est. 1918) and Willard Hotel (est. 1847) in downtown Washington, DC.

296  LETTERS FROM KOREANS AND JAPANESE

If the date is not convenient for you, please suggest some other date; although the first Tuesday in June will be best for us here. Either Bishop Hamilton[6] or Dr. Wood[7] of the Church of Covenant may preside over the meeting.

Yours very truly,
**Syngman Rhee**

SR/BCL.

3) **June 17, 1919** [Typed Letter]

**American Headquarters of the Republic of Korea, Office of the Secretary of States, Washington, D. C., Continental Trust Bldg. Fourteenth and H Streets Northwest** [location from letterhead]

My dear Dr. Griffis:

Your kind letter just to hand. I thank you for it. I am going to write to the Scribners Company,[8] urging them to publish a new edition, and I think many other Koreans will do the same when they hear of it.

I am sure it will be a great thing to have the article you intended to publish in the North American Review printed in the "Asia".[9] I am sorry that the former was not able to publish it on account of the political matters at home, but I hope the latter will do it.

Thank you for the correct copy of your address delivered at the mass meeting here. It will be a very valuable part of the report of the meeting which I am intending to publish.

The Columbus[10] people told me that they would send the invitation soon, and I trust they have done so by this time. All expenses connected with your trip will be paid. I think they are expecting to have a fine meeting there. I am sending you herewith a copy of the program they are planning.

Sincerely yours,
**Syngman Rhee**

---

[6] John William Hamilton (1845–1934) was a bishop of the Methodist Episcopal Church, elected in 1900.
[7] Charles Wood (1851–1936) was a Presbyterian minister and pastor at the Church of the Covenant in Washington, DC, from 1908 to 1928.
[8] Scribner & Co. (est. 1846; now Charles Scribner's Sons) is a publisher based in New York, New York.
[9] The *North American Review* (1815–1940, 1964–present) is a triannual journal founded in Boston as the first American literary magazine, now published by the University of Northern Iowa. *Asia* (1898–1946) was a monthly journal published in Orange, Connecticut, by the American Asiatic Association.
[10] Not able to identify if Columbus is a place name.

Will try to have your article published in the Saturday Evening Post.[11] Kindly hold it until we let you know the result.

**4) July 5, 1919** [Typed Letter]

**Republic of Korea** [location from letterhead]

Dear Dr. Griffis:

I thank you for your note dated the second, inst. I understand that you are about to set out for a travel. I shall be glad to hear from you from time to time and from various places.

I will refer to you if any inquiry comes to me concerning a history of Korea. I am sure such work would do a great good for Korea.

Because of this belief, I desire very much that you would undertake this work at once and have it published. I will guarantee that there shall be no loss of any kind in this undertaking, and that the required number of copies shall be sold in due time. Kindly consider this matter, and let me hear from you at your early convenience.

I have written a letter to Scribners Sons and Company of New York,[12] urging them to publish a new edition of your valuable book, "Korea, the Hermit Nation."[13] My secretary has written to some Koreans urging them to do the same.

With best wishes of the season, I am

Sincerely yours,
**Syngman Rhee**

P.S. Thank you for the cards and the suggestion. We will see some motion picture people.

**5) July 12, 1919** [Typed Letter]

**Washington, D. C.**[14]
Dr. William Elliot Griffis,
Glen Place, Ithaca, New York.

My Dear Dr. Griffis:

Your kind letter, dated July 7, came to hand. Thank you very much for the suggestion to read "The Secret Memory of Count Tadasu Hayashi".[15] I shall do so at my earliest opportunity.

[11] *The Saturday Evening Post* (1821–1969) was a weekly magazine published in Philadelphia, Pennsylvania.
[12] Scribner & Co. (est. 1846; now Charles Scribner's Sons).
[13] William Elliot Griffis, *Corea: The Hermit Nation* (London: W. H. Allen and Co., 1882)
[14] In letterhead: Provisional Government, Republic of Korea.
[15] Hayashi Tadasu, *The Secret Memoirs of Count Tadasu Hayashi, G. C. V. O.*, ed. Andrew Melville Pooley (New York and London: G. P. Putnam's Sons, 1915).

# 298 LETTERS FROM KOREANS AND JAPANESE

**REPUBLIC OF KOREA**

SYNGMAN RHEE
PRESIDENT

July 5, 1919.

Dear Dr. Griffis:

I thank you for your note dated the second, inst. I understand that you are about to set out for a travel. I shall be glad to hear from you from time to time and from various places.

I will refer to you if any inquiry comes to me concerning a history of Korea. I am sure such a work would do a great good for Korea.

Because of this belief, I desire very much that you would undertake this work at once and have it published. I will guarantee that there shall be no loss of any kind in this undertaking, and that the required number of copies shall be sold in due time. Kindly consider this matter, and let me hear from you at your early convenience.

I have written a letter to Scribners Sons and Company of New York, urging them to publish a new edition of your valuable book, "Korea, the Hermit Nation." My secretary has written to some Koreans urging them to do the same.

With best wishes of the season, I am

Sincerely yours,

*Syngman Rhee*

*P. S. Thank you for the cards and the suggestion. We will recommend motion people picture*

Figure 40 Syngman Rhee (Yi Sŭng-man 이승만)'s letter to Griffis, dated July 5, 1919 (Box 69, Folder 3, Griffis Collection)

I have written you a letter asking you whether it would be possible for you to take up the writing of the Korean history, as you had suggested to me some time ago. I hope you have received it before this.

With kind personal regards, I am

Sincerely yours,
**Syngman Rhee**

SR/IM

## 6) Aug. 17, 1919[16] [Typed Letter]

**Korean Commission, 1808 Massachusetts St N.W., Washington D.C.**
[location from Griffis's note on another copy]
Dr. William Elliot Griffis,
Glen Place, Ithaca, N. Y.

Dear Dr. Griffis:

I hope you are having an enjoyable summer. I have read with great interest your valuable article, "Japan's Debt to Korea",[17] in the August number of the "Asia", and I want to congratulate you heartily for it. I am sure it will do a great deal for the cause of Korea particularly at this time.

Some time ago, we were communicating about publishing a History of Korea, and I hope it will be convenient for you to undertake the task, I am ready to pledge that I will buy 500 copies of it, or more if need be, at the market price as soon as it comes out, in order to safeguard the financial end of the undertaking for the publishers and to encourage them. Kindly let me hear from you on this manner.

With kindest personal regards, I am

Sincerely yours,
**Syngman Rhee**

SR/bcl.

## 7) Sep. 23, 1919

**Korean Commission, 1808 Massachusetts Avenue N.W., Washington, D. C.** [location from letterhead]
Dr. William Elliot Griffis,
Ithaca, New York.

My dear Dr. Griffis:-

I am glad to receive your kind letter and to know that you are arranging with the Princeton University Press[18] to publish your History of Korea. I would like very much to see your book printed soon and if necessary, I will guarantee the sale of a certain number of copies, or in other word, I will purchase say five hundred copies at market price when published. I hope this may help a little.

Yours very truly,
**Syngman Rhee**

---

[16] There is another copy with the same content without Syngman Rhee's signature.
[17] William Elliot Griffis, "Japan's Debt to Korea," *Asia* 19 (August 1919): 742–749.
[18] Princeton University Press (est. 1905) is an academic publisher based in Princeton, New Jersey.

# 14     *Saitō, Makoto (斎藤実) (1920)*

### SAITŌ MAKOTO (斎藤実) (1858–1936)

Saitō held various military positions due to his outstanding performance in the First Sino-Japanese War and the Russo-Japanese War. In September of 1919, Saito was appointed as the third Japanese governor-general of Korea, following the March First Independence Movement. He was immediately under the threat of an assassination attempt by a Korean nationalist, which he narrowly escaped. His terms as governor-general (1919–1927, 1929–1931) were evaluated as successful, and he was awarded the title of viscount in 1925. In 1932, the assassination of Japanese prime minister Inukai Tsuyoshi made Saito his successor. He supported the Japanese colonial state of Manchukuo in Manchuria and withdrew Japan from the League of Nations. Ultimately, financial scandals forced Saito and his cabinet to resign from office. In 1936, Saito was assassinated during the Imperial Japanese Army's attempted coup.

**1) Jan. 27, 1920** [Typed Letter]

**Keijo, Chosen**

Dear Dr. Griffis,

Your favor of November 4, 1919, has duly come to hand. Your name, your face, and your work are so familiar to me that I feel your letter to be by no means the first that I have ever received from you. I highly appreciate your endeavors to promote international amity, and am especially grateful to you for your taking an interest in my work. In compliance with your request, I am sending you 6 volumes of 古蹟圖譜[1] which is I believe the work you mean by "The History and Antiquities of Chosen". I shall be more than pleased to give you any of our publications that can be spared. We are fortunate in possessing

---

[1] *Chōsen Koseki Zufu*, 15 vols. (Seoul: Chōsen Sōtokufu [Government-General of Korea], 1915–1935).

two copies of your book "Corea, The Hermit Nation"[2] in our library and shall be most happy to add your new book to our shelves when it is published.

Very sincerely yours,
**M. Saito.**

Dr. W. Elliot Griffis,
Glen Place,
Ithaca, N. Y.

## 2) **Mar. 5, 1927** [Typed Letter]

**Keijo[3]**
Dr. W. E. Griffis,
The Kamenoi Hotel,
Beppu.

Dear Sir:-

It is with great pleasure I acknowledge receipt of your correspondence of March 1 and letter of introduction from the Hon. Mr. Sengoku,[4] informing me of your proposed trip with Mrs. Griffis[5] to Chosen in the near future.

I am indeed pleased to learn that you have included Chosen in your itinerary, and am looking forward to seeing you again in this part of the world.

I shall appreciate it if you will inform me of the date of your arrival here as soon as you have decided on it.

Yours very sincerely,
**M. Saito.**

---

[2] William Elliot Griffis, *Corea: The Hermit Nation* (London: W. H. Allen and Co., 1882).
[3] In letterhead: Government General of Chosen.
[4] Sengoku Masayuki (1872–1935) was a viscount in the Japanese House of Peers.
[5] Sarah Frances King Griffis (1868–1959).

# 15 *Shibata, Zenzaburō*
## (柴田善三郎) *(1921)*

SHIBATA ZENZABURŌ (柴田善三郎)

(1877–1943)

Shibata Zenzaburō served in the Chosen Bureau of Education in the Government-General of Korea. Shibata was also the chief secretary of the cabinet from 1932 to 1933 in Japan. From 1932 to 1943, he served as a member of the House of Peers, the upper house of the Imperial Diet of Japan.

1) **May 20, 1921** [Typed Letter]

**Chosen, Keijyo[1]**

My dear Mr. Griffis:

I have received your letter, dated April 18th. I have been acquainted with you for many years through the books, written by you on China, Japan and the other eastern countries. I am very much interested in your books. Please introduce true conditions of Korea to the world by your powerful pen.

At your request. I will send you the copy of Manual of Education[2] for 1920 with the pamphlets: "The other side of the Korean Question",[3] "Administrative Reforms in Korea",[4] AND "Politics and Religions in Chosen".[5] "Educational Chosen"[6] will be sent to you afterwards, for before long it will be published.

Yours very truly,
**Z. Shibata**

---

[1] In letterhead: Government General of Chosen, Bureau of Education, Seoul.
[2] *Manual of Education in Chosen* (Seoul: Gakumukyoku [Government-General of Korea, Bureau of Education], 1920).
[3] Frank Herron Smith, *The Other Side of the Korean Question* (Seoul: Seoul Press, 1920).
[4] *Administrative Reforms in Korea: Articles Reprinted from the "Seoul Press"* (Seoul: The Seoul Press, 1919).
[5] *Politics and Religion in Chosen: Attitude of the Government towards Christianity* (Seoul: The Seoul Press, 1920).
[6] *Educational Chosen* (Seoul: Gakumukyoku [Government-General of Korea, Bureau of Education], 1921).

# 16   *Sin, Teh Moo (신태무) (1901)*

SIN TEH MOO (신태무) (?—?)

As the Korean chargé d'affaires, Sin was tasked with liaising between the American and Korean governments. He was one of seven envoys to the United States. In 1905, Sin met with the assistant secretary of state of the United States, Alvey Augustus Adee. During this meeting, he voiced the request of King Kojong regarding who should be appointed as the minister of Seoul, presenting a telegram to the American official. Throughout his time as a diplomat, he also held a close relationship with Lady Ŏm, the highest-ranked concubine to King Kojong. He is known to have reported on one of the Korean princes, Ŭihwagong (later Ŭich'inwang), who was studying at Roanoke College and was a competitor to Lady Ŏm's son. After Japan forcibly closed Korean diplomatic missions following the Japan-Korea Treaty of 1904, he sought help from the United States State Department.

1) **Jan. 11, 1901**

**Legation of Korea, Washington** [location from letterhead]
Rev. Wm E. Griffis
Ithaca, N.Y.

Esteemed Sir,

Your letter of the 9th inst. requesting information concerning the Korean Empire has been received.

I regret to inform you that I haven't any printed documentation pertaining to the finances, resources or foreign trade of our country. Otherwise I would be pleased to accommodate you.

Very sincerely yours
**Sin Teh Moo**

Charge' d'Affairs a.z.

# 17  *Sonoda, Hiroshi (園田寛) (1923)*

SONODA HIROSHI (園田寛) (1883–?)

Sonoda Hiroshi was the chief of the Foreign Affairs section of the Government-General of Korea. Sonoda had extensive experience in government, serving as the secretary of the Monopoly Bureau, the counselor for the Ministry of Education, and the chief of the General Affairs Division. He was a secretary and inspector general of the Government-General of Korea, as well as the chief of the foreign affairs section, the accounting section, the finance section, and the forest department. Sonoda served as the governor of South Pyŏngan Province in 1929. After his retirement in 1931, he became a director of the Yokohama Chamber of Commerce and Industry.

**1) Oct. 8, 1923** [Typed Letter]

**Government-General of Chosen, Keijo**
Dr William E. Griffis,
Pulaski, New York.

My Dear Dr. Griffis:-

I am directed by His Excellency, Baron Saito[1] to forward you under separate cover, the books listed below which are the only ones available at present,

1. Album of Korean Archaeology Voi. VII.
2. Guide to the stone monuments in Chosen.
3. Reports of investigations made on manners & customs.
4. Korean dictionary.
5. Riddles of the Korean people.
6. Collections of Korean manners.
7. Museum Exhibits illustrated Voi I and III.
   Trusting that these will prove of some interest to you.
   With all good wishes,

I am, yours faithfully,
**H. Sonoda.**

Chief of Foreign Affairs Section.

---

[1] Saitō Makoto (1858–1936).

304

# 18     *Usami, Katsuo (宇佐美勝夫) (1912)*

## USAMI KATSUO (宇佐美勝夫) (1869–1942)

Usami Katsuo was the director of the Interior Department of the Government-General of Korea in Seoul. After graduating from Tokyo Imperial University in 1896, he entered the Ministry of the Interior. Usami became the counselor of Tokushima Prefecture in 1897, the governor of Toyama Prefecture in 1908, and the governor of Tokyo Prefecture in 1921. Before 1921, Usami served as the deputy secretary of the Interior of the Korean Government and as the secretary of the Interior Department of the Government-General of Korea. In 1934, Usami was appointed to the House of Peers, the upper house of the Imperial Diet of Japan, where he served until his death.

1) **July 31, 1912** [Typed Letter]

**Seoul**[1]

Dear Sir:—

I herewith take pleasure to send to you, for your reference a printed copy of the "Study on Japanese and Korean geographical names in Ancient Times,"[2] author of which is Dr. S. Kanazawa,[3] Professor of Tokyo Foreign Languages School, charged with the work by the order of this Government General.

Very Sincerely Yours,
**K. Usami**

Director of the Department of Internal Affairs, of the government General of Chosen, Seoul.

---

[1] In letterhead: Government General of Chosen, Bureau of Education, Seoul.
[2] Shōzaburō Kanazawa, *Nissen kodai chimei no kenkyū* (Tokyo: Chōsen Sōtokufu [Government-General of Korea], 1912).
[3] Shōzaburō Kanazawa (1872–1967) was a Japanese linguist who taught at institutions including Tokyo Foreign Languages School (est. 1899; now Tokyo University of Foreign Studies), Tokyo Imperial University (est. 1877; now University of Tokyo), and Tokyo College (est. 1882; now Waseda University). His research and teaching focused on Korean, Japanese, Ainu, and English.

# 19 Watanabe, Noboru
## (渡邊昇) (1910, 1921)

WATANABE NOBORU (渡邊昇) (1838–1913)

Watanabe Noboru was a Japanese politician and notable Christian figure. He was instrumental in the arrangement of the Satsuma-Choshu Alliance, a military power formed in 1866 to overthrow the Tokugawa shogunate of Japan and restore imperial rule to Japan. He was the first chief justice of the Court of the Government-General of Korea from 1910 to 1923. In 1916, Watanabe was appointed as the honorary director of the Seoul YMCA, and he maintained close ties with Korean Christian figures, such as Yun Ch'i-ho 윤치호. After returning to Japan, he served in the upper house of the Japanese legislature as a member of the House of Peers

### 1) Aug. 8, 1910

**Seoul, Korea**

My dear Dr. Griffis:-

Many thanks for your letter of encouragement dated on the 14th of March. Under the divine guidance things here are very much improving. We are very thankful for it, especially for the progress of His Kingdom both in the Japanese and Corean people. We sent to you the following publications which I think you may be interested.

Annual Reports of the Residency-General
Annual Reports of the Education Dept.
Photographs, Pictorial Post Cards.

Yours sincerely,
**N. Watanabe.**

### 2) Apr. 5, 1921 [Typed Letter]

**Seoul**
Dr. Wm Elliot Griffis,

Dear Friend,

I duly received your kind letter of the 30th of October last, and am very glad to learn that you are well, so well indeed that you have been to Europe for the tenth time to work for that great cause of international brotherhood.

As to the material of historic interest you ask for, being an outsider myself, I thought it best to seek information from those who are conversant with such matter. So I asked Mr. Kanjiro Oda,[1] and his reply was so delayed that my answer to you has also been delayed for so considerable time, for which I must ask you to excuse. But when I came to know what had caused the delay on the part of my friend, I could not but be really surprised. It has been known that Mr. Oda asked for information in his turn to a Korean gentleman by the name of Mr. Li Nung Wha,[2] and Mr. Li took such pains in writing his answer that it made quite a volume consisting of 550 pages! In this considerable document Mr. Li deals principally with Confucianism in Korea. It covers a period of about 1000 years from Simla [sic read Silla] Dynasty to Li Dynasty,[3] and I think It contains quite important information.

Apart from the above, I am supplied with a document consisting of 30 pages and dealing with the influence of Korean Confucianism and Buddhism exercised upon Japan.

Still another is in the form of a publication, written by the same Mr. Li nung wha, and is entitled "History of Buddhism in Korea"[4] It is of two volumes and can be had at Yen 6.50 a copy.

Lastly I may mention "Koseki Zufu"[5] (Historic remains illustrated) consisting of six volumes. But I think this is the same that was presented to you by Governor-General Saito.[6]

With the exception of the last-mentioned all the documents and publications are written in classical Chinese or in mixed script of Korean and Chinese, and I am afraid that they will be of little use to you, if sent as they are. But if you can use them, I will send them to you on receipt of your answer.

As to Japanese archaeologists or historians of Korea who deal with the past, I may mention you the following names:

[1] Oda Kanjiro (or Oda Mikijirō; 1875–1929) was a Japanese lawyer and secretary of the Chu-suin (advisory body) for the colonial governor-general of Korea. He was commissioned by the Government-General to conduct research on the history and customs of Korea.
[2] Yi Nǔng-hwa (1869–1943) was a scholar of Korean religion and history and the author of histories such as *Chosǒn Pulgyo T'ongsa* [The History of Korean Buddhism] (Seoul: Sinmun'gwan, 1918) and *Chosǒn Haeǒhwasa* [The History of Korean Kisaeng] (Seoul: Hannam sǒrim, 1926). A pro-Japanese collaborator, he conducted land investigation, historical research, and textbook development for the colonial Government-General between 1918 and 1941.
[3] Silla (57 B.C.E.–935 C.E.); Chosǒn (1392–1910).
[4] *Chosǒn Pulgyo T'ongsa* (Seoul: Sinmun'gwan, 1918).
[5] *Chōsen Koseki Zufu*, 15 vols. (Seoul: Chōsen Sōtokufu [Government-General of Korea], 1915–1935).
[6] Saitō Makoto (1858–1936).

308   LETTERS FROM KOREANS AND JAPANESE

<div align="center">Japanese</div>

| | |
|---|---|
| Old Architecture | Mr. Chuta Ito,[7] Professor Tokyo Imperial University Kogako Hakushi[8] |
| Old Architecture | Mr. Tei Sekino,[9] Professor Tokyo Imperial University Kogako Hakushi |
| Old Sculpture | Mr. Koun Takamura[10] Professor Tokyo Fine Arts School |
| Old Sculpture | Mr. Chunosuke Niino,[11] member of committee for preservation of old temples |
| Old Paintings | Mr Chujun Nakagawa,[12] Professor Tokyo Imperial Univ. Bungakushi[13] |
| Old Paintings | Mr. Seiichi Taki,[14] Professor Tokyo Imperial Univ. Bungaku hakushi[15] |
| Fine Arts in general | Mr Yusaku Imaizumi,[16] chief, Okura Meusium [*sic* read Museum]. |

<div align="center">Korean</div>

Mr. O Sei Chang,[17] Seoul.

The following gentlemen have also some knowledge of Korean history.

| | |
|---|---|
| History proper | Mr. Shogo Oda,[18] Editorial staff member, Government General Chosen |

---

[7] Itō Chūta (1867–1954) was an architect and architecture historian, and a professor at Tokyo Imperial University (est. 1886; now University of Tokyo). He designed various traditional and modern buildings, including the Chōsen Jingū (1925–1945), a Shinto shrine constructed in Seoul during the colonial occupation.

[8] Doctor of engineering.

[9] Sekino Tei (or Sekino Tadashi; 1868–1935) was an architecture historian and professor at Tokyo Imperial University. In 1902, he was hired by the Government-General to conduct a survey of traditional architecture in Korea.

[10] Takamura Kōun (or Nakajima Kōzō; 1852–1934) was a sculptor and professor at Tokyo School of Fine Arts (est. 1887; now Tokyo University of the Arts). His work focused on the modernization of wood carving.

[11] Chunosuke Niino (?–?) was a sculptor and official of the Commission for the Preservation of Old Shrines and Temples.

[12] Nakagawa Chujun (1873–1928) was a professor at Tokyo Imperial University and the curator of the Oriental Department of the Boston Museum of Fine Arts (est. 1870).

[13] Bachelor of arts.

[14] Taki Seiichi (1873–1945) was an art historian, professor at Tokyo Imperial University, and the author of *Japanese Fine Art*, trans. Kazutomo Takahashi (Tokyo: The Fuzambo, 1931).

[15] Doctor of literature.

[16] Imaizumi Yusaku (1850–1931) was an art collector, art historian, and professor at Tokyo School of Fine Arts. He worked for the Tokyo National Museum (est. 1872) and Okura Museum of Art (est. 1917).

[17] O Se-ch'ang (1864–1953) was a calligrapher, historian of Korean calligraphy, and one of the founding members of Sŏhwa Hyŏp'oe (1918–1936), Korea's first association of visual artists. He was also a translator, journalist, and Korean independence activist.

[18] Oda Shōgo (Oda Seigo; 1871–1953) was a scholar of Korean history and a professor at Tokyo Imperial University. He was commissioned by the Government-General to develop colonial textbooks in 1910 and to write a history of Korea in 1925.

Watanabe, Noboru (渡邊昇) (1910, 1921)    309

| | |
|---|---|
| History proper | Mr. Kanjiro Oda, Secretary Chusuin (Korean Council) |
| Old fine arts | Mr. Kumashiko Suyematsu,[19] Secretary, Prince Li Household.[20] |
| Old fine arts | Mr. Soetsu Yanagi,[21] author. |

I hope that the foregoing information will be of some use to you. To any further inquiry you may make I shall be very pleased to answer.

With best regards,

I remain,

Yours most sincerely,

**N. Watanabe.**

---

[19] Suematsu Kumahiko (1870–1935) was the chief manager and curator of exhibitions at the Prince Yi Household Museum (Yi Wangga Pangmulgwan; est. 1908; now the National Museum of Korea).

[20] The Prince Yi Household Museum (was an art museum built in Ch'anggyŏnggung Palace under the auspices of the Korean royal family. After the Japanese annexation of Korea (1910), the museum was restructured into the Government-General Museum (1915), and it has been a Korean national museum since independence (1945).

[21] Yanagi Sōetsu (or Yanagi Muneyoshi; 1889–1961) was an art critic, philosopher, and founder of the *mingei undō* (folk art movement). His interest in Korean folk art led to the establishment of the Korean Folk Art Museum (or Chosŏn Minjok Misulgwan; 1924–1945).

# 20     *Ye, Cha Yun (이채연) (1890–1892)*

### YE CHA YUN (이채연) (1861–1900)

Ye Cha Yun (Yi Ch'ae-yŏn 이채연) served as a Korean diplomat to the United States as the chargé d'affaires from 1887 to 1906. During this time, he promoted independence and pro-American policies. Ye was one of the eleven deputy ministers sent to establish diplomatic relationships with the United States. Ye was instrumental in keeping close relations with the American government. For example, there was a record of his conversation with then–U.S. secretary of state Walter Q. Gresham, during which he requested American intervention and advice to set up a postal service and a railroad system in Korea. Interestingly, in October of 1890, Ye made American headlines in the *The New York Times* with the birth of his son, who was the first "native-born" Korean in the United States.

### 1) Oct. 17, 1890

**Legation of Korea, Washington** [location from letterhead]
Dr. W.E. Griffis

My dear Sir:

Please accept my thanks to you, for your kind congratulations on the birth of my son. The historical event of his birth (if God spares him) will make him to think himself a great boy to have been born on the same day that your beautiful country America was discovered.

I hope someday your children and my boy will meet and then they will be able to tell him how pleased they were to see the birth of (the then little baby they are talking to now) in the newspaper.

My wife, I am glad to say, is doing well.

I remain your good friend,
·Ye Cha Yun.

### 2) Aug. 11, 1891

**Hotel Berwick, Narragansett Pier, R.I.** [location from letterhead]
Dr. W. E. Griffis

Dear Sir:

I have to write to you that am here now near your city. Also my wife is with me. We are going to visit your city when we return to Washington about the

**LEGATION OF KOREA**
**WASHINGTON.**

Oct. 17th 1890.

Dr. W. E. Griffis,
My dear Sir:
Please accept
my thanks to you, for your
kind congratulations on the
birth of my son. The
historical event of his birth
(if God spares him) will make
him to think himself a great
boy to have been born on
the same day that your
beautiful country America
was discovered.
I hope some
day your children and my
boy will meet and then they —

Figure 41  Ye Cha Yun (Yi Ch'ae-yŏn 이채연)'s letter to Griffis, dated October 17, 1890 (first page) (Box 69, Folder 20, Griffis Collection)

will be able to tell him
how pleased they were
to see the birth of (the then
little baby they are talking
to now) in the newspaper.
My wife, I am
glad to say, is doing well.
I remain
your good friend,
Ye Cha Yun

Figure 42 Ye Cha Yun (Yi Ch'ae-yŏn 이채연)'s letter to Griffis, dated October 17, 1890 (second page) (Box 69, Folder 20, Griffis Collection)

*Ye, Cha Yun (이채연) (1890–1892)*     313

22nd inst. We will stop at the Adams House, couple of days, at your city. Then we will be glad to call on your house.

I am

yours respectfully
**Ye Cha Yun.**

### 3) **Sep. 30, 1891**

**Legation of Korea, Washington** [location from letterhead]

Dear Dr. W.E. Griffis:

I received your letter of yesterday and am very glad to hear that you returned home safely and that [you] had a pleasant time in Europe.

Please call on my Legation while I am here if you can. Still very sorry that I could not meet you at Boston.

Yours sincerely,
**Ye Cha Yun**

### 4) **Oct. 3, 1892**

**Legation of Korea, Washington** [location from letterhead]

My dear Dr. Griffis:

Your very kind and most interesting letter of Sept. 28th has been received and contents noted. I have given careful attention to the questions which you asked of me and have written home to that effect as I would prefer higher authority in Chosun for their opinion previously to stating mine.

I thank you for your kind interest in this matter but I feel sorry to state that I will not be able to give you the necessary information for some future time.

I am

very truly yours,
**Ye Cha Yun**

To
Dr. W. Elliot Griffis
638 Fremont St
Boston.

314   LETTERS FROM KOREANS AND JAPANESE

5) Nov. 15, 1892

**Legation of Korea, Washington** [location from letterhead]

Dear Sir:

In reply of your kind letter of yesterday I venture to enclose two names who, I consider, to be the most famous in the literary annals of my country and hope you will take all the responsibility for me in the future time on this recommendation.

   With kind regards

Yours truly
**Ye Cha Yun**

# Acknowledgments

We would like to thank the following people for their help with many hours of scanning, transcription, research, and copyediting: Mary Margaret Doherty (1st project), Brandon Park (1st and 2nd project), Alexandra Deangelis (1st project), Joseph Cajigal (1st and 2nd project), Beyza Anil (2nd project), and Joyce Ko (2nd project). We would like to especially acknowledge Eunice Lee's tireless work for annotations, Flora Kim's editorial help, Haruko Wakabayashi's help with the Japanese language, and Professor Hyun-soon Sohn for her willingness to share the late professor Sang-hyun Yang's Griffis Korean photo images. We would like to thank Professor Hye Eun Lee for her continuous support and advice. Our deep gratitude goes to Dr. Fernanda Perrone, the Griffis Collection curator, who has been the expert guide in all matters Griffis for the past twenty years and has facilitated a number of publications. We would like to express our gratitude to Professor Soo Hur, a modern Korean historian at Seoul National University; Professor Jae Won Chung of Rutgers University for his help in translating Professor Hur's Korean text into English; and Professor Ross King of the University of British Columbia for taking time to write recommendations that contextualize the significance of the Griffis Korea Letters from their lenses of expertise.

All the images published in this monograph were provided by the Griffis Collection, Special Collections and University Archives (SCUA) at Rutgers University. We express our deep gratitude to Rutgers University Libraries.

<hr>

This monograph would not have been possible without the 2021–2022 project (full title: "Research on the Korean Materials in the William Elliot Griffis Collection at Rutgers University Libraries: Transcribing, Annotating Griffis Korea Letters and Unpublished Manuscripts, Building a Supplementary Online Archive, and Publishing a Monograph") funded by the Overseas Korean Cultural Heritage Foundation (OKCHF), a follow-up project of the 2018–2019 project ("Research on the Korean Materials in the William Elliot Griffis Collection at Rutgers University Libraries: Evaluating, Annotating Significant Korean Studies Materials and Hosting an International Workshop"). We acknowledge our sincere gratitude to the OKCHF for the generous support.

# Index

An Ch'ang-ho (C. H. Arhn), 285n8, 289, 289nn26–27, 290, 295n2

An Chung-gǔn, 96n27, 254

Battle of Kanghwa (Kangwha incident), 63, 63n28

Bird, Isabella Lucy (Mrs. Isabella Bird Bishop, Mrs. Bird-Bishop), 35, 35n65, 107

Bunker, Dalziel A., 111, 115, 115n22, 117, 129, 142, 142n34, 145, 146, 170, 170n172, 171, 171n176

Chaeryǒng (Chai Ryung, 재령), 4, 180, 180n2

Chautauqua Movement, 46n124, 169n163

*Cheguk Sinmun*, 156n109

Chejungwǒn (Severans Hospital, 제중원), 20, 23n4, 30n38, 31, 31nn40–41, 31n44, 85, 94n14, 164n142, 192, 193, 228, 237

Chemulp'o (Inch'ǒn, 제물포), 4, 27n21, 29, 31, 31n45, 57, 59, 59n10, 59n13, 60, 60n16, 62n21, 67, 68, 68n43, 70, 71, 92 table 2, 106, 106n6, 109, 145, 148n76, 156, 161n136, 171n182, 172n187, 174, 175, 202, 215, 220, 284

Cho, Queen Dowager (Queen Sinjǒng, 조대비), 30, 30n36, 32, 32n48

Ch'oe Ch'i-wǒn (Choe Chi Won, 최치원), 135, 135n14, 136

Chosen Christian College (Union Xn College, Yonhui School, Severance Union Medical College, Yonsei University), 23n4, 31n40, 75, 81, 118n35, 192, 193, 228, 253

Chosǒn (Chosun, Ye Dynasty, Li Dynasty), 2, 91n7, 135n13, 135n15, 140, 146, 159, 159n128, 167, 307, 313

*Corea, The Hermit Nation* (Griffis), x, xin1, xiii, xiv, xix, xx, xxxn3, 1, 3, 15, 23, 23n6, 37, 71, 73, 74, 91, 105, 106, 106n8, 108, 120, 130, 200, 201, 226, 272, 292, 297, 301

Corean-American Treaty of Amity and Commerce, 31n45, 287

*Corea of Today* (Gilmore), xxiii, xxxn10, 113, 113n16, 114, 114n20

Denny, Owen Nickerson (Judge Denny), 25, 25n11, 27, 27n29, 29, 170, 170n170, 190, 190n11

Dinsmore, Hugh Anderson, 9 table 1, 26, 28, 28n30, 30

Eckert, Franz, 172, 172n186

Ewha Haktang (Ewha, Ewha Mission School, Ewha Womans University), xvi, 6, 60, 62, 79, 89, 240, 241, 241nn3–4, 244n12

First Sino-Japanese War (Sino-Japanese War, Japanese Chinese war), xiv, 116n29, 174n2, 175, 175n6, 300

Foote, Lucius Harwood, 25, 25n12, 29n34, 168, 168n155

Foulk, George Clayton, xxi, xxxn7, xxxi, 5, 15

Government-General of Korea (Government General of Chosen, Government General, Japanese colonial government, Government, New Government), xvi, xxii, 64, 64n29, 64n32, 65, 66, 67n35, 68n48, 85, 86n4, 96, 99, 201, 231n9, 258n9, 279, 300n1, 301n3, 302, 302nn1–2, 302n6, 304, 305, 305n1, 306, 307nn1–2, 308, 308n9, 308n18

governor-general of Korea, xxii, xxxin22, 96n27, 99n34, 197n2, 198, 44n10, 254, 300, 307, 307n1

Hansǒng Sabǒm Hakkyo (Government Normal School, Higher Government Normal School, Seoul Normal School), 148, 148n78, 149, 149n81, 149, 242, 257

*Hansǒng Sinbo*, 156n109

Hastings College, 8 table 1, 270

*Histoire de l'Eglise de Coree* (Dallet), 167

*History of Korea, The* (Homer B. Hulbert), xvii, 146, 146n64, 147, 149, 150, 150n88, 153, 155, 162, 164, 166, 167, 169

*Hongbǒm Sipsajo (14-jo)*, 144, 144n56

*Hunmin Chǒngǔm* (book; *Hoon Min Chong Eum*), 135, 135n17

Hunmin Chǒngǔm (writing system; Han'gǔl, Ǒnmun, 언문), 135n13, 143, 143n52

Imjin War (Japanese invasions of Korea), 100n41, 146–157, 147n70, 147n75, 158n119

Independence Club (Tongnip Hyǒphoe, 독립협회), 27n27, 33, 33n55, 289n27, 291

*Independent* (*Tongnip Sinmun*, 독립신문), 48n128, 129, 148, 148n76, 157n115, 214, 260

Jaisohn, Philip (Sŏ Chae-p'il, Suh Jai-pil, Soh Jay Pill, 서재필), xi, xxiii, 4, 34n59, 47, 47n128, 148, 148n76, 156, 171, 188nn2–4, 189nn6–8, 190, 190n10, 260–266, 261 fig. 37, 262n1, 263 fig. 38, 265n7, 291, 295, 295n2

Japanese annexation of Korea, xxv, xxvii, 1, 4, 28n31, 40n91, 58, 83, 99, 215, 223, 253, 282, 287, 289, 309n20

Japan-Korea Annexation Treaty, 83n1, 145n59, 215n7

Kabo Reforms (갑오경장), 33n54, 145n60, 265n6

Kanghwa Island (Kanghwa, Kangwha), 59n13, 60, 60n17, 63n28, 177. *See also* Treaty of Kanghwa

Kapsin Coup (갑신정변), 26nn16–17, 33n54, 47n128, 140n28, 188, 188nn2–3, 260, 265n6, 286n13

Keijo Station (Kyŏngsŏng Station, Seoul Station), 282, 282n3

Kija Chosŏn (Kija dynasty), xvii, 135n12, 146, 153n97

Kim Ok-kyun (Kim Ok Kiun), 140, 140n28, 188nn2–3, 189, 189n5

Kojong, King (고종), 4, 20, 23nn3–4, 25, 27nn21–22, 27n28, 28, 28n31, 30n35, 31n41, 34, 34n60, 39nn87–88, 40, 41n96, 48, 78n2, 94n14, 106n9, 111, 129, 140n32, 144n56, 160, 161n135, 171, 171n179, 171n181, 172, 172n188, 172n190, 189, 286n13, 303

Korea Branch of the Royal Asiatic Society, 81, 93, 93n10, 94, 157, 279n1

Korean Bureau of Land Survey (Yangji Amun), 44n113

*Korean Conspiracy Case, The* (Brown), xxvii, 203, 204, 225, 225nn2–3

Korean legation (Legation of Korea), xvi, 20, 25, 26, 26n18, 27, 269, 303, 310, 311 fig. 41, 313

Korean National Association (Taehanin Kungminhoe), 270, 283, 283n1, 285, 285n4, 285nn6–8, 286nn9–10, 288, 288n21, 288n23, 289, 289nn24–25, 289n27, 295n2

*Korean Repository* (*Seoul Repository, Chosŏn Sosik*), 33, 33n49, 39n88, 73, 73n6, 74n9, 94n14, 106, 113, 138, 146, 149, 150, 173, 174, 174n1, 175, 177

Korean Student Alliance, 270, 272, 272n1, 288n22

*Korean Students' Review*, 270, 272n1, 288, 288n22

*Korea Review*, 39, 39nn88–89, 78, 78n2,

94n14, 150, 150nn86–88, 151n92, 155n103, 156n108, 157n117, 158n122, 160, 161n136, 162, 166, 167, 167n154, 168, 173, 260, 262, 262n3, 264, 265

Koryŏ (Koryŏ Dynasty; 918–1392), 36n74, 91n7, 100nn40–43, 101, 101n47, 153n95

Kŭmgang Mountain (Diamond Mountains, Keumgang San, Kŭmgangsan), 90, 90n1, 91

Kyŏngju (Kyungju, Kyŏngju, Kyungjou, Kyung-joo), 3, 86, 86n3, 92, 100, 100n37, 157, 157n114

Ladd, George Trumbull, xxiv, xxxn12, 9 table 1, 83, 83n2

League of Friends of Korea, 260

March First Independence Movement (March First Movement, March 1st Movement, March First Uprising), xxv, xxvii, xxviii, xxxn19, 5, 6, 64nn29–30, 65n34, 68n48, 75, 118n35, 174, 195, 197, 197n2, 244–245, 244n11, 262n1, 300

Masan, 284

McKenzie, Frederick Arthur (F. A. MacKenzie), xxiii, 4, 45, 45n119, 47, 47n127, 195, 195n9

Min Chong-muk (Min Chong Muk, 민종묵), 145, 145n58

Min Yŏng-hwan, 140n32

Min Yŏng-ik (Min Yong Ihc, 민영익), 26, 26nn16–17, 140n32

*Modern Pioneer in Korea, A* (Griffis), x, xvi, xxxi, 39n90, 47, 47n127, 139n24, 178

Mokp'o (Mokpo), xxvii, 71, 284

Myŏngsŏng, Empress (Queen Min, 민비, 명성황후), 25n12, 26n16, 27n28, 30, 30n35, 34n60, 35, 140n32, 168n155, 170n171, 171, 171n179, 172n190, 188, 280n7

*New Korea* (*Sinhan Minbo*, 신한민보), 270, 283, 286nn9–10, 288, 288n21, 288n23, 291

Ŏm, Lady (Lady Om), 172, 172n190, 303

105-Man Incident, 108, 225n2

O Se-ch'ang (O Sei Chang), 308, 308n17

Pai Chai Haktang (Paichai Haktang, Pai Chai School, PaiChai school, Pai Chai Hakdang, 배재학당), xix, 6, 39n88, 57, 63, 63n25, 64, 64n29, 67, 68, 69, 69n52, 71, 142, 142n37, 241, 250

Pak Chŏng-yang (Pak Chung Yang, 박정양), 26n15, 27, 27n23, 27nn25–26

Pak Yŏng-hyo (Pak Yong Hyo, Prince Park, 박영효), 33, 33nn54–55, 188, 188nn2–4, 189n5, 265, 265n6

Pak Yong-man (Y. M. Park), 285n8, 286, 286nn10–11

*Passing of Korea, The* (Homer B. Hulbert), 129, 165, 165n147

Pogunyŏgwan (Po Ku Nyo Koan, 보구녀관), 55, 56 fig. 11–12

Provisional Government of the Republic of Korea (Korean Provisional Government, Imsi Chŏngbu), 108, 211n3, 262n1, 270, 278, 283, 285n4, 291, 294, 297n14

Pusan (Fusan, Füsan), 30, 90, 92 table 2, 147, 147n75, 148n76, 174, 196, 233, 233n17, 284

P'yŏngyang (Pyeng Yang, Pyengyang, Pyeng-yang, Pyang Yang, Pyong Yang, Pyung Yang, Pingyang, Ping-an, 평양), xvi, xviii, 3, 4, 68, 68n48, 75, 77, 92 table 2, 99, 106, 125 fig. 23, 130n2, 146, 148n76, 197, 201, 202, 209, 210, 211, 216, 217, 219, 220, 221, 221n3, 222, 222n4, 231, 232, 233, 258, 259, 284

Pyongyang Chosun Jesus Presbyterian Seminary (Chosŏn Yesugyo Changnohoe Sinhakyo, Pyongyang Theological Seminary, 조선예수교장로회신학교), 9n5, 192n2, 201, 231n9, 232

*Queen of Quelparte, The* (Archer B. Hulbert), xxvi, 157, 158

Quelpart (Island of Quelpart, Isle of Quelpart, Cheju Island), 147, 158, 159n125, 162, 162n140, 232, 232n13, 233

Rhee, Syngman (Yi Sŭng-man, 이승만), xi, xvi, 4, 71, 262n1, 270, 285n8, 286, 287, 287nn16–17, 289n25, 291, 294–299, 295n2, 298 fig. 40, 299n16

Righteous Army, 274n3, 277

*Rocky* (*Urak'i*, 우라키), 249

Ross, John, 1, 90, 93, 93n12

Russo-Japanese War, xxiii, 38n85, 40n91, 44n114, 95n20, 160n132, 161n134, 171n183, 254, 286, 300

*Samguk Sagi* (Kim Pu-sik), 153n95

*Samin P'ilchi* (Homer B. Hulbert; *Geographical Gazetteer of the World*, 사민필지), xvii, 129, 131, 131n6, 166n150

Sands, William Franklin, 172, 172n188

Scranton, William Benton, xxviii, 3, 6, 18 fig. 1, 31, 31nn41–42, 90, 120, 121 fig. 21, 122 fig. 22, 142, 143, 145, 174

Sejong, King (Say Jong, Say Jong Tai Wang, Sejong Taewang, 세종대왕), 135, 135n13, 135n15, 135n17, 136, 136n20

Seoul-Chemulp'o Railroad (Kyŏngin

Railroad), 34, 34n57, 38, 47n127, 229, 229n4, 282n3

Seoul Electric Company (Hansŏng Chŏn'gi Hoesa, Korea Electric Power Corporation), 39, 39n87, 47n127, 172n191

*Seoul Press*, 63, 63n27, 98, 98n31, 269, 302n4

Seoul-Pusan Railroad (Fusan R.R., Seoul-Fusan Ry., Fusan railroad, Kyŏngbu Railroad), 38, 38n82, 41, 59, 162, 229, 229n4

Silla (Silla Dynasty), 86n3, 92, 100, 100n37, 153, 157, 157n114, 307

Songdo (Song Do, City of Sunto, Kaesŏng), 3, 38, 106, 106n10, 233

Soongsil Haktang (Union Christian College, Soongsil University), 68n48, 75, 91n5, 232

Sorae (Sorai, Sorae P'ogu, 소래포구), 4, 68, 68n43, 180

Sorokto, 86n4

Sunjong, King, 172n190

Taegu (Taiku, Daiku), 3, 4, 84, 85, 86, 87 fig. 16, 88 fig. 17, 125 fig. 23, 232, 232n15, 258, 259, 284

Taewŏn'gun (Hŭngsŏn Taewŏn'gun, Tai Wan Kuun, Tai on Kun, 대원군), 27, 27n28, 28n31, 63n28, 106n9, 280

Taiku Leper Hospital, 86

Tan'gun (Tangun), 153, 153n97

*Tongguk T'onggam* (Sŏ Kŏ-jŏng; *Tong Kuk Tong Gam*), xvii, 130, 130n3, 139

Tonghak Peasant Revolution (Tonghak Revolution), xiv, 116n29, 142n33, 174n2, 175n6

Tongnimmun (Independence arch, 독립문), 34, 34n59

*Tragedy of Korea* (McKenzie), 45, 45n119

Treaty of Kanghwa, 28n32, 31n45, 33n53, 106n8

Union Biblical Institute (Hyŏpsŏng Theological College, Hyŏpsŏng Sŏngkyŏng Hagwŏn, Methodist Theological University, 협성성경학원), 62n21, 81, 174

*Unmannerly Tiger and Other Korean Tales, The* (Griffis), x, xvi, 46, 215

U.S. legation (American Legation), 20, 23n5, 25n12, 26n15, 30, 31, 32, 40, 41n94, 111n3, 168n155, 170, 172n188

Von Möllendorff, Paul Georg (Von Mollendorff), 169, 169n165, 170, 170n168

320 Index

Wŏnsan (Wunsan, Wonsan, Gensan, Genzan, Yuensan), 4, 58n5, 90, 91, 91n3, 92 table 2, 93, 174, 174n3, 194, 194n3, 195, 195n7, 199, 284

Yanagi Sōetsu (Yanagi Muneyoshi), 309, 309n21
Yi Nŭng-hwa (Li Nung Wha), xxii, xxxn9, 307, 307n2
Yi Sun-sin, 158, 158n119
Yi Wan-yong (Yi Wan Yong, 이완용), 145, 145n59
YMCA (Y.M.C.A., Young Men's Christian Association), 47n127, 90, 108, 110, 110n3, 169, 228, 250, 251, 252, 253, 257, 267, 282, 306
Young Korean Academy (Hŭngsadan), 285n7, 289, 289nn25–27, 290
Yuan Shikai (Yuan Shi-Kai), 27n23, 27n26, 48n129, 170, 170n167
Yu Kil-chun (You Kill Chun, 유길준), 26, 26n17
Yukyŏng Kongwŏn (Royal English School, 육영공원), 20, 39n88, 111, 115n22, 125 fig.23, 129, 133, 142, 142n34, 145, 145n62, 166n150, 170, 170n172, 171, 171n176
Yun Ch'i-ho (윤치호), 306

# About the Editors

YOUNG-MEE YU CHO is Professor of Korean Language and Culture in the Department of Asian Languages and Cultures at Rutgers, The State University of New Jersey. She is the one of the three editors for the new series, *DITTA: Korean Humanities in Translation* (Rutgers University Press). Her publications include *Parameters of Consonantal Assimilation* (1999), *Integrated Korean* (2000–2021), *Korean Photographs in the William Elliot Griffis Collection* (2019), *Teaching Korean as a Foreign Language: Theories and Practices* (2021), *You Call That Music?!: Korean Popular Music Through the Generations* (2022), and *Rereading Chang Lee Wook* (2022).

SUNGMIN PARK is Resource Description Librarian at Rutgers, the State University of New Jersey. She coauthored two book chapters on the Griffis Collection published in *Korean Photographs in the William Elliot Griffis Collection* (2019) *and Beyond the Book* (2022).